KU-432-570

Caroline completed a PhD in History at the University of Durham. She has a particular interest in the experience of women during the First World War, in the challenges faced by the returning soldier, and in the development of tourism and pilgrimage in the former conflict zones. Caroline is originally from Lancashire, but now lives in south-west France.

Also by Caroline Scott:

FICTION:

The Photographer of the Lost

When I Come Home Again

NON-FICTION:

Holding the Home Front: The Women's
Land Army in the First World War

The Manchester Bantams: The Story of a
Pals Battalion and a City at War

The Visitors

CAROLINE SCOTT

**SIMON &
SCHUSTER**

London · New York · Sydney · Toronto · New Delhi

First published in Great Britain by Simon & Schuster UK Ltd, 2021

This paperback edition published in 2022

1 3 5 7 9 10 8 6 4 2

Simon & Schuster UK Ltd
1st Floor
222 Gray's Inn Road
London WC1X 8HB

Simon & Schuster Australia, Sydney
Simon & Schuster India, New Delhi

www.simonandschuster.co.uk
www.simonandschuster.com.au
www.simonandschuster.co.in

A CIP catalogue record for this book
is available from the British Library

Paperback ISBN: 978-1-3985-0819-4
Audio ISBN: 978-1-3985-1457-7
eBook ISBN: 978-1-3985-0818-7

Typeset in the UK by M Rules
Printed and bound in Great Britain by CPI Group (UK) Ltd, Croydon, CR0 4YY

MIX
Paper from
responsible sources
FSC® C171272

For J & Z, as always. x

Huddersfield Courier, 13th May 1923.

NATURE DIARY

Note: Readers of this popular column will be interested to learn that our country diarist, Esme Nicholls, will be travelling to the southwest of England this summer.

While we will miss her observations of our own fields and footpaths, we are sure that Mrs Nicholls' dispatches from Cornwall will be of curiosity to readers. We look forward to learning more of the flora and fauna of the ancient land of King Arthur.

Chapter one

The girders of the bridge framed the view in geometries of light and shadow: a dazzle of white lines and wrought-iron angles, and the gleam of water below. Esme Nicholls stood up to see. There were luggers with red sails down on the river, little boats at anchor, and a ferry making the crossing, the waves in its wake like a thread drawn through silk. The train whistled and a cloud of steam billowed out, streaming on the wind. There was something declamatory about the whistle, and as the arches of the bridge curved away behind, Esme realised that they'd crossed the border. The rattle of the wheels on the rails changed – it quietened now – and she thought about Alec making this journey in reverse, the steam pulling in the opposite direction. It was strange to know that she was finally in his county. The memories he'd shared with her were the briefest sketches, just suggestions and fragments, but this place was in the sound of his voice and in his choice of words, in his looks and his manner, and, as such, it seemed to be an essential part of who he was.

Esme had closed her eyes as the Devon hedgerows slipped by, but now it was important to take in all the details. She

saw hawthorns twisted by the wind, embankments carpeted with cowslips, hedges that sparkled after the rain, and woods of beech and hazel. There were fields of sheep, tangles of fleece blowing on barbed wire, and a meadow full of rabbits that turned, paused and ran from the train. Bindweed wound around railings, and banks of willowherb billowed.

The train idled, for no apparent reason, between fields of barley and potatoes, and halted in country stations, where no one alighted or boarded. The engine hissed and Esme looked for a sign on a platform. Many of the place names sounded foreign when she tested them in her mouth. And who were all these obscure saints? She couldn't recall any of their stories from Sunday School. Of course, Alec would know these names. These landscapes would be in his memories, wouldn't they? He would be able to tell her the stories. But Alec wasn't here.

Ribbons of bright water cut through the mud of an estuary and the masts of sailing boats leaned at irregular angles. The shapes of oystercatchers punctuated the place between the land and the skein of light that might be the sea, and in the foreground wind-stunted oaks accelerated away. A rhythm of sunlight and shadow flashed across the window. Esme closed her eyes and saw flickers of Alec's face, but it was his photograph smile that she pictured, not memories.

The woman in the opposite seat was sleeping now, her clicking knitting needles finally stilled in her lap, and Esme was glad that no eyes were observing her as she considered what she might find of Alec here. Would she hear his accent

4

in the voices? His inflexions? His teasing humour? Would she see his dark eyes looking out from the faces of young men? Esme glanced at the woman opposite her, sleeping with her mouth in a slight smile, and remembered watching Alec sleep. She had spent hours watching him sleep. How could his eyelids have stilled and his dreams have ceased to be?

The train jerked. Esme caught her reflection in the window and licked her handkerchief to wipe smuts of soot from her face. Banks of bleached marram grass slipped behind her mirrored eyes, hummocky land that might once have been sand dunes, and then, breaking out through tall pine trees, there, at last, was the sea.

Beyond the glass, the Atlantic Ocean was oyster grey and glimmering pink. This was the sea in which Alec had swum as a child, she imagined, where he'd perhaps played in boats as a boy and helped to cast out his father's nets. She pictured his young, strong, brown arms in a glitter of sea spray and sunlight, and it was an enchanted image. But was it real? The roll of waves shimmered on the pewter water and she searched for a recollection of his voice, some words of his about the sea, but all she found were lines of other people's poems, and her reflection in the window was alone.

Esme contemplated the vastness of the sea's expanse beyond the curve of the horizon. Mentally spinning a school-room globe, she found the names Newfoundland and Nova Scotia. That was the next landfall, wasn't it? The crests of waves sparkled gold and the black silhouettes of gulls tilted around a boat. She suddenly felt very far away from home,

and far from him, and what would the next stage of this journey bring? Much as she would like to spend this summer looking for Alec, she would be in the company of strangers tonight. Esme wasn't certain what would be required of her in this house, and what sort of people she would find there.

'You mustn't be alarmed by their manner,' Mrs Pickering had cautioned, as the trunk was being loaded into the motor car early that morning.

'Their manner?'

'Gilbert is inclined to cultivate *eccentricities*.' Mrs Pickering had split the word into its syllables, which seemed to make it jagged and troubling. 'As other men take to collecting jade carvings or apostle spoons in their middle years, I'm afraid my brother accumulates bohemian sorts and outlandish opinions.'

'But Mr Edgerton is a perfect gentleman!' Esme had protested. 'I remember he played the piano with great tenderness when he last visited, and he named all the varieties of the hellebores.'

Gilbert Edgerton had been summoned to Fernlea for Christmas on a couple of occasions. Esme recalled a sandy-haired chap with excellent manners. He had carved the turkey with graceful proficiency and been most complimentary about her bread sauce. Gilbert hadn't struck Esme as a man inclined to outlandishness. She understood bohemians to be people who lived in garrets and subsisted on cheese rinds, who might burn their own poems for warmth and make up the rent through shady enterprises. Gilbert wasn't

that sort, was he? A libertine? A sensualist? Surely not. Not for the first time, Esme wondered if Mrs P perhaps enjoyed identifying improperness in her brother.

'Gilbert was brought up to be a gentleman, and at his core he's still tweed and toasted teacakes, but he does like to gather odd types around him, and they all rather encourage each other. Do you know, one of his acquaintances picked up his dinner plate and licked it last time I was there, and not so much as a raised eyebrow from the rest. Can you imagine? I didn't know where to look. I suspect that, like small children, they take a pleasure in shocking newcomers.'

Esme couldn't help noticing a certain relish in Mrs Pickering's voice as she recalled this shock. She had last made the journey down to her brother's Cornwall home two years ago, but she'd moved into a hotel after her first night. Some of Gilbert's rooms had no ceilings, she'd told Esme; many of the floors were missing boards and half of the roof tiles were off. When she'd realised that the bathroom facilities were a bucket in an outhouse, she had promptly decamped.

Gilbert now promised that the renovations were complete, and he could provide comfortable guest accommodation for his sister's convalescence. But how did Gilbert define comfortable? Could his yardstick for these matters be trusted? There had been some debate around this subject, and Esme had been instructed to promptly send a telegram if the house was still covered in scaffolding when she arrived. Until this morning, Esme had believed that she was being sent on ahead to assess bricks and mortar, bathrooms and bedding, but she

now wondered whether Mrs Pickering expected her to put etiquette in order too.

Esme knew that Gilbert had managed the family woollen business before the war, and that he had come home a company commander. He'd had a good war; that was what they said. Mrs Pickering had told her how Gilbert had wanted a change of scene afterwards, a period of recuperation in a kind climate, and he had gone down to Cornwall to paint watercolours. That wasn't outlandish, was it?

The guard looked in and touched his hat to her. 'The next stop is the last on the line, miss. Will you be requiring assistance with the trunk?'

'I will, if you'd be so kind.'

The train leaned, enclosed within the shade of trees again, and then Esme saw a golden bay ahead. As she looked out at the blond curve of beach and white breakers, she understood why men might feel a compulsion to pick up a paintbrush, the urge to capture the light through a tree, or a glint of the sea. The view beyond the train window wasn't so much a Turner, she mused – there wasn't nearly enough lashing and spuming going on – but it could be one of Constable's gentler seascapes. As she would be mixing with people of artistic sensibility, Esme had felt it worthwhile to familiarise herself with the pages of an art encyclopaedia. It seemed sensible to know something of the territory and the terminology. It was certainly picturesque, Esme thought as she looked out now: iridescent, elemental, an opalescent littoral light. She nodded at this selection of vocabulary.

As the train slowed, she saw lines of bathing huts in the bay and boats pulled up onto the foreshore. There were clusters of cottages curving around the coast and a rocky headland. The ocean was viridian, umber and ultramarine, while the wheeling seagulls were precise flicks in white chalk and black ink. She had never seen sea that was those colours before, or a sky so intensely blue. Indigo, azure, aquamarine, she thought – the words finding new meaning as she tested each in turn – cerulean, malachite and mother of pearl. Was there some peculiar quality to the light? Even the hues of her own clothes, the herringbone pattern of her travelling suit and the polka dots on her blouse, appeared to be brightened. It was like looking out through stained-glass windows or stepping into a tinted postcard. All of her imagined scenes of Alec's childhood suddenly flickered from sepia into colour.

Chapter two

Esme breathed in the smell of the sea, pulling the sweet, salty air deep into her lungs as her father had taught her during childhood excursions to Scarborough. She could taste it at the back of her throat. Dr Mangan had said that the sea air would do Mrs Pickering good, that it would be as fortifying as a tonic, and this now felt like sound advice. Esme shaded her eyes with her hand to cut out the glare. There were smart-looking houses on the hillside above, pink spires of valerian growing out of granite walls, and posters for day excursions on the platform. How curious that the taste of this wind, the scent of hot seaweed and the brightness of the light, all so unfamiliar to her, would have been the sensations of Alec's childhood. The sky was full of the noise of herring gulls, all tumbling caws and cries.

Having tipped the guards for muscling the trunk down onto the platform, she went to look for the promised driver.

'Excuse me. Could you be ...'

A man in a straw hat was leaning against a cart and dragging on a cigarette. He raised his hand to her in a non-committal way, or – she hesitated – perhaps he was simply yawning? The

gesture might be one and the same. The face in the shadow of the hat certainly wasn't Gilbert Edgerton. But perhaps he was one of the artistic types, Esme thought, noting the cerise handkerchief in his top pocket and that he was wearing odd socks.

'Good afternoon. Do forgive me, but are you possibly here to meet me?' she enquired, wanting to make a good first impression. 'I was expecting Mr Edgerton. Gilbert Edgerton? Are you perhaps here in his place?'

'I'm sorry to disappoint you,' the man said, though he didn't look particularly sorry. He had a wide, thin-lipped mouth, which seemed somehow sardonic, as if he was perhaps savouring a private joke. 'Gilbert is tied up. You'll have to make do with me instead.'

He was a tall, thin man. Esme supposed that slender was the word that best suited him. He was elegant too, in a raffish sort of a way, but she conceded that one begrudgingly. He made no effort to elaborate on who 'me' might be and she hesitated as to whether she ought to introduce herself.

'How do you do? My name is Esme Nicholls.'

'Yes, I know perfectly well who you are,' he said. 'You're Mrs Pickering's woman, aren't you?' He held out his hand, but his eyes were too busy elsewhere to meet hers. 'Garwood. Sebastian Garwood.'

His voice had a quality that might be called fruitiness in a stage review, and he drawled through his vowels. It was like a voice that one might hear on the wireless, only not quite so nice. If this man was presenting the evening concert, Esme thought that she might turn the dial.

'I expected that Mr Edgerton might be here with the motor car,' she said. 'I'm afraid that the trunk is an almighty weight.'

The cart against which Sebastian Garwood was leaning was of a rickety construction. An elderly man was inhaling hard on a woodbine at the reins. The horse was well past its gymkhana days too.

'The motor car is in Penzance with Gilbert. Perhaps you could look on this alternative as enchantingly rustic? This is Evans.' The elderly man turned, finally, and touched his hat to Esme. 'He'll get your trunk up.'

The arrangement was certainly rustic, but Esme wasn't convinced by its enchantment, or its practicality. She looked at Mr Evans. He was all of five foot and the wrong side of seventy. 'But it's heavy. *Terribly* heavy,' she emphasised.

'Well, I would offer to assist, only . . .' Sebastian Garwood waved a demonstrative circle with an ebony walking cane. He sighed and said, 'War wound.'

Esme nodded. Those words to which there was no reply.

Sebastian smoked another cigarette while the porters hoisted the trunk, and Esme occupied herself with a second round of thanks and apologies. She felt Sebastian's eyes on her now and again, rather too obviously sizing her up. Esme wasn't accustomed to being appraised by strange men, and she felt self-conscious and travel-soiled under the weight of Sebastian Garwood's regard.

'And that? Is that Mrs Pickering's too?'

Esme looked down at her suitcase. It was an imitation

crocodile-skin case that Alec had bought for their honey-
moon and stencilled with their initials. For Esme, it contained
memories of that week in Seahouses, but Sebastian's gaze
seemed to make it a poor and shabby object.

'My suitcase. I'll have it on my lap.'

With the trunk finally secured on the back of the cart,
Sebastian swung himself up and said, 'Well, come on then.'
It was an effort to clamber up with her suitcase. Artistic types
didn't have the most considerate manners, Esme decided.

The road from the station wound up a hill and Esme
looked down on whitewashed cottages. The rooftops were
all angles of slate and lichen, all mullet and mackerel colours,
and beyond there were harbour walls and a silver arc of sand.
The wheels of the cart clattered over cobbles.

There was an agreeable bustle to the town and Esme
took in the windows of butchers' and bakers' shops. There
were brass lamps in the doorway of a chandler's, a display
of children's fishing nets and kites outside the ironmonger's,
and a café advertising Lyons Tea. She saw posters for Kodak
cameras and the latest Mary Pickford film, antique shops and
a seashell emporium.

'How charming it is,' she said.

'If you like that sort of thing. It's all becoming touristic,
I'm afraid. Don't you think? It had a charming *naïveté* once.'
He pronounced the word with French vowels and a flourish
of fingers. 'Yes, it was insanitary and stank to high heaven
of herring, but it was authentic. Now it's all pasty shops,
postcards and souvenir seashells. People pile in on charabancs

all summer, types thronging in from Newquay with their Thermos flasks and broods of feral children. Sorts motor down from Swindon and Surbiton, wanting putting greens and tennis courts and holiday bungalows, complaining that the lanes need widening, and leaving their orange peel all over the clifftops. It will have lost all its truthfulness within another five years.'

'Truthfulness?'

'You know what I mean.'

Esme wasn't sure that she did.

In other company, she might have exclaimed at the quaintness of the quayside. Along the seafront, children were sitting on overturned hulls and digging in the sand. She saw piled ropes, chains and crab pots, floats and nets, and the returning tide glittering like a shifting, shattered mirror. A family was playing cricket further down the beach, the father with his trousers rolled up to his knees. The wind brought their laughter closer and then away. Boys were chasing and then retreating from the white edge of the waves. The afternoon sun pulled long silhouettes on the sand, picked out ridges and ripples, and silvered the serpentine curves of channels of water. Esme pictured Alec, the wind rifling his hair, making him boyish again, and his eyes narrowed to the sun. She lifted her face, tasted salt on her lips, and felt that same breeze shifting around her. She smelled tar and old ropes, rusted chains and sun-warmed seaweed. It was almost painful that she couldn't share these impressions with Alec.

'You're a widow, I suppose.' Sebastian Garwood's voice intruded on her reverie.

She opened her eyes and felt his examining gaze. Was it that obvious?

'Yes. I lost my husband during the war.'

It had been nine years since Alec left. It was seven years, this past week, since his death. Esme sometimes looked at men who had come home and considered: why had they been lucky? Why had they made it through while Alec had not? Was it only down to chance, to being in the wrong place at the wrong time, or did they have some substance that her husband lacked? She knew that it wasn't healthy to think like that, that it didn't do any good, but sometimes she couldn't help it. How was she meant to put her mind at rest when there were so many gaps in the story, so many scenes that it was deemed inappropriate for her to see? If she could ask questions, if she could better understand what had happened to Alec, she might find it easier to accept that word 'widow'. But Esme looked at the walking cane that leaned against Sebastian Garwood's leg and knew that she shouldn't, and couldn't, ask.

'Gilbert told me that his sister employed you as a gardener during the war. I'm trying to picture you being purposeful in khaki breeches, but can't get beyond scenes from Restoration comedy.'

'I was the gardener at Fernlea for three years.' Esme turned away from the scrutiny of Sebastian's heavily lidded eyes. She didn't want this man imagining her saying risqué lines in

trouser legs. 'Mrs Pickering has fine collections of euphorbias and peonies. It was an honour to look after the garden.'

'How bizarre. One saw such things in the picture papers, of course – girls posing with ploughs and pitchforks – but I always assumed it was pretend, just dressing-up box stuff, titillation for the camera and the morale of the masses.'

He rolled his 'r's through the words rather too pleasurably, Esme thought. 'No, I can assure you that it was very real.'

'But now you're back in your housekeeper's parlour, eh? Back in your place and with nice clean fingernails again. Is it a blessed relief, or do you dream of mulch and leaf mould?'

Back in her place? That was how they saw it, wasn't it? Esme would like to tell this man that she had certificates for pruning and propagating, that she knew the Latin names of all the plants in Mrs Pickering's garden, and that she could strip down, oil and rebuild the motor of a lawnmower. She would have liked to tell him that the garden had given her reason to get up in a morning, that it had been the only thing that gave her cause for optimism. It didn't do to carp, and one mustn't question one's lot in life, but how she missed the undisturbed sleep that only came with mental and physical exhaustion, and the sight of the first snowdrops pushing through.

'I am grateful for my place,' she said.

'Hmm,' Sebastian said, as if this dissatisfied him. 'No wonder young women take to gin these days and run amok.'

They turned away from the quayside, down narrowing streets. The granite houses seemed huddled together, as if

accustomed to wild weather or inclined to keep secrets. Many of the cottages had staircases up to the front door, small windows and tall chimney stacks. Laundry tugged on lines suspended across the street and cats skulked in the gutters. In this extraordinary light, the granite was not grey, but violet and rosy pink in the shadows. Even the whirligigging seagulls looked gilded.

The hill rose and they left the noise and animation of the port behind. Their pace slowed with the gradient; Esme felt the trunk shunt, and Evans clicked his teeth to the nag. She began to worry that the poor old beast might stall and stumble, sending them tumbling back down to the sea, with Mrs Pickering's bathing suits, evening shawls and gloves whirling all around them. Esme had packed the trunk carefully, folding garments in tissue paper, but Mrs P had kept opening it and adding to it, pushing in cocktail dresses, fur wraps and hats that were certain to be crushed. She'd even thrown in packets of wafer biscuits, a primus stove and a selection of tinned meats for emergencies. The image of Mrs P opening a tin of pressed ham in satin evening gloves didn't quite work. Was that the sort of thing one did in Cornwall?

Mr Evans, who didn't seem to be inclined, or required, to speak, swatted a fly from the back of his neck. Esme wondered, when Mrs Pickering came down at the weekend would she too have to sit on this splintering plank seat and watch bluebottles buzzing around a nag's behind? Was this the comfortable hospitality that Gilbert had promised? Esme pushed an image of a bucket in an outhouse from her thoughts.

The road climbed ever higher and the clouds gathered together as they moved into moorland. Somehow she hadn't imagined that Cornwall would have moors. She and Alec had often walked over the tops at home, following the old packhorse paths, looking down on the glimmer of the reservoirs, spotting curlews and merlins, but he'd never indicated that he recognised anything familiar in the landscape. Had Alec not seen that? Esme watched the shadows of clouds moving over the undulations of the land and fastened an extra button on her jacket.

'Gilbert usually likes to give a little speech about the fine moorland of West Yorkshire at this juncture,' Sebastian said. He drew his lips back over his teeth, but the smile didn't reach his eyes.

'It's true that we have handsome moors. They have inspired many artists and poets.'

'Indeed – and a Heathcliff in every homestead, I believe. All of that brooding and inter-breeding must get terribly tiring.'

Was he laughing at her? Esme turned away and watched the roadside brackens and foxgloves pass by. They were heading up into the clouds now and mist shifted over the crags on the horizon. She wondered if Sebastian wasn't perhaps a bit of a Heathcliff himself.

'Is the house in a village?' Esme asked.

'No. We enjoy our splendid isolation. Or we normally do, anyway.'

How much further west could they go? Were they not

already approaching the edge of the map? It was interesting to see tormentil and milkwort flowering at the wayside, and the shiny new leaves of hart's-tongue fern uncurling from a wall – she must make a note of that – but she wasn't enjoying being in the middle of a lonely moor with a man whose manners she couldn't predict. Did he feel that she was intruding into his splendid isolation?

'How formidable it is.'

'Isn't it? Magnificent, eh? Strange and savage. Gloriously uncultivated. A world away from all the tat and tawdriness.'

Whatever Sebastian's contempt for commerce and agricultural cultivation, Esme was glad to see the shapes of farmers' fields ahead, the lines of hedges and dairy cows. The sea was there to the right again, a hazy indigo now with the clouds parting above it, and then, in a fold in the moorland, she saw a church spire. The lane narrowed, the cart slowed as they approached cottages, and she breathed in the scent of new-cut grass. The houses were low and somewhat stolid looking, huddled around the church. Lichen yellowed the slate roofs and the feathery tops of pampas grass showed over granite garden walls. Esme smiled down at begonias in porches, lace-curtained windows and borders of hydrangeas and hollyhocks.

'Is this your nearest hamlet?'

'We're further on.'

Esme remembered that Gilbert's house was called Espérance, but she knew little of its precise co-ordinates, other than that it was situated some way beyond the last stop

on the train line. She recalled, from her schoolgirl French, that *espérance* meant hope, but she felt her faith flagging as they left behind the potted fuchsias and arrangements of petunias.

'Much further on?'

'Only a little.'

They made a sharp turn down a lane then, and there ahead, over an escallonia hedge, she saw a honey-coloured house with mullioned windows and trellised roses either side of the portico entrance. Swags of wisteria softened the symmetry of its frontage and its wholly tiled roof glimmered in the late afternoon sun.

'Here?'

'Yes,' Sebastian said. 'Our humble homestead. Is she not a picture?'

Was this the sort of house in which Alec might have grown up? Would he have had a garden with roses to play in as a boy, this scent of honeysuckle and the soft, golden light? Would he have been able to hear the sea in the distance when he closed his eyes at night, and have the hum of bees in the mornings? Esme hoped it might have been so.

'It's a perfect house,' she agreed.

Chapter three

Rory was working in the greenhouse when he heard them coming. The cloud of dust was there first, then the noise of the wheels and the old pony's hooves on the lane. Hal had been helping him tie up the tomatoes and pinch out the side shoots, a satisfying nip with the thumbnail, and he now pointed a forefinger that was stained quite green.

The cart pulled onto the drive and Rory could see the woman sitting next to Sebastian. She was wearing a black cloche hat and hugging a red suitcase on her knee.

'Ah, the deputation from God's own country. We'd better form a welcoming party, hadn't we? Are we presentable, do you think? Do we pass muster?'

It was humid in the greenhouse, hot and heady with the prickling red-green scent of tomatoes, and Hal's hair was sticking to his forehead in damp curls. He wiped his face on a shirtsleeve that wasn't entirely clean and smiled at Rory. He put a hand through his own hair and tucked his shirt tails into his trousers.

It's not Gilbert's sister? Hal wrote on his notepad.

'No, it's Fenella's housekeeper, a Mrs Nicholls, I believe. The formidable Fenella is following her down at the weekend. Mrs Nicholls is here to inspect us, I understand, to make sure that we're all shipshape and not doing anything that might offend Fenella's delicate sensibilities.'

Delicate? Hal underlined it.

'Well, quite. But apparently Mrs Nicholls is here to clap her hands and inspect beds and moral fibre.'

Hal drew an exclamation mark.

Rory nodded and wiped his hands on his trousers. 'Absolutely. I suppose we'd better head out and face the firing squad, hadn't we? Spit and polish, eh? Female beings amongst us – do you suppose it will change things?'

Hal shrugged.

They walked around to the front of the house as the cart was pulling to a halt by the door. Sebastian was giving Evans instructions in an unnecessarily loud voice, and Rory could see the woman's hat rotating.

'I was braced for a matronly harridan, but I might have miscalculated,' he said under his breath. The woman was perhaps in her late twenties and was pretty in a startled-nymph sort of a way. Rory could see dark curls under the brim of her hat, a neat nose and a pink mouth that looked like it wanted to ask lots of questions. 'The poor girl,' he said, turning to Hal. 'What have we done, exposing her to Sebastian?' He threw his cigarette away and raised an arm. 'The wanderer returns. What news from the outside world?'

'I met the postman on the lane.' Sebastian passed a handful

of letters to Rory as he swung down from the cart. 'More clamouring from your paramours?'

Rory looked at the handwriting. Did Sebastian have to give that impression? 'No. Standard monitoring letter from my mother.'

The girl sat straight-backed, with her hands folded over the suitcase on her lap. She looked marooned, sitting up there on the cart on her own. Rory recalled an etching of Marie Antoinette seated on a tumbrel being conveyed to the guillotine. She stared ahead, as if she wasn't sure what to do next. *Poor kid*, he thought.

'Couldn't you at least have put her suitcase on the back? Did you even offer?'

'She said she wanted the thing on her knee.'

Rory turned to the girl. 'Please, do let me help you down. I'm so sorry. What must you think of us? Can you forgive our manners – or lack thereof?' He offered a hand up to her. 'It's Mrs Nicholls, isn't it?'

'Esme,' she said as she took his hand. 'Thank you.'

It was a slim hand with tidy fingernails. It was rather pleasant to hold, but he spied Sebastian's eyes sliding and a grin on his face that wasn't entirely nice.

'I'm Rory.' He doffed a pretend hat. 'I am pleased to make your acquaintance. And this is Hal. We're glad to have you here.'

Hal made a note on his pad and held it out to her.

'Oh,' she said. 'How kind. I appreciate your welcome.'

She took her hat off and smiled up at him. Her eyes,

connecting with Rory's now, were large, intelligent and the colour of polished green agate. She looked like a young woman who was neat in her ways, but one lock of hair had escaped from its pins and bounced against her cheek as she spoke. There was something peculiarly beguiling about that ringlet of hair, Rory thought. A coral bracelet slid up her white wrist as she tucked the wayward curl back behind her ear.

'Let's get your luggage into the house,' he said. 'It will do us good to have some female company. It will make us wash behind our ears and sit up straighter in our seats. I do hope you will be happy here.'

She had a sweet smile, he thought, her mouth curled fetchingly at the corners, but he also briefly saw sadness in her face. It was just a glimmer, only a passing shadow, yet it made an impression on him.

Hell, why did he suddenly feel that he urgently needed to scrub his fingernails, brush his hair, and take the sadness away from this young woman's face?

Chapter four

Esme took Alec's framed photograph from the top of her suitcase. Holding it close to her face, she let her eyes linger on the details of his features. She sometimes liked to imagine him together with her parents, animating their photograph faces into a moving picture of an afterlife in which they were all gathered around a table and looking their best, with sleeked hair, healthy complexions and much to discuss. Esme occasionally thought that she would like to join them at that table, to step over to the other side and take the seat that would ultimately be hers, but could she be certain that it really existed? Were they truly there and waiting for her? Could she be *absolutely* sure? She wanted to be with Alec again, so desperately sometimes, to hear his voice, to grip his hand in hers, but she also knew that he wouldn't want her to throw her future away, no matter how unpromising it might presently look.

She was accustomed to seeing his face among the familiar objects on her bedside table – there, in its place, between the conch shell carved with the Lord's Prayer and her grandmother's broken length of jet beads – but there was

something different about looking at Alec's photograph in an unfamiliar setting. Here, taken away from the backdrop of her own bedroom, in a place where she wasn't yet sure of the routine, or her role, there was a newly unsettling sensation in connecting with Alec's eyes. She felt a small fresh stab of loss and questions suggested themselves in the angle of an alien light. She placed him down, carefully, on the nightstand.

Esme hugged her arms to her chest as she surveyed the room that would be hers for the next three months. Up in the eaves of the house, there was a view out over the garden and she was certain, as she opened the window, that she could hear the distant sound of the sea. The walls looked freshly whitewashed and the floorboards were toffee-dark and glossy with age. The light cast intricate shadows through the lace curtains, and there was a vase of sweet peas on the washstand, all shades of pink and rich purples. The scent of them was a memory of a garden that had once been her own.

She stood still and listened to the calming coo and purr of the wood pigeons. There was also a low hum of voices down below and then the young man with the red hair was running across the garden. She had noticed, as he took her suitcase and helped her down, that he smelled distinctly of greenhouse tomatoes. That scent somehow seemed to match his colouring; he had quite the reddest hair she'd ever seen. He had smiled at her with kind eyes, and after Sebastian's company, she had been glad of his kind words, but he had held onto her hand slightly longer than was necessary and there had been some awkwardness as to how to move away.

The coat hangers clattered as Esme opened the wardrobe doors. It was a big old mahogany wardrobe, with racks for ties and belts and gentlemen's shoes, and it made her summer skirts and blouses looked somewhat insufficient. She was reminded of the wardrobe that she had once shared with Alec, when there had been ties and belts to fill the spaces. Where were they now, she wondered. Whose necks and middles did they presently adorn? She had given most of Alec's clothes to Mrs Barton for the church jumble sale. If she hadn't been obliged to leave Marsden Road, would she have kept them? Would she still be bringing them close to her face and trying to breathe him in? Esme closed the door on the rattling hangers and pushed her suitcase under the bed.

The young man who'd been introduced as Hal had carried Esme's suitcase up the stairs and, together with Rory, they had hefted the trunk to the room that was intended for Mrs Pickering. Esme had followed them, apologising for the weight of the trunk again, and had seen it settled inside a room that was papered with a chintz print. She had noted the shiny brass bedhead and the general good order with approval. She wouldn't need to send a telegram.

She'd heard Hal make noises of exertion as they negotiated the trunk around the bend in the staircase, but he didn't speak. He was golden-haired and grey-eyed, a face that ought to have honey for tea and whistle blithely down a dappled lane, only no words issued from his mouth. Rory had a technique of communicating in sentences that only required a nod or a shake of the head in reply. When any more complex

27

response was called for, Hal reached for a notepad. He had looked at her through his eyelashes when, prompted by Rory, he'd held out a sentence welcoming Esme to Espérance. The writing was all tangled up with drawings of boats, and she'd found it hard to read. Sensing his shyness, she had felt awkward as her eyes lingered over his letters. Had he ever been able to whistle?

Esme tested the springs of the mattress and listened to the unfamiliar noises of the house: the gurgle of water in the pipes, a door closing and footsteps on a landing below, a sudden burst of male laughter, and the caw and claws of a seagull scrambling on the roof. If it rained, she would hear it pattering on the slate tiles, she supposed. But how peculiar to be spending a night in a house that was solely occupied by men. She had seen no female faces and now could hear no womanly voices. Did none of them have wives? Were there no other staff here? She noted, with some relief, that there was a lock on her bedroom door.

A china clock ticked on the little mantelpiece and she looked at the time. She thought of the black, slate clock in her room at Fernlea. It was one of the few relics from her grandparents' home, but it never kept good time. Her room in Fernlea always smelled slightly of damp (perhaps that was what stopped the clock?) and the plaster was crumbling behind the sprigged wallpaper. This sunny room was brighter, clean and comfortable, but it was shadowed by her own uncertainty. She poured water into the washbasin and put a cool, damp hand to her forehead and her neck.

Hearing a noise of feet on the stairs, Esme dried her hands and straightened her blouse. At least the final flight of stairs, which led only to this room, gave her some indication of people approaching, but must they take the staircase quite so fast? She stared at the door in the moment of silence that followed, knowing that someone was on the other side. She listened, and wondered whether somebody was listening on the landing too. It was some seconds before a hesitant knock came.

'I brought you up some tea,' said the voice on the other side of the door. 'I thought you might be parched after your long journey. I'm not disturbing you, am I? May I pass it around the door?'

'Of course. Thank you,' she said to the disembodied voice. It was a friendly voice, possibly Rory.

'I don't mean to be a nuisance,' he said, as he stepped around the door with tea on a tray. It was indeed Rory.

'Not a nuisance at all. It's very considerate of you.'

She smiled at him. But then – had he just winked at her? She looked away, suddenly feeling alarmed to be alone in a strange room, with a strange young man, who was winking. Only, was that really what it was? She looked at him again. No, it was something involuntary, a response he couldn't control, and which evidently troubled him. How terribly unfortunate.

'Most kind.'

'Not at all.'

Had he registered her noticing? Was the considerate thing

to maintain eye contact or to look away? Which would make him more self-conscious? Esme decided that she shouldn't look away.

'On here?'

'Yes, thank you.'

She watched him place the tray down on the chest of drawers. With his high cheekbones and widely set eyes, his face reminded her of an illustration from a folktale. He might be Jack the woodcutter, or Ivan who plucked the Firebird's tale, and could be handsome if he were tidier. His eyes were a light, brilliant blue, the sort of eyes that might be called *limpid* in the face of a romantic hero in a novel. And the colour of his hair wouldn't be quite so remarkable if it were smart, she considered, if it was short and neat, but instead it hung in curls around his collar.

'I hope you'll be comfortable in here,' he said. 'This room has a nice view of the garden, doesn't it? The house martins have been nesting under the eaves. Usually, when you come into this room you can hear them all chattering away, like gossiping neighbours over the garden wall. Most of them fledged last week, but they're still coming and going. When you see them up close, they wear little white stockings, like miniature Georgian gentlemen. They return to the same nests year after year, probably since before Gilbert bought the house. They might well have been coming back here for decades, generation upon generation. Imagine that, eh? It's meant to be lucky, isn't it? There's a line in *Macbeth*, but I can't remember it. We had

to keep washing the windows downstairs, but we'd never dream of evicting them.'

Esme liked him for the little white stockings and the way that he smiled as he made this speech. His teeth were very clean and even, she noticed. She turned her teacup in her hands and said, 'How lovely.'

Rory rocked on his heels, as if slightly embarrassed by his own sudden burst of loquacity, and Esme noticed that he was wearing leather sandals, like a gladiator, and how filthy his feet were. Beneath his scent of grass clippings and green-houses, there was also a distinctly masculine smell when he moved, and she was aware of his physicality. His presence seemed to fill the room and make it feel smaller. Esme sipped her tea and kept her eyes averted from Rory's feet.

'Anyway, if you need anything, Esme, please do ask.' He lifted his red eyebrows when he said her name, as if it amused him, but not in a teasing way.

'Thank you.'

'Gilbert should be back around six and we have dinner at eight. I'm sure he'll be glad to see you. He was most com-plimentary about your bread sauce and Christmas pudding. Righto, I don't mean to keep you from your unpacking, but if you need a hand with anything, do shout.'

With a nod, he was gone from around the door, and she heard his retreating footsteps on the stairs.

Esme drank her tea and looked out at the garden from the window. The smell of honeysuckle was rising and China roses stirred on the trellis below. Mrs Pickering had

explained that the house had previously been called Lane End Farm, but that hadn't quite set the tone that Gilbert sought, and so he'd changed its name. Espérance. Hope. Esme listened to the soft, complacent cooing of the wood pigeons. She remembered standing in the garden of 58 Marsden Road, nine years ago, and how that sound had seemed to be the very essence of contentment, a sound that said everything was safe and well in the world. But how little she had known then. How much she had taken for granted. The low afternoon light made a lantern of the linden tree, the dark red roses glowed and Esme tried to picture Alec's face in colour again. She knew that she couldn't bring him back, but she could hope to find more of him here, couldn't she?

Chapter five

Esme watched the clock in the hall. Having heard a motor car pulling up, she'd reasoned that she ought to present herself in one of the public rooms, but standing here now, with five closed doors before her, she wished that she better understood her role in this house, and the layout of its rooms. Mrs Pickering had said that this visit ought to be a change of scene for Esme too, a break from routine, but she wasn't exactly a guest, was she? What would be expected of her here? How should she behave? Mrs Pickering probably wouldn't appreciate how difficult it was to negotiate that ambiguity.

The walls of the hall were painted a sunny yellow, not at all a colour that any of their acquaintances in Mytholmroyd might choose, but somehow in this old house, in this mellow evening light, it didn't seem garish. An alcove was lined with sagging bookshelves and there was an upright piano under the stairs, a variety of hats tumbled onto the top of it, and a collection of abandoned boots gathered around its base. She would have paired the shoes up and stacked the hats, but was that her responsibility? Esme vaguely wished that an easily

intelligible charter of rules, duties and etiquette might appear on the yellow walls.

She felt sand grinding beneath the soles of her shoes, and there, in the light now, was a line of footprints across the flagstones. The sight brought back an image of Alec's feet running down a beach nine years ago and the memory of how she'd placed her own feet in his prints as she'd followed. That summer, her life had a momentum and a sense of direction. Esme had felt that she knew where she was going – only she'd got it all wrong. The glimmering footprints disappeared as the light shifted and the brief sense of Alec's proximity left with it.

'Are you hovering?'

Esme looked up. The voice had startled her. Sebastian was leaning in the porch, a cigarette in his hand, and blowing smoke at the garden. Had he been watching her through the open door all this time?

'Will you be sneaking around all summer, listening at doors and peeping through keyholes? Has Fenella instructed you to spy on us?' He laughed. He seemed to be both irritated and amused by this idea. 'You might as well go into the drawing room. It's the door on the right there. Gilbert will be down in a moment, but you can have a nice poke around until he arrives.'

Was that what they thought – that she was Mrs Pickering's spy? Why would he imagine that she might want to spy on them? She was too shocked to point out that he had been the one who was watching her.

Esme turned the handle and walked into a red room. She was glad to shut the door on Sebastian. Perhaps it would be easier here once Mrs Pickering arrived, but how was she to get through the next three days? Gilbert didn't believe that she'd be peeping through keyholes too, did he?

Esme stood with her back to the door and took in the room while she steadied her breath. It was as if the interior décor of this house had been taken from the colours of an artist's paint box. This was obviously not the residence of a town solicitor, or a respectable clerk, she thought, but neither was its aesthetic austere. It was clearly a home, and not just a statement for show. As she looked around, she saw that objects cluttered every surface in this room – seashells, antique silk slippers, painted birds' eggs, ammonites and African masks – all arranged without any apparent sense of order or meaning. There were dried heads of hydrangeas in vases, a jug of peacock feathers, butterflies in ebony frames and majolica plates painted to look like the bottom of rock pools.

Sebastian's accusations made her feel that she ought to sit in a chair and stare at her toes until Gilbert arrived. But she was only taking in her surroundings, wasn't she? On the walls there were paintings of clifftops, harbours and monoliths. Postcards were pushed in around the frames, reproductions of artworks and tinted views of Venice, Constantinople and Copenhagen. This room was full of other people's histories, passions and travels. There was so much to take in, so much that was curious and exotic. She recognised the man in the portrait over the fireplace, though. Gilbert Edgerton looked

down over the room, or, that is to say, an oil-paint version of Gilbert. He'd been refined to something rather more sleek and svelte and firm of jaw in this portrait; it was a burnished and varnished version of the man she had met two Christmases ago – and how alike, and unlike, his sister he was.

Crocheted blankets, patchwork panels and silk shawls were thrown over the backs of chairs and there were cushions that looked as if they might have been cut down from Persian saddlebags. There were so many patterns, textures and colours in this room, so many objects that must have meaning and stories attached. Esme supposed that it would take her a long time to learn the narrative that had brought all these artefacts and their owners together. She'd keep her eyes lowered in their presence, she decided, but she would like to know what had drawn these men to this place, and why they were so protective of their privacy.

A tortoiseshell cat was curled asleep on the windowsill (it had been camouflaged amongst all the clutter) and a grandfather clock ticked loudly, slowing the passage of time. There was a smell of floor polish and an aromatic scent, like nutmeg or cloves. Wisteria scrolled against the sky and tapped, very softly, at the window. It was like a house in which a children's story might be set.

Five men lived here, Esme knew. This room suggested that, five years on from the end of the war, they were living rich, colourful, complex lives. She imagined what her marital home would be like now if things had been different. What pictures and souvenirs would she and Alec have

accumulated? What travels and memories would they have made together? It was strange to think that these men might have crossed paths with Alec in France, that their histories and fates might have intersected. She knew that Gilbert had spent some time in the Béthune area. At some point over this summer, would she be permitted to ask him more about that? As Esme looked around this room, she thought that the war might never have happened – none of the objects here linked the lives of the house's inhabitants to that history – and yet its shadows were everywhere in her room at Fernlea. That didn't quite feel fair.

Alec had been in furnished lodgings when they'd first met. He wasn't meant to take women into his room – his landlady was particular about that – but Mrs Watkins had been at church that Sunday morning, and Esme had wanted to see where Alec lived.

She'd been staying with Lillian, her cousin, since she'd lost her father, and though Esme only had one room that was entirely her own, she'd filled it with objects from her parents' house and it felt like home. She had her mother's bisque milkmaids by her bedside, her father's rosewood candlesticks on the chest of drawers, and her grandparents' clock keeping time (or not) on the mantelpiece. Her room indicated the sort of people she came from, Esme realised, and perhaps suggested the person she aspired to be. She'd assumed that Alec's room would tell her who he was too, and so she'd been surprised by how entirely bare it was.

'It's tidy, I suppose,' she'd said.

'Isn't tidy a virtue?' He'd laughed. 'You make it sound like something disappointing.'

'It's so impersonal. It's like a monk's cell.'

'A monk's cell with flock wallpaper and the world's most lurid Afghan carpet?'

Esme acknowledged that the carpet was rather loud. 'Does it not give you a headache?'

'Permanently. Why do you think I'm so keen to sit in cafés with girls?'

Mrs Watkins' over-busy furnishings made the room seem to hum slightly, but as Esme looked around, she saw nothing of Alec here. There were no objects on any of the surfaces, no ornaments, no photographs, none of the clutter of a normal life.

'Did you tidy up for me coming? Have you pushed everything into drawers?'

'I didn't know you were going to inveigle your way in, did I? I wasn't expecting that. I didn't have you down as such a fast worker. Anyway, men don't have knick-knacks. It's a feminine thing, isn't it? We don't do vases and figurines, collections of thimbles, paperweights and whatnots. I think you'll find that applies in general.'

There was a small sink in the corner of the room, with a toothbrush and shaving paraphernalia on the side of it, a neat stack of papers and a pen on the desk, but those were the only personal possessions that Esme could see. There wasn't even a book by his bedside.

'Is it that you've not unpacked? Do you not feel settled here?'

'Hell, I wasn't expecting this scrutiny!' He blew his fringe up in the air and blinked wide eyes at her. 'I unpacked several months ago and feel quite settled, thank you. Will you not be satisfied until you've rootled out some secret collection of hatpins or china poodles? I brought a couple of pictures with me, thinking that I might hang them on the walls here, but I haven't got around to putting them up yet. Should I present the exhibits to the court in my defence?'

'Yes,' she said. 'I think that might be wise.'

As he'd reached inside his wardrobe, Esme saw that was orderly too. His shirts hung neatly, and even his pyjamas and handkerchiefs were crisply pressed and folded. Was this Mrs Watkins' motherly ministrations? It suggested a fussiness that slightly amused Esme.

'You might have arrived yesterday and be planning to flit tomorrow.'

'Well, you must galvanise me not to flee the scene.'

Alec produced a large paper bag from the wardrobe and slid two framed prints from it.

'Where are they?' Esme asked, as she walked them over to the light of the window. The thatched roofs and cottage gardens were tinted in pastel tones. 'Is this the village you're from?'

'I'm not sure they're any location in particular – they're generically, non-specifically Cornwall, ticking all the boxes to qualify as picturesque. They used to hang over my parents'

fireplace and were homely there, but they don't fit here some-
how. Perhaps they feel oppressed by the pattern of the rug?'

'Non-specific, but picturesque,' she repeated, and raised
an eyebrow at him. 'Is that you too?'

'I don't know if that's a compliment or an insult! Why do
I suddenly as if I need to prove myself to you?'

She was about to tell him that she'd merely have liked to
see a photograph of his parents and a plant on his windowsill,
but he'd laughed as he pulled her towards him.

They had moved into Marsden Road with boxes of napkin
rings, Staffordshire dogs and sherry glasses from her parents'
house, but almost nothing from Alec's side. It hadn't mat-
tered, though, because she'd had such pleasure in choosing
cutlery and china of their own, curtains, rugs and a bed-
spread. Esme had made their house into a home, and Alec
had never complained as she furnished around him. She'd
forgotten about his oddly anonymous room, accepting that
was what young men's rooms were like, as he'd said. It was
only afterwards, as she looked back, that she'd realised how
few possessions he'd had, and how little he'd talked about
the place he came from. She had kept the occasional glimpses
into his childhood like treasured photographs; but they were
just snapshots from a life, not quite in focus, disjointed and
insufficient now.

When Mrs Pickering had asked Esme to accompany her
on this trip, she'd begun to think about the possibility of
visiting the house where Alec had grown up. She'd become
certain that there'd be some comfort in being able to picture

him there, having all the details of the street right, and seeing the windows that he'd looked out through as a boy. She'd searched through his papers looking for an address, but there was nothing, and neither was there anything on file at the *Courier*. All that anyone recalled was that Alec had moved up from Penzance. So, three weeks ago, Esme had written to the office of the town clerk there. Would they give that information away, though? Would there be anything on record? As yet she'd received no response, but might she hear something before her stay in Cornwall ended? She knew, as she stood here, that she couldn't be more than five miles from the house that Alec had once called home.

Esme eyed the bookshelves while she waited for Gilbert. There were volumes of poetry, books on pruning roses and identifying wild flowers, on art, ancient cultures and Cornish folklore. Mrs Pickering said that you could learn a lot about a person from their bookshelves (though, as her own shelves were all light Georgian romances and the misfortunes of Victorian governesses, Esme had never been entirely sure what Mrs P meant to imply with that assertion). She looked along the line of titles and considered what she might deduce about this household. There was a predilection for antique nudes, but it might have been much worse.

'Do feel free to borrow anything,' said Gilbert Edgerton's voice from the doorway. Esme turned, wishing that she hadn't been caught so obviously examining the bookshelves. Would he tell Sebastian that he'd found her poking around? 'I

remember that we had a most interesting conversation about Thomas Hardy the last time we met, and whether he actually gets a kick out of torturing his heroines. What would that be – two years ago?'

He advanced towards her with his hand outstretched. It was a relief to finally see a familiar face and an uncomplicatedly friendly smile.

'Mr Edgerton, it's lovely to see you again. I'm so grateful to be able to accompany Fenella.'

'Gilbert, please. We're glad to have you here. It seemed the perfect solution.'

As Esme looked at Gilbert now, in his balding corduroy trousers and out-of-shape tweed jacket, she mentally drew a line through the word bohemian. She crossed out eccentric too. Apart from maybe being a little stouter, Gilbert didn't look any different than he had two Christmases ago. Would Mrs Pickering be disappointed by the lack of flamboyance and debauchery?

'Fen sounded much recovered when I spoke to her on the telephone last week.'

'Dr Mangan is pleased with her. He's confident that she's seen off the influenza, but he recommended deep breaths of sea air, a seat in the sunshine and rest. She gives such a lot of time to her committees. She quite exhausted herself this spring. The widows and orphans can be very demanding.' Esme heard her employer's words echoing in her own voice.

'Quite right. Mother always used to say that Cornwall did

wonders for her constitution. I'm glad you're here to provide a compassionate ear and a kind arm to lean on.'

Mrs Pickering had spent four hours in the millinery and mantle department of Thomas Kaye & Son at the weekend, so Esme couldn't really see her requiring an assisting arm, but perhaps she would like to give the impression of slight infirmity to stimulate some tender feelings in her brother?

'I've never been to Cornwall before,' she said. 'I've never been this far south. There were glorious views from the train. You had childhood holidays here, didn't you?'

'We did!' Gilbert said, with noticeable enthusiasm. 'Father used to take a house for July and August, and our summers were all crab sandwiches, saffron cake and dabbling in rock pools. There's something special about this part of the country, there always was – the light, the old stones, the space, the tranquillity. It's a rather charmed place to live. I hope it will work its charms on you.'

Esme remembered that she'd had a conversation with Gilbert about Alec two years ago. She'd told him how difficult it was to find peace of mind, to know acceptance and tranquillity. Had he recalled that? If so, she was grateful to him.

'It's a handsome old house,' she said.

'Isn't she a gem? I looked at so many properties that had been cruelly modernised, all the soul ripped out, but this old place had its wainscotings and ghosts intact. Please, do be seated. Do make yourself at home.'

Esme lowered herself into an armchair. A knitted blanket

was draped across it. Someone had clearly taken care to compose the folds, but she could feel where the stuffing was coming through the upholstery below.

Gilbert was stroking his beard when she looked up. He was leaning against the fireplace, and her eyes couldn't help but skip between his profile and his portrait. Was he expecting her to comment on it? Was this a deliberate pose? Esme wasn't sure exactly what she ought to say.

'You've got yuccas and bamboos, I noticed. Is that an agave by the gate?' It seemed a safe diversion.

'Isn't it super? We rarely have a hard frost and spring comes early here. I've chanced some banana plants and gunneras too,' he said, beginning to fill his pipe. 'I think May is the loveliest month, don't you? I've had such fun putting this garden together – it was nothing but gorse, brambles and the old orchard at the start, you know, but it comes on each year and I have grand plans for it. You'll be here for the most glorious season.'

Gilbert smoked a long-stemmed, cherry-wood pipe, which he might well have whittled for himself. It was the kind of activity that Esme could imagine Gilbert doing. She liked the woody scent of his tobacco.

'It looks so well established. It's hard to believe that you've only been here for three years.' The back garden at Marsden Road had been just a lawn and a hornbeam tree when she and Alec had moved in, and it had given her pleasure to create borders. She'd studied books from the library, sent off for seed catalogues, and had drawn out all the designs. She'd

kept those drawings, but it had pained her to leave the roses behind. 'I'd love to hear about your plans. I hope I'll get time to explore the garden.'

Would she have time to herself? Mrs Pickering hadn't been at all clear as to what the schedule would be here. Esme had inherited Mrs Webb's routine at Fernlea – Monday was laundry, Tuesday was ironing and mending, Wednesday was cleaning the silver, and so the weeks went round – but what would the order of her days be here? Would she have free time at the weekends?

'You must make sure that you find time. Fen is most keen that this should be a break for you too, that this visit should also benefit your constitution.'

'That's most considerate.'

Had Mrs Pickering said that to Gilbert? She had recently observed that Esme was looking tired and asked her if she was feeling unwell. Had Mrs P seen that she was in low spirits? The thought both touched and alarmed her.

'Anyway, Clarence has been marinating, sautéing and furiously whipping up great vats of mayonnaise in preparation for your arrival. He brought a bucket of crabs up this morning and you are our guest of honour this evening. Would you humour a chap in his advancing years?' he asked as he offered her his arm.

Chapter six

Esme had been dimly aware of noises coming from the garden when she was in the drawing room – the hum of the bees and the chatter of the sparrows through the open windows – but as they crossed the hallway now, she heard mingling voices and a clatter of pans.

'After you, dear lady.' Gilbert bowed with exaggerated gallantry as he held the door to the dining room.

From another man, this might have been teasing, mocking even, but Esme heard kindness in Gilbert's tone. It was most odd to enter the dining room on his arm, though, and to realise that she would be the only female at the table. Was this where she would be expected to eat this summer? Esme dined in the kitchen at Fernlea, at the scrubbed pine table, with Mrs Williamson and Dulcie. She only ate with Mrs Pickering in the dining room at Christmas and Easter, but was this the normal arrangement here? Was this the eccentricity of which Mrs P had spoken?

Down the centre of the room was a dark oak refectory table. This piece of furniture could have been salvaged from a monastery, but it was made homely with a line of

mismatched candlesticks and a froth of cow parsley in a jug, and the men seated at it clearly hadn't taken a vow of silence. There were carver chairs at either end and benches down the sides. Sebastian, Hal and Rory had been deep in conversation across the benches, but they curtailed their debate and stood as Gilbert ushered Esme to one of the chairs. He then took the carver at the head of the table, looking very much like a pope on his throne. How peculiar it was to face him from the opposite end of the table, almost as if she might be second in seniority. Rory smiled at her as she settled at his side. Who normally occupied this chair? Had one of the men been demoted? She hadn't yet figured out the hierarchy here. Esme knew that Gilbert had been the commanding officer of the men with whom he now lived, but what rank were Sebastian, Hal and Rory? It was a pity they didn't have helpful stripes on their shoulders. She hoped she hadn't ousted Sebastian from this seat and given further cause for offence.

'Introductions, eh?' Gilbert said. 'Sebastian you know, of course, Hal, Rory.' His hand picked out each man in turn. 'But you haven't met our estimable chef yet, have you? Here's the chap himself!' The swinging door revealed a red-faced man carrying a laden platter. 'Esme, this is Clarence.'

He placed his load down on the table and offered her his hand. 'Clarrie, please. Everyone calls me Clarrie. I'm only Clarence when I'm in trouble with my mother.'

Was this man their cook? The way he leaned an arm on the table and downed a glass of water suggested that he wasn't

47

staff. Was he another of Gilbert's artists doubling up as a chef? It was all most confusing.

'You'll meet Miles as well this summer,' Gilbert went on. 'He was one of our cohort, but I'm afraid that he's absconded.'

'He took a wife,' said Sebastian. 'Most improper.'

'A cardinal sin.' Gilbert nodded, but then hesitated. 'Are cardinals allowed wives? Anyway, he's promised to bring his inamorata down at some point this summer, so you'll have met the full fraternity before you depart. I do hope you'll enjoy yourself.'

Gilbert was treating her quite as if she was their equal, inviting her to play her part in the to and fro of conversation and call these men by their Christian names. How was she to negotiate this etiquette? Esme wasn't accustomed to male company – yes, she spent her Saturday afternoons with Mr Maudsley, but that wasn't at all the same thing. He was just Albert Maudsley, who insisted on planting the annuals in symmetrical patterns, took a pride in overwintering pelargoniums, and who had come back from the war with white hair. He was someone with whom she could speak on an equal footing; after all, they had done the same job, earned the same wage, and she didn't especially think of him as a *man*. They talked about eliminating aphids and improving compost together, and how his wife was a martyr to varicose veins. That was entirely different; there was no difficulty there, no ambiguity, but Esme didn't know where she stood with these men and how she was expected to behave.

'Thank you,' she said, uncertainly.

The platter that Clarrie had placed on the table was like a still life of garden bounty. Radishes and baby tomatoes were nestled in salad leaves, and there were slices of beetroot and cucumber, blanched beans and crescents of fennel.

'*Un antipasto italiano.*' Clarrie nodded at the table. 'Only slightly anglicised, and *bagna cauda*. Are you familiar with it? Its origins are in the mountains of Piedmont, I believe, though I learned it in a brasserie off the Boulevard Saint-Michel. It means hot bath. You dip, you see?'

'*Eccellente!*' said Gilbert. 'Please, Esme – ladies first.'

Esme felt distinctly self-conscious as she helped herself to vegetables and then was observed by the whole company while she dipped an exploratory radish. But Gilbert nodded, said, 'Just so,' and the sauce prickled sharp and salty on her tongue, warm and oily against the cool crispness. When she looked up again, they were all helping themselves, all hands were dipping in the bowl, and so her self-consciousness abated – but was it quite nice that they were all submerging their salad items in a communal font?

'Every last leaf is from our own patch,' said Gilbert, oil glistening in his whiskers. 'I'm a herbaceous border man myself, as you know, but Rory is a wizard in the vegetable garden. What he can't achieve with a pitchfork and a cartload of well-rotted manure!'

She caught Rory's eye, and he looked down at his plate, smiling rather shyly. Esme wasn't at all surprised if he was embarrassed; she couldn't disagree with the method, but manure was hardly a word for the dining table.

'Gil might have nothing to do with the vegetable garden, but he does like to keep a note of the weight of the potatoes and apples that we harvest.' Rory waved a baton of cucumber as he made this caveat. 'He logs all the numbers in a journal and boasts about our economies.'

'And I have every right to boast!' Gilbert laughed.

'We had a vegetable garden at Fernlea,' Esme said. They seemed to want her to contribute to the conversation. 'It's all been lawned over again now, but I used to find it satisfying. We were pretty much self-sufficient.'

'I look forward to giving you a tour of the garden here and comparing notes,' Rory said.

'I should like that,' she replied.

Esme looked away as Rory's eye started twitching again. The tic made him blink hard and, once it started, he appeared to find it impossible to stop. He blinked like he was concentrating, like he was about to make some profound or heartfelt declaration, but it was clearly involuntary, and she pitied him for that.

'As well as feeding our bellies and our souls, our garden also slakes our thirst. Do pass the jug down to Esme, won't you? This is our *vin ordinaire*. Only it's not actually *vin*, or particularly *ordinaire*. It's cider,' Gilbert elucidated, 'from our orchard.'

'You simply can't trust the water,' said Rory, taking the jug, his expression suggesting that this was an often-rehearsed line.

'Safer than the water, but it has a mule's kick.' Clarrie raised a cautionary eyebrow.

Cider was a drink that rosy-cheeked rustic types imbibed

in paintings, causing them to fall into untidy slumbers under trees. She mustn't be doing any of that. Esme's days of care-free tipsiness were long gone and she sensed that she needed to keep her wits about her in this company. She shook her head at Rory. 'Thank you, but I won't. I'll risk the water.' She noticed that Gilbert wasn't drinking the cider either.

'So you're a killjoy as well as a snitch?' Sebastian observed. 'What a frightful bore this summer is going to be.'

'Steady on,' said Gilbert, his voice raised and that of an officer suddenly. 'That's well out of order. Am I a killjoy too?'

The table silenced for a moment. As Esme looked around, they all seemed to be staring at their glasses. She felt the tension in the room. Sebastian pushed his chair back and looked as if he might be about to walk out.

'Go on, then,' she said to Rory. She felt she needed to do something to break the atmosphere. 'I'll try it. I don't want to be a bore.'

'You shouldn't feel obliged,' Gilbert said. 'No one should ever feel obliged.'

Sebastian mouthed something that Esme didn't catch. He downed his glass and glowered, but Gilbert put a hand to his shoulder. His lip curled like that of a chided child.

Rory cleared his throat. 'Some of the trees in our orchard are very ancient,' he told Esme, turning towards her and starting to fill her glass. 'We did a wassailing ceremony on old Twelfth Night last year. We drank the health of every tree and drove the evil spirits out with our god-awful singing.'

She smiled at him, glad to feel the tension lifting. 'What

fun that sounds. You're very lucky to have an orchard and to live in such a lovely old house.'

'It's heaven here in summer,' he said, 'but it's perishingly cold in the winter.'

'I'm afraid it's true,' said Gilbert. 'The walls might look solid from the outside, but the wind finds all the gaps.'

'We wear gloves and overcoats in the house, and go days without washing,' Clarrie added, with a little too much enthusiasm.

'We huddle around the fire and toast crumpets on forks,' Rory went on, something like fondness glinting in his eyes. 'It's companionable.'

As Esme looked around the table, it struck her that their conversations wove together like those of a family. They even seemed to have the occasional spat like a family. Is this how it had been for men out there in France and Flanders? She had never imagined that Alec might have toasted crumpets with his senior officers, but was this the way they'd talked over there?

'Renovating the house has been a labour of love,' Gilbert continued. 'We're slightly rough around the edges still, but we have most modern conveniences now, and we've learned plumbing, plastering and roofing along the way. It's been a collective endeavour, and that's the way we like to work. The kitchen is Clarrie's domain, but beyond that we all muck in together, you'll find. We're a co-operative and an enlightened democracy, are we not, my dear boys?' He cast a beneficent look around the table, letting it linger

particularly on Sebastian. 'All rank abandon ye who enter here, et cetera.'

Abandon rank? This is what Mrs Pickering had alluded to, Esme realised. These sentiments might be laudable, but it was hardly practical. How was one meant to know how to act, how to speak, where one fitted? It was different for them; they were men, and not in receipt of a salary from Gilbert's sister. To Esme this seemed like a system full of potential traps and trip wires. And how on earth was she meant to handle Sebastian's volatile temperament?

'Yes, we have a flushing toilet now!' Clarrie pronounced. 'The geyser and the bathroom suite were put in last year. It was an outside lav before, and we took turns in a tin bath in front of the fire.'

'Goodness,' said Esme. She was relieved that the promised bathroom facilities were real, but should she really be talking about lavatories and bathtubs with five strange men?

Clarrie wore round horn-rimmed spectacles like Harold Lloyd, and when Esme looked at him in profile, she could see how thick the lenses were. He laughed a lot, a wholehearted boom of a laugh, and he had the sort of London accent she'd heard from comedians in music halls. It was noticeable against Gilbert and Sebastian's educated voices. There might be no rank here, but these men clearly had diverse backgrounds. Esme wondered what had brought them together and what kept them here.

'I'm afraid that we do have to share, though,' Gilbert apologised. 'Not the bathtub, I mean, but the facilities. To have

a formal rota would be authoritarian, I feel, but we do have to do some negotiating over bath days and the practicalities of heating the geyser.'

'Of course. I understand,' said Esme. How long would she have to wait for a slot on the not-quite rota? When would her appointed day arise?

'It's my turn tomorrow, but you can take my place,' Rory offered. 'I can have a swim instead and you must be longing for a soak after your journey.'

'That's very kind of you.'

His arm was next to hers on the table. He'd rolled his shirt-sleeves up as far as his elbows and she could see the line where the sun had tanned his skin. They were strong-looking arms and he had the sort of capable hands that would know how to fix stopped clocks and broken china. She thought of Alec's hands, his bitten-down fingernails, and always a smudge of ink on his second finger. Esme remembered the feeling of his fingers linking through hers, his arms around her, and the smell of his warm skin in the sunshine. She looked down at her plate.

'What else do we need to tell Esme?' mused Gilbert.

'You must be careful of the locals,' Rory said. 'You've heard the stories about wreckers and smugglers, haven't you?'

'Surely that's only in novels?'

'You think? We have a whistle and a truncheon that we usually lend to lady visitors. Just to be on the safe side.'

'You are joking?'

His face cracked. 'Of course, I'm joking!' He grinned at her over his glass.

Esme considered, is this was what life was like in the dormitories of boys' schools? Did their mothers still send them parcels of fruit cakes and socks? Did they whisper to each other at night and have secret jokes, and songs, and codes? Would she be permitted to hear the whispers and learn the codes?

'Thank you,' she said. 'I'm grateful for the cautions and the practicalities.'

Rory stood to light the candles and the ceremony of it made them all fall silent for a moment. Esme watched the flames dip and then draw longer. The glow of the candles made an island of the table and seemed to bring the faces around it closer together. Light flickered on the ceiling and the rest of the room was pushed back into shadow. All the tensions seemed to have gone now. Rory shook out the match, and she let him refill her glass. He blinked blond eyelashes in the candlelight.

They all ate with great relish, Esme noticed, as the platter circled the table a second time. With the exception of Hal, that was, who spent much time carving his food up into small pieces. Did the issue that silenced his voice also limit his appetite? His eyes flicked down every time she looked in his direction. She thought it sad that he wasn't able to participate in the conversation. Other than when Rory made an effort to involve him, he appeared to be shut away in a private world.

Apart from the dipping, which might be Continental, but which didn't seem entirely polite or hygienic, their table manners were mostly conventional. The crudités were

followed by dressed crabs, then a rhubarb tart with clotted cream. Gilbert talked about how Clarrie had worked in restaurants in Paris and had a genius for pastry and sauces. There was proper use of cutlery, Esme observed, sparkling glassware and laundered napkins. The cruets looked as if they'd been recently polished and lemon slices floated in finger bowls. Which one of them had licked his plate in front of Mrs Pickering? Had they misbehaved expressly to provoke her? Would they do it again?

The volume of the conversation rose as the meal progressed, laughter rang out and the cider jug was refilled. Esme noticed that Gilbert stuck to drinking water, but the cider really was very pleasant.

'How did you come to work as a gardener?' Rory leaned towards her and smiled as he inclined his head.

'I grew up following my father around the borders at home. It always gave us great pleasure to see the seedlings coming up, the blossom breaking on the plum trees and to pick the first peas. He knew all the Latin names and he'd clap his hands with pleasure when I remembered them.' The other men were occupied in a conversation about a portrait that Sebastian was painting, so only Rory heard her words, but why did she feel that she could tell him this? 'I worked in a museum after I left school, but I was expected to leave when I got married. I saw Mrs Pickering's job in the classified adverts and the idea of fresh air and physical work appealed at the time. I think it amused her to employ a woman. She seemed to enjoy telling people that she'd taken on a female gardener.'

'I can imagine Fenella making much of that.' He grinned and showed his nice teeth again. 'I bet all her charity committee ladies wanted an Esme too.'

'Mr Maudsley had finished in the February, so there was a lot of work to catch up on, but it gave me great satisfaction. Maurice, Mrs Pickering's late husband, collected hellebores and euphorbias, it was his passion, and so it was important that they were cared for. It was more than just a collection of plants, you see?'

It was a pleasure to talk about the garden again and to voice why it mattered. She was aware that the cider was loosening her tongue, but Rory listened attentively, and appeared to be genuinely interested. She felt entirely at ease talking with him, and there was a respite in stepping back from the noisy conversations of the rest of the table. She sensed a sincerity in him, a sympathy, and she liked it when he smiled with his eyes.

'It's a bit odd to have gone from being a gardener to a housekeeper, though,' he said. 'I imagine those to be two very different lives.'

His voice was low and gentle, and there was something familiar in its tone, something that Esme recognised, but couldn't quite place.

'I never intended to become a housekeeper. The idea of me being in service would horrify my mother.' She couldn't help but smile as she said it, but should she admit that to him?

'How did it happen?'

'Mr Maudsley came back. Mrs Pickering had offered to keep his position open for him, and she couldn't renege on that. Then, when Mrs Webb announced that she wanted to retire as housekeeper, I was offered her job. It's not what I expected to be doing, but I'm grateful for it.'

Life was now a weekly cycle of dusting and polishing, errands and tradesmen, planning menus and Mrs Pickering's wardrobe. Mrs P told her that she was dependable, sensible and capable – but were these the virtues that her sixteen-year-old self would have aspired to? At the grammar school she'd been taught by women who had fought for their education, and an imperative and urgency had been threaded all through those lessons. What would those women think of the choices she'd made since leaving school? Life was now routine, steady and secure, but it was a long way from the challenging and stimulating life she'd been taught to expect.

'Do you miss working in the garden?'

'I do. I'd recently lost my husband when I started at Fernlea and I found some solace in the work. The needs of the garden demanded my attention. Every day there were tasks that I had to focus on, and somehow there was a comfort in watching the seasons turning.'

She hadn't said that aloud before, hadn't previously confided those feelings to anyone. What made her think that this man, who she hardly knew, might understand? But he nodded his head and she sensed that he did.

'I'm sorry about your husband,' he said.

*

As they leaned back in their chairs and took to cigarettes, Esme excused herself from the table. It was a long time since she'd had so much to drink and she was starting to feel slightly woozy. Clarrie had observed that she seemed to be getting the hang of cider, and though he'd said it in a friendly voice, she'd suddenly felt embarrassed. Esme reminded herself: she'd been sent here to work and she ought to be showing these men that she could be useful to them, shouldn't she? As she stepped into the kitchen she took in a chaos of soiled pans and dirty dishes. Clarrie might know how to make a marvellous sauce, but what disorder he left in his wake. Did they have a woman come in, a daily help, or did they do their own washing up? For all of Gilbert's talk of mucking in, she couldn't picture the group of them clustering around the sink with dishcloths in their hands.

Esme looked around the room as she rolled up her sleeves. There were racks of copper pans on the walls and a book-case full of culinary tomes with French titles. *Almanach des Gourmands*, Esme read along a spine, and *Le Pâtissier Royal Parisien*. The hop garlands hung along the beams gave the room a sweet, musty scent and there was a jug of lilac blossom on the table. The kitchen at Fernlea always had a vague smell of gas and cabbage. Esme couldn't recall that there'd ever been flowers.

'You left us,' said Clarrie from around the door. 'Were you bored?'

She turned to him and smiled. 'No! Not remotely. I just thought that I ought to make a start on the dishes.'

'Oh, these things can wait.' He waved a dismissive arm at the sink. 'That's not what you're here for. We'll do it together in the morning.'

How much more difficult it would be in the morning. It would all have hardened to a nasty varnish on the plates and how terribly unpleasant the smell of the crab shells would be. This seemed rather slovenly to Esme, but was she in a position to question these practices?

'Perhaps I could at least rinse and stack the plates?'

'Absolutely not! I won't hear of it. I insist that you come back and take a *digestif*.'

Clarrie's eyes crinkled genially when he smiled, and Esme allowed herself to be led from the kitchen, but she couldn't help picturing Mrs Pickering's raised eyebrow. How was she to navigate these standards?

It had become warm in the dining room (or perhaps it was the apple brandy that made her cheeks glow?), so Esme decided to step out and have a breath of air before taking the three flights of stairs back up to her room.

The light from the dining room windows spilled into the garden, casting golden rectangles onto the extinguished colours of the roses. She stood and listened to the men's voices, the amicable rise and fall of their conversation. The earlier tensions had gone, but she clearly hadn't made an ally of Sebastian, and she had already realised how swiftly the mood could shift here. It was because of Sebastian's words that she'd let Rory fill her glass, and keep on refilling it, but

every night wouldn't be like this, would it? She felt she hadn't behaved entirely properly, it wasn't the start she'd wanted to make, but then how was she meant to fit in here? Esme felt far away from home, and all that was familiar, and had no idea what the next three months might bring.

As her eyes adjusted, she discerned layers and shapes in the darkness; the branches of the magnolia against the ink-blue of the night sky, the glow of the viburnum blossom, and the pricking of stars. A scimitar moon was tangled in the treetops and she breathed in the scent of lilac and wisteria. It was like the garden itself was sighing. She was aware of the scurry of creatures too; the shapes of bats flitted and curved, the wings of unseen moths purred, and everywhere the rasp and rustle of insects.

'Listen,' somebody said. Rory's voice was there suddenly at her side. Esme couldn't see him, but sensed his movement.

'I think I can hear the sea.'

'Yes. It always seems louder at night, like it creeps in closer. But there's something else there too. Listen,' he said again. 'Listen for the notes.'

It was there then, as he said it. It was like a musician tuning up a flute at first, that repetition of the same long note, once, twice, three times, and then a liquid tumbling and rising through the musical scale.

'Is it a woodlark?'

This night-time birdsong was like nothing she had heard before. It was insistent, compelling, sounded to be so close by, and yet Esme couldn't pinpoint which direction it was

coming from. She felt an urge to crouch down so as not to break the moment.

'A nightingale,' he whispered.

'Are you sure?'

'Yes. Positive. I heard them in France. They're not meant to be in Cornwall, though. They're not meant to come this far west.'

'I was going to say that it's a joyful sound, but I'm not sure now. Is it joy or is it sorrow?'

'Her wings would tremble in her ecstasy, and feathers stand on end as 'twere with joy, and mouth wide open to release her heart of its out-sobbing songs.'

'What's that?' She could just make out his profile now and the glint of his eyes. 'Is it a poem?'

'John Clare. You must read it. I'll lend you the book. In ancient Persia, they believed that nightingales pressed their breasts against rose thorns as they sang. They loved the roses so much, so passionately, that they pierced themselves upon them. A sort of an exquisite, ecstatic agony.'

'A song of painful love?'

'It's a romantic notion, isn't it?'

Esme remembered a young man with dark eyes who had once whistled tunes for her, who knew poems and legends, and who had passions. Just for a brief moment, it could have been his voice speaking out of the night.

'Yes,' she said into the darkness.

Chapter seven

Her first task of the morning was to lift the lid of Mrs Pickering's trunk. The clothes inside had creased, and Esme supposed it hadn't helped that she had sandwiched her holiday attire with layers of periodicals and romantic novels. As she unpacked and hung garments to straighten on hangers, she contemplated the colours of Mrs Pickering's summer dresses, and thought how dull her own wardrobe was. When had she started wearing brown and grey? She supposed it was after she stopped wearing black, but couldn't recall that it had been a conscious decision. All Esme's clothes were sensible, everything was respectable and neat, but what insipid feathers she wore these days. Next to Mrs P's peacock colours, she was a dusty sparrow. No wonder Sebastian had supposed she might be a bore.

A few weeks ago, Mrs Pickering had observed that Esme was looking thin and that her hair was losing its shine. She ought to give a little more care to her appearance, Mrs P had suggested, and perhaps she might make herself some new cheerful outfits for the summer? Esme knew she meant to be kind and encouraging, but it had smarted. A woman

of limited means, and some disappointments, has restricted options. With all her charitable work, Mrs P really ought to appreciate that. These days, a treat was a scented bar of soap or a length of ribbon; that was as far as it extended.

'We can't all be peacocks,' she told her reflection in the wardrobe mirror. And, after all, she was here to work, wasn't she? It wasn't her job to provide stimulating and glamorous company for Sebastian Garwood.

Esme opened the window and breathed in a scent of salt and roses. She might be a seagull up here, looking over it all. She imagined what it would be like to swoop out of the window, over the fields and out to sea, how it would be to look down on the paths and the waves, and to lunge on the wind, fluid and free, with no restrictions but the power of her own wings and whims. She missed having her own space, her own time, the freedom to make her own decisions far more than she missed having new dresses.

As Esme looked down, she remembered standing out in the moonlit garden with Rory. The birdsong had held an odd enchantment. She had felt a confusing rush of both longing and joy in that moment, and the memory of it was unsettling. Was it foolish to have stood out in the dark with a stranger? Had she told Rory too much last night? After the tensions with Sebastian, she'd felt relieved to have his relaxed company, to recognise the friendliness in his eyes, and to hear the warmth in his voice. He was very easy to talk with, and she'd found herself wanting to share thoughts and experiences with him, and to see him smiling in response to her words. But

she shouldn't want that, should she? That wasn't appropriate. She must beware of cider.

The sun cast slanting shadows across the floorboards and illuminated the pattern of the curtains, which billowed slightly on the breeze. It was a pleasingly feminine room with its chintz walls and rosy counterpane. There was a painting of fishing boats in a harbour over the bed (too modern for Mrs Pickering's taste), a framed sampler stitched with the words *I Shall Not Want* and a watercolour of a vase of peonies shedding their petals. Esme tested the springs of the mattress, sniffed the sheets and plumped the pillows. She ran a finger along the skirting boards, and the top of the wardrobe and was pleased to find that someone had dusted this room with commendable thoroughness. To most people's standards the house was clean, and they'd clearly made an effort, but Mrs Pickering could be unpredictably exacting. Esme would need to scrub the limescale from the bathtub and the rime of salt from the windows. Could she beat the sand from the rugs without insulting Gilbert? She leaned out of the window, her elbows on the sill. Somewhere among all the subtropical splendour and productive vegetable beds was there such a humble thing as a washing line?

Esme stepped out into the garden. The honeysuckle was full of coral-pink curlicues of blossom, and she breathed in its sweet, dewy scent. She closed her eyes to the dazzle of the sunlight, and for a moment she was back in the garden of 58 Marsden Road, making plans for lupins and aquilegias,

listening to Alec turning the earth with a pitchfork. They had so many good intentions that first summer, but by the autumn he had gone, and she had missed him working at her side. She lingered a moment longer and listened; she could hear the strike of an axe on wood on the other side of the house, the sparrows and the bees, and a call and reply of cuckoos. Esme opened her eyes and walked on into the uncertain here and now.

There was a line of hydrangeas in front of the house, opening in shades of mauve and soft baby blues. It gave way to a lawn, freshly striped by a mower, and surrounded by mixed beds. It was a blousy cottage garden, with hollyhocks, snapdragons and sweet peas coming on. The colours shimmered in the warming air.

The far side of the garden was different. There were tropical plants here, shapes and colours that she'd only previously seen in catalogues. She recognised bamboos, palms, myrtles, aloes and banana plants, but there were other varieties to which Esme couldn't pin a name. Those lush leaves might have come from a jungle, and these flowers could have been plucked from a Chinese vase, or an Indian shawl. The knowledge that these plants would be far too tender for the garden at Fernlea made her once more feel far from home.

She followed a brick path between beds of camellias and calla lilies. A white clematis scrambled through a gnarled pear tree, and light broke and shifted on the path ahead. In the distance, on a less manicured lawn, she could see Gilbert occupied with boxes in his arms. He placed them down with

noticeable care and then stood with his hands on his hips sur-
veying a brick structure. It had a chimney on top and looked
as if it had been blackened by a fire. Was it a smoke house of
some sort? Whatever he was occupied with, it seemed to be
serious business, and she decided that she probably shouldn't
intrude. It wasn't the time to request a tour through the tax-
onomy of the flower beds.

She walked around the side of the house. At the back was
the vegetable garden. Esme followed a path between raised
beds and saw broad beans and French beans, rows of peas,
potatoes and lettuces, raspberries, gooseberries and black-
currants. There were lines of marigolds planted between
the cabbages, nasturtiums twined between the beans, and
lupins spiked among the rhubarb. There was something
whimsical, a charming folly about these candy-pink spires.
She could smell turned earth, mint and lavender. The scents
were stronger than in the garden at Fernlea somehow,
the colours more intense, and everything was gilt-edged
by the sun.

Esme felt the warmth of it on her scalp and realised that
it was a long time since she had sat in a garden and simply
breathed, and listened, and noticed the heat of summer on
her skin. Her hands had been stiff with cold that winter, but
the sun seemed to soften her joints now. It made her feel taller
and more supple. She stretched her shoulders and breathed
deeply. The heat, the colour, the scents seemed to awaken
her senses; until this moment she hadn't been aware how
much she'd missed having the space just to pause, to listen

and look and feel, but she took it in now like gulps of sweet, cool water after long thirst.

Beyond the greenhouse, she could see the orchard. The old trees leaned, showing the direction of the prevailing wind, and she recognised Rory at the far side, swinging an axe over a large pile of wood. He was absorbed in his task and didn't notice as she walked towards him. She watched him work, the lift of his arms, and the satisfying clunk of the split wood, and it seemed efficiently done. There was a grace to the way he moved, she thought, a liquid ease, and that made his facial tic all the more striking. The rest of his body suggested that it shouldn't be that way. Esme wasn't sure that she ought to disturb him, but then he stilled and leaned on his axe as he looked towards her.

'Sorry! I should know better than to distract a man swinging an axe.'

He was wearing a fisherman's jersey and might well have washed in with the fleet, but his boots were clodded with earth. He wiped perspiration from his forehead with a sleeve that was unravelling slightly.

'Don't apologise. I've been at it for an hour, so I'm glad to be distracted.'

'I walked through the vegetable garden. It's like a harvest festival.'

'It's doing well this year, isn't it? I dig in lots of muck and well-rotted seaweed, and we're in a hollow here, so we're protected from the worst of the wind.'

He had a careful way of looking at her, she noticed, as

if he was being cautious not to misinterpret anything she might say.

'Are these the cider apples?'

'They are. It's glorious to be in here in April, all humming with bees, and on a windy day it blizzards with blossom. It's like a rosy snowdrift.' Rory's long eloquent fingers made a fall of petals between them.

'Have you got blisters?'

'Yes.' He examined his palms.

'Can I get you anything?'

'No. Don't worry.'

'Your accent sounds familiar.' She'd heard it last night, but it was more pronounced now that he was away from the other men.

'I'm from your part of the world originally, though I haven't lived there for a good few years. My parents are from Todmorden. They have a farm over the tops.'

'You're not far from us at all.'

'No,' he said. He rubbed his eyes. He did this a lot. Sometimes the rims of his eyes looked quite red. It made the blinking stop, but only briefly. 'It's nice to hear a familiar accent. Gil told me that you write for the *Huddersfield Courier*.'

'Just a weekly column. My husband was a reporter, so I can't claim that the arrangement is entirely free of nepotism.'

'Don't be so modest! I admire you for that. I wrote a book when I moved down here. I was writing for myself really, but I have occasionally dithered over the idea of sending it off to a publisher.'

'What's it about?'

'It's a book about the war. It mattered to me when I wrote it; there were scenes that I wanted to record and feelings I needed to express, but I'm not sure anybody else would want to read about that. It's probably very self-indulgent.' His hair fell over his eyes and his smile was shy then.

'If a book about my husband's battalion existed, I'd be keen to read that. There's much about his war that I don't know and many wives and families must feel similarly. You ought to try to get it published.'

'Thank you,' he said. 'Perhaps I'll think about it again. Clarrie used to be a newspaper man too. He worked in a print works on Fleet Street before the war and he still does inky things. There's a press in the barn. He makes linocuts and sells prints in a gallery in town. They do quite well.'

'But I thought he was a chef?'

'He's been that too. We're all many things, aren't we?'

He pronounced it like a philosophy, so that she wondered what different parts there were to him. 'I suppose we are.'

'We're planning pyrotechnics for Saturday.'

'Fireworks?'

'A ceremonial flame to mark Fenella's arrival.'

'It sounds like some sort of pagan rite.' Esme pictured Mrs Pickering as a pre-Christian goddess with a helmet, a trident and a fanfare of flame.

'What? Your mouth is curling upwards at the corners.'

'I'm not sure how Mrs Pickering will react to that. A bonfire?'

'A firing. Gil is getting ready to stock the kiln.'

'Ah, it's the pottery kiln. I saw him on the other side of the garden.'

'Yes, and I'm chief fireman and stoker. Woodcutter at the moment, though.'

'How exciting,' said Esme. *How dangerous-sounding*, she thought.

'Of course, unpacking the kiln is the fun part,' Rory went on. 'You never know what you'll get, what disasters and miracles will emerge from the ashes. For the sake of Gil's blood pressure, we all have to pray for more miracles than disasters.'

Esme supposed that Rory must be around her age, but he seemed both older and younger than his years as he talked, both worldly and innocent somehow. He pulled his jersey off over his head and she couldn't help but notice that his shirt was clinging to his chest with perspiration. Esme told herself that she mustn't notice such things and applied her eyes to the tabby cat that was now winding around her ankles. She knelt to stroke the cat and felt its back arching towards her hand.

'What's he called?'

Rory looked down at her. 'Patrick.'

'That's a funny name for a cat. Aren't they obliged to be called Tiddles or Tom?'

'I don't think it's actually a law.' He laughed, but then seemed to hesitate. 'He's named after a friend.'

The cat's fur was warm with the sun. He rolled onto his side, showed Esme his white belly, and teased with claws. 'It

feels a little odd to be tickling the tummy of a small person called Patrick.'

'He's clearly enjoying it. I think you've got a job there.'

She would have liked Rory to tell her about his friend, and why it was appropriate to name a cat after him, but he pressed his lips together, and for some reason Esme felt that she shouldn't pry.

'I know that Sebastian paints, Clarrie makes prints and Gilbert pots, but what do the rest of you do?'

'I'm an illustrator and do commercial design work. I wish I could do more painting and fewer letterheads and shop signs, but it's the commercial work that keeps me going. Hal makes ships in bottles.'

'The sort of objects you see in antique shops? What a peculiar occupation.'

'His grandfather was a sailor and taught him the secrets.'

Esme imagined a salty seadog grandfather and a mute miniature Hal nodding at his side. But had he always been mute? Could she ask that? While Rory seemed happy to talk, she sensed that she must tread carefully in certain areas. She watched the cat scampering away after a bird.

'Does your friend Patrick chase sparrows too?'

'Less bloodthirstily, but, yes, you're not too far from the truth.'

His smile was rather wistful at that, and his eyes were far away for a moment. Esme sensed that she'd stepped close enough to the edge.

Chapter eight

When she'd first woken she'd supposed that the noise was the nightingale again, but no. As Esme lay and listened, she realised that it was a human voice. Someone crying? A man crying? It was an unsettling sound, particularly as she couldn't discern whose voice it was. She'd sat up. She heard distress, and was that fear? There had been a sound of doors opening and other voices then; she could pick out Clarrie's accent on the landing below, then Gilbert's voice, and though she couldn't make out words, she'd heard a careful and a comforting tone. Esme had looked at her bedside clock and saw that it was coming up to five. Should she go down too, or was this a private matter? Was this something that she wasn't meant to be hearing? Eventually, the doors had opened and closed again, and the whisper of words had faded away. She'd managed to get back to sleep after a while, and when her alarm had gone off she'd wondered if the noises in the night might have been a dream. But it hadn't been, had it?

If anyone had been upset in the night, there was no indication of it around the breakfast table this morning. Esme saw no signs of agitation or concern. Rory's eyes were no

more red than they normally were. The crying voice might have been any one of them, but she listened to their talk of paint suppliers and seed catalogues and was glad that the trouble had passed. She noticed how they exchanged smiles as the toast rack and jam pots circulated between them, and occasionally hands were put to shoulders. There were strong bonds within this group, she observed, links that she didn't yet understand, but she also sensed a fragility. It made her feel that she must be cautious about asking questions. While they all appeared to be relaxed this morning, the memory of the voice in the night left her feeling tense.

A bowl of strawberries was passed around the table, the scent of them the very essence of summer, and she watched the men eating with their fingers. Food seemed to be central to their life; mealtimes here were a communion and a celebration, taken slowly, thoughtfully, pleasurably. They all downed their tools to eat meals together, and although no one said grace, there was a sense of gratitude in the way that they shared the food and conversation. Esme thought of the toast and margarine that she often ate on the go at Fernlea and the supper trays that she balanced on her knees. The image of it was distinctly dismal by comparison with this sunny, conversation-filled kitchen. Rory put a saucer of milk down for the cat, Gilbert piled blackcurrant jam onto a teacake, and Esme considered where Mrs Pickering might fit around this table.

'Will you be sending Mr Evans' cart for Mrs Pickering?' she said. She felt that she ought to ask.

'How loyal Esme is!' Sebastian pointed his fork at her. 'She's frightened that Fenella might get a splinter in her *derrière*.'

Smoke was winding from a cigarette in a saucer at his side. Esme didn't think it was altogether nice to wave a fork or to smoke at the breakfast table. Mrs Pickering certainly wouldn't approve of that. Had Sebastian made his mind up to dislike her? Was this how it was going to be?

'No, I wouldn't dare.' Gilbert smiled down the table. 'I'm planning to get the motor car out and give it a polish this morning. My sister's behind will be well accommodated on an upholstered seat.'

'Excellent.'

'I've finished packing the kiln, so we could light it before lunchtime.' Gilbert said this to the table in general. He never explicitly issued orders, but such suggestions were invariably put into action, Esme had noticed. She recalled the sudden shift in his voice on her first night. For all Gilbert's talk of democracy, he clearly was the senior officer here.

Rory looked up from spreading honey on his toast. It ran down his knife and he licked his thumb. 'It's all ready to go. Just tell me when.'

'It never loses its thrill.' Gilbert turned towards Esme and she could see something eager in his eyes. 'It feels like an ancient ceremony, handed down through antiquity, and there's always the excitement of not knowing how it's going to turn out. I do hope that Fenella will appreciate it.' The hesitation that tailed into his voice echoed Esme's own

doubts. 'Would you like to come with me in the motor car this afternoon? We could have an ice-cream wafer on the seafront en route.'

Esme recalled how Sebastian had curled his nose at the postcard stands and charabancs. How he must despise ice-cream wafers. 'I would like that,' she replied.

'Sebastian's teasing doesn't upset you, does it?' Rory asked. He was sorting through the post in the hall. 'He has an odd sense of humour. You do know he's only jesting, don't you?'

'Are you quite sure about that?' Esme watched him shuffling the letters. 'I think he's got it into his head that I'm some sort of spy for Mrs Pickering, that I'm here to observe you all and report back.'

'Did he say that to you?'

'Pretty much,' she admitted. 'You don't all think that, do you?'

'No, of course not!' His eyebrows lifted. 'Hell, you haven't worried about that, have you? Fenella and Sebastian had an altercation last time she came down. They both got rather territorial over Gilbert – who has the right to put an oar in and where – and he accused her of interfering. That's why he's in a mood at the moment, but he shouldn't drag you into that. I'm sorry. I'll have a word with him. He had no right to say that to you.'

'Thank you. I'm glad you don't think I'm a snitch.'

'Not remotely!' He stashed a letter in his pocket, and crouched to lace his plimsolls. When he looked up again, he

gave her a lopsided smile. 'I was going to carry some boxes up to Hal's room. Do you want to come up with me and see what he does?'

'He won't think I've come to snoop on him?'

He laughed. 'Damn Sebastian. Let it go!'

There was another flight of stairs off the second floor, darker and narrower than the staircase up to her own room. Esme supposed that it might once have led to the servants' quarters. She noted a dusty corner, a cobweb, and the frayed hems of Rory's ascending trousers. She didn't suppose that she could do much to remedy Rory's somewhat raggedy sartorial style, but she should sweep this staircase. As they stepped onto the landing, there was a scratching and a tapping noise, and Esme wondered if this part of the house might have mice (Lord, that would have to be sorted out!), but, as Rory pushed the door, she realised the noises were coming from Hal sitting at a workbench.

'You don't mind me showing Esme, do you?' Rory asked.

Hal looked up from his work and shook his head. Esme raised her hand to him, but couldn't help feeling that she was intruding into his private world. 'I don't want to interrupt,' she said.

A tiny boat was fixed to the workbench in front of Hal, complete with intricate rigging and four full sails. He was holding a paintbrush in his hand and there were bobbins of cotton, pins and blades scattered about. The room smelled of varnish and glue.

'May I look?'

Behind Hal, the shelves were lined with little boats in bottles. Esme had occasionally seen such objects in the windows of old curiosity shops, but never a whole flotilla of them. Galleons, clipper ships and schooners rocked on plaster waves, so many never-ending voyages in brandy, rum and dimpled whisky bottles. She looked closer and saw that names had been painted onto the bottles in a curly gold script. *Nancarrow*, she read, *Curlew*, *Santa Maria* and *Arethusa*.

'How does the ship get into the bottle? The masts would never fit through the neck. What's the trick?'

Hal put his brush down and looked as if he was deciding whether to trust her with this information. He reached for his notepad and she waited while he wrote.

I'm not meant to tell anyone.

'Oh.' It took her aback slightly and she suddenly felt that she'd been presumptuous to ask. It was becoming more and more apparent that this was a house in which one had to be careful about asking questions.

'I think it might be magic,' Rory said.

He definitely did wink at her then, and Esme saw that he'd registered her slight discomfort.

'Perhaps you're right. Magicians are particular about keeping their tricks secret, aren't they? Don't they swear blood oaths of silence in the Magic Circle? Or maybe that's Freemasons?' She looked at Hal and detected a slight softening in his expression. 'I suspect it's something that requires great dexterity.'

It's technique, not magic, he wrote. *My grandfather taught me.*

He was a sailor and learned to make them when he was on long voyages. I made my first one while we were in France – the first one without my grandad's supervision, that is.

Esme felt his eyes watching her as she read. It was like hearing Hal's voice for the first time. He gestured at a Bénédictine bottle.

'What patience you must have.'

He shrugged. *We had a lot of time on our hands.*

Esme stepped closer and saw the name *Espérance*. There were choppy waters inside the green glass and the little boat's sails looked as if they were being buffeted by swirling winds. 'The same name as your house?'

We were its crew and we were sailing home. I liked to imagine that.

Esme pictured a miniature Hal and Rory inside the tiny ship and a diminutive Gilbert at the wheel. Was this finally their safe harbour, then?

'They're all made from odds and ends,' said Rory. 'Just bits and pieces. But we have to drink a lot of whisky to keep him in bottles.'

'So I see. Are they based on real ships?'

They're mostly invention. Each one takes several weeks to make, and while I work on it, I think up a crew and their life stories, a cargo and a voyage. I keep a log of them all.

'Each one is a story?'

Yes. I suppose.

Esme thought that this household was perhaps rather like a ship in a bottle, sealed away from the rest of the world here, each of the crew playing his part, and each with his own

secrets and stories. She would like to read their ship's log, to understand their particular journeys, and how they'd all washed up here. Would they tell her these tales with time?

Rory talked all the way down the stairs, about how witty Hal was, how sharp and mischievous he could be. He was very generous, Esme considered, extremely kind to his friend, but it was difficult to recognise the version of Hal that Rory described. She hoped that she might get to meet that young man before the summer ended.

Rory paused on the corridor. 'I don't suppose you'd be interested in seeing my humble efforts too, would you? I make no great claims of creative genius, but it might amuse you for five minutes.'

'Of course,' she said. 'I'd be delighted to see your work.'

Rory's room was two doors down from the bathroom, as it turned out, and if his hair and trousers had given her an impression of artistic disorderliness, this space confirmed that character.

'Golly,' said Esme.

'Sorry. It's a bit of a mess, isn't it?' He went ahead, quickly gathering items of clothing from the floor and pushing them into a linen basket.

The only furniture was a chest of drawers, a desk placed before the window, and in the middle of it all, a not terribly well-made bed. It didn't seem quite right to Esme to be looking at the rumpled sheets of a man she'd met only three days earlier.

'I ought to have tidied up in here before I invited you in. Only, it was impromptu, you know?'

Looking around at the room, Esme decided that many things in Rory's life must be impromptu. The walls and the floorboards were white, and the large windows let in lots of light, but everything – the walls, the furniture, the typewriter on the desk – was covered with a splatter and speckle of paint.

'Do you get much on the paper?'

'Sometimes.'

'I thought I'd heard a typewriter.'

'Does the noise carry? I'm sorry. I hadn't realised.'

'No, don't apologise. The clack of the keys and the ping at the end of the line are curiously soothing.'

There were postcards and photographs pinned to the walls. She leaned in and saw minarets and Madonnas, the faces of saints and fishermen, fairground carousels and standing stones. There were smooth pebbles, pieces of driftwood and sea glass on his shelves, and squeezed tubes of paint everywhere. Esme wanted to start tidying the paints up. It was difficult to resist the urge to order them into a rational rainbow, but this was his space and she should respect that, she told herself. There was a distinct smell of linseed oil, of paraffin and cigarettes.

'Is it healthy? Is it safe? Don't you worry about combusting?'

He laughed. 'It hasn't happened yet.'

'You could be toasted in your bed sheets. The whole thing might go up.'

A patchwork quilt was rumpled over the bed. She remembered the quilt that had covered her parents' bed, how all of the hexagons of fabric held significance and memories and stitched the story of their lives together. What story did Rory's patchwork quilt tell? A tall stack of books teetered on the bedside cabinet, topped with an over-spilling ashtray. She would have liked to look at the spines and to know what he chose to read before he closed his eyes each night.

'I am touched by your concern,' he said, his eyelashes tilting down. 'Here.' He reached a conch shell from a shelf and placed it gently against her ear. 'Can you hear the sea?'

She could feel the cool smoothness of the shell and his eyes concentrating on her face. He watched her as she listened. She had to look away.

'Yes.' Was it relief that she felt when he eventually took his eyes from her face? She wasn't certain.

The sun slid three yellow trapeziums across the floor and dust dazzled in the air. On the windowsill, next to a jam jar of brushes, there were several fragments of stained glass and twisted pieces of lead moulding. Lit from behind, the glass was blood red, a jewel-bright blue and deep forest green. The colours were beautiful, but the shapes of the lead suggested violence or great heat.

'Old glass?' she asked.

'I picked them up in Belgium. They were from a cathedral window.' He said it quietly.

Esme remembered standing in York Minster with her father, the spring light pushing through the Rose Window.

She also recalled pictures in the newspapers of Belgian cathedrals brought to the ground. The levelling of a cathedral seemed like an enormous event. She tried to imagine what almighty force it would take to bring down York Minster. It was incomprehensible. Had this quietly spoken, gentle man witnessed scenes like that? Had Alec seen such things? Occasionally, when she wished that Rory would speak, the conversation stopped, and Esme felt that she didn't know him well enough yet to prompt him to restart. She supposed that he would tell her if and when he wanted to.

'These are yours?' She picked up a watercolour sketchpad.

'Yes. It's the Logan Rock, but I haven't finished it yet.'

There was something unguarded about Rory's eyes, she thought. Sometimes, when he didn't speak, his eyes continued to communicate. He showed his feelings there. He couldn't help it. Right now, there was a distinct vulnerability in his eyes, and Esme felt she must carefully consider her next words.

'You've got a very distinct style.'

His watercolours were luminous and wet, full of sea spray, wind and blown sand, almost as if he might have made some co-operative creative pact with the elements. They were all dash, energy and fragments of handwriting woven into the scene. Was it poetry? Esme supposed that it might be, but she couldn't pull its loops apart.

'How diplomatic you are! My bread-and-butter work is mostly advertising and illustrations for magazines. It's all particular, defined, targeted to sell a product. I love the

freedom of painting and the fact that there are no rules and nothing to sell.'

Esme smiled at him. 'I can see the pleasure in the way you paint. You don't do portraits?'

'No. Not really. It's not my thing.'

'But your trees are like portraits,' she said, as she turned through the pages of the sketchpad. He painted beachscapes and the moorland, mostly in wild weather, monoliths and venerable old trees. 'I look at them and feel that I know their characters.'

Some of them were whimsical, and others might be spellbound wizards or old gods, but they were all somehow poetical. Their physicality seemed to express an inner life and a biography. Drawn by Rory, trees were mystical and majestic. Esme liked that he looked at trees that way.

'Thank you for saying that. Sebastian is rather scathing about my advertising work. He says it's tawdry and that my pen is a prostitute.' He widened his eyes at his own words and then laughed as he looked away. 'I'm sorry. I shouldn't have told you that!'

'What sort of subjects does Sebastian paint?'

'Beautiful women in excellent hats, mostly – society ladies in cocktail dresses. He makes them all vibrant and sensuous. He likes to do them in their feathers and pearls.'

'And I suppose he never charges them? I assume he does it just for the sake of art?' She closed the sketchpad. 'He doesn't like me much.'

'It's not personal.' He frowned sympathetically. 'He's just

protective of what we have here. He's pretty uniformly rude to all visitors, to be honest, but his bark is worse than his bite. Sebastian doesn't go out to earn himself many points in the politeness department, but Gil says that he has a gift, and so we all mustn't mind Sebastian's manners. Or lack of 'em.'

'Were you an artist before the war?'

'I was articled to a firm of architects in Leeds. My working day was all pieces of tracing paper and double-checking measurements. I had a contract to go back to, but it all changed.'

'This truly is freedom, then?' She nodded at his sketchpad.

'It is. See, no right angles! No rulers!'

'I'm glad for you.' She would have liked to ask him what had triggered his change in direction, but supposed that the war might be the answer and Mrs Pickering had advised her to swerve that subject whenever possible. She had implied that bringing the war into a conversation might open a door through which all manner of chaos and embarrassments might rush. Only, it seemed to be the answer to so many questions these days, and Esme wished that she could see the secrets that hid behind that door. 'Did you illustrate your memoir?'

'I did.'

'I'd be interested to see those drawings.'

'A lot of them aren't particularly nice.'

'No?' She could tell that he didn't want to show them to her. She could see it as he stepped back. Did they not realise how difficult it was when everyone told her that she shouldn't ask about the war? Was it really so very wrong of her to want them to talk about it? To know what they'd experienced and

how they'd felt? To have a sense of how Alec had felt and why he'd been in that place at that time? She would have liked to say that to Rory, but then she looked at his face and remembered the noise she'd heard in the night. Had it been him? It had come from this landing. She felt a fleeting urge to put her hand to his cheek as she saw the flickering under his skin starting again now. She turned away.

'Is that a fiddle?' she asked.

'Yes.'

'Do you play?'

'Not as well as I might, but I like to collect songs and it's a way of working them out.'

'Collect songs?'

'Folk tunes. Gypsy tunes. Many of them have never been written down, they're just out there, only existing in memories and when they're played, and there's a danger they might be lost.'

Esme imagined these old tunes like wraiths passing through the lanes. For one odd moment she had an image of Rory with his fiddle and a butterfly net trying to catch them.

'What? You're smiling.'

'I'm imagining you pursuing your peripatetic songs.'

'I've spent time with the gypsies,' he said. 'In camp with them. There's a lot of old knowledge, much we can learn from them.'

'I'm sure.' Esme hoped that he wouldn't try to share his gypsy learnings with Mrs Pickering. She had no time for that sort of thing.

He had a nice voice, she thought. It was level, calm and kind. She tried to recall the particular inflexions and tone of Alec's voice. There were phrases of his in her mind still, favourite sayings and snatches of lyrics that he'd liked to sing, but she could no longer precisely conjure up the sound of his voice.

'I promised to lend you this, didn't I?' Rory reached a book from the tottering pile at the side of his bed.

'What is it?'

'John Clare. The nightingale poem.'

'Thank you.'

The colour of her memories was fading, Esme realised. They were no longer in sharp focus, and the scents and the taste were gone. Like Rory's gypsy melodies, would her memories of Alec stay if she spoke about them? Would sharing them stop them from slipping away? She didn't have anyone with whom she could talk about Alec, but, though she hardly knew him, Esme felt that she might trust this man. He might let her talk. He might understand. They might understand one another. Why was it that she sensed that?

Chapter nine

They sat side by side on a bench and looked out to sea. There was a salty brightness to the air. Gilbert had got ice cream in his moustache, but Esme didn't like to mention it. He touched his hat to a man in oilskins.

'It's very pretty here,' she said. 'Quaint. Charming.'

Gilbert nodded and wiped his beard with a handkerchief. 'It is, isn't it? And the light is exceptional.'

'Why is that? I noticed it as soon as I arrived. It makes me think of the inside of oyster shells.'

'It's to do with the sea being on three sides and the mica content in the sand, I believe – refractions and reflections.'

'What fortunate physics.'

'Isn't it? It's a special place. Quite a world apart – partly because, as Sebastian says, it takes so damned long to get down here from anywhere. There's space to think here, don't you find? Space to breathe.'

'Yes, I feel that.'

She had sat side by side with Alec on a bench once, she remembered, and they had eaten ice cream cornets. Alec's had been melting and he had licked where it had dripped

down his wrist. She remembered his eyelashes shifting and the grin that he gave her – boyish one moment and then something else. That grin wasn't there in any photograph. Alec's smile seemed far away now. How she wished that it might have been otherwise, even if he had come back needing space to breathe.

'Did Sebastian paint the portrait of you that's in the drawing room?' Esme asked now.

'He did. Sebastian has a great talent for capturing personality in paint. He has that knack. Not all artists do. He sees the essence of his sitters, and he can seize it and put it down on canvas. That's the difference between a fine artist and a camera: it's all in the summation and communication of the subject's character. A good artist can convey the psychology as well as the physicality.'

'I can see your personality in that portrait.' Esme wasn't sure that she saw a good physical likeness – it was so blatantly flattering – but she understood Gilbert's point about photographs. The camera only ever captured parts of Alec, different angles of his character; she didn't have a single image that really summed him up.

'We must have Sebastian do you,' Gilbert said.

Esme suspected that Sebastian didn't think much of her personality and she wouldn't like to have it scrutinised by him. She rather hoped that this was merely a vague politeness on Gilbert's part. 'I worry that I might have offended Sebastian. I really don't mean to intrude.'

'*You* offended *him*?' Gilbert turned towards her. 'I was

concerned that it might be the opposite way around. I've wanted to apologise for Sebastian's behaviour the other night. He went too far. He can be irritable and overprotective, but there's no excuse for him being rude to you.'

Gilbert looked embarrassed and Esme felt rather sorry for him. They all seemed to be in the habit of apologising for Sebastian's manners. What did he need to feel so protective of, though? 'Don't worry. Rory said much the same thing to me earlier. There's no need to apologise.' Seeing Gilbert's discomfort, she felt she perhaps ought to deviate away from the matter of Sebastian's sensibilities. 'Rory showed me his paintings.'

'Rory is interested in capturing the *genius loci* of the place.' Gilbert smiled. He seemed glad to change the subject too.

'He's trying to see the personality of the landscape in the same way that Sebastian is analysing the sitters in his portraits?'

Gilbert appeared to contemplate this question as he tapped his pipe out and tucked it into his breast pocket. She marvelled at how he didn't regularly set himself alight. 'Yes, just so,' he eventually said. 'He used to carry a sketchbook with him when we were in France. His drawings were extremely eloquent.'

Esme would have liked to ask what Rory's eloquent drawings communicated, but he'd already suggested that this wasn't a sight for her eyes. 'He clearly loves the landscape here.'

'Oh, he does. Dear boy, he's had a rough couple of

years,' Gilbert mused obliquely, 'but being here is good for his soul.'

Some people said that Fenella Pickering was imperious, that she was formidable and a snob. Yes, on occasion, she could pronounce like a duchess in a theatrical farce, but Esme thought she was a woman of great dignity. She had a fine profile, Esme considered now as she watched her employer examining the furnishings of her room. She imagined that Boadicea might have looked like a young Mrs Pickering. She had carriage, a certain stateliness and stamina. Even while Dr Mangan was fussing over her influenza, she had dictated notes for her committees and had her nails French manicured. Esme couldn't really imagine Mrs Pickering taking time to convalesce, but apparently, that was what she meant to do in Cornwall.

'Did you see the dresser?' Mrs P asked now. 'That used to be in my mother's drawing room.'

'The one painted blue with the moons and stars?'

'Quite! It's oak underneath. And what he's done to my father's desk! I can still picture Daddy there, frowning over the household accounts, but the things that are painted on it now!'

Esme knew that Mrs Pickering's grandfather had been a handloom weaver who had yanked himself up by his bootstraps. To her credit, Mrs P never hid that history. Indeed, she was proud of it. She liked to tell it to her widows and orphans, extolling the virtues of industry and ambition. Hard

graft had earned old Mr Edgerton a six-bedroom detached gentleman's residence, plasterwork ceilings, mahogany panelling, and an Oxford degree for his son. He had worked hard to achieve his respectability and comfort, his stone gateposts and the word *Endeavour* spelled out in coloured glass over the front door. In turn, Fenella had inherited elocution, a suite of amethyst jewellery, and the confidence to voice her opinions on five local charitable committees. A large quantity of brown furniture had also come down the family line, and been divided between Fenella and Gilbert on their parents' passing. Esme, who was tasked with dusting the brown furniture in Fernlea, thought it rather jolly that Gilbert had painted his share so colourfully. Fenella, seemingly, didn't.

'Snakes and apples?' Esme recalled. 'I was trying to figure it out. Is it alluding to the Garden of Eden? Temptation and innocence lost?'

'It's certainly that – and Gilbert grinning behind it like the Lord of Misrule. He was such a darling boy, you know. He had golden curls and was never any trouble, but what would Mother think of him now? There's something childlike about this need to paint every surface, don't you find?'

'It's definitely exuberant.' Would that word do? 'The drawing room must be challenging to dust.'

'Do you imagine that they bother?' Mrs Pickering ran her finger along the chest of drawers and held it aloft to exhibit. 'They've had this room done specially.' She sounded almost disappointed. 'They're all looking more unkempt too. Have you ever seen such dreadful red hair?'

'Rory?'

'Rory, is it? Yes, of course, it is. He was here last time, but one does get these boys muddled up. Rory *le roux* – at least his mother had the comfort of an education.'

'I think it's quite striking,' Esme dared.

Mrs P didn't look convinced. 'I bet it struck his poor mother. I remember now – he's a Rory O'Connell, isn't he? What a name! He sounds like a rabble-rouser, doesn't he? Or perhaps a giant in a W. B. Yeats poem.'

'He's from Todmorden.'

'Isn't that disappointing? He'd be so much more interesting with a soft Dublin brogue.'

Esme did occasionally wonder if Mrs Pickering, like her brother, would perhaps enjoy collecting 'types'.

'His father owns quite a sizeable farm,' Mrs P went on. 'Gilbert told me. It's his inheritance, but for the moment he's "finding his path", in Gilbert's parlance. I'll bet his mother wishes he'd hurry up about it. Has he started blinking at you?'

Esme hesitated. She suddenly found herself feeling protective of Rory. 'He has.'

'It's terribly unfortunate. You don't know where to look, do you?'

'I've noticed that it seems to come on when he feels self-conscious. He doesn't do it when he's had a drink.'

'Perhaps he ought to have more to drink.' Mrs Pickering sat down at the dressing table and began to powder her nose. Esme watched her reflection. 'He's written a book, you know.

Gilbert encouraged him to do it. He told him that he ought to express his *feelings*.' She widened her eyes at this word. 'My brother is very committed to that sort of thing these days, but I'm not convinced that it doesn't encourage them all to dwell and be oversensitive. Life in the real world is brutal and it's difficult to get through it without a backbone.'

Esme wondered what feelings Rory had needed to express. What was it that they were all dwelling upon? She picked up the brush and counted the strokes as she pulled it through Mrs Pickering's hair. She sat up straight in her chair; no one could ever question Mrs P's backbone.

'I'm not sure that Sebastian is thrilled to have us here.'

'That's because we're interlopers in his little Eden. He can be most uncivil, but Gilbert goes around apologising for him. Do you know, last time I was down here he had the temerity to suggest that I tyrannise Gilbert. *Tyrannise!*' She brought her hand down on the dressing table. Esme could imagine the scene. 'I told him that caring for a person requires more than compliments and indulgence. Have you seen that portrait of Gilbert over the fireplace? Talk about obsequious! That just about sums him up.'

'It's certainly rather flattering.' Mrs Pickering's hair had been set into permanent waves for the summer and it was rather satisfying to see it spring back in shape. Esme pinned it up and picked out the curls over her ears. Mrs P liked it styled that way, but Esme couldn't help feeling that it made her look rather like a spaniel.

'Flattering? It's a fantasy. Bless him, Gilbert didn't look

like that at twenty. Of course, he thinks it's marvellous. Well, you would, wouldn't you? Wouldn't we all like to lose thirty years and three stone?' She sucked her cheeks in and highlighted with a little rouge.

'Does Sebastian do that with all his portraits?'

'He does if they're paying enough. And that's precisely why they pay, I expect. It's all very clever really, very artful, one has to acknowledge that, and he's the only one of them who makes any decent money, so I suppose he'd better carry on working his special magic.' Mrs Pickering shifted in her seat and the bamboo chair creaked. 'I was fully supportive of Gilbert coming down to Cornwall, but I thought he'd meet new company, get in with *nice* people. It's a great pity that he can't shed these hangers-on. He won't have a word said against his "dear boys", but I'm not convinced this is the healthiest environment.'

Were they not nice? The jury was out on Sebastian, but surely Rory, Clarrie and Hal weren't malign influences? 'Gilbert looks well, though. He looks contented here.'

'He does,' Mrs P sighed. 'I won't deny that, but I can't help worrying about him. I mean, what sort of a living can you make from selling bits of pots? And have you seen the way they get through whisky?'

While the rest of them got through a good deal of cider and whisky, Gilbert drank fruit cordials and camomile tea. Esme wondered if he perhaps suffered from biliousness, but didn't like to ask. 'They do seem to be a close group. I guess that war must be a very bonding experience for men.'

Mrs P launched an eyebrow. 'Bonding? They're like barnacles. But then, wouldn't you stick close to someone who charges you no rent and pays all the bills? No, his little coterie will all have to go back to the real world one day, to proper jobs and responsibilities, and it will be such a rude shock to them. Perhaps that would be for the best, though.'

Esme remembered the little ship *Espérance* in its Bénédictine bottle and imagined it listing on its plasterwork waves. She hoped that it might manage to stay sequestered away from the shocks and choppier waters of the real world.

'I trust you are all in good health?' Mrs Pickering surveyed the gathering from the head of the table.

Esme had been demoted to the benches tonight. It felt as if some normal equilibrium had been restored with Mrs P's arrival; rules and roles had shifted back into place, but there wasn't quite the reassurance in this that Esme had expected to feel. Yes, she might now cease to be the prime target for Sebastian's comments, but she also realised that she'd enjoyed something of the anything-goes informality of this table. She'd liked sitting between Rory and Clarrie, listening to their talk of hopes and ideals, and the quiet moments when they turned and spoke just to her. The outside world had blown in with Mrs P and it presently felt like a slightly chilly wind.

'We're all in impeccable health,' Gilbert replied. 'And particularly excited about tonight's festivities.'

'Is young Rory excited too? All this running back and

forth. He seems to be working terribly hard. Shouldn't you be doing something too, Gilbert?'

Rory had already excused himself from the dinner table twice in order to tend the flames. Resuming his seat now, he did appear to be enjoying himself, but he also looked as if he could use the attention of a soapy flannel.

'This is a critical time,' he said, giving Mrs Pickering his most charming smile. 'It's vital that we maintain the temperature.'

'Hmm,' said Mrs P.

'How far off do you think we are?' Gilbert asked.

'Another couple of hours, perhaps? There's plenty of wood left. It's absolutely roaring at the moment. We could sit around it with a glass of rum punch later.'

'With some ceremonial chanting and a sacrificial offering for the kiln gods?' Mrs P smiled into her glass. She was in good spirits, Esme saw.

'If you wish to lead the chanting, Fen, I'm sure we'd all be happy to follow.'

Mrs P blinked slowly at her brother, as if this suggestion wasn't worthy of acknowledgment. 'Talking of health, I've brought you some of the peppermint tea you liked from Wadsworth's. Did Esme tell you? Mr Dodd didn't have the indigestion mixture that I bought you last time, but I've got in a supply of flannel bands in case your sciatica returns.'

'Hell, I'm surprised you haven't brought me a bath chair as well!' Gilbert looked around the table as if he required

support. Sebastian scowled. Clarrie seemed to be suppressing a smile.

Esme had noticed a large bag of medications in Mrs Pickering's room. Was Gilbert in delicate health? He looked perfectly fit. Mrs P was a great believer in cod liver oil and syrup of figs, but she'd brought half a chemist's shop with her for Gilbert. Was this how she expressed her love for her brother, through pills and potions and peppermint tea? Esme could appreciate why this might irritate Sebastian.

'It would be polite to say thank you,' Mrs P suggested.

It was curious to look at Mrs Pickering and Gilbert side by side. While there was some similarity in their features – the grey-blue eyes and the long narrow nose – they were like children who might have been separated at birth and raised in completely different environments. Yes, Mrs Pickering was ten years her brother's senior, but they could be a generation apart. While Fenella was crisp, angular and precise, Gilbert was somewhat baggy, tweedy and whiskery. If Mrs P was a crystal decanter, Gilbert was a slipware flagon, Esme thought. But was he a flagon with hairline cracks that she hadn't yet detected?

'More importantly, how is *your* constitution feeling now?' Gilbert enquired.

'It is a boon to breathe the clean air again, even if it does have a distinct hint of wood smoke this evening. You will be relieved to know that I will require no exertion or entertainment for the first week. I must follow doctor's orders. I shall merely avail myself of a comfortable garden chair and not be a whit of trouble to you. You will hardly know I am here.'

'And in your second week? Are you planning to be trouble then?'

'Well, it depends. I might be. I mean to get you shipshape here this summer. Even if I'm convalescing, I will be able to direct Esme. I was reading the other day of how many varieties of germs may be harboured in household dust.'

Mrs Pickering judged people on their dust; she evaluated them by the cleanliness of their windows, the gleam of their brasses and how regularly they beat their carpets. When she made home visits to the widows and orphans, she would sometimes write her name on a dusty shelf in order to shame them. It was a giveaway for moral contagion, she said.

'Do you not realise how obsessively we've cleaned for your arrival?' Gilbert raised his hands in exasperation. 'We've been quite paranoid about it, knowing you'd be running your finger around all the skirting boards. I defy you to find dust!'

Mrs P's expression suggested that she took this as a challenge laid down. There was something almost coquettish in her smile.

They processed down the garden with torches, chairs and blankets. Mrs Pickering linked her arm through Esme's, and Rory lit their path. Esme supposed that she ought to place a shawl around Mrs P's shoulders – that was the sort of thing one should do – but even twenty feet away, she could feel the heat coming off the kiln. Sparks crackled up into the sky.

'Is it not terribly dangerous?' Esme asked, raising her voice. 'It sounds like Beelzebub is trapped inside.'

'Only middlingly dangerous,' Rory replied.

She couldn't help but feel fearful for him, though, as he approached and pushed more logs into the fire. The growling kiln looked as though it might explode at any moment.

'Splendid,' said Gilbert.

Gilbert didn't have much involvement in the firing himself. All the dirty, hot and dangerous jobs were delegated to Rory. But then, he didn't seem to mind. He appeared to be taking a boyish glee in all this messing around with fire.

'It reminds me of Bonfire Night.' Mrs Pickering smiled at the flames. 'We ought to have treacle toffee and black peas. What do you say, Gilbert?'

'Black *peas*?' Sebastian repeated. 'Is that like caviar in the north?'

'Liberally doused with malt vinegar,' Mrs P elucidated and turned her shoulder on Sebastian. Esme noted that she had an adept manner of not giving oxygen to his jibes. 'Parkin, toffee apples and sparklers – it does remind me of our childhood. Perhaps that's the root of it, Gilbert, this urge to play with mud and flame?'

Hal's eyes met Esme's in the dark and she saw a glint of amusement there.

Esme could feel the heat of the fire on her cheeks. From time to time, the kiln gave a particularly deep growl. The white-hot wood would slump and sparks shot out like Roman candles. Esme wasn't at all sure that it was safe, but it was certainly spectacular.

Clarrie circulated with a jug of warm punch. It was

sweet and buttery and contained a good slug of rum. 'Pirate recipe,' he said.

At that moment, a cone of white flame broke from the chimney. It roared into the night sky like the devil had broken out and was leaping for his freedom. They all raised their glasses and cheered.

'To the kiln gods!' Gilbert cried.

Mrs Pickering cursed so softly that it was almost inaudible.

'It was all rather elemental, wasn't it?' said Esme, as they climbed the stairs later that night. 'I was nervous at points, I'll admit. I wasn't convinced that it wouldn't explode, and they were getting so close to the flames.'

'Boys and fires,' said Mrs Pickering, sounding like she'd seen it all before. 'Gilbert was like that as a child, you know, always wanting to poke a stick at a fire and play with the candles. I can see him now as a boy of five picking candlewax off his fingers and then crying because his hair had caught and he'd frightened himself. I'm afraid that they don't grow up much. Have you had the story of the magazine yet?'

Mrs P sat down at the dressing table and Esme began to unpin her hair. 'The magazine?'

'No? You surprise me. They love talking about it. They can spend hours reminiscing about it and if you're not careful they'll start reciting poems. Of course, it was all silly stuff, jokes and cartoons, something such as schoolboys might cook up together. They only did it for a few weeks, just while they were in Arras, and it had nothing of a circulation, but

they talk about it like they were on the editorial board of *The Times*.'

'This was during the war?'

'Yes, it's always there behind the bonhomie. Don't let them fool you. They'll never shrug it off.'

Mrs P made the war sound like a lingering infection, Esme thought. 'All of them? Do you think?'

'I know it. I've seen it. They all carry it around, and how-ever civil they might appear on the surface, it rages on in their minds. In my experience, they're apt to bring it out at the most inopportune moments. Do be aware of that. They spring it on you like a nasty surprise.'

'How sad for them.' As Esme brushed Mrs Pickering's hair, she wondered what unfortunate scenes she might have witnessed. Was this conclusion drawn from her charity work, or had she observed the springing of nasty surprises in this household?

'If one treads carefully, unpleasantness can be avoided, but it's best to be forewarned and on guard.'

Was there unpleasantness in this household? Was that the noise she'd heard in the night? Were there hints of it in Sebastian's prickly incivility and Gilbert's herbal teas? If so, what lay behind this? What might have happened to them to cause it? If she could untangle the secrets of Espérance, Esme felt that she might better understand the gaps and inconsist-encies in Alec's letters.

As she blew out her bedside light, she considered what Alec might have been like had he come home. Would it

have raged in his head too? Would she have had to tiptoe around him lest some terrible memory be triggered? Would she always have been minding her words and watching his eyes? Whatever the dangers and difficulties, Esme wished she'd had the chance.

Chapter ten

It was as if the owl and the nightingale had decided to synchronise an all-night duet. It was there every time Esme stirred, piercing and insistent, and each time she had to make sure that it really was the noises of birds and not men's voices. She kicked her sheets off, turned her pillows, and lay there wondering who had cried and why. Through half-opened eyes, she watched the morning light stretching across the ceiling.

She had flicked through Rory's poetry book before she'd gone to bed and found chains of those words repeating through her head now. It was a well-thumbed volume, fingerprinted and book-marked, the corners of certain pages folded over, and words underlined in pencil here and there. She had read the marked poems carefully, picking slowly through the lines, looking for the particular significance that the phrases might have for Rory. All the lines that he'd underlined were positives, she'd noticed. They were all ecstasies and exaltations, and that was generally his daytime personality; he was optimistic, appreciative, enthusiastic – and yet, what was it that flickered across his face and made

his conversations stop and start? Could it be his voice that she'd heard in the night? She hoped it wasn't.

The breeze billowed the curtains and brought in the scent of rock pools and roses and the sound of gulls. She poured a glass of water and stood by the open window. Down below, the grass glinted wet with morning dew, and a ribbon of smoke drifted upwards. She thought that she would like to put her feet in the wet grass.

Esme crept through the sleeping house. As she tiptoed past closed doors, she felt that she could almost hear the house breathing; a slow, calm release of breath. It was all at rest. She would make a cup of tea, sit quietly and breathe in the morning scents of the garden. No one would be up for another hour.

The kiln was still smoking. When she'd drawn her curtains last night, she'd seen the red glow of it and heard their laughter. What time had they finally retired back to the house? If Mrs Pickering hadn't been here, would she have sat up with them?

Esme watched the morning mist lifting. In this opalescent light, the garden was a watercolour and the birdsong was like a salutation. As the sun broke through, it seemed to kindle the scent of each plant; in patches it was the honeysuckle that made itself known, and elsewhere the sweet peas. The china roses smelled spicy, an intense, warm, somehow antique smell. Was that how roses smelled in Pompeii and the gardens of Babylon?

She had dismissed her waking urge to walk barefoot,

but the wet grass tickled coolly at her ankles and she could see her own footprints when she looked back, dull in the glittering green. Dew clung to the sedums and the dahlias, and the alchemilla sparkled with perfect round globes of light. Everything was new. Everything fresh. The leaves had gilded edges, so that each branch might have been taken from an altarpiece, each flower a devotional study plucked from an illuminated manuscript. Esme lifted her closed eyes to the sun and tasted the faint iodine tang of the sea on the air.

A bird startled out of the pear tree, so close that she felt the wind pushed from the downward stroke of its wings, so close that she wasn't certain that its wingtips hadn't touched her face. Were those stars still in the blueing sky? Or just the prickles of new light on her eyes? She smiled at the song of a blackbird and the persistent calls of a cuckoo, and then, dipping under the clematis, Rory was there.

'I'm sorry!' She had nearly walked into him. She lifted her hands and stepped back. 'I didn't see you. Do forgive me. I didn't think anyone else would be up.'

'No, I should apologise. I was deep in my own thoughts.'

'I couldn't sleep,' she said. 'And it looked so lovely down in the garden. It's all pearly and clean and still.'

'Isn't it? I'm often up and walking at this hour. It's the best time of the day. Everything feels newly made.'

'Like it's all been freshly laundered.'

He smiled at that. 'I don't want to disturb you.'

'No, you're not. Not at all,' she said. Patrick the cat was

following Rory, Esme noticed, trotting along behind him like a faithful dog. 'The nightingale was very loud last night, wasn't it? I kept waking up and hearing him.'

'For the first night it was charming, like a miracle, but it has become rather insistent, hasn't it?'

'It has,' she agreed. Patrick was winding around Rory's legs now and he bent to put a hand to the cat's ear. As he did so, she noticed his feet. 'But you've got no shoes on! Doesn't it hurt your feet?'

'No. I like it. I often don't wear shoes. I like to connect with the earth. You can feel it when you walk barefoot, the temperatures, the textures . . .'

'. . . the thorns, the grit, the cows' leavings in the grass.' She pressed her lips together, resisting the urge to smile. 'I'm sorry. I'm not making fun of you.'

She looked down at his feet. How filthy they were. When was his next appointed bath day? He pushed his hair out of his eyes. She hoped that she hadn't offended him.

'You should try it some time.'

'Me? Oh, I don't think I could. What if someone saw?'

He raised an eyebrow. 'Yes, what if someone saw?'

'Well, they'd think me eccentric, wouldn't they?'

'Like me, you mean?'

She was glad to see him grin as he said it.

They walked side by side through the vegetable beds and down towards the orchard. There was something easy and graceful about the way that Rory moved, she observed, as if he might be a dancer or an acrobat. He looked comfortable in

his own skin this morning. A blackbird swooped low across the garden in front of them and the cat scampered after it.

'Mrs Pickering began telling me about your magazine last night.'

'She did?' He grimaced. 'It was a bit of nonsense, really – as I'm sure she told you. We only did it for a few weeks, but it was an experience that brought us all together. I suppose we got to know each other. It was only jokey stuff, of course: silly skits, caricatures, limericks, poems. Dear God, the poems!' He blew cigarette smoke at the sky and laughed.

'Who wrote the poems?'

'Gil.' He widened his eyes and whispered. 'He thought they were magnificent and he must never be dispossessed of that belief.'

'Gilbert was your senior officer, wasn't he?'

'Yes, so no one could reject or correct his verses. I think he must have been fed a lot of Shelley and Byron as a child. Sebastian and I drew the cartoons, Miles wrote satirical pieces and Hal did the jokes and the limericks. Clarrie was our technical whizz and the cornerstone of the whole enterprise, of course. We'd found a printing press, you see, and a man who knew how to use it.'

Esme noticed that he smiled as he talked about this time, but then he never seemed to be too far from a smile. 'Why did you stop?'

'The damned inconvenient, inconsiderate war. It cared nothing for our artistic enterprises. We got moved on.'

'That's a shame.'

'Yes. Isn't it? We were shifted to Saint-Quentin and print-ing presses aren't portable beasts. Plus the army then decided to provide us with other occupations. It brightened our lives for a while, though. Even if we didn't make anyone else laugh, it amused us.'

'Miles lived here with you too?'

'Yes, but only for a short time. He writes for a music mag-azine in London now. Music was always a passion for him.'

Esme wondered: what distinguished this man from the group? She was curious as to why the rest of them chose to live together here, while this Miles was pursuing a different course. What was different about him? She remembered what Gilbert had said about Rory having had a rough couple of years but life here being good for his soul. Did Miles have a more robust soul? And what precisely had been wrong with Rory?

'I can imagine you all,' she said, 'working at your cartoons and your verses. I can picture it.'

'Can you?'

'Yes, all just a little younger. A little more inno-cent perhaps.'

'We were more innocent once.'

'I think we all were.'

From *The Winter in the Spring*
by Rory O'Connell

April 1916

This morning, we left the village and walked towards the wood. Poplars lined the road, regular as telegraph poles, and I could see the untidy shapes of magpies' nests against the white sky. It is very flat here, mostly fields of cabbages and beet, and though we can occasionally hear the shelling, the war is still somewhere out of sight. Patrick and I leaned on a gate for a while and watched the progress of a plough. It cut a clean line, straight and true, like a wave breaking, and it was pleasant to watch the field striping and the heavy horses steaming on the turns.

We walked into a thicket of oak and hazel, picked our way through brambles, through the rowans and a tangle of honeysuckle, and found ourselves looking at a carpet of wood anemones and grape hyacinths. Standing there, in that blue shimmer and in soft shadows, felt almost like a spiritual experience. Was it reinforced by the knowledge that the

frontline is only fifteen miles away and that we're heading towards it shortly? But today was not for thinking about the war. We went further into the wood, and pointed out celandines, primroses and dog violets. Patrick has brought his *Boys' Own Nature Book* with him and takes pleasure in knowing the names.

He has brought his birding field glasses too. He collected eggs as a boy, he has told me, though he says he now regrets taking them. Patrick is from Keighley, so we have some landscape and experiences in common. I shared the story of how Michael and I would collect a bucket of frog spawn every spring and spend hours crouched over it, looking to see the black blobs lengthening into tadpoles. I told him how my mother had accidentally kicked the bucket over one time and then had spent an hour on her knees, swearing as she scooped tadpoles with a teaspoon. Lying there on our bellies, watching beetles and swapping stories, Patrick and I might have been twelve years old again and the war just a narrative from a boy's story. Occasionally, when Patrick laughs uproariously, he reminds me of Michael, and I am glad to have someone here with whom I can share idiotic jokes, memories and apprehensions.

Cuckoos were calling, back and forth, through the wood and then three long notes rang out. There was something metallic in the sound, something bright and bell-like, but it was also intimately sweet.

'It's a nightingale,' Patrick said.

We sat still. I hardly dared breathe. All of our attention

was fixed on the unseen bird and the repetition and breaks in its notes.

'It can't be,' I whispered. 'Here?'

'I swear it is. I bet you my field glasses.'

In that still silence we were intensely aware of the detail all around us, and then the trilling notes of birdsong became more insistent.

'I've never heard one before. Have you?'

'Only on a gramophone recording.'

Three sustained notes were repeated, pure and piercing, and then a pause. It wasn't a joined-up song, like a blackbird's, but there was an arresting directness and focus to the notes, as if the bird might be performing from a musical score. There was also a forcefulness to it, a great energy, and I felt that the nightingale must be putting its whole heart and soul into its song.

'It's a small, brown, nondescript bird,' Patrick whispered, and I got the impression that he was reciting the *Boys' Own* annual. 'Similar to a robin, except its throat and breast are a greyish white. It makes its nest deep in the dense undergrowth and lays olive-brown eggs.'

'I couldn't have imagined anything small and nondescript could sound like that.'

What pipes and trills it made! I felt surrounded by the sound. It seemed to be coming from somewhere close by, but search as my eyes might, I couldn't see the bird. It confused and compelled my senses. With the source of the notes unseen, it was like the countryside itself was singing.

'It makes me feel that this is just an intermission,' Patrick

said then, quite out of nowhere. 'All of this, I mean – the guns, the war, us being here. This bird probably comes back here to sing every summer, and what does he care about the position of the frontline? That inherited behaviour is so deeply rooted. There's probably a whole chain of nightingales, generation upon generation, who have sung, found mates and nested in this wood, stretching all the way back to a time when we fools were slinging arrows at one another.'

I imagined that chain of melody, an unfinished phrase stretching back through time, and I didn't know whether to sob or to hug Patrick. It made me feel like standing up and walking away from the war. What did it matter? What is there really to be won or lost? But what a tragedy it would be if guns trained on that wood and the chain broke. What would happen if the nightingale couldn't come back and raise a brood next spring? At that moment, a whirl of universal disorder seemed to spring out of the break in the nightingale's song.

So far, the curiosities of our journey have been fields of tobacco, sugar beet and crossroads shrines, seeing French women dressed in deep mourning, the sound of foreign words in children's mouths, and the taste of *grenadine*. Up until now, the war has been ammunition dumps and post-cards stitched with silk flags for sale in village windows. We have seen no actual warring yet, only the behind-the-scenes mechanics, but the noise of it gets louder and, with that, we know we're getting nearer.

Our new commanding officer had arrived when we got back to the billet. His name is Edgerton and he's been transferred to us from the West Yorkshires. His family is in textiles and he has travelled widely for business in the Far East. He has a passion for oriental prints and ceramics, and he talked most interestingly of rustic wares and folk traditions. Sebastian cornered him this evening, and recited all those stories of his days at the Slade and the Grafton gallery. I've heard it all before, but the two of them hit it off, and I left them working their way through a bottle of whisky. Captain Edgerton insists that we call him by his Christian name, Gilbert, which feels most unmilitary, but he seems like a good egg. He can't be more than thirty-five, but he sucks on a pipe and clearly enjoys giving fatherly speeches. He has the manner of an energetic curate, or a popular schoolmaster, I thought; slightly earnest, a little cautious, but keen to do everything properly and to be liked. We could have done far worse. Patrick and I told him about the nightingale and he immediately recited lines of William Wordsworth. (I think that a C.O. who has Wordsworth on tap is perhaps not a bad thing.)

> 'O Nightingale! Thou surely art
> A creature of a fiery heart:
> These notes of thine – they pierce and pierce;
> Tumultuous harmony and fierce!
> Thou sing'st as if the God of wine
> Had helped thee to a Valentine.'

It is so quiet here tonight that I'm aware of the scratch of my pen as I write, but earlier in the evening we could hear the thud of artillery. I picked violets in the wood, pressed them in my notebook and have just folded them into a letter to my mother. I wanted to tell her that it wouldn't have surprised me if wood nymphs and dryads had been watching us, but she has little patience for fancifulness. The fields of the farm are full of peewits, crows and hedge sparrows, but my parents aren't the sort to linger on birdsong, and I haven't learnt to distinguish it. When Patrick gives a name to a pattern of notes it delights me, though, and I'm trying to commit the phrases to memory.

I have never felt more intensely alive than I have these past weeks. I feel strong, healthy, and my senses are keener too. I'm more aware of everything that is around me now, and there is so much that I want to do and see. I'm greedy for life and I feel an urgency to make up for all that I have missed. I have already wasted so much time. Is that mortality? Maybe. I prefer to blame an ecstasy of birdsong.

Chapter eleven

Esme's pen hovered over the blank sheet of paper. With the thought that a letter might be waiting for her in the post office, she was finding it difficult to focus. Could she have an address for Alec's childhood home by the end of the day? But before she could go to the post office, she must finish her article. She took a sip from her glass of water and tried to apply herself to this task. Gilbert had insisted that she must use the desk in the window bay of the drawing room and help herself to any of the books from the shelves. She looked out. Beyond the curlicues of wisteria and the rising spires of delphiniums, bees bumbled, gulls tilted in the sky and footsteps and voices carried along the gravel path. Gilbert was doing his breathing exercises out on the lawn, and Hal and Rory had gone off to paint the greenhouse with lime. Esme kicked off her sandals, put her feet to the cool flagstones, and closed her eyes in an effort to concentrate.

Where should she start? Over the past nine years, Esme had become accustomed to observing the world as one who must deliver a page of text every Tuesday morning; the considerations as to how she might structure and colour her

weekly article were never far from her mind. Occasionally, it was difficult to fill a page, but this morning it was the opposite problem. There was so much that she wanted to cram into her quota of words: flowering species that she'd previously only read about, birds that never migrated as far north as Yorkshire, moths, beetles and butterflies that she'd seen in illustration, but which now were crawling and fluttering all around her. How was she to begin to prioritise all of that? As she'd told Mr Stevenson about the planned Cornwall trip, he had advised her to try to give a flavour of the place, to pick out the commonalities and contrasts between there and Yorkshire, but there was so much here that was different. How was she to compress that within her word limit? Her pen stuck and scratched at the paper at first, but then the ink and the words came fast.

Absorbed in her descriptions, in her deletions and revisions, Esme was startled by a noise. A bird had hit the window with a loud rap. She leaned over the desk and saw it there, a sparrow on the window ledge. It was panting through its opened beak – she breathed with it, one, two, three times – and she could see its little red tongue. But then the panting stopped. Esme watched the bird and knew it was dead. Was there a moment in those three panting beats when spirit and body had parted? Had she just witnessed that? She thought about Alec's last moments, imagined the last breaths leaving his red lips. It made her chest feel tight.

She nudged the sparrow onto the dustpan and carried its weightless body towards the hedge outside. It fell stiffly onto

the soil. How could a creature that moved so fluidly become brittle within minutes? Should she bury it? Should she dig a hollow and cover it over? If she left it, some animal would take it away – that was nature – but surely it was silly to think of digging a grave? She told herself that she shouldn't be sentimental about a common house sparrow and yet she felt as if she'd witnessed something intimate in the moments of its last breaths.

Her pen idled on the paper and an ink blot spread. Her chain of thoughts had broken. Was it naive to suppose that a bird might have a spirit? Was it foolish to imagine that humans had a soul? Perhaps we were all just here and then not. Breathing, writing, thinking one moment and then no longer. How long had it been before Alec's body stiffened? Was there anything left of him now, but crumbling bones and mouldering fragments of uniform? There had to be more than that, didn't there?

Esme finished her glass of water and made herself look at the page. She deleted, edited, cut back descriptions, slashed through a paragraph and counted her words again. When she'd got it down to the required length, she wrote out a fair copy in a careful hand. She read it through one more time and then folded it into the envelope with her covering letter. It was done. Only once she'd sealed the envelope did she let her mind return to souls and sparrows.

She walked back over to the hedge. Surely the cat or a larger bird would have taken it by now? But, no, the sparrow was still there. Still dead. A ruffle in its feathers made her

look again, but there was only a bluebottle. How long had Alec lain unburied until he had been collected up? Did the bluebottles crawl over him too? Over his red lips? The image was an agony.

She met Gilbert in the hallway. 'I'm going to walk to the post office,' she told him.

'It's a good long walk. Wouldn't you like me to take you in the motor?'

'No. It's very kind of you to offer, but I do feel like some air and exercise.'

She needed to feel the stretch in her muscles and for new sights to crowd in front of her eyes. She had to be conscious in the here and now and to overprint the images in her head. Moreover, if a letter was waiting for her in the post office, she'd need to open it straight away. She didn't want anyone's eyes, no matter how kind, to watch her as she did that.

There was golden lichen on the old walls, pennywort and stonecrop. Lizards basked in the sun, then flickered away, and red admirals flitted. When she put her hand to the stones, they were warm. Rose-chafer beetles shone among the browning May blossom, glinting a metallic copper green, they might be scarab jewels unearthed from an Egyptian tomb, and ferns cast scroll-shaped shadows. The meadow was full of damselflies, ladybirds and honeybees. It all hummed and scuttled and grasshoppers sprang away from her feet. She breathed in the sweet, fresh scent of it and felt the gathering heat of the sun on her shoulders.

The shadows of cows slanted in a closely cropped field and there were dark boulders on the rise beyond. Esme remembered folk tales from home about giants tossing stones at one another as they warred for the heart of a water nymph. There was something equally strange and unsettling about these black rocks. She walked on and the path cut between gorse bushes, releasing a scent of warm coconut as she brushed past. A butterfly landed on her arm, flickered blue-green wings once, and was gone. A flock of sparrows burst out of the blackthorn.

Esme followed the rabbit path towards the sea, feeling the spring of the turf beneath her feet. The wind tugged at her clothes as she stepped out towards the edge. It caught her with such sudden force that it made her step back and laugh in surprise. She watched the crossing paths of the sea traffic, the coal steamers and the luggers and the white-sailed holiday yachts. The sea changed colour as clouds passed over, at one moment green and the next purple, peaking silver then, as if strung with metal thread, back to the deepest ultramarine and rippling pink.

She hadn't captured even a fraction of this in the text in her pocket, but then how could she convey this ever-changing marine light in sentences? Words weren't sufficient; all the phrases she'd summoned up were too flat, and this light couldn't be pinned down into static adjectives. It was a landscape that should be painted, instead of described, she thought; these soft greens and lilac shadows, the cerulean blue of the sky and the shifting rainbows of the sea might

have been composed expressly to challenge an artist. Esme understood, as she looked out, why they felt the need to paint it; and why they must keep on painting it again and again, until they had got the light right and put the glitter on the waves.

A gull rose slowly, forcing its strength against the wind, the tips of its wings trembling. There were clumps of thrift nodding on the headland, kidney vetch, sea carrot and yellow poppies. The sight took her back to the poppy that Alec had pressed into one of his last letters. She had framed it, and hung it on the wall, but its rich blood red had faded to a barely there orange-pink. Sunlight, and the passing of seven years, had left it looking like the ghost of a poppy. Would its colour disappear altogether one day, along with the details of her memories? She turned and walked on towards the town.

Would Alec have names for these plants and those butterflies? She remembered how, in the early weeks of their acquaintance, she had shown him wimberries and wood-lice, and he had called them urts and chuggypigs. She had liked him to say these comical dialect words, and to repeat the playground chants of his childhood, so different from her own. These words and rhymes had made him charmingly exotic once, but they now made him seem foreign and distant.

She had first met Alec at the museum. He was writing a story about the bequest of pheasants and finches, and Mr Waterfield had suggested that Esme could show him through the taxidermy collection. She had handed Alec her

magnifying glass and watched the curl of his long eyelashes. With his dark eyes, he might have been Spanish or Italian, and she didn't recognise his accent.

'I can see rainbows in their feathers,' he'd said. Esme had noticed his neat, white teeth when he smiled, the little dimples at the sides of his mouth, his smell of soap and peppermints, and all the colours in his magnified eyes. He didn't appear to be politely humouring her, and so she had walked him through the collections of mosses and moths, then the bison bones, the flint arrow heads and the fragments of Roman pots.

'I'm not from this part of the country,' he'd told her, 'and there's much here that's unfamiliar and curious to me.'

By the end of the afternoon, Esme had shown him the botanical engravings, the beetles and the narwhal bone, and had agreed to meet him for tea on Saturday. He had ended up staying until it was time to lock the museum doors.

That was nine years ago, and Esme looked down on the town and wondered if this view would have been familiar to Alec. He'd have known St Ives, wouldn't he? The rooftops were all moth wing and mackerel colours, and the narrow streets smelled of fish. Cats slunk disdainfully and sniffed at what puddled in the gutters. There were cats everywhere, sunning themselves on doorsteps, flicking from light to shade as they slinked down alleys, and stalking between the crab pots. She followed the lanes down towards the quayside and lingered for a moment to listen to the cry of the gulls and the foreign lilt of the voices around her. Yes, Alec's voice was here. She heard that same singsong accent.

They had met in the Mikado Café on the Saturday and discussed ferns and fossils over teacakes. She'd told him that she liked old books about folklore and herbalism, and he'd talked about the habits of bees and the mathematical patterns in music, seashells and pine cones. What a pleasure it had been to talk with someone who was interested and asked intelligent questions. It had been the most natural thing in the world to share her opinions and aspirations with him, and it had been thrilling to discover the places where their interests overlapped. When he had looked at her over the rim of his teacup, lines of John Donne had come to Esme's mind.

The next time they'd met, by the bandstand, she had told him that she'd like to learn to ride a motorbike, walk the Pyrenees and had an ambition to write a book about the flora and fauna of West Riding. He'd given her a long, evaluating look at that. 'I can't get you wheels or mountains,' he'd said, 'but my editor wants to recruit a local writer to contribute a nature column. I could make an introduction, if you'd like?'

Mr Stevenson had been pleased with the sample articles she'd submitted. Esme had been thrilled at the idea of being able to call herself a writer and she loved Alec for making it happen. Sometimes he looked over her shoulder and suggested a comma, but he did it so kindly, and she was always grateful. Occasionally, Alec praised a phrase and she'd spend the day with those particular gilded words repeating in her head.

Becoming a wife hadn't been among her schoolgirl aspirations, but Alec had pulled the rug under that. He had asked

her to marry him just six weeks after they'd met. In her imagined future life with Alec they would travel and learn together, would share and laugh. She had pictured them in foreign squares, where there would be fountains and statues of generals with unpronounceable names; the scents and voices around them would be unfamiliar, but they would sit together at an iron table, have drinks with ice cubes, feel the sun on their upturned faces and talk of all the sights they had seen. They would be braver together, travel further, and never be like those couples who sat in disappointed silence. It was true that she knew almost nothing of his background and his people (as Lillian, her cousin, had repeatedly retorted), but he had a respectable profession, twenty pounds in Post Office Savings and eyes that seemed to see into her soul. What more did she need?

She walked through the town now and took in its details with a keen eye. It mattered to notice chimney stacks and staircases that Alec might have recognised. The cottages weren't prinked to be picturesque, and there was nothing here that was genteel or designed; it looked more organic than constructed somehow; it might have been washed up by the sea over centuries, and was a workaday place, all salt-rimed, barnacled and serviceably patched. But there was a charm in its timelessness, how it was all the colours of cockleshells, and the jangling blue-green of the Atlantic seemed to be there at the end of every alleyway. Gulls wiped their beaks on the quay, a barefoot girl balanced along the front on tender tiptoes, and men in blue jerseys sucked on pipes and stared at the

sea. Esme listened to the slap of waves against the titling hulls and the ringing of the masts. The thought that these alien sounds might be familiar to Alec gave him a new strangeness.

Esme had become a wife in the spring of 1914. She hadn't anticipated that, as a married woman, she'd be expected to give up her job at the museum. It had surprised her to realise that everyone else took this for granted. That had felt unfair, and it had briefly smarted, but she still had her weekly articles, and she quickly found herself absorbed in the curious new satisfaction of pressing Alec's shirts, and seeing him in all lights and all moods. It was only after he left that she began to miss the things she'd given up.

They'd had five months of living as man and wife, but by the October, there was no one to cook and clean for, and Alec's shirts hung unworn in the wardrobe. The house was very quiet that autumn, and the days very long. Esme took time over the letters she wrote to Alec, sending him all the flowering plants and birdcalls, and remembering to put her commas in the right places. In return, he sent her the damp canvas and camaraderie of various military camps, months of the Fylde Coast, Wensleydale and Salisbury Plain, then finally chalk streams and skylarks from France. For two years, their life was an exchange of written words, but then one day his letters stopped.

Esme stood in the post office queue now and remembered the shock of that last letter, addressed in an unfamiliar hand. She knew of women who had sensed the death of their husbands. They had felt it, they said; they had instantly known

some sense of loss. But there had been no telepathic hints for Esme, no signals or sensations. She hadn't been ready for seeing that letter.

When Alec had joined up, Esme had suspected that he wanted to witness some real news, to see some headline events. As she'd read the newspapers, she had dreaded that he might be close to those headline towns, or moving across those diagrams where arrows indicated fronts and pushes. But, in the end, it wasn't a big push or a shifting front that had put Alec in his grave; he'd died in a collapsing building, that last letter had said, a non-event that made no press report, and which had left Esme questioning what it was all for.

The bell over the door tinkled, the queue moved forward and the man behind her coughed. Esme remembered that she was here, and now, and must step forward.

How empty the days had then seemed when Alec's letters stopped coming. Mr Stevenson had told her that she must continue to write her articles. People needed a relief from the war, he said; one part of the newspaper, at least, should maintain an interest in such enduring subjects as the change of the seasons. Readers would welcome the reminder that spring must always follow winter. Esme knew that he was right, that she had it to do, but how much less pleasure there was in writing now. How dulled the colours. How repetitive the birdsong.

The woman behind the counter gave her a professional smile. Esme handed over the coins for her stamp and took a breath before she asked the question.

'There might be a letter for me here,' she said. 'I told them I'd be able to collect mail care of the post office. Could you possibly check for me?'

Esme opened the envelope as soon as she was out of the door. She skimmed through the paragraphs, all the formal parlance and clauses, but it was there at the bottom of the page: in December 1912 Alec Nicholls was resident at 17 Penwithian Road, Penzance. She could go there. She could see it. It was something.

Esme stashed the envelope in her pocket and blinked at the light. The sky was a writhing white swirl of seagulls and with their melancholy cries her thoughts returned to that other envelope. Consequences had spilled out of the letter that said Alec was dead. The house seemed so empty, knowing that he wasn't going to return to it. There was too much space, too many rooms without him there to fill them, and too much rent to pay. When Mrs Pickering had interviewed her for the gardening job, she had asked about her marital status. Being widowed herself, Mrs Pickering had expressed sympathy when Esme had told her about Alec, and had said that a room could be made available if a live-in position would suit her better. It was a practical solution, but turning the key in the door of 58 Marsden Road, and knowing that she would never cross the threshold of her marital home again, had been almost too much.

Arriving at the back door of Fernlea, with the suitcase Alec had bought for their honeymoon and her box of assorted ornaments, Esme had felt like the survivor of a shipwreck.

She hadn't considered how the move would require her to dispose of so many objects that represented her life with her husband and her parents. She had sold off the furniture, their rugs and curtains, and given boxes of family keepsakes to Lillian, but it had been so difficult to part with Alec's clothes. Should she have tried harder to hold on to things?

Esme had been grateful for Mrs Pickering's sympathy and charity, but she suddenly found herself with little time and space that was entirely her own. Her past was condensed down to a box of books, photographs and candlesticks, and she had cried when she'd found a list of destinations that she and Alec had dreamed of visiting together. As Esme had begun to light candles for him, she realised that his death had taken away much more than the sound of his laughter and the feeling of her hand in his.

Esme walked back now, past the rotating postcards, the displays of shells, scones and seed cake, past the antique shop with crested china in the window, and the little boats in bottles. All of these images, these scents, these sounds, might have been parts of Alec's past – or not. Their life together had seemed to run at fast speed, like in the cinema when the film spools. It was all urgently in the moment, accelerating forwards and looking to the future. Looking back, Esme didn't suppose that she'd told him much about her family or her childhood either; she'd never walked him to her parents' graves or shown him the house where she grew up. But now that she couldn't ask Alec questions, it mattered. She wanted more of him – more images, more details, more

understanding, more time. She wished she could rewind the film and go through it all again in slow motion.

As she climbed the hill, Esme saw the shapes of gravestones against the sea. She paused and leaned on a wall to catch her breath; she could hear the beat of her own blood in her ears and realised that she'd been walking too fast. Shading her eyes with her hand, she looked at the cemetery. She was accustomed to graveyards that were all green shadows, closed-in places veiled by ancient trees and deferential hedging, but this wind-whipped hillside was so exposed, so bright. It was hard to believe that there might truly be bones here.

Esme walked between the rows and read the names of men drowned at sea. The headstones leaned at odd angles, so that looking along the lines, they seemed to rock as if still on the waves. There were ropes, chains, anchors and the teeth of whales carved into the stones. She moved between the lines of closely packed graves and spoke the words of the inscriptions aloud, but Alec's name wasn't on any of these stones. Gulls drifted on the current, cried over the peaceful dead, and Esme thought of Alec's name on a cross in a photograph and how terribly faraway that was. She might have an address, she might be able to go to Penzance now, but it was so little really.

Huddersfield Courier, 27th May 1923.

NATURE DIARY
A MOST UN-ENGLISH COUNTY

The naturalist, William Henry Hudson, described Cornwall as a 'most un-English county'. Travelling down the length of the country by train, I saw changes in topography and land management – history, culture and natural resources giving each region its particular look – but this remote southwest corner does seem to be something quite apart. While there are some sights here that remind me of Yorkshire – the shapes of the banks of heather and bracken, and the billow of the cottongrass on the heights – there is also much that is unfamiliar, and as I look at the landscape around me I have a sense of being a very long way from home.

Hardy souls have scraped a living here since prehistoric times, gradually clearing the boulder-strewn fields, defying the Atlantic winds and the searching salt. The small field systems created by these early settlers give a distinct look to the landscape of this valley. I am told that the field boundaries follow exactly the same lines now that they do on the most ancient maps. Are these walls as old as the dolmens and the

stone circles? They're perhaps not much younger. There's a striking sense of both antiquity and continuity here, of people following the same patterns, but how foreign it all feels to me.

Cornish hedges are not hedgerows as we know them; rather they are stone-faced earth banks, more substantial and permanent-looking than our own dry stone walls. Step closer and you'll see there's a whole catalogue of botany to be observed between these sun-warmed stones, a mosaic of mosses and lichens, tormentil, pennywort, cat's ear, spleen-wort and dog's mercury. Snakes and slow-worms wind between the ancient roots, dormice doze through the winter, and in the spring the wrens make their nests in these ancient walls. The seasons roll around, nature eternally renews, the landscape changes and stays the same, and our own lives seem but the blink of an eye.

Chapter twelve

Rory almost walked into her as she came around the corner of the barn.

'I'm so sorry,' he said as pressed flowers and scrolls of fern fluttered from the notebook in her hand. He bent to pick them up. Some of the petals were as thin as tissue paper. He was careful to take them gently between his fingers.

'No, it's my fault,' Esme said. She knelt down at his side. 'My mind was elsewhere.'

'Devil's-bit scabious.' He held a blue flowerhead to the light. 'You've diced with danger there. Here they tell children that if they pick the flowers, the devil will appear in their dreams.'

'Is that true?'

'It's true that they say it; I can't vouch for the devil.' He held the last of them out for her on his palm. He was very conscious of the touch of her fingertips. Pinpricks of sunlight cut through the brim of her straw hat and dazzled on her shadowed face. 'Did you have a good walk? I think I might have spotted you on the path. Did you go into town?'

Rory had seen her walking out towards the cliffs, saw her

bend to smell the gorse, reach out to touch the walls, put her binoculars to her eyes, and pause to make notes in a book. It wasn't that he'd meant to follow her, only that the path was difficult underfoot. He'd worried about her getting too close to the cliff edge, and he wanted to know what she was writing in her book.

'Yes, thank you. I had a letter to take to the post office. I walked along the coastal path. It was exhilarating. I feel as if I've been hosed down with carbonated water and left out on the line to billow in the wind.'

He'd been careful to stay unseen and had kept at a distance. He'd ducked down each time she glanced behind. As he did so, he'd wondered whether he really ought to be turning back instead. Had she felt that she was being followed? He hoped she hadn't.

'There and back? That's a good long way.'

'There's such a lot to look at. I started to make a note of the plants, birds and insects that I didn't recognise, and I seem to have made rather a long list.'

She'd paused regularly to observe, he'd noticed, to examine a flower, or take in a vista, to shade her eyes as she watched a bird. She also appeared to be talking to herself. Rory thought that he would like to be walking at her side, and sharing the names of the plants and the sound of the birdsong with her.

'Perhaps we might walk together someday? I can't claim to know the name of every moth and beetle, but I am interested.'

'Yes,' she said. He saw that she'd hesitated for a moment, but then she nodded. 'I would like that.'

She unwound the field glasses from around her neck. He wanted to tell her that he had Patrick's glasses, and how they'd seen a golden oriole once in France, but then there was so much that he would have liked to tell her. Why was that? The wind was blowing her hair and it flickered around her face. There was a vitality about her, he thought, but it was slightly buttoned up, slightly constrained by her good manners; she was a tame rabbit as she sat at her employer's side, but he suspected that she might once have been a hare. Had the direction of her life shifted fundamentally too? He wanted to ask her more about that, and to share the memories of the woods and the birds with her, but he realised that he must be careful what he said.

'I spent a good hour in the cemetery,' she went on. 'I lost track of time. That's exotic too. I kept seeing the names of wrecked ships carved on the gravestones.'

'You can know a place by its graveyard, can't you? Its history, its trades, its names and its disasters. They sum a place up.'

'This place evidently has a salty history.'

He had started to write down the things that he liked about her, had somehow needed to define it in sentences: her straight green gaze, the small gap between her front teeth, how her voice lifted when she was interested – it was there again now – and the sound of her laughter. Rory wasn't sure why he had done this.

'The landscape here has a wildness, doesn't it?' she asked. 'It feels elemental and timeless in some way. Don't you think? I wouldn't have been surprised to round a headland and spot some druidic ceremony going on. It feels like time works differently here, like past and present might be all tangled up together.'

'I sometimes feel as if I'm looking through the wrong end of a telescope.'

'Yes! Precisely that.' She smiled and seemed pleased at the understanding between them. 'I saw a hare. Don't they say that's a bad omen? But it always feels like good luck to me. Hares aren't quite creatures of our ordinary world, are they? There's a strange sensation when your eyes meet theirs. Supernatural – do you know what I mean?'

'I do.' The sun picked out streaks of auburn in her hair and cast shadows under her eyelashes. Sometimes her hair was the colour of liquorice and other times it was a female blackbird's wing. He had a most peculiar sensation when his eyes met hers. 'The swallows have been nesting in the barn. Let me show you.'

He pushed the door open and watched her eyes picking the shapes out in the gloom. It took a moment for his own eyes to adjust and then he pointed at the beams.

'They haven't all fledged yet. The parents are still keeping an eye on the nests,' he whispered. 'One of the chicks fell out last week. It flopped onto the floor and it looked so clumsy on the flagstones, dragging its tail, his little feet not made for walking. He looked like a broken clockwork toy and was making the most awful piercing squeak.'

'What did you do?'

'Perhaps I shouldn't have gone near him, but he looked ready to fledge, he kept trying his wings, and I was worried that the cat would get him. I walked him out onto the lawn, intending to put him down there, and just watch and wait, but before I could get there he took off out of my hands. Up he swooped, suddenly all muscle and velocity and doing what he was made for. It was one of the most joyful things I've ever seen.' He looked at her and saw that she was smiling.

'That's beautiful,' she said.

'Yes, it was. Clarrie's printing press is in the other side of the barn.' He didn't want her to walk away yet. 'Would you like to see it?'

He led her through, past the old cow stalls, to the far end and opened the doors so that she could see. Dust dazzled in the light as he lifted the sheets.

'It must weigh a ton.' She pursed her lips and whistled softly. 'How did you get it in here?'

'A team of burly men and much swearing.'

She put her hand to the metalwork. It was a handsome piece of machinery, its glossed ironwork embossed with twining snakes and cherubs' wings. Rory liked its smell of ink and oil. He watched her face and her fingers taking it in.

'She's an old girl,' he said, 'made in the 1860s. She was in a bad way when she came here, all seized up and rusted, but Clarrie has lavished her with patience and grease, and she works a treat now. Imagine how many words she's committed to the printed page over the years.'

'How many diverse causes and passions she's expressed.'

'Exactly.' He plucked a cobweb away and held it up in his hand. In a different time and place he might have been able to say anything to this young woman, he sensed. There was an instinctive understanding between them, he felt, and he could have been himself with her. Was that instinct right? But here and now there were so many things that he mustn't say to her, he realised. He wanted her to trust him, to share with him, to like him, he couldn't help that, but she wouldn't if she knew it all, would she? 'Your husband was from this area, wasn't he?'

'He was from Penzance, but he moved up to Huddersfield for work. He assumed that, writing for a paper with a bigger circulation, he might have more scope, more variety. He hoped he'd get to cover more interesting stories, but he still ended up writing about church fetes and vegetable competitions.'

'It was a heck of a long way to go to write about prize-winning marrows. Was he desperate to get out of Cornwall?'

He'd said it in jest, but the seriousness with which she considered his question made him regret his levity.

'I don't really know why he came so far north,' she said. 'To be honest, I can't recall that I ever asked why he ended up in Huddersfield in particular. This is the first time I've been to Cornwall. Alec didn't talk about his childhood much, and so when I arrived here it surprised me. I think if I'd grown up here and left, I'd miss it. I'd want to talk about it. Wouldn't you?'

'I guess we all have a different version of normal and sometimes we crave something else.'

'I'd hoped that I might be able to locate some friends or relatives here. He had no immediate family, but there must be people down here who remember him, mustn't there?'

'I would have thought so.'

Rory rather regretted the direction of this conversation. She looked pensive and slightly sad now. He supposed that it was all part of her grieving; as she couldn't make any new memories with her husband, she wanted to gather to her all the fragments of his life that remained. He could comprehend that instinct, but he was sorry to notice how her voice had flattened. She had been so much more animate just moments ago. He wanted to take her up onto the moor and show her the colours of the campion, how the kestrels hung in the air, and to make her smile again. But then, the ghosts and the memories had to have their time. Could it be that she felt regret too? Did she know guilt? He could feel the twitch starting again. The bloody thing. He hoped, for her sake, that she was simply missing the company of a man who had loved her.

From *The Winter in the Spring*

April 1916

We have marched ten miles eastward today, through a region of orchards, passing calvaries on the crossroads. We finally halted and took off our packs in the square courtyard of a farm. Chickens and geese flapped around our feet, and children stared up at us with wide eyes. We are bedding down in the barns here tonight. Though we're just three miles behind the frontlines now, the sound here is of children's laughter and the squawk of geese. Only occasionally are we startled by the heavy thump of a shell.

It is good to slip straps from aching shoulders and to slacken into straw. Packs of cards begin to slide through fingers and space is finally found to read letters from home. Dust glitters where the sun pierces the old walls of the barn. Steaming tea and bread are passed around.

Swallows are building nests between the beams of this barn. They come and go, flitting between the cobwebs and the gaps in the tiles, and appear to be entirely undaunted by our noise and bustle and cigarette smoke. The female returns again and

again with straw and pellets of mud, and blithely carries on with her building work. We all start to watch the swallows, and our voices and sentiments soften. I pick out the whispered words and realise that the men are placing bets on how many eggs there will be and when they'll start to hatch. I almost don't want to remind them that we won't be here to see that.

I presently feel acutely aware of the change of season; the trees breaking bud, the appearance of the butterflies, and the piercing screams of the swifts as they hurl themselves upward on scimitar-shaped wings. We have marched past meadows spangled with dandelions and daisies today, looking like benign fairylands. The greening fields and the song of the warblers feel like irrefutable truths when everything else is uncertain. The war ceases to exist as I watch a butterfly breaking out of its chrysalis. I feel such tenderness towards the banks of cowslips and the nesting swallows.

We are fortunate to have clean straw to fashion into bedding for the night. I lie back, close my eyes, and as I breathe in a familiar sweetness, I am instantly back at home on the farm. It seems that the war must claim Michael too now. My mother writes and tells me that my brother was called before the tribunal again. My father must manage the farm without him, they say. I can tell from my mother's letter that they are shocked by this decision; they didn't ever believe that the war would take Michael away and, if I'm honest, I never imagined it either. It is strange to think that, within months, my brother could be out here too.

*

The night sky is a pink-grey on the horizon and light quivers around it. It might be a summer storm coming our way, only I know it's not. I find myself looking for a pattern in the flickering light – it flashes perhaps three or four times per minute, but not at regular intervals. Its sound, an echoing blast and a horrible crump, is more disturbing than the familiar growl and crack of thunder. Is there a vibration in the air too, a breath or something other than a breeze – or is it my imagination? The unpredictable rhythm of the flickering sky suggests to me that so much balances on chance.

I smoke a cigarette in the farmyard and the shape of a white owl glides over on noiseless wings. Following its path across the sky, I look away from the trembling horizon and up to the reliable stars. We spend a lot of time looking at the stars these days. I have never taken the time to learn the constellations, but Patrick sent home for a map of the night sky, and now we spend hours trying to pinpoint the pole star, Orion's belt and the seven sisters that navigated Odysseus home. It is good to look at bigger things; it seems to put here and now in perspective (though I'm not quite sure what to do with that). We know where to look in the sky for Venus, the plough and the great bear now, and we make wishes on shooting stars. Mostly we wish that we were not here, that we were in warm beds, between clean sheets, but we share stories as we watch the slow revolution of the universe, and occasionally on these nights I feel that I am happy.

'It's funny to think that the same stars are out over

London, isn't it?' says Clarrie, suddenly there and drawing hard on a woodbine at my side.

'It is.'

'I sometimes wonder if my folks look up and have the same thought.'

Clarrie is the officers' cook and rumour has it that he's just broken up with his girl at home. I recall having seen a photograph of a young woman called Jenny, who was swinging on a cardboard crescent moon. Is she the one Clarrie is thinking of as he looks up at the night sky?

'I guess it's different, being at home, isn't it? They have their own concerns.'

'I suppose.'

Clarrie used to spend his spare time writing letters to Jenny, but her photograph has disappeared now, and he says that he wants to travel after the war. He was talking about Paris last night, and then we all began to name the cities that we hope to visit one day. Between us, we roamed around most of the globe. I pictured myself pulling on a rucksack and walking the west coast with a watercolour box. As we'd drifted into the hypothetical realm, this possibly wasn't especially ambitious of me (it certainly paled next to Sebastian's talk of Marrakesh and Hyderabad), but at that moment I couldn't think of anything that would give me more pleasure. We concluded the evening by pledging to send each other postcards.

There's a loud thud – closer this time – and, for a minute, the sky looks like Bonfire Night. Lights rise, curve and sink back to the horizon. Just for a second, it is a spectacle, gleeful

pyrotechnics, but then I hear Clarrie curse under his breath. The shapes of bats flitter, the owl screams, and I think of the men placing their bets on the swallows.

'Have to say, right now I'd rather have their worries than mine.' Clarrie exhales a plume of smoke. 'We're going up in the morning, aren't we?'

'Yes,' I reply. 'First thing.'

Chapter thirteen

'Did you enjoy your walk?' Mrs Pickering asked.

'Yes, thank you. I was longing to see the sea. I'm sure I can hear it here sometimes, particularly at night, but then it could just be the wind. Is it my imagination, or do you hear it too?'

'The wind does strange things,' said Mrs Pickering.

That was a somewhat enigmatic observation, Esme thought. Mrs P was sitting on a reclining chair under the dogwood tree and the shifting pattern of dappled light on her face made it hard to read her expression. There was a Georgian romance balanced on her bosom, dashing soldiers in scarlet on the cover and brittle-looking girls in white dresses, rising and falling with her breath. Her eyes flickered between Esme and the open page. Did she not want to be distracted from her wooing soldiers?

'I'm not sure that Rory didn't follow me. I might be mistaken, but I'm certain I saw him a couple of times when I looked back.'

When she'd spotted him the first time, she'd assumed that he simply happened to be walking into town too. She had hesitated as to whether it would be polite to let him catch

up, but then he'd disappeared from sight. He'd been there a second time, though. She was about to raise her arm to him when he'd ducked down behind the gorse. Could he really have been following her? Why would he do that?

'You must be careful there. I've noticed the way he looks at you. We all enjoy a bit of admiration, but he's hardly a catch, is he?'

A hiccup of laughter accidentally fell out of Esme's mouth. Mrs P's directness could be like a glancing blow from a heavy object. 'I'm not casting out any nets!'

Esme couldn't deny that she'd noticed the way he looked at her, and sometimes shyly glanced away; how he always seemed to want to engage her in conversation, and show her objects that might please her. But he knew that she was married. They'd talked about Alec. Rory understood how it was, didn't he? He did realise that she still considered herself to be a married woman? She liked his company, they were interested in the same subjects, he was considerate and easy to talk with – but should she be careful? Was she enjoying being with him too much?

'Good, because he might be charming, but he's a dreamer.' Mrs Pickering rearranged her cushions and leaned towards Esme. She evidently meant to make a point here. 'I mean, all of that wandering the lanes with poetry books. How does that put food on the table or get the laundry done?'

'He's just got a commission to do some artwork for a firm of seed merchants. He's drawing bulbs and annuals for a catalogue.'

Esme wasn't entirely sure why she felt the need to defend Rory, but for some reason she wanted him to be walking lanes and thinking about rhymes instead of laundry. Who wouldn't, given the choice?

'It's not regular work, though, is it? He was training to be an architect before the war, you know, he was going places. Gilbert told me.'

'I don't think he liked working in an office. He said that he was tracing designs and shuffling numbers all day.'

'At least he had numbers to shuffle. What does he have now? Bits of commissions here and there. A room full of paintings that will never sell. Well, you wouldn't buy one, would you?' Mrs P turned to the tray at her side and poured a glass of water. She left Esme to contemplate the question. 'Do sit down. You're looming. Anyway, what did you do in town?'

Esme sat, as directed, on the grass. 'I walked around the cemetery.'

'The cemetery? Heavens, aren't there nicer features to see?'

'It was interesting. I wondered if I might spot any relations of Alec's there.'

Mrs Pickering looked at her rather penetratingly. 'Your Alec's people were from the south coast, weren't they?'

'From Penzance.'

She'd been trying to remember what Alec had told her about his parents. Esme knew that they had both died in 1912 – earlier in that year all three of them must have been there in Penwithian Road – and that his mother had nursed

his father through a long illness. She knew their names, of course, and what they did for a living, but she'd never seen a photograph of them, and she realised now that she had no idea what their home life was like. What did they talk about over the dinner table? What books did they read? Did they look like Alec?

'Are you tempted to go there?'

'Rory just asked me the same question. I am curious to see the place where Alec grew up. It's part of who he was and I'd like to be able to picture him there.'

It wasn't that Alec had been evasive, she considered; he merely wasn't expansive on the subject. When she'd asked what sort of home he'd grown up in, he'd said, 'An ordinary house.' But what did 'ordinary' mean? One person's ordinary is another's extraordinary, and the light, the colours, the scents and sounds of this place were so different from those of her own childhood. As she'd walked back from St Ives, she'd tried to picture what Penwithian Road might look like, but was it a granite cottage or a brick terrace? Was it a dark house, cluttered with handed-down ornaments, or did the reflected light of the sea flicker over white ceilings? Could he see a quayside from the window of his childhood bedroom? Now that she had an address, she needed to go there.

Her mind also returned to the question that Rory had asked: why had Alec moved all the way up to Yorkshire? It hadn't previously struck her how far he'd travelled, but having now made that journey herself, she was newly conscious of the distance. He could have got a job on a bigger

paper in Plymouth or Portsmouth. Why did he want to be so far from home? Was it just chance that had brought him to her town?

Mrs Pickering nodded. 'It's perfectly understandable that you'd want to see his old home. You shouldn't do that alone, though. We could go together. Gilbert could take us in the motor car and we could have an afternoon around the shops in Penzance.'

Esme was grateful for Mrs P's concern, but wasn't sure that she wanted to share the journey, or have it turned into a shopping trip. If she went there, she'd like to do it on her own. Quietly. Unobserved. With the space to think her own thoughts and make her own judgements.

'The prospect of finally being able to go there does make me feel a little daunted,' she admitted.

'A pilgrimage to Penzance, eh? I do see why you might want to do it, but I'm sure that Alec wouldn't want you to upset yourself.'

'No,' said Esme.

Was that what it would be – a pilgrimage? The word brought to mind an image of flowers placed on a tomb and quiet footsteps backing away. It implied that a destination must have been reached, all outstanding questions answered and a state of peaceful resolution attained. It was a word that had an echo of a door closing and a reverent silence in its wake. But Esme didn't feel settled in her mind. She still had so many questions. How could she ever close that door unless they were answered?

NATURE DIARY
THE FEATHERED SOULS OF SAILORS

The overnight rain has flattened the cow parsley along the lane, but the elder is coming out now, and there is talk of cordial and cakes in the kitchen. One white blossom follows another, and as I pause to breathe in the sweet scent, it strikes me that they are like the lacework of two different regions. I remember that my mother would never cut a branch from an elder without first asking the tree's permission, and here in Cornwall elder trees are similarly held in great esteem. In days of old, people carried elder twigs in their pockets and fixed them to the horns of cattle in order to fend off the evil eye. Superstitions multiply in places where life and livelihoods are precarious, and the people here believe in omens and apparitions, charms and witches. These folk beliefs seem to form an essential part of daily life.

Standing out on the headland, I watch herring gulls tilting, resisting the breeze. They glance and blade against the air currents, scissor and lift, and I recall reading that the souls of

mariners return as gulls, petrels and albatrosses. I've noticed fishermen in the harbour taking bread crusts from their pockets and throwing them to the gulls, and I'm told they will tolerate no cruelty to these birds. Do they genuinely believe in this lore, or is that simply tender-heartedness? Perhaps they wouldn't admit to either. I see the appeal in that idea of feathered reincarnation, though, these winged souls staying close to friends and home waters; and as a gull flutters down, and boldly struts towards me, I want to recognise a familiar spirit in its eyes. We examine one another for a moment, the gull and I, and is there something there? But, no, alas, I see only alert animal instinct in its bright citrine-yellow eyes.

From *The Winter in the Spring*

April 1916

We passed through an area of old fighting today and I remembered the name of the village from last year's newspaper stories. How long ago that seems. One can hardly call it a village now; it is all mounds and craters, piles of stone and splintered roof timbers. Spiders have woven webs in window frames where the glass has fallen, the sun picked out the edges of rotting sandbags, and gnats dithered over pools of water. Clover and forget-me-nots are now creeping over the broken ground, and all is being drawn beneath a coverlet of green. The war has passed on, and there were only ghosts and blackbirds there today. A female was sitting on her nest, built on the tin roof of an abandoned dugout. She chattered at us as we passed and we stopped to listen.

'I should like to sketch it,' Sebastian said to me. 'It's not my usual sort of subject, but it's a powerful image, don't

you think? Themes of renewal and continuity – I could do something with that.'

Sebastian was making a living as an artist before the war and takes pleasure in talking about it. The existence of that other life – these past painterly glories – evidently gives him comfort. He reams off the names of London galleries where he's exhibited, dealers and collectors, and talks of the mechanics and materials of his trade. He uses words like distemper and gouache, primer and gesso, tempera and turpentine. These words are slightly mysterious to me, with their hints of alchemy and the archaic, and they're as beguiling as a rhyming poem. I want to learn the application of them; I feel hungry for that as Sebastian talks, but I also feel slightly jealous of the casualness with which he tosses this vocabulary into his everyday conversation.

There was no time to pause for sketching today, though. We marched on, into the dimming light, and I felt both dread and wonder. What an extraordinary thing it was to finally be moving up to frontline trenches after over a year in training. How peculiar that this is our end destination after those long fifteen months. I tried to hide my jumpiness as we went forward, to pretend that this was all as I expected it to be, but unease wriggled in my belly and my nerves seemed to push up to the surface of my skin, making me sensitive to every sound, light and smell.

We have been put in with a Division of Welshmen who've been in France since last November. They wear mud-matted

sheepskins, like warriors from some Greek myth, and make us feel distinctly naïve in our clean, unproven khaki. They talk as if they've been here for decades, and tell us that this is a nursery sector, and not like it once was. They say it almost regretfully, apologetically, but I'm not sorry to hear that. There is reassurance in this and their bright, singsong accents.

The Welsh employ an impressive variety of curses as they share anecdotes about the wiliness of enemy snipers. I find myself wanting to crouch as I move in the line, and stories about patient snipers biding their time don't do anything to discourage this inclination. An instinct for self-preservation curves my spine, but then I catch assessing eyes on me and amusement on faces as they turn away. My mother likes to tell people that I am a junior officer and a temporary gentleman, much as she used to like to boast of me being at the grammar school, but I think I might prefer to be an inconspicuous ranker and keeping my head down.

One of their corporals invited me to look forward through a trench periscope this evening, and as the Verey lights went up, I saw a place of smashed keeps in the garish green light, all tangled with stakes, wire and broken limbs of trees. It was sufficiently unreal that it might have been a still from a cinema screen, or a fantasy from a magic lantern, but I smelled the rot and the stagnant water, and the cold found its way down my collar. Could I hear foreign voices out there? Could I see movement? The rockets fell, and all was shuttered in darkness again, but I know that it's out there now.

Our sandbag defences aren't convincingly impenetrable. These walls, patched here and there with old doors and window frames, pallets, fence posts and sections of wicker-work, don't exactly look like an impassable redoubt. Smoke billows occasionally from the incomprehensible place beyond our lines and enemy trench mortars send up red sparks as they rise. I wish the parapet higher, the wire more impregnable and the smoke further into the distance.

My accommodation this evening is a cubbyhole bunk lit by candlelight. I can smell the earth walls behind the canvas, hear water dripping above and my rabbit-wire mattress complains under my weight. We may have reverted to cave men, but there was a jam jar of cow parsley on the table where we ate tonight, and it seemed to bring civilisation to our company, reminding us to mind our manners and use our cutlery properly. In the flickering light, I noticed photographs of family groups pinned to the walls and sketches of under-dressed women cut from *La Vie Parisienne*. I could hear my mother's voice saying that they were going to catch a chill on their kidneys. It's strange how these things come back to you.

We are drinking whisky now and the Welsh officers are telling the story of their first months in France, winding their narrative together with yarns that might well have been stolen from *The Mabinogion*. I can hear someone singing an old folk song in the line, a lilting, melancholy melody, and the voices around me talk of pikestaffs, goats and ghosts. I close my eyes for a moment and time unravels; we might

be the infantry of some antique war, holding the same lines that men have defended for millennia. Perhaps it never ends, only pauses.

This first period of trench education has taught me that the purpose of a second lieutenant is mostly filling in reports, completing the blanks in forms, counting stores, and censoring letters. I am either crossing words out or trying to make them fit them into boxes. This role is, thus far, somewhere between clerical and housekeeping, but all of it conducted in slightly muddy ditches with the occasional whip crack of bullets overhead. The part that has most affected me – quite unexpectedly – is reading the men's letters. It is like hearing their private thoughts and some of them are most surprising. Perhaps we are all much more complex and contradictory than our outward personas suggest? Occasionally, I feel like I'm earwigging in the confessional. Hearing these intimate, hushed voices makes me look at the men differently. Knowing the way that they talk to their wives and mothers – the pet names, the endearments, the glimpses into their home lives – makes me like them, but also leaves me feeling a great weight of responsibility.

Hal has obviously enjoyed being among his countrymen. I've overheard him mentioning place names that connected them (Swansea, Pendine Sands and Carmarthen Bay) and laughing when recalling shared experiences. This commonality made his accent more pronounced, I noticed, and brought a lilting lightness into his voice. It was rather a shock

to discover that he is also a fine singer. How peculiar it was to listen to him singing hymns, that sweet voice emerging from a mouth that moments earlier had been recounting a tale of beery youthful mischievousness, generously peppered with profanities. I think he was almost sorry to be told that we were being relieved.

We came out of the lines last night, tramping back muddily and wearily, retracing our steps down the communication trenches and then back on to those darkly pooled white roads. We will be in reserve for the next week and the men are doing working parties. With an hour free this afternoon, Patrick and I took off with his field glasses. Lying on our bellies, we watched a tangle of tattered-looking trees. It seemed an unpromising spot; I thought we would be disappointed, but then Patrick grabbed my arm.

'See!'

The expression on his face suggested that he had just witnessed a miracle, but my eyes couldn't pick out the astonishing sight. 'What am I meant to be looking at?'

'Did you not see the yellow flash?'

'No. What is it?'

He didn't answer for a minute. He was focusing his field glasses. 'There,' he finally said. 'By jingo it is.'

'By jingo it's what?' I asked, slightly frustrated.

'It's only a blinking golden oriole, isn't it?'

He unwound the strap of the binoculars and handed them to me. I followed the direction in which he was pointing. I could tell that he didn't want to give the glasses

up, but he needed me to witness the vision too. There, finally, I located it; in the top of a tree there was a bird with a bright yellow body and a black wing. It looked so exotic, so improbable, like something that should be seen in a jungle, not in a scrubby copse in northern France. Its short beak was open and it appeared to be singing, seemingly entirely oblivious to us and the war. I tried to focus my ears and picked out a sound that was uncannily like a human whistle.

'It's not exactly well camouflaged, is it? It looks somewhat overdressed for the occasion.'

'I've wanted to see one for years. It's the number one spot in my bird book.'

I handed the glasses back and couldn't help but grin. I looked at Patrick's face in profile and saw that he was grinning too. How odd that boyhood wishes might be realised in this place. I felt very close to Patrick at that moment. It has surprised me how the men write about friendship in their letters, about a feeling of comradeship and wanting to fight for each other. They write about these matters without any embarrassment, or mawkishness, or artificiality, and I understand that feeling too as I grin back at Patrick. He is my closest friend out here and I would fight for him without hesitation.

It matters to hear the birdsong now, to notice the celandines at the roadside and to remember the particular pattern of a tortoiseshell butterfly's wings. It also matters to share memories, to find links, to have friends. Though

we took no casualties during our first stint in the line, we are aware of the precariousness of life now, how finely balanced it all is, and with that revelation so these things become precious.

Chapter fourteen

Esme had learned to avert her eyes as she passed the bathroom door. It was invariably ajar, and the men seemed to think nothing of carrying on conversations while one completed his toilette at the sink and another lolled in his bathwater. Were these the habits of a soldiering life?

'Good morning!' Rory's voice called from the doorway now. 'Did you sleep well?'

She glanced quickly in his direction. He was standing at the sink, wearing a vest and pyjama bottoms, and lathering his chin with shaving soap. Esme examined the swirls of the Turkey carpet.

'I did. I'm not sure if it was the fresh air or the silence, but I slept like a log last night. I don't think I heard the nightingale, and I have to admit that it was a pleasure to have an undisturbed night. That sounds terrible, doesn't it?'

'It's been marvellous to hear it, but I'll admit that I did put a pillow over my head a couple of nights ago.'

'You too?' She glanced up and saw the razor striping away lines of shaving soap and showing the new clean contours of his face.

'I believe they stop singing when they find a mate,' he said. 'Let us hope our friend has found true love and that he may remain quietly coupled up for the rest of the summer.' His eyes caught hers as he angled his face at the mirror, and he grinned. She looked away and listened to the noise of his razor dipping in the water. 'I wondered if you'd like to come and see the mermaid in the church this morning?'

'A mermaid?'

'Not a fleshy one dragged from the depths; a wooden one. But she's very old and has quite a personality.'

He wiped steam from the mirror with his towel. She could smell the sandalwood scent of his shaving soap and remembered a morning, long ago, when Alec had let her hold the handle of his shaving razor and put it to his cheek. It had been an act of trust, but also profoundly intimate. How nervous she had been to touch him with the blade. How tenderly she had felt towards his skin. Rory rinsed his face in the sink and, straightening, smiled at her in the mirror. She recalled Mrs Pickering's cautions, but he was hardly predatory, was he? What danger was there in visiting a church with him?

'Thank you,' she said. 'I'd like that.'

There were white lilies on the altar. Esme lit a candle for Alec and realised that it was four weeks since she'd last done so.

'Has there been a funeral?' Though there was no one else in the church, instinct hushed her voice to a whisper.

'A couple of days ago. Old Matthew Carew. He was ninety-

three. Born in the year that William IV came to the throne. It's hard to imagine being that age, isn't it?'

'It is.'

It had seemed pitch dark inside, after the dazzle of sunlight on stone, but her eyes adjusted, and she saw the details in the shadows now. The pillars and arches were simple, crude almost, and looked extremely ancient. The roof might well be the inversed hull of a boat. Blue light cut through the altar window. A stained-glass sun and moon revolved over Jerusalem.

'She's here,' Rory said. 'She's what everyone comes to see.'

Esme bent to see the carving of the mermaid on the end of the pew. Her tail was slung low on her hourglass body, like the dropped waist on a flapper's dress, and looked as though it might slip from her hips. The carving of the tail was still crisp, and it was as much bird as fish, Esme thought, its texture somewhere between scales and feathers. It might flicker at any moment.

'She was meant to have lured away the finest singer in the choir,' Rory said. Esme could hear a smile in his voice. 'He fell hopelessly in love with her, and she with him, so he left his earthly life behind and followed her down under the waves, never to be seen again.'

'Why put an image of her in the church?'

'She's a warning, I suppose. Sins of the flesh, and all that?'

'Is that working? She looks like a lot of hands have touched her.' The mermaid's round belly was glossed, like a polished apple, presumably where centuries of fingers hadn't been able to resist extending to touch.

'That patina is a bit of a giveaway, isn't it?'

'I wonder who scratched away her face. Were they angry with her, or afraid of her? Is it to keep her from beguiling more susceptible choirboys?'

Her face looked as if it had been gouged away. Esme could see where the tip of a knife might have cut into the wood. The absence of the mermaid's face was somehow disconcerting; men might have been unable to resist stroking her curves, but someone clearly couldn't stand to look her in the eye.

'There's something potent about her, isn't there?' Rory asked. 'She might wriggle at any moment. Don't you think?'

'What's in her hand?'

'A quince, people say – the symbol of Aphrodite. Some scholars believe that the fruit Adam and Eve ate from the Tree of Knowledge might actually have been a quince. If you look, there's actually no mention of an apple in Genesis. In ancient Greece, a new bride and groom would retire to their wedding chamber and eat a quince together.'

'There's a quince tree in the garden, isn't there?'

'There is. Have you ever smelled one? They have a peculiarly seductive scent.'

Rory was standing behind her. Esme could smell his shaving soap and cigarettes, and just for a moment it might have been the scent of Alec's skin. Had he ever been here to see the mermaid? She couldn't recall that he'd ever spoken of it, but it was the sort of legend that Alec liked. Had he stood where she did now? Had his fingers reached out and touched?

'You look as if your thoughts are far away,' Rory said.

'Do I?' She turned to him. 'I was wondering if my husband had ever been here.'

'You can talk about him with me if you want to.'

'Can I?'

'There are people who I've lost and who I miss.' He frowned, just briefly. 'I'm happy to listen, if you want to talk.'

'I'm sorry.' Who was it that Rory missed? She couldn't tell if he wanted her to ask. She tried to read his face, but she couldn't. 'I don't get to say his name out loud very often.'

'How long ago did he . . . ?' He said it softly.

'It was seven years ago last month. Time is a curious thing, isn't it? The days have seemed to go by terribly slowly, but I can't believe it's seven years. I haven't been able to visit his grave yet.'

'I imagine that must be difficult.'

'It's regret, more than hurt, that I feel now when I think of him. I'm sad that he didn't get to become the man that he might have been, and that we didn't get to know each other better. We only had seven months of being together. We met in the March and he left in October. That was it. He's still only twenty-two in my photographs. That's terribly young, isn't it?'

'It is.'

She sat down in a pew and looked at the columns. The interior of this church might not have changed in a thousand years. The peppery scent of lilies mingled with that of damp stone. Rory sat down beside her.

'Would it have made a difference if you'd been able to

163

have a funeral? If he'd been brought home, and you could put flowers on his grave?' He hesitated. He was speaking slowly and rather cautiously. 'If you don't mind me asking?'

She considered his question. The wind whistled through the roof tiles. 'I think I would feel more at rest if I could visit his grave and see his name cut into a headstone. It would be easier to comprehend, probably easier to accept, more final somehow. As it is, he feels to be very far away and there's so much that I don't know, so many small details that I'll never have. Was he afraid at the end? Was he in pain? How long was he there before he was found? It's difficult to be told by letter that someone you love has died and not to have an explanation of why and how that happened. Death is too big a thing to accept without an explanation of the circumstances. That's not unreasonable of me, is it?'

'No. Not at all.'

'Mrs Pickering visits her Maurice's grave every Sunday and I envy her that. Doesn't that sound terrible? I occasionally feel jealous of women who can buy chrysanthemums. I look at snowdrop bulbs and wish that I could be planting them around Alec. It's the first time I've admitted that to anyone. I probably shouldn't be saying all of this to you.'

Rory was sitting with his hand on the pew in front. She saw his fingertips lift, just perceptibly. What was he thinking? Had she already said too much?

'I'm glad you feel you can talk to me.'

'I'm going to France this autumn. I should have gone sooner, really.'

'Where is he buried?'

'In a place called Le Touret, east of Béthune. I'm getting the ferry to Boulogne and then I'll travel by train. I've worked it all out. I feel like I've been holding my breath for the past seven years, but if I see his grave, maybe I'll be able to breathe out.'

Esme kept the photograph of Alec's grave in a drawer. She didn't look at it often, but she'd needed to have it. There was dew on the grass in that photograph, a glint of light caught by the camera. She had needed to read his name on the cross, to take in all the details under a magnifying glass, but it was still hard to believe that Alec's body was under that wet grass. The photograph wasn't enough.

'Are you going on your own?'

'There's no other family.'

'And no friends who could go with you? Are you sure that's a good idea? I mean, it's not an easy trip to undertake, logistically or emotionally.'

'I wouldn't know who else to ask.'

'There are charities that organise these sorts of trips, I believe, and arrange for people to be accompanied. I've read about that.'

He pushed the creases out of his trouser legs as if this smoothness was suddenly important. Esme knew that she shouldn't be saying these things to him.

'I'm not sure that I'd like some well-meaning charity worker steering me around, politely backing away at the moments when it's conventional to cry, handing me hand-kerchiefs and comforting bible texts.'

'No.' He paused. 'How about me? I could go with you.'

'You? But you barely know me.'

He smiled at that and pulled his hands through his hair. 'You're not dangerous, are you? Should I be worried for my safety, my reputation? Perhaps I shouldn't be alone with you now.'

'That's an awfully big ask. You were near Béthune at one point, weren't you? Gilbert told me that. I can't particularly imagine that you'd want to go back there.'

'I wouldn't say that it would be my first choice of travel destination, but I'd be honoured to accompany you. It would stop me worrying about you.'

'You'd do that?'

'I have been thinking about going back. There are graves that I need to visit too. Will you consider it?'

'I will,' she said.

Whose graves did Rory have to visit? She knew so little about him really. Did that flicker on his face come from bottled-up sadness and secrets? Would it do him good to let that out? Esme wanted to tell him that he could talk to her, that he could trust her – but how to say that? She thought of Mrs Pickering's talk of war raging on in men's minds, never-ending, and wished that she could find the right words.

When his hand touched hers she knew that he meant it as a consoling gesture, but why was she so acutely aware of the light pressure of his fingertips? She looked at him. His eyes moved over her face, as if he had something he needed to say and was considering where to begin, but then he pressed

his lips together and lowered his eyelashes. What was it that he'd almost said?

Esme glanced up as she heard the door. The candle flames on the altar flickered and dragged, and a woman came in carrying a metal bucket. She nodded to them briefly, dipped a mop in the bucket, and began to work her way across the tiles. There was suddenly a harsh disinfectant smell above the scent of lilies, and with the presence of another person in the church, the atmosphere shifted. Esme took her hand away. Perhaps she should she have done so sooner.

Rory sat up. He leaned his arm on the back of the pew between them. 'In the meantime, if you want to go to Penzance, that one is more easily navigated.' His voice was a whisper again. 'We could go this afternoon, if you'd like.'

'Today?'

'Unless you've got other commitments? Would you like to do that?'

'Yes,' she said.

Chapter fifteen

'Where are you from?' she'd asked Alec that first Saturday when they'd met up in the café. 'I can't place your accent.'

'I have an accent? Do you think?' His eyebrows had lifted. 'And after all those years of elocution lessons!' He shook his head and gave a rather conspicuous sigh. 'I'm from Cornwall.'

Alec was more relaxed today, in a teasing, playful mood. Esme liked how laughter always seemed to be bubbling on the edge of his words. She couldn't always tell when he was being serious, though.

'I've never been that far south.'

'It's a lovely place to be a holidaymaker, but it's not the best if you want a career.'

Esme had watched him spooning sugar into his tea. She knew that he'd moved to Huddersfield for the job with the *Courier*, and that he was ambitious about his journalistic career. He didn't look like someone who worked long hours in an office, though; he had the healthy complexion of a man who might work out in the fresh air, but perhaps that was Cornish colouring? There was ink on the pad of his second finger, she noticed, and he clearly chewed his fingernails.

Esme considered telling him that he shouldn't take so much sugar in his tea, and oughtn't to bite his inky fingers, but she contented herself with watching him instead. His open talk of ambitions, his hunger for experience and travel, had echoed her own aspirations, but there was also something uncomplicated and satisfying about just looking at this young man as he stirred sugar into his tea.

'Were you sorry to leave?'

'I was ready for an adventure.'

'In Huddersfield?'

He barked a laugh at that. 'I didn't know what it was like.'

His eyes were bright, expressive and black as sloes. He widened his eyes when he joked or exaggerated, which was often, showing the whites, like an actor or an Indian dancer. Esme wondered if he might have practised this in front of a mirror.

'Tell me about where you grew up.'

'You want to know?'

She wanted to listen to him talk, to watch his eloquent eyes, his lips shape words, and occasionally stretch into that grin; she wanted to hear his voice, his laugh, and to be able to picture the place that he came from.

'Yes. I have no idea what Cornwall is like. I keep a list of destinations that I hope to visit one day and I might want to add it.'

'Hell, now I feel as if I'm interviewing for a job with a travel agency. There's lots of gorse and seagulls. The gorse scratches and the gulls steal your pasty out of your hands.'

'I'm not sure that Thomas Cook would give you the job. What does it look like? Are there hills, moors? Do you come from a village or a city?'

'You do ask a lot of questions,' he said. 'It's fishing ports: boats, nets, crab pots, harbours, warehouses, that sort of stuff. Luring mermaids flaunt themselves on every rock, every tumbledown cowshed has a King Arthur legend, pixies and smugglers run amok, and the whole thing smells of fish.'

The tea urn hissed and Esme remembered to sit up in her seat. When they'd first taken their table she'd been conscious to sit straight-backed, holding her chin up, wanting to look ladylike for him, but he'd leaned towards her with his elbows on the table, and she'd found herself copying him. Looking ladylike didn't normally trouble her terribly, but she'd put on her best blouse this morning, taken care with her hair, and rouged her cheeks. She vaguely wished that she'd practised her smile in front of a mirror too.

'I feel you might be glossing over all the good bits. Do you smell of fish?' He smelled of cologne and ginger cake from this distance, but she would very much have liked to put her nose to his neck.

'How frightfully rude! I probably grew up smelling of herrings, but now I live in Yorkshire, so I smell of soot, grease and sheep, like you.'

When Esme tried to picture Alec's childhood, the backdrop was a collaged image of a seaside town, where nothing was solid or specific. She had pieced together impressions of

Cornwall from biscuit tins, railway posters and descriptive passages in novels. But, as she looked out of the motor bus window now, she realised that she hadn't really got it right.

Esme saw fancy plasterwork, ornate railings and a row of shops painted in the colours of Neapolitan ice cream. Rory's finger pointed out elements of good Georgian architecture and curious Moorish motifs. She hadn't expected it to be a place with so much cornicing, columns and finals. Alec was always more interested in the present moment and making plans for the next time they met up – he was a man who looked forward, not a yesterday sort of person – but yester-days were all Esme had, and so much of it was gaps, imprecise and now clearly constructed in the wrong architectural style. His town was more than nets and warehouses.

'What street was it again?' Rory asked as they stepped down from the bus.

'Penwithian. Do you know it?'

'I think it's behind the church.'

As she'd sat facing Alec in the café that day, Esme had noted his shiny brogues and his clean collar. He might have inky fingers, but everything else about him was polished and laundered. Because of that, she'd always assumed that he must come from a clean, respectable home. There would be white sheets and a gleam on the furniture, a sense of orderliness and a mother who was particular. She might not recognise its architecture or its ornaments, but she was certain about this part. As Esme walked through the streets of Penzance, she gave Alec's childhood home a view of a

garden, a smell of beeswax polish and hung lace curtains at its windows.

She stood at Rory's side and looked up at the street sign. How strange it was to be here, to have finally stepped into Alec's past. She had a sense that his eyes might be watching her. She almost expected him to walk up the street towards her – only, it wasn't the street that she'd been imagining. Alec hadn't deceived her, she reminded herself – she was the one who had given it a garden full of hollyhocks and billowed white washing on the line – but she couldn't quite put that tidy young man inside this down-at-heel terrace.

'Do you want me to knock?' Rory asked.

'To knock?'

'There might be no one at home. But you did mean to, didn't you?'

Esme looked at the house. The lace curtains at the window were yellowed and a broken gutter had left a green stain down the stonework. The peeling paint on the door showed the grain of the wood beneath and there was a slight smell of drains. In her memories, Alec smelled of shaving soap, sandalwood, ink, peppermints, eucalyptus and Player's cigarettes. Did she want to change that? But she needed to know the place and the people he came from, didn't she?

'Yes,' she said, and watched Rory's hand reach towards the door.

They seemed to stand there for a long time, looking at the door, at their feet, and then glancing at one another. Rory's red eyebrows made question marks. She was about to suggest

that they go when she heard footsteps on the other side of the door and the noise of a bolt being pulled.

The man had a fuzz of grey whiskers on his cheeks. When he rubbed his chin, Esme saw that there were nicotine stains on his fingers. She remembered Alec's clean, olive skin and white-toothed smile. Had he got older, would his complexion have become sallow? Would the cigarettes have stained and his eyes have lost their brightness?

'I'm sorry to disturb you.' Esme was glad that Rory was talking; she wouldn't have known where to begin. 'Only my companion here is looking for relatives of her late husband, Alec Nicholls. He used to live at this address before the war. I know it's a long time ago, but you wouldn't happen to know the Nicholls family, would you?'

The man sucked on his teeth, pulling his cheeks into hollows. When he spoke, his accent wasn't like Alec's – or, rather, it was an exaggerated version of Alec's voice. 'I can't say as I do. Nicholls at this address? I've been here the best part of ten years. There was a widow here before and the house was full of cats. It took us months to get rid of the smell. She wasn't a Nicholls, as I recall.'

'I'm sorry to have bothered you,' Esme said.

The linoleum in the hallway was curled and cracked, and there were scuff marks on the skirting boards. She could see a line of laundry suspended across the room beyond. A woman's voice shouted to silence the irritable wails of a baby. Was this really the place where Alec had grown up? Could there have been a mistake?

'No bother,' said the man. 'Maybe ask at the pub on the corner? Jack's been landlord since Noah was a lad.'

'Thank you.' Esme stepped back. She'd spent so long imagining what this house might be like, but now she didn't want to be here.

'Should we try the pub?' Rory asked.

'No,' she said. 'It doesn't matter. I'm not sure what I was hoping to find.'

'You miss him. You want more of him. You wanted to find traces of him here. It's perfectly natural.'

Had she been mistaken in what she was missing, though? Coming here, she'd hoped to know Alec better, but she now felt that she'd misunderstood him in some way. She'd been filling in the gaps with her own assumptions, fashioning a version of him that she wanted to believe in, and that Alec didn't live on this street. What else had she got wrong? Instead of bringing Alec closer, she now felt him moving away, and there was so little left for her to grip on to.

From *The Winter in the Spring*

June 1916

We have moved to rest billets, west of Béthune, and are told that we will be here until the end of the month. In reward for having displayed a 'fine fighting spirit' in the Richebourg sector (I quote the Lieutenant General – *viz*. we did as we were told and didn't have a total funk), we are gifted a period of sports and parades.

Béthune is full of pleasures and excitements, remarkably so as it's not so far behind the frontline trenches. Its shop windows entice us with displays of English novels and chocolate *bouchées* in silver paper, bars of scented soap, jars of bath salts and tins of flea powder. We linger in front of fanned arrangements of fountain pens, packets of writing paper the colour of clotted cream and trays of thrillingly sharp new pencils.

Our mood is also improved by having fresh company. Miles Sanderson has been transferred to us from the Somersets and is a welcome blast of new energy. It has revitalised us to

listen to jokes that we haven't heard before and he spins a good yarn. Miles, Hal and I spent a most agreeable afternoon sitting outside a café in the sunshine yesterday. We started off with glasses of *grenadine* and good intentions, but soon slid into *vin blanc* and gossip.

The men are allowed to request passes in order to sample the charms of Béthune, but to discourage them from partaking of too many of those delights, they are being kept occupied with football, boxing, cricket matches and evening concerts. The battalion band parades with drums and bugles, thumping its way all around the billets several times a day.

Hal leaned his head back and squinted against the sun. 'They were at it before seven this morning. I know I'm probably atrociously disloyal to country and regiment, but, dear God, the infernal bashing and blasting and tooting!'

'Did it not stir the martial spirit in you?' I asked. 'Did it not swell your chest with pride?'

'No, I just found myself saying words that my mother forbids. I could feel her giving me a withering look from afar. You know, there are ways of dealing with these things.' Hal took a mouthful of wine and there was something distinctly impish suddenly in his smile. 'When I was a kid, my Uncle Rhodri used to bring his euphonium over every Christmas. Of course, there were no jolly carols, no 'Jingle Bells' or 'Ding, Dong Merrily'. Not for Rhodri. He knew all the most miserable ones, and how to stretch them out. My mam would make us sit and listen, and it really put the bleak into the midwinter, I can tell you. But then I heard my old man

joking about putting cheese in his ears, and the cogs in my infant brain started whirring, see. When everyone else was out of the room I tampered with Rhodri's trumpet. I stole a nice wedge of Caerphilly from the larder and I rammed it down good and proper with the rolling pin.'

Miles laughed and clinked his glass against Hal's. 'Did it work?'

'I've never seen a man's cheeks go so red or heard such ripe language from a Methodist. I got a hiding, but it was worth it. There must be somewhere in this town where we can buy cheese.'

'Have you heard the drummers practising?' I asked.

'That bastard Tomlinson with the big bass drum? Have you seen him? He likes it too much, he does. The way he thrusts and struts.' Hal stuck his chest out in imitation.

'I mean the drum rolls. Has Gilbert told you what they're planning?'

'No,' said Miles. 'Go on.'

'There's going to be a practice attack next week. They're intending to mark out a field, have it all flagged out, with nice tidy tape lines to represent the enemy trenches. The drums are meant to simulate heavy and sustained shellfire, apparently.'

'Theirs or ours?'

'Ours, I hope.'

'Grand,' said Hal. 'Perhaps we might use triangles to replicate machine guns too?'

The gap between symbol and reality is slightly ridiculous,

but hearing the drummers practising their rolls yesterday – such very long drumrolls – made my chest feel tight. I would be happy if we could stick with simulations, cleanly marked-out fields, and an evening concert after the final whistle.

The camp was full of rumours last night. Everyone knows that something big is coming and all the men seemed to be debating what our part in this action might be. The general mood is one of keenness – they're all ready to do their bit – but I find my eagerness edged with apprehension. Gilbert hasn't told us much, and if he knows more, he's not sharing the details yet.

I took an early walk along the river with him and Patrick this morning. Mist clung to the water and the light was ethereal, the rising sun gilding the grasses. We mostly walked in silence, each of us occupied in our own thoughts, until we happened upon a skylark in the meadow. It was pouring out its rapture for the morning, the notes thin, but so sweet. It sang on both ascent and descent, but only when it was in upwards or downwards motion, as if it was overjoyed by its ability to fly and kept rediscovering this thrill over and over. It was almost silly, but it was impossible not to feel lifted with it. It was an irresistibly delightful bird. I found myself grinning rather foolishly. I looked at Patrick and saw the same expression on his face.

'*A privacy of glorious light is thine,*' Gilbert said.

'Keats?' I asked.

'*Whence thou dost pour upon the world a flood of harmony.* Wordsworth. I'll lend you the volume.'

Gilbert gave me a stack of poetry books when we got back: Keats, Wordsworth and John Clare. I decided that I would indulge in birding and poets for the next fortnight (if I can avoid the football and the boxing), but as I turn through the volume of Wordsworth this evening, I can't concentrate. My mind skips away from the rhythm and the rhymes and I find myself thinking about artillery bombardments and arrows on maps. I close my eyes and try to bring back the glad sound of the skylark, the laughter of friends and a song playing on a café gramophone, but it's the roll of drums that returns to me. It seems to be there at the back of my mind all the time now. What does it signify?

Chapter sixteen

'And what does the furrowed brow signify?' Mrs Pickering asked at dinner. 'What did you do with your afternoon?'

Clarrie had cooked gurnard in a tomato broth, scented with orange, saffron and fennel. He called it *zarzuela*, and had been reminiscing about working for a chef from Marseille, but Mrs Pickering had made an almighty fuss over fish bones. Though Esme was aware of the conversations around her, she hadn't really been listening until Mrs P turned to her now. In her mind, she'd still been staring at that door and thinking of all the questions she ought to have asked.

'We went to Penzance,' she replied.

'*We?* You and Rory?'

'I decided to go and look for Alec's house and he helped me find it.'

'What a helpful young man he is.' Mrs Pickering raised an eyebrow as she regarded Rory down the table. 'Was it as you'd pictured it?'

Esme considered the question. She didn't want to admit that she'd imagined it rather cleaner and smarter. 'It's silly, really – I'd assumed that his home might exude some special

magic. I suppose I wanted to love it, and to recognise Alec's personality in it, but I couldn't see him there. It was just a very ordinary terrace house.'

'You almost sound disappointed.'

'Not really. Not that.' There was something slightly sour about the word disappointed, but she did feel dissatisfied. 'It wasn't the house I was expecting, though, and that made me aware of how little I know about his life before we met.'

'But it's the life you had together that matters, isn't it?' Gilbert asked. Esme hadn't realised he was listening in to their conversation. 'You know how you felt about your husband and his feelings for you. That's the important thing, isn't it?'

'Yes,' she said. But why had she felt a moment's hesitation?

Mrs Pickering gave her hand a quick squeeze. 'Now that you've done that, you must look forward. I can hardly imagine that your Alec would want you to be spending your summer haunting his old addresses. He'd want you to be feeling the sun on your face, wouldn't he? Breathing the sea air, sightseeing, shopping, living a little, doing young people's things?'

He hadn't suggested sightseeing or shopping, but Rory had hinted at something similar. Alec wouldn't want her to be sad, he'd said. Wouldn't he prefer her to be experiencing the pleasures of his county, rather than looking for the reasons why he left? They both seemed to be drawing a line, Esme thought, as if she now must be satisfied having seen Alec's house. But she didn't feel remotely satisfied and questions

seemed to be forcing their way between the cracks in her expectations. Had Alec deliberately let her imagine his childhood sunnier and more comfortable? Were there parts he'd been ashamed of? Had he felt that she might judge him? Was she doing so now? And what else had he edited out?

'Talking of young people's things' – Gilbert banged his spoon to bring the table to attention – 'I had a letter from Miles this morning.'

'How's life in the dirty old city?' Sebastian asked. 'I trust it's all suitably decadent and dissolute?'

'Miles is our runaway. Our escapee,' Clarrie explained to Esme across the table. 'He writes for a music magazine now and he's married to a jazz singer.'

'His wife is called Zoubi,' Rory put in.

'Is that a foreign name?' Mrs Pickering asked.

'No, it's stage. She's actually Zoubizou on her posters. Of course, I remember her when she was plain old Veronica from Bethnal Green,' Sebastian said. 'She was an artists' model back then. Our paths crossed in London before the war.'

'Zoubizou always makes me think of the noise of a bluebottle,' Clarrie mused. 'Or perhaps a mosquito. She's naked in the National Gallery, you know.'

'I'm sorry?' Esme looked at Clarrie. He didn't seem to be joking. She wasn't sure that naked bodies ought to be mentioned over poached fish. Was this an appropriate topic for the dining room? But, then, this particular dining table appeared to have little in the way of limits.

'Nude, not naked,' Sebastian corrected. 'It's not the same.'

'Isn't it?'

'Of course not. Nude is art. Your disrobed body in the bathtub is something altogether different.'

'How do you know?' Clarrie asked.

'Darling, I do!' Sebastian laughed before he turned back to Mrs Pickering and reapplied his authoritative face. 'She's in a portrait. She's sitting on a horsehair couch, if I remember rightly, done in oils by Augustus John. Apparently, it itched.'

'The sofa,' Clarrie clarified. 'Not being painted in oils by Augustus John. Although that might have tickled too. Is it three children they've got now?'

'Two,' Gilbert replied. 'They've both been nut brown and naked every time I've seen them, like little healthy peasants. Zoubi says that it's important for children to be natural, though I think they might actually be feral. Anyway' – Gilbert banged his spoon again – 'what I wanted to tell you all is that they're coming down here for the Midsummer weekend. You will enjoy meeting them, Esme. We always have a riot when they're here.'

She watched Rory's profile. He was leaning against the wall exhaling ribbons of blue-grey smoke. They wound into the blue-black night.

'It's not cooling down tonight, is it?'

'It was stifling in there,' he said. 'I needed a bit of air.'

His voice sounded slightly tired. Esme realised that she'd asked a lot of him today. 'I wanted to say thank you. You were very kind this afternoon. You were amazingly patient.'

'Amazingly?'

She heard his smile. 'Yes. Exceedingly patient. Beyond-the-bounds patient.'

'I'm sorry we didn't find anything for you. I did hope for a charming aunt who'd ask us in for tea, or a delightful cousin who might have a house full of photograph albums.'

'I knew really that there was no family. It was wishful thinking.'

He turned towards her, his face still half in shadow. 'I wish that you had more people, that there were family and friends around you. I wish you had a dear, doting brother who could take you to France, or a sweet godmother to confide in.'

'How good at inventing kindly families you are! I have friends,' she said. 'I felt that today.'

'I'm glad you felt that, because it's true.'

There was a warmth in his voice, but also a hesitancy. Why was that? Did he feel that she was establishing a boundary by calling him a friend? It wasn't something that she'd made a conscious decision to do, but still, perhaps it was sensible.

'Mr Nightingale has started again,' he said. 'Can you hear? I hoped he'd found his true love.'

'I guess it mustn't have worked out.'

'Poor soul.'

His voice drifted away. He seemed uncertain what to say next, but Esme could feel his eyes on her in the dark, an intense look, but then the contact breaking. She heard his feet turning and saw the arc of his discarded cigarette. 'I think that I should perhaps try to get some sleep,' he said.

'I hope you can,' she replied. 'I should go in too. Goodnight.'

It was the right thing to do, the proper way to behave. He couldn't be more than a friend. She couldn't be disloyal to Alec, but she felt a pang of sadness and regret as she watched Rory walk away.

From *The Winter in the Spring*

July 1916

It is still hot as we set out at dusk, and a swarm of bluebottles drones around us. They're horrid, bloated things and they seem to have a compulsion to land on our faces. We flinch, curse and flail our arms at them, we've seen the places where bluebottles gather, but they're determined to follow us. Sweat prickles on my top lip.

We've been ordered back up to the section of trenches from which we launched the attack three days ago. The position has been subjected to heavy shell fire, on and off, for the past twelve hours. The company that we're relieving have taken significant losses, I'm told, and are badly shaken. They need to get out, and the section needs to be held, but I can't say that I presently feel any keenness to replace them. The sky ahead is black. The rumble of artillery has barely paused all day.

We step aside to let the stretcher bearers pass, and I notice

a collection of new graves at the side of the road. I visited one of the cemeteries up near Béthune last month and talked to a gardener who was working there. He told me that they receive bags of flower seed from England, had transplanted wallflowers, pansies and forget-me-nots from abandoned gardens in the village, and that he was collecting cuttings from roses. There was pride in his voice, and I saw gentleness and care in the work. These roadside graves have crudely fashioned crosses, made from ration crates, I think, and none of them stand at quite the same angle. There are no roses here.

Patrick bends in the ditch and, when he straightens, I'm surprised to see the yellow flowers in his hand. He fixes a sprig in his buttonhole. It looks faintly ridiculous against his mud-spattered tunic.

'Very jaunty. Got a formal engagement? What is it?' I ask as I then watch him fixing a flower to my own chest.

'St John's wort. In days of yore they'd fix it over the door frames on Midsummer's Eve. It protects you from evil spirits.'

'And shells?'

'You never know.'

We go into the communication trench in single file. I can't say that I recognise this trench, but I feel a mix of dread and weariness knowing that we've been here before. Three days ago, 160 men of this battalion didn't make the return journey. We are still seven officers down. I shouldn't let my brain calculate the odds, but it's horribly easy to be drawn into that maddening arithmetic. Based on our last stint, the men have

a one-in-three chance of become a casualty; a one-in-four chance of dying in this part of the line. I don't want to look at the men around me and calculate who is for it this time.

'Mind the wire!' shouts a voice ahead, and then, 'Mind the holes! Pass it down!'

We halt. The light is fading and, as I look back, the line of men behind me is a swaying chain of glowing cigarette ends, like a string of Christmas lights. Whispered speculations pass back and forth down the line. But then we start again. The trenches become more battered as we move forwards. The walls are blown out in places, and in the gathering darkness we pick over banks of earth, tangles of telegraph wire and now two slumped bodies. Just a couple of months ago this sight would have shocked us, but now we walk past lifeless bodies without looking twice. How can that be right?

I know that the shell is coming for a fraction of a second before I hear it. There's a change in pressure that minutely registers itself on my eyes, my diaphragm and my skin, and a fleeting moment of awful certainty before the impact is real. It's like the sky is splitting, a terrific blast of light and sound. The earth around me feels to be roaring upwards, and then it's all falling down again. Stones and soil ricochet off my helmet, splinters zip and I see a shower of sparks. It carries on falling, and I keep my head down, but then I hear a noise like a wounded animal behind. I look around and in the flashing light I see that MacNeil is holding his thigh. Blood is seeping between his fingers and I hear his voice chanting, 'Please God, please God, please God'. There's no pause, no space

between his words. He reaches out and grabs my hand with his red fingers and all of his pain and fear is going into that grip. I tell him that I'm going to apply a field dressing, that he must wait here, but that help will come for him. I have to shout above the noise. He doesn't want to let go of my hand, though, and it's difficult to unwind my fingers from his. In the devilish pyrotechnics I make out clots of dark blood, and I feel disturbing textures as I push the dressing on. I leave MacNeil holding it in place, and tell him that the stretcher bearers will come for him. But will they? I can feel that grip on my hand still as I go on, the stickiness of his blood, and his words become an incantation that loops endlessly in my own head. Sweat trickles down my back.

As we go forward, there is almost no break in the noise and darkness pitches about. It rushes and roars around us, and my thoughts no longer form themselves into words. All I know is sensation: the fork of leaping light that leaves an echo behind my eyes, the lurch of the earth beneath my feet, the smell of lyddite and smoke, the sourness of fear in my mouth and the slam of sound that is so very much more than a drumroll. Is this what it is like to walk towards an earthquake? Is this what it feels like to approach a volcano? It is of that scale. Every instinct tells me that I should be running in the opposite direction.

We come up into the front line and I see men huddling in holes. One of them raises his face to me and his eyes are wild. I shine my flashlight at two collapsed dugout entrances before I find an officer. The space behind him is in darkness,

but he turns and I follow him down the steps. As he lights a candle, I see his bloodshot eyes.

'You're lucky that it's eased off a bit. It kept blowing the candles out before.'

'It was lively on the way up.'

'It's been like that for most of the day. We've been digging men out, and trying to get the wounded back, but all we can do with the dead is keep them out of the way. We had a couple of men become hysterical, nerves completely gone, and it put the wind up everyone else. Even the rats seemed to be hysterical at one point. They came surging into the dugout, a great filthy, squeaky wave of them. Impudent little bastards!'

His tone is falsely merry. I'm not certain that his nerves are entirely right. He puts a grimed finger out and touches the yellow flower in my buttonhole.

'Off to a wedding? What's it for?' he asks.

'For luck,' I reply, thinking how ludicrous it looks now. I'd forgotten it was there.

He laughs. 'You'll need it here.'

PART TWO

Huddersfield Courier, 17th June 1923.

NATURE DIARY
THE OLD MAGIC OF MIDSUMMER

As Midsummer's Day approaches, the hayfields glimmer green-gold and shift with tints of mauve and pink. Centuries ago, when the natural world seemed all powerful, this was a time of ritual and revelry. Bonfires were lit on hills all down the length of Cornwall. These fires were meant to reinforce the sun's light by sympathetic magic, ensuring good crops, and they were believed to have a purifying power. People danced around them and jumped through the flames. New babes were passed above the fire, and engaged couples leapt over hand in hand. People wanted to stay close to the light on this night, because danger lurked in the darkness; at this turning point in the solar cycle it was believed that the veil between this realm and the next was at its thinnest. Witches were active on this night, faeries were looking to play tricks and the unquiet dead walked abroad.

Herbs gathered on Midsummer's Eve were believed to have special medicinal potency. St John's wort, which comes into bloom from mid-June, was particularly associated with

the Midsummer festival. For the druids this was the plant of the sun god, possibly on account of its bright yellow flowers. It was hung over the doors of houses and cattle stalls to repel evil spirits, mischief and thunderstorms.

Midsummer was also a time for love divination. Young women would cast hempseed in churchyards at midnight. Tossing the seed over their shoulders, they would repeat the words: 'Hempseed I scatter. Hempseed I sow. He that is my true love come after me and mow.' Expectant eyes would then search the darkness for an apparition of their husband-to-be.

It's rather a shame that we have lost some of this magic and merrymaking. In our rational machine age it is refreshing, just occasionally, to dance around fires, and marvel at pyrotechnics, and to hope there may be better times to come.

Chapter seventeen

Esme held the ladder for Gilbert as he stepped down. He'd wired greenery over the front door, branches of oak and laurel and flowers of St John's wort.

'For luck,' he said, standing back to admire his work. 'We'll take all of it that we can.'

The drawing room was full of yellow flowers too: jugs of echinacea and roses, and a large vase of gorse over the fireplace.

'It smells just like my grandma's coconut cakes,' she said.

'Zoubi loves blooms, and it's nice to have an excuse for a little indulgence, isn't it?'

There was much indulgence going on in the kitchen too. Clarrie had been cooking for the arrival of their guests for days. This morning every surface was covered with meringues and tartlets and choux buns. Esme wondered, were they all a little smitten with Zoubi? They were making a tremendous fuss. Rory had even given up his room, and planned to sleep in the barn on a camp bed. He was being very gracious about it, and said that he'd slept in far more insalubrious accommodation, but it had taken him a day to

clear all his work away. Esme had cleaned the windows and scrubbed paint flecks from the floorboards of his room. There was still a faint smell of paraffin, but at least the ashtrays had been emptied, and all the terribly flammable papers had been tidied away.

'They had yellow roses for their wedding,' Gilbert went on. 'Miles asked me to be his best man, you know. I was touched by that.'

'I'm sure you were.'

'I'll not lie. I did shed a tear or two.' He smiled fondly at the memory. 'We took flowers to dress the church, and it looked so fresh and optimistic. We drove buckets full of roses over – Persian Yellows, Albas and great armfuls of alchemilla – not that Shoreditch doesn't have florists, but it mattered that they were from the garden here. It mattered to Miles and it mattered to me. The car smelled divine, but Sebastian had a bad reaction to the pollen. His eyes puffed up and streamed all the way through the service. He looked like he was terrifically moved by the occasion.'

'What a nice thing to do.'

Esme remembered the smell of bluebells in a church, the parting clouds illuminating the stained-glass angels, and how the forget-me-nots in her wedding bouquet had wilted with the heat of her hand. She'd momentarily felt sad as she noticed that, but then she'd looked up to see Alec standing at her side and the smile stretching on his face. She'd hoped that her memories might become sharper and fuller once she'd seen the places that had made Alec into the man he

was, that she'd be able to picture the precise colour of his eyes again and hear his voice in her mind. But the pieces weren't fitting together and now she couldn't quite bring his smile into focus.

'Are you quite well?' Gilbert asked. 'I'm sorry. What an insensitive old fool I am.'

She turned away as she reached for her handkerchief. 'No, not at all. It's me being silly.'

'There's nothing silly about it.' He put his hand on her shoulder.

Esme swept the fallen leaves from the flagstones and began to dust the drawing room. She made herself look closely at the titles on the bookshelves and the ornaments on the mantelpiece, rather than let her thoughts stray back to Alec. She focused on the words carved into the cowrie shell, the spirals of the ammonite and the placid expression on the face of the brass Buddha. Which of the men did each of these objects belong to and what journeys had brought them here? She wished that she could sit for a day in this room and simply listen to them telling their stories, but perhaps they would tonight? Would they reminisce about being together during the war? Would they talk about being in the line near Béthune?

She decided to have a go at the piano with a bowl of sudsy water. How satisfying it was to reveal the shine of the black lacquer. It was like the wash of water over pebbles on the beach, illuminating lustrous colour. But it was difficult to clean the keys without accidentally plonking out a tune.

'I thought it was something *avant garde*,' said Mrs Pickering from the stairs. 'I've just spotted that they've got poor Hal cleaning windows. He's leaving more streaks than he's eliminating. I'll bet there was none of this kerfuffle before *we* came.'

'They do seem rather keen, don't they?'

'As if the arrival of the Queen of Sheba were imminent.'

'I helped Clarrie set the table for dinner earlier. They've wired roses onto the back of Zoubi's chair. It looks like the throne of the May Queen.'

'Dear me,' said Mrs P.

'Have you met them before?'

'No, but Gilbert has talked about them so much that I feel I have. I am curious, I have to admit. They all talk so fondly of Miles, and he does appear to be the member of the group with the most robust backbone – I mean, he's the only one with a family and a regular job, isn't he? He's got on with his life, looked forward, while the rest of them cling together here. I am interested to see what he's actually like.'

'Yes, I am too.'

'You mustn't be intimidated by Zoubi, though. Remember she's really a Veronica and sounds Bethnal Green behind the bedroom door.'

They were planning to have drinks as soon as the visitors arrived, so Esme went up to change. As she buttoned her white blouse, she thought how prim she would probably look next to Zoubi, but this was who she was; Alec had

once called her his May Queen, and there was no reason to be intimidated, was there? She put on her coral necklace and remembered the feeling of Alec's fingers fastening it at the back of her neck. But she checked herself at that: she must keep her thoughts in the room tonight. She gave herself a stern look in the mirror – it was almost worthy of Mrs Pickering – and told herself that she must simply enjoy the company of this group of friends this evening and be grateful to be included.

Esme glanced out of the window as she heard the motor car turning into the gate. Standing on her tiptoes, she watched them getting out down below. She could hear Gilbert making an enormous fuss and the laughter of his guests. Zoubi was wearing a pale pink dress and had brown hair set in Marcel waves. She didn't look particularly vamp-ish, or likely to shed her clothes. Miles put a sunhat on his head as he stepped out of the car, so Esme didn't catch much more than dark hair and a white shirt, but he extended his hand towards his wife as they entered the house, and Esme liked him for that. She heard Rory laughing in the hallway and smiled as she turned from the window.

She could hear music playing as she stepped down the stairs, and voices raised above the beat. The conversation paused, bracketed with laughter, and their voices sang along with the chorus. How young they all sounded, how carefree.

Esme followed the noise and stood in the doorway of the drawing room, watching them unobserved. Zoubi was

sharing a story about the journey, doing the accent of a fellow traveller on the train. She knew how to tell an anecdote, where to pause, and how to make her audience laugh. The men were lounging in the armchairs, already with glasses in their hands. Rory was perched on the arm of the sofa, grinning rather boyishly. It was like watching a play, Esme considered, a satisfying final scene that brought old friends back together again, and she almost didn't want to break in and spoil the moment. She lingered in the shadow of the doorway a minute longer, but it was then, as she took in the room, that she saw him.

He was sitting cross-legged on the floor, at the base of Gilbert's chair. She only saw his face turn to profile for a moment, but that was enough. She stepped back from the doorway.

Chapter eighteen

Esme had to sit down on the bed. She'd taken the stairs fast and felt dizzy. She looked at his face in the framed photograph at her bedside. It couldn't possibly be, could it?

Alec Nicholls had died in May 1916. He was killed when a shell hit the building in which he was sheltering, and he was buried in a military cemetery to the east of Béthune. Esme had a photograph of his grave, a wooden cross with a metal nameplate attached. The photographer, to whom she had paid thirty shillings, had taken care to focus in on the lettering, and there was nothing uncertain about it. There was his name, his regiment and number, and the date of his death. He had been dead for seven years now.

How then was he presently sitting cross-legged on Gilbert Edgerton's Afghan rug three floors below?

Esme had known women whose husbands were reported 'missing, believed killed', and she had thought how cruelly open-ended that word – missing – was. She had felt sorry for them. They would never see a name on a grave, or be able to look at a map and know that he was there. They couldn't have flowers sent, a date to mark, or find some comfort in

lighting a candle. They must just leave the back door on the latch and hope.

There had been nothing indecisive or oblique about the letter Esme had received. Its words were almost blunt in their directness. There were no possibilities, or maybes, or likelihoods. Alec was bluntly dead in black and white. There wasn't even any sympathetic softening of it, no skirting around that truth with euphemisms. They had sent her the facts and figures of his death. She had never seriously considered that those facts might be wrong.

It couldn't be him. How could it? It must merely be a likeness, or her mind playing tricks. This young man, called Miles Sanderson, merely looked like Alec. Or perhaps she wanted him to look like Alec? She knew that the mind could be capable of trickery. That was how women saw ghosts, and signs, and heard familiar phrases in the words of spirit mediums. Esme told herself that this was the case. And yet, when she tried to stand up, her knees buckled. She was sick in the washbasin.

She had shocked herself, frightened herself, that was all. She'd been silly. She wiped her mouth and looked herself in the eye in the mirror. A pale woman with bloodshot eyes looked back. Something trembled around the corners of her mouth. She couldn't make it stop.

She should have a glass of water and compose herself. That was the thing to do. She should take five minutes to calm herself, and then she must go down the stairs again and introduce herself to this man who resembled Alec. She would

look him directly in the eye and know that it wasn't him. All the differences would then be obvious and she would realise how foolish she had been. But just to pour a glass of water was difficult. She wiped away a tear and told herself to be sensible.

Esme lay on the bed for a moment. Her heart was racing. She felt that she wasn't entirely in control of her own body or her mind, but she concentrated on her breaths. She must carry the basin down to the bathroom, she told herself, wash her face and collect her thoughts. It was foolish to drag this out. The sooner she saw him and understood her error, the sooner she would feel herself again. This confusion would pass. She must let it pass.

She leaned against the banister and took each step carefully. On the second-floor landing, she could hear the gramophone, and she hurried to the bathroom door and locked it behind her. She rinsed out the basin and stood by the window to get a little air. Closing her eyes, she listened to the sparrows in the wisteria and the faraway maybe sigh of the sea, but then Gilbert was stepping out onto the lawn with Zoubi and pointing up at the roses.

Esme stepped back, but continued to watch from behind the curtain. Zoubi was younger than she'd first supposed. Maybe in her mid-twenties? She dressed rather older, clothes that were evidently chosen to make her look more sophisticated and worldly than her years. She was younger than Esme, probably, and though she smiled confidently, there was something unfinished-looking about her face. Esme thought again of the man in profile who she had glimpsed in

the drawing room – was he too young as well? Alec would have been thirty now. Time had moved on.

She looked at her reflection in the mirror over the sink. Her colour had come back, but she still felt unsteady. It had been a scare, that was all, a moment of confusion. By this evening, she'd laugh about it. She would tell Rory about her mistake when she got a quiet moment and he'd understand, she felt. She blinked hard and bit at her bottom lip. Her breath misted the mirror.

She was turning to the door when she heard footsteps and voices on the stairs. Rory seemed to be carrying up their luggage.

'No, of course, it's not a bother,' Esme heard him say, and waited for the response.

'It's awfully decent of you, old man,' his companion replied, and although the phrasing wasn't familiar, there was enough there that Esme recognised. She had to lean back against the wall. It was the voice that had once laughed with her own, with which she had shared secrets, domesticities and intimacies. It was the voice that had said 'for ever and ever' in a church and which she'd so desperately wanted to hear again. She knew then that she wasn't wrong.

The door to Rory's room creaked open and there was the noise of them carrying suitcases in. Rory was saying how he didn't mind camping out in the barn, and how he hoped to see bats in the rafters, but Esme wasn't really listening for his voice. She waited and felt as if every nerve in her body was poised in anticipation.

'Gil said you've heard a nightingale this summer?' said Alec's voice through the wall, and there was no longer any doubt. Esme crouched down with her arms around her knees. She had no idea what she was meant to do next.

Chapter nineteen

'Esme, are you in there?' It was Mrs Pickering's voice. 'We were expecting you downstairs.'

Esme watched the door handle rotate, hoping that she'd remembered to turn the key in the lock.

'Esme?' Mrs Pickering said again. 'Please come to the door. I'm concerned.'

'I'm not feeling well.' She didn't want to have to go to the door. 'I was asleep. I think I must have eaten something that didn't agree with me at lunchtime.'

'Oh, my dear! Everyone else is well – I can't think what you could have eaten. May I come in?'

'Will you give me a minute? I'm in bed. I'm feeling ghastly.'

She only opened the door a fraction. Esme wasn't absolutely sure why, but she didn't want to have to look Mrs Pickering in the eye.

'Have you been horribly sick? You look like you've been crying.'

'I feel lousy. I'm so sorry. I'd like to go back to sleep.'

'What a pity for you. You'll miss all the fun.'

'Would you apologise to everyone for me?'

'Of course. Perhaps Clarence could bring you some supper up on a tray? Maybe just some tea and toast?'

'I couldn't eat, but thank you for the thought. I'll sleep it off.'

'Sensible girl. Sleep well. You'll feel better in the morning.'

Would she? What was meant to happen tomorrow? She heard Mrs Pickering's footsteps descending the stairs, then bursts of laughter and piano keys. She pictured Alec sitting at the piano. It couldn't be. And yet it was. In an instant, the central fact of her existence had inverted; his death, her loss, which had determined the direction of her life for the past seven years, wasn't real. The shock of that reversal made her body shake.

Esme wasn't certain that she'd slept at all. She had spent the night working through possible explanations: from amnesia to ghostly apparition and back again to her own insanity. It didn't make any sense. No theory was plausible.

Was he aware that she was in the house? Had her name been mentioned and would he have worked it out? What would he do next then? Would he leave this morning? There was part of her that might be relieved if she did hear the car engine starting and see them going again. Her instinct was to stay hidden behind her bedroom door until he had gone, but another part of her needed certainty and to see him. She wanted to look at him, touch him, tell him that she had never stopped loving him. She had never stopped missing him. If

she could look him in the eye, would she see that he still loved her too? But how could he?

The clock in the hallway had struck ten, eleven, midnight, and the music had carried on playing. She'd heard a low, husky female voice singing sometime later, a voice that must have been Zoubi's, and then raucous applause. She'd heard them laughing. Had they been dancing too? Had Alec danced knowing that she was up here?

She looked at the luminous hands of her bedside clock. It was coming up to six and the house was silent. No one would be stirring for a couple of hours. Could she tiptoe out to the bathroom? Could she creep down to the kitchen?

She held her breath as she stepped past the door of their room. How strange it was to think of him in there, in a bed with the woman who he now called his wife. Wasn't *she* still his wife? Could he have lost his mind? Could he have forgotten she existed? She had read newspaper reports about men returning with amnesia and having no memory of their wives and children. Could it be that?

The kitchen was full of dirty dishes and smeared glasses. Poor Clarrie. She ought to be helping him with this, but she didn't want to face any of them today. The visitors were staying for two nights, she knew. She could feign illness for two days.

She cut a slice of bread and poured a glass of milk. The sun was lighting up the garden, and dew was glinting on the roses. She could have two minutes of fresh air. She looked at the kitchen clock, turned the key in the back door and stepped out into the garden.

The morning air was cool. It had been so hot in her room overnight, she had tangled in her damp sheets and her head had throbbed. She took deep breaths and stole out between the raised beds and along the path to the orchard. The wasps were already gorging on the fallen apples and the air was full of a low hum.

Esme leaned against a tree trunk and closed her eyes. She listened to the bees and the sparrows, the wings of a wood pigeon and the breeze shifting the leaves above. All was as it had been and yet everything had changed.

When she opened her eyes again, he was there.

Alec, who was meant to be dead, who had been dead for seven years, was now standing just inches away from her.

Her back jolted against the tree. He put his hand up as if he meant to cover her mouth. Did he think she was going to scream? She nearly had. But then he lowered his hand and she watched his eyes taking in her face. His eyes were exactly as she remembered them. His face was as familiar to her as her own reflection. She saw shock and trepidation there – and recognition? Did he know her?

'Are you a ghost?' she finally said. 'Only, I don't understand how I can be looking at you otherwise.'

His eyes seemed to search her face. Hesitancy twitched at the corners of his mouth. 'Part of me wishes that I might be. Perhaps this would be easier if I was. No, I'm not a ghost.'

'I don't know how to explain it then. What am I seeing? Do you know who I am? Do you remember me?'

His lips parted, but he looked as if he wasn't sure what

to say next. Could he have amnesia? Was that it? Could he have been confused and lost all this time? It might explain so much. She couldn't tell what he was feeling. She couldn't read him. But then he said her name and a rush of realisation came with that word.

'Esme. I didn't think I'd ever see you again.'

'You're dead, though. They told me you were dead. I've seen your grave.'

He rubbed his eyes. 'Alec Nicholls is dead.'

'Who are you, then? *You're* Alec Nicholls. You're my husband.'

He seemed to have to think about this. 'I am and I'm not.'

'I don't understand,' she said again. She clenched her fists and focused on the feeling of her fingernails digging into her palms. If she could feel that, then this was real, this was happening, he was really here.

'I don't expect you to.'

She stretched her fingers out towards him. Part of her wanted to touch him, to pull him to her and to kiss him. Did he feel the same? Why wasn't it happening then? He looked a little older around the eyes, and his hair was longer, but he was still her Alec. A war, and his death, might never have happened. Every inch of his face was familiar, but his words made no sense; this tension and the fact that he didn't step towards her made no sense.

'I cried for you,' she said. 'I cried for weeks, months, years. I wore black. I lit candles in churches. My life has all changed.'

'I'm sorry. I wish it could have been different. I hate that you've cried.'

'This doesn't make any sense to me. You can't be here.'

'I shouldn't be.' He folded his arms over his chest and she heard him take a deep breath. His expression suggested he was trying to make a decision. 'This shouldn't have happened. If I'd had any suspicions, been aware of any link, I wouldn't have let it happen. I knew Gil was from Yorkshire, of course, but I didn't realise his sister lived in Huddersfield. Then she said your name last night, and it was obviously you. I mean, what are the odds? I didn't know what to do.'

'Where have you been?'

He shook his head. 'You don't want to know about the places I've been.'

'I *need* to know where you've been!' It was only as he put his hand to her arm that she realised she'd raised her voice. How peculiar it was to feel the grip of his fingers on her arm. 'You have to explain this to me,' she said more quietly.

'I will. But listen, there's something I need to ask of you first. In the circumstances, I have no right to ask anything of you, but I'll beg you if I must.'

She looked at him, barely taking in his words. 'What?'

'Alec Nicholls is dead. He died a long time ago and there's no going back now. As far as they all know, I'm called Miles Sanderson. That's the person I've been since 1916 and I can't go back to being Alec. You're the only person here who knows that he ever existed, and it has to stay that way. They can't know. We'll leave tomorrow morning. If you need

211

anything from me – money, I mean – I'll give you an address to write to, but I have to carry on being Miles now. I know it's a lot to ask of you. God knows, Esme, I do appreciate that it's a hell of a lot to ask of you! But will you keep my secret?'

'I loved you, though,' she said. 'I still love you. You never expected to see me again?'

'I couldn't. I realise that I owe you an explanation, and I will tell you, but I can't come back. I couldn't then and I can't now.'

'Owe me an *explanation*? Just that? Only that?'

'Esme, I know this must be a shock for you, and hard to understand, but please—'

'You started again. You started a new life. That's it, isn't it?'

'Miles? Where are you, darling? Are you down there in the garden?' It was Zoubi's voice calling from an upper window.

'I will explain it all, I promise, but not now.'

'You'd better go to your wife,' she said, falteringly. How could she be saying those words to him?

They were having breakfast in the garden. Esme could hear them sitting around the table, their voices merging together. She heard them laughing and picked out Alec's voice. Was she going mad?

There was a knock on her door at ten and Rory's voice was there then.

'Can I come in? I've brought you a tray.'

'I'm not well,' she said.

'Yes, Fenella told me. I am sorry. We all missed you last night and we've been worried about you. Can I come in and put this tray down?'

She could hear the concern in his voice, but she didn't want to face him. 'I'm in bed. Could you leave it on the landing? I'll get up in a bit, but I'm feeling washed out.'

'Is it that bad? We've been talking about going swimming and I wondered if you wanted to come. It might make you feel better.'

'I don't feel up to it. But thank you.'

'I'm sorry. There's breakfast for you here. I'll come and see you later. May I?'

'If you wish.'

It didn't feel fair to turn him away, she could picture him on the other side of the door, but what was she meant to say?

Esme watched from the window as they all headed off down the path with towels under their arms. Rory and Hal were trying to trip each other up like schoolboys. Alec had an arm around Zoubi's shoulders. He had begun again. He'd made his choice.

She took his photograph out of the frame so that she could see him better. Yes, those were his same eyes, just slightly more lined at the corners now, as if he had found much to laugh about over the past seven years. That was his same straight nose. His cheekbones and the shape of his jaw were the same. That was his mouth, the lips that had said ''til death do us part', which, she supposed, it sort of had. There was

no clause in the service about coming back after death. She had no idea what the rules were now.

It was only in the first few weeks that she'd allowed herself to consider the possibility of it being a mistake. She had only very occasionally permitted herself to imagine a scenario in which Alec came back. After all, it wasn't healthy to think like that. Women who had thoughts like that made themselves ill. They had to learn to move on, that's what people said. Alec had evidently learned how to move on.

When she had briefly allowed herself to dream, she'd pictured a ragged version of him reappearing on the doorstep. Injured, maybe. Possibly confused. There had been a mistake in the paperwork, he would say. They would face each other with shock at first, then tears of relief and joy, and how sweet it would be. As he stepped into the house, they would fall into each other's arms, coursing with pain and passion. What foolishness that was. It was a scene from a play or a novel.

The shock had been there this morning, and the pain, but where was the joy and the passion? Her first instinct had been to reach out and touch him, but then she'd seen the alarm in his eyes, and within seconds he was talking about secrets. He'd looked jumpy. He didn't look as if he was pleased to see her.

Surely the Alec she had known wouldn't have done this? He had loved her, hadn't he? She had believed that they were happy. In his letters, he'd said that he missed her (again and again), that he longed to come home to her, and he'd talked of what a fine life he would make for them when the war was

done. But had she ever really known what sort of life he'd had? She looked at Alec's photograph face. Had she known him at all? She shut the bedside drawer on his photograph.

Mrs Pickering knocked again towards the end of the morning. 'Esme? May I come in?'

'I'm not very presentable. I'm still being sick.'

'Would you like me to call a doctor? Have you got a temperature? Please, will you open the door?'

Esme didn't want to let her in, but she also didn't want her to summon a doctor.

'You do look washed out.' Mrs Pickering sat on the edge of the bed and peered at Esme a little too closely. But she placed a cool hand on her forehead and there was something motherly and tender in that gesture. Just for a moment, Esme wanted to lean towards Mrs Pickering's hand and to tell her all of it.

'I feel wrung out.'

Mrs Pickering had occasionally come into her room at Fernlea. Esme remembered that she had once picked up Alec's photograph. Did she not recognise him? But Esme saw that she had no idea.

'Does anything hurt?'

'It's probably a bug. Perhaps it's influenza?'

'You poor girl. They've all gone swimming. It would have done you good to have the company of some people your own age.'

Esme imagined Alec splashing in the sea, his laughing

face in the sunshine. She pictured him holding on to Zoubi in the water.

'You do look glum.'

'Don't linger. I don't want to give you my germs.'

'Zoubi hoped to meet you. Rory talks about you all the time, you know. He's given you star billing.'

'Please, do pass on my apologies.'

'Actually, there are small mercies. They've brought a photograph album and are threatening to take us through their children's early years tonight. Perhaps I'll come up here and say I need to nurse you? I'm really not up for first steps and potty training over the *amuse bouche*.'

Esme had forgotten about the children. How could she have done? The thought of it made her feel light-headed.

'How many children have they got?'

'Two. But I wouldn't be surprised if there's a third en route and an announcement is made tonight. She's got that look about her. You know? Like a lioness after a kill.'

She and Alec had talked about children, they'd agreed that they wanted a family, but then the war had come. She wondered if they looked like him.

'Miles must be delighted.'

'Smug.' Mrs Pickering laughed. 'Gilbert suggested that it might be nice if each of the boys could take a turn to be a godfather. Imagine, she'd have to have a brood!'

'Five?'

'Zoubi's face sank at that, I can tell you.'

*

The whitewashed walls of Esme's room changed colour through the day. She listened to them having lunch in the garden and realised that she was tuning her ear to pick out his voice. She couldn't make out the words, but she could tell that he was sharing a story, and then the group laughed at its conclusion. She could also, here and there, pick out his laughter. It wasn't a sound that she'd imagined she'd ever hear again. She veered between elation, anger and sorrow, and didn't know where to stop. She felt exhausted and yet her brain wouldn't slow down. There were too many questions, too much that didn't make sense. Panic flooded through her body.

In the afternoon, she tore up his photograph and then cried as she pieced it together again. How had Alec been stuck back together again? Had he ever really been torn apart? If it wasn't true, how could he have let her believe it? Did he not realise what she'd been through? Did he not care?

She decided that, indeed, he did owe her an explanation.

Chapter twenty

Esme fastened the clasp of her chain, as he had done on their wedding night. The locket contained his photograph and he had given it to her as a gift that night. Would he recognise it and remember? She rouged her pale cheeks, took particular care with her hair and held her chin a little higher as she looked at her reflection in the mirror. What right did he have to assume that she would keep his secrets?

'Esme!' Gilbert was crossing the hallway with a cocktail shaker in his hands. 'I'm so glad you're feeling better. Would you like a Martini? It would see you right.'

'That sounds very civilised.'

'Come on. We're all out in the garden. Let me introduce you.'

Zoubi was wearing a dress printed with zebra stripes, red leather sandals and earrings that might have been bartered from an African tribe. Her eyelashes were thickly kohled and Esme thought that her hair might be dyed, but her wide, lipsticked mouth was pulled into a generous smile.

'How divine to meet you,' she said when Gilbert introduced

them. 'The boys have told me so much about you, and your tummy upset has put them all in a fret. See how cheered up they all are now!'

It was extraordinary to take in the face of this woman, the mother of her husband's children. But her smile lingered, it seemed sincere, and Esme sensed that she wanted to be liked. It was also apparent that she had no idea about her husband's secrets. He had kept them both in the dark. Esme felt pity for this clueless girl.

'And our dear Miles,' said Gilbert, 'whose absence you've heard us lamenting.'

'I have,' she said. 'How do you do?' She held out her hand towards Alec, and he took it with a polite but unsmiling bow of the head.

'I'm pleased to meet you.'

How peculiar to feel the touch of his skin. How well she knew the grip of his hand. She both wanted to cling on and throw it off.

'I almost feel as if I know you already,' she said.

She could see the anxiety in his face. He didn't know if he could trust her. She hadn't yet decided whether he could.

'Come and sit with me, Esme.' Mrs Pickering made space next to her on the swinging chair. 'How are you feeling?'

'Better. Thank you.'

'This will put the hairs back on your chest.' Gilbert handed Esme a cocktail and Mrs P clinked it against the rim of her own glass.

'You still look pale,' said Rory. He was lying on the grass,

plucking at daisies, and Esme could see concern on his face. 'You shouldn't have felt obliged to get up.'

She smiled at him. 'Don't worry.'

'Rory told us you write a newspaper column,' Zoubi said. 'I think that's marvellous.'

'It's only a weekly article, a nature column for our local newspaper,' she replied. She couldn't help looking at Alec. 'But I enjoy writing it and have been glad of the focus and the regularity of that work over the past few years.'

'You should talk with Miles. He writes for a magazine, don't you, darling? There must be places where your worlds overlap.'

'I'm sure there are,' said Esme.

It wasn't that she expressly wanted to stick pins in, but Alec deserved to feel uncomfortable. She watched him as the group talked. He didn't involve himself much in the conversation and spent a good deal of the time examining the contents of his glass, but how unchanged he was. Esme couldn't stop her eyes returning to his face. So many men had come back from the war looking older or depleted, but he was suntanned, his hair was streaked a little lighter and his skin had a healthy glow. He looked like life was suiting him. At times, as Esme sat there watching him, she wanted to go over and touch his face, his hair, his hands. At other moments, when he smiled, she wanted to strike him.

They had set up the dining table in the garden, and when Clarrie asked for assistance, Esme was glad to break away from the talk of nightclubs and childcare.

'We're travelling around Europe this evening,' Clarrie said. 'I don't know whether to call it *hors d'oeuvres* or *antipasta* or *mezze*. Have you got an appetite?'

'Not really, but I'm sure your guests will love it.'

'Are you still feeling ill?' Rory asked, holding the tray while she and Clarrie loaded it with dishes. 'You should have stayed in bed if you're unwell.'

She thought how considerate he was, but his eyes examined her a little too closely. 'I'm far too nosy,' she said. 'I wanted to see your visitors.'

'I think we'll all be glad of some different conversation. We had an hour of Angelina's teething last night, and a prolonged analysis of Teddy's taste in nursery rhymes. I caught Sebastian rolling his eyes at one point. I love them both dearly, and am delighted for them that they're happy, but they are rather wrapped up in the marvel of their own family life.'

Would she have to listen to that? She wasn't sure that she could. 'That's normal, I suppose, isn't it?'

'I suppose it is.'

'Gil thinks that Miles looks anxious,' Clarrie said. 'He thinks something is troubling him. He's concerned that they might have some money worries.'

'Oh dear,' she replied. Was it wretched of her to be glad if Alec was feeling worried?

Gilbert had seated her between Zoubi and Hal. How unreal it was to listen to this young woman talking of knitting bootees and sewing pinafore dresses for Alec's children. How

could that be true? As Zoubi's eyes held her own, Esme felt that this woman was keen to make a connection, but she didn't know how to reply to her talk of teething troubles and potty training.

Hal, to Esme's left, was drawing zebras and tigers on his notepad. His pen moved from sketching and formed the words: *Are you feeling down?*

'No. I'm fine.' She smiled at him, but wondered what he'd observed. 'Thank you.'

Are you sure?

She nodded but felt Hal's eyes moving over her face.

Conversations spun between them as they passed dishes around the table. Mrs Pickering raised a concern that the olive oil would repeat on her, but Clarrie told her that it would lubricate her joints. Gilbert joked that, so long as it didn't lubricate her tongue, it wouldn't be an issue. Much wine circulated too, and in the glow of it, Esme watched Alec. He was talking with Gilbert about a mutual acquaintance, and as Esme listened, she became aware of the scale of his double life. How long had he been Miles for? She gathered, from Zoubi's conversation, that they'd been together for three years, but his relationship with Gilbert evidently went much further back. Had his life already split into two while she was writing letters to him in France?

'Gilbert told me that you met Miles when you were on holiday down here,' she said to Zoubi. She caught Alec's eye as he glanced across the table. 'It must have been quite the whirlwind romance.'

222

'We met on the beach. He was helping to drag a boat up the sand and I thought he was some young Celtic warrior striding out of the waves. It was lust at first sight, I'll admit. If he hadn't followed me to London, I'd have been finding reason to holiday here again within the month.'

Gilbert laughed. 'There was no danger of that happening. He was smitten too. We saw all the signs. You can't deny it.'

'No,' Alec replied quietly.

'Did you live at Espérance for long?' Esme asked across the table.

'Only for a few weeks.'

'Miles grew up down here,' Zoubi said. 'Imagine! What a charmed place to be a child, eh? But he loves the city. Don't you? I'm not sure if it was me or London that was the real attraction.'

What had he told Zoubi about his past? Presumably, none of them had any idea that he'd lived in Yorkshire before the war. It was astonishing to think that there was a version of Alec's life story that excluded her entirely.

'Miles was wonderfully helpful when I was looking for a house,' Gilbert said. 'He put me in touch with an agent and instructed me to lace up my hiking boots and to walk the lanes of this valley. All of the best things are hidden behind hedges and in hollows, he said. And he was right. I wouldn't have found this old place without that advice.'

'How fortunate,' said Esme. Rory was leaning his elbows on the table and supporting his chin with his hands. She could sense him watching her.

'I hoped I might be able to keep him here too, but, alas, the siren voices!'

'I've heard the stories about mermaids luring men away around these parts,' Esme said.

Gilbert laughed. 'But not to Shoreditch!'

'It's not as if I lured him to Patagonia!' Zoubi protested. 'It's only four hours on the train, Gil, and you're always welcome.'

Alec smiled at his wife and then his gaze met Esme's again. She saw no guilt or regret in his expression.

'I'm only teasing,' Gilbert said. 'You know I am. Nothing gladdens the heart more than a love story, and we all want you to have a happy ever after.'

Chapter twenty-one

Esme helped Clarrie take the plates back into the house. When they returned, everyone had changed places. Zoubi was now sitting next to Alec, and his hand was on her bare shoulder. Gilbert was having a hushed but intense conversation with Sebastian, and Rory had swapped over to Zoubi's chair, where he was teetering back on two legs as he smoked a cigarette. For a moment, it felt like a parlour game in which everyone had shuffled partners. Only Esme wasn't sure who she ought to have been allotted.

'Miles has decided to go back tomorrow,' Rory said. 'He's having an attack of conscientiousness. We're trying to persuade him otherwise, but he won't have it.'

'I've got to keep my job!' Alec pulled a hand through his hair. He looked slightly rattled. 'I'm not at liberty to loaf around like you.'

'It's not conscientiousness – it's obsequiousness and paranoia,' Zoubi chimed in. 'Max said you could be away until Wednesday, didn't he? Do you have to jump through hoops for him? Must you always be the best boy in class?' She

put out her bottom lip. 'We haven't had a break for ages. I need a few days away. It will do the children good too.'

'Didn't your mother say that Teddy pushed her to the verge of a nervous breakdown last time?'

'She was only joking!'

Zoubi filled her husband's glass to the brim and gave him a teasing little smile.

'Max wasn't happy. He was in a foul mood when I left. I feel I ought to be back in on Monday morning.'

Zoubi rolled her eyes. 'Oh, you are a bore.'

It was entirely bizarre to watch the dynamics between them, Zoubi occupying the role that had once been Esme's. How confusing it was. There was a tension in Esme's limbs that urged her to stand up and tell them all the truth. What would Alec say then? Would he deny it? How could he expect her to maintain this pretence?

'We've lost our allure, haven't we?' said Rory.

'He's losing his.' Zoubi playfully stuck out her tongue at Alec, but then leaned her head towards him and rested her cheek on his shoulder.

'Will you excuse me?' Esme said as she left the table.

She poured herself a glass of water at the kitchen sink and stood among the dirty dishes. What right did Alec have to ask this of her? Was she really meant to sit there and watch?

Clarrie walked in with a tray of glasses. 'How are you feeling?' he asked.

'I've got a bit of a headache. I might turn in shortly.'

226

'They do have a habit of all talking at once.' He smiled. 'It makes my head spin too.'

Esme took her glass of water down through the back garden and sat on the bench in the orchard. Swallows were arcing in the blue-pink sky and the long grass hummed with crickets. She would have liked just to watch the sky darken with no thoughts in her head except the names of the constellations. This new knowledge, this altered reality, felt like something heavy that she must now carry around.

She saw him coming down the path and wasn't sure whether to walk away or to run towards him. How strange it was to see his features approaching out of the twilight – the face that she'd missed for seven years, which still spoke to her in dreams, but which she'd struggled to keep in focus and animate in her daytime imagination. All of the details of his body, his voice and his manner had become more important as the time stretched, but now he stood in front of her looking like he didn't want to be there.

'We're going to head off in the morning,' he said. He put his hands in his trouser pockets and frowned at the ground. She saw that his shoulders were tense. 'I can't stay here. I feel like I'm lying to everyone.'

'And aren't you?' She couldn't keep the edge out of her voice.

'I didn't want this to happen, Esme.'

'I'm sure you didn't.'

'I didn't want to hurt you. You know that, don't you? I'd never wanted to hurt you.'

'Really? It was kinder to let me think you were dead?'

'I realise what it must look like, me and Zoubi, but she has no idea about any of this, and I don't want to make her suspicious. I'm trying to be normal with her, but this is so difficult.'

'*You* feel it's difficult? Yes, we must all protect Zoubi's feelings.'

He held his hands up. 'It's not that I haven't thought about you. I thought about you at every stage and what you must be going through. Don't imagine I haven't struggled with that. At first, I was going to write to you, to explain it all, but there was so much to explain. It was too much of a mess.'

'A mess? That's one way of putting it. You do owe me an explanation, Alec, if nothing else. Surely you see that? You broke my heart. I mourned for you. I lost the house. My life has changed in every way and none of them for the better.' She looked at him and wondered if he could appreciate that. 'Meanwhile, you seem to have been having rather a nice time.'

'It's not like that. There are parts that are hideous. I was pushed into this situation and it's all so complicated. I hate hearing you say that it broke your heart.'

He looked solemn and sincere, but could he mean it? 'What happened?' she asked.

'I don't know how to begin to explain.'

'Well, let's give it a try.'

'You're angry.'

'Of course I'm bloody angry. And confused.'

He put a cigarette between his lips and shook his jacket for matches. The flame flared and there, in the sudden light, were his familiar mouth and fingertips. 'Can I sit down?'

Esme found herself looking at his hands, listening to his breath, and then feeling the weight of his leg, there, against her own. The smell of his cigarettes was the same, his shaving soap, the smell of his skin. How intently she had missed his touch, his closeness. Did he not feel that too?

'It's difficult to know where to start.'

'At what point did the lies start? At what point did I stop knowing you? How long have you been Miles Sanderson?'

'You never stopped knowing me.' He leaned forward, rubbing his temples with his fingers. When he sat back again, his face was different. 'But I got into trouble.'

'Trouble?'

'I did something stupid. Idiotic. I lost control and there were going to be consequences.' He flicked his cigarette ash away. 'I got into a fight.'

'A fight? You never fight.'

'You don't know what it was like. You couldn't begin to imagine. We'd been through some nasty action that winter. I'd seen and done things that leave you questioning who you are and I wasn't thinking right that spring. I wasn't making good decisions.'

She watched him. He talked with the cigarette in the corner of his mouth. She remembered that Alec did that. There were other mannerisms and sounds in his voice that

she didn't remember, though. He touched her arm with the tips of his fingers and she flinched.

'You never told me any of that. You could have talked to me – written to me, I mean. It might have helped. You hardly told me anything in your letters about how you were feeling. I always had to read in between the lines.'

He shook his head. Having begun, he meant to tell it now, she could see. 'There was a fight in a bar. I can't even remember how it started now, but I lost my rag. I got the red mist and I just remember that I wanted to stop him talking. I wanted him to shut up.'

'Who?'

'I don't know. I didn't know the man. I never knew his name. But he wanted to push me, he wanted a fight. Men do sometimes. Everyone had been drinking, and it suddenly got out of hand. Tempers flared, tables were turned over, glasses were smashed and it all kicked off. I broke a glass. He hit me first, but I cut him—'

'You cut him? You cut a man with a broken glass?' She'd felt angry with him a moment ago, but now she was horrified. 'Badly?'

'Badly. As soon as I did it, I knew I was in trouble. Everything in the room stopped and they were all looking at me. So I ran.'

She stared at him. 'How could you? You're not that sort of person.'

'I wasn't in my right mind, Esme. You wouldn't understand it. Nobody in England knew what it was like.'

Had she failed him somehow in that? It felt as though there was a hint of an accusation there. 'No. You're right. I don't understand.' She watched him wiping his eyes. An instinct told Esme to put a hand to his shoulder; a different, louder, instinct questioned whether she knew this man at all. 'How seriously was he injured?'

'I didn't hang around to find out. The whole place erupted. I had to get out and get away. I was in a fix, Esme. I was in serious bother. You must understand that. I couldn't go back.'

'When was this?'

'1916. We'd just come out of a stint in the line. It would be the May.'

'They wrote to me that month. They told me you were dead. I got an official letter. I sent off and got a photograph of your grave. There's a grave with your name on it in a place called Le Touret.'

'I expected they would. I did think about you getting the news. I'm sorry, Esme.'

What a small word sorry was and how easily it was said. Had he really thought about how she felt as she'd received that news? 'But how did that happen? How can there be a grave with your name on it? I don't understand that.'

'I ran that night and kept on running. I didn't know what to do, or where I was going, but I knew I was in trouble. I had his blood on my hands. My hands were sticky with it and I couldn't wash it off. It was all down my fingernails. I didn't know whether I'd killed him.'

'Killed him? Good God, Alec, you're not like that!'

'You don't know.'

The Alec that Esme had known had cared about writing tidy sentences, and played the organ in church on Sundays. He was interested in fossils and liked Kipling stories. He was funny, charming, gentle – her Alec wouldn't have done a thing like that.

'No, I don't, do I?'

'I kept on moving as long as I could. I didn't know what direction I was going in, or how long I'd walked for, but I went on until I was exhausted. When I came to a house, I crawled into the cellar, thinking that I might be able to have a bit of kip and then move on again at first light. I did, but when I woke up there were other voices and then the shelling started.'

Esme watched him. His face was half hidden in the darkness, but she could read it well enough. She could sense the difficulty in his features as he revisited this moment. She could hear it in his voice too.

'Go on.'

'I thought I was dead then, and there was part of me that wouldn't have minded. I heard the incoming shell and then it was coming down all around me. I lost consciousness, I don't know how long for, but I woke up again and the dust was settling. It was in my eyes and in my mouth. There was rubble all around. I lay there for a long time while I figured out if I was able to move, but I could, and I did. I crawled out.'

'I was told that you were killed when a building collapsed.'

'I almost was.'

'What happened?'

'Someone else was in the cellar. When I dug myself out, there was a poor sod in the mess above. That was the voice I'd heard, but he was dead now. Very definitely dead. About my build. About my height. I know his name, but I couldn't tell you what he looked like because most of his face was gone.' He turned to her. 'I'm sorry. I probably shouldn't tell you that. But I'll never forget the mess of his face. That image won't ever leave me.'

Esme remembered the mermaid with her scratched-away face. The image had struck her, it had stayed with her, but she'd never expected to link it to Alec.

'Carry on.'

'He was my saviour, you see? This was my chance to wipe the slate clean.'

All she could see was his profile and the glint of his eyes, but she could hear the crack in his voice and an appeal for her understanding. 'You swapped places with him.'

'There were letters in his pockets. He was a second lieutenant in the Somersets. He had a wife, and a daughter, and he was called Miles Sanderson. I left him with my dog tags and pay book. The hardest part was leaving a letter from you in his pocket, knowing those might be the last words I'd ever have from you, but he was my chance and I had to take it. He was dead. That was the end for Miles Sanderson, but he gave me my life back – or, rather, he gave me his life. I owe everything to him, you see. He let me begin again.'

233

'So he's in the grave with your name on it? Have you ever contacted his wife and daughter?'

He shook his head.

'That poor woman. What are they thinking – that he chose not to come home? They must be waiting for him still. They might be looking for him. They might turn up one day. What if they see your name in a newspaper?'

'Unless they read obscure music magazines, they're not likely to see the name in print. If they ever turn up, I'll say I'm a different Miles Sanderson. I have thought it through. I've had to think about all of these matters.'

'They must have so many questions.'

'But at the moment they can still hope, can't they? Isn't that better? Don't you think? What could I say to them?'

His words struck her. How could he ask her that? Did he not realise that he'd ended her hope? 'You ought to have told them something.'

'It was chaos. People don't understand that – and it got even worse that summer. Men were disappearing all the time. Do you know how many thousands of men are listed as missing? Miles Sanderson became just one more question mark.'

'But you did that – you made that decision. You made him a question mark.'

'I didn't kill him, though, did I?'

She turned away from him. The white shapes of moths fluttered in the branches above. She remembered that in Cornwall moths were said to be the spirits of the dead. Her

Alec had told her that once. Who was this man who now looked out through Alec's eyes? 'So you slipped into this Miles Sanderson's life. How did you manage that? How did people not realise?'

'I ran into Gil's crew near Béthune. I told them I'd been transferred to them but had lost the paperwork. I made up a story. I've had to tell a lot of lies. That was difficult at first. I was frightened that I'd trip up, that I'd get caught out.'

'But you evidently took to it!' The hollow laugh that came from her own mouth surprised her. 'I believe you were great fun, a great hit with Gilbert's crew.'

'I'm not entirely sure how I got away with it. Luck? Determination? Timing? I threw myself into being a person that they'd want around.'

'Charming Miles who could turn anything into a musical instrument and who always had a ready joke.'

'Life was both hideously complicated and very simple back then.'

'I wish you'd written to me, even if it was to tell me this. Hearing that you'd started again with another woman would have been better than being told that you were dead.'

'It sounds horrible when you put it like that.'

'It was horrible. It *is* horrible! But I'd prefer to have known.'

'I didn't want it to be like this. I've spent so much time thinking about how I might tell you, how I could explain it in a letter, whether I could risk coming up to see you. I wanted to see you. I wanted to talk to you.'

'But you didn't.' If he'd really wanted to, if he'd genuinely

cared, he'd have done it, wouldn't he? She found herself feeling impatient with his insistent, empty words.

'It's quite something to put in a letter, isn't it? The number of letters I wrote and threw away! And I didn't know what was happening in your life. Time went by extremely quickly. Before I knew it, a year had passed. You might have remarried for all I knew.'

How could he say that? It seemed so absurd, so far from the reality of her experience that she almost laughed. 'Can you seriously have imagined that I might remarry?'

'I thought about you all the time. Please believe me, Esme. I hate knowing that you've been so unhappy.'

He put his hand over hers and that contact was both familiar and alien. She imagined his fingers sticky with a stranger's blood and wanted to pull her hand away.

'Did you not expect to see people who you knew down here?'

'I only stayed for a few weeks. I supposed it might be okay here, that it might work out, but then I realised it was a mistake. I worried that someone might recognise me. I didn't want to mix with people. Gil assumed that I was suffering with my nerves, bless him, but it wasn't what he thought it was. I had to get away.'

'I hope you didn't use Zoubi as an excuse to get away.'

'I didn't.'

'So it was love?'

'I appreciate that this part doesn't make me look good either.'

'No.' She could barely comprehend that while she was mourning him he'd been playing about in boats and meeting girls.

'She was very keen.'

'Was she? And your defences were low, I suppose? But your parents were Methodists and she's naked in the National Gallery.'

'Have you seen it? It's rather good. She said that the horse-hair sofa prickled her bottom. Even Methodists take their clothes off sometimes, you know.'

There was a lift in his voice, an edge of humour. She remembered that voice. It shouldn't be saying these things, though. 'Evidently.'

'Zoubi makes her own costumes. She's clever with her fingers. You might like her, if you got to know her.'

'If I got to know her? Yes, we've got so much in common, haven't we? Sewing, a husband—'

'Esme . . .'

Music was coming from the house. The beat of it carried across the darkened garden. They must all have moved inside. How was she meant to go back in there, knowing what she did now? How could she sit and listen to Zoubi talking about Alec's children? How could she watch them together?

'Have you no idea how much this hurts?'

'I'm so sorry.'

She could feel his breath against her neck. She longed to lean her head against his shoulder, to close her eyes and make all the complications go away.

'I don't know you at all, Alec. Or Miles. Or whatever your name is this week. I'm married to you, but I don't have the first clue as to what sort of man you are. It seems I never did.'

'A man who has been supremely stupid and who wishes with all his heart that he could turn back the clock. Please, Esme— '

'She doesn't know any of it?'

'Of course not. I've told her an edited version of my life. She thinks I left Cornwall for London before the war. She doesn't know that I moved up north. Nothing of that. I've had to be careful.'

'What an excellent basis for a marriage. I can't help wondering if I got an edited version too. I went to Penzance last week. I visited your old address. Sentimental old me, eh? The man who lives there now hadn't even heard of you.'

'That's not surprising. It must be getting on for twelve years since I lived there. Don't imagine that all my life has been a fabrication. What we had was real. You do believe that, don't you?'

Esme heard the appeal in his voice, but how could it have been real? She was also struck by the past tense. 'Was it?'

She looked up and saw the pole star. Alec had once told her that it was called the star of the sea, and that it was the fixed point, the constant in the night sky that could always guide a lost sailor back to port. It was the due north that had brought Odysseus home, he had said, navigating him across ancient, wine-dark oceans, and it had remained true through all those millennia. But Esme realised that Alec would never

238

come home now, that he was no longer her fixed point, and with that, all the stars seemed to swing.

'Esme ... you won't tell her, will you? They can't know. If you say a word, everything will fall apart.'

'Part of me thinks that she ought to know what sort of man you are. It's bigamy.'

'I'm sorry,' he said. 'I know I keep saying it, but it's all I can say.'

'Sorry doesn't feel like enough.'

'What will you do?' he asked.

'With your secret, you mean?'

'Yes.'

'You don't deserve to get away with it, but what good would it do if I were to tell them?'

'You won't say anything, then?'

'They all love you, you know. I'm not sure you deserve that either.'

'Probably not.' He looked down at his hands. 'Will you be okay?'

She stood up. She could hear Rory's voice calling her name. 'Do you care?'

The lamps had been lit in the house. Esme stood for a moment in the privacy of the darkness. How homely and congenial it all looked from out here. Tonight she felt very much on the outside.

Gilbert walked past the window, stepped out of sight, and then passed back again, laughing, with a glass in his hands.

Clarrie was doing a most unlikely pirouette and Sebastian's long fingers banged the back of a chair. She thought about Alec in a bar with broken glass in his hands; drink, a flare of anger, shouting and upset chairs, and a moment of madness. They really didn't know him either.

The piano was playing now – Alec, presumably – and a woman's voice was singing. After he'd told Esme his story, he had walked back into the house, sat down at the piano stool and was now playing 'Baby, Won't You Please Come Home'. Esme felt unmade by his confession. How could he carry on so lightly? Had she, all this time, been mourning a man who didn't exist?

In the gloom, she almost walked into Rory on the path.

'I've been looking for you. Did you not hear me? I wondered where you'd got to.'

'My head was pounding. I needed a little quiet time to myself.'

'She is a bit much, isn't she?'

Esme could see his lopsided grin in the light from the window. 'It's not particularly my sort of thing.'

'They're great fun in small doses, but I am looking forward to the house being quiet again. I might take the motor bus over to Tintagel tomorrow. Would you like to come with me?'

She heard the lift in his voice. 'Perhaps another time. This week has run away from me. I need to write my article tomorrow and get it to the post office.'

'Later in the week, then?'

'Perhaps,' she said.

He stepped towards her and put a hand on her arm. 'You sound tired.'

'I am. I need to go to bed. Will you excuse me?'

'Of course.'

A moth tapped against her window, so insistent that it might be the touch of a fingernail to the glass, or the striking of a small stone. She had to get out of bed to look. Its wings flittered against the pane – an emperor moth, she thought, or with its horns and glowing whiteness, it might be the king of all ghost moths. But there were no ghosts any longer. There were no mysteries. There was only the blunt and bloody truth. What was she meant to do with that?

Chapter twenty-two

From her bedroom window, she watched the motor car turn out of the gates. Esme had listened to their voices on the stairs. They had insisted on saying *au revoir* instead of goodbye, but she didn't expect that she'd ever see Alec again.

The rest of them had already breakfasted, and the kitchen was now stacked with the detritus of two meals. She really ought to help Clarrie with the washing up – there was such a lot of it – but the conviviality in the kitchen was rather too much. With a cup of tea and a slice of toast in her hands, Esme made her exit, telling Mrs Pickering that she would need to get on with her article today. She climbed the stairs and stared at the blank page. The words wouldn't come.

The sun beat on the gravestones, on the worthy, the blessed and the definitely dead, and picked out shadows in the lettering. Esme made a note of the lichens, of the insects and inscriptions, and thought of a cross in France with Alec's name on it. This autumn, she would have travelled to France. She'd have let Rory accompany her, and would have bent down and cried at the side of that cross. Her tears would

have fallen onto earth where a stranger was buried. Didn't that man's wife deserve to know the truth? Shouldn't she be able to make that journey?

Esme hardly knew the man who had once been called Alec Nicholls, she realised now. Yes, she had finally seen the house where he was born, and had walked the streets that were the backdrop to his childhood, but that person who broke glasses in bars, and who took letters out of dead soldiers' pockets, wasn't the man she'd chosen to marry. Had she known he was capable of such actions, she wouldn't have wanted to marry him. Had that always been in his personality? Was that something else that he'd covered up? Or was that what the war had done to him?

The war memorial in this churchyard looked curiously ageless. Crudely hewn from granite, it might already have weathered here for a thousand years. It could be some Celtic wayside marker, or a memorial to a Roman legion, she considered, the moss-grown figures at its pinnacle long-forgotten generals or old gods. Esme touched her fingers to the words *In Honoured Memory*. Could all of her memories have been wrong?

The photograph of Alec's grave was in the top drawer of the dressing table in her bedroom in Fernlea. It was mounted on black card, and she kept it folded in white tissue paper. She had needed to have it, to see it, to read the letters of his name, to have that proof. But that photograph was a fiction and she knew the truth now. She didn't know what she would do with it when she got home.

The clouds rolled over the hillside behind, over the patterns of the field boundaries, the farms and the outcrops of rock, and she watched the shadows of the graves turn. The land rose up behind the church, so that standing here she looked straight onto the roof, its slate tiles all the colours of mussel shells. This here and now, this present moment was real; so much of her history was not.

It was strange to think that her last letter to Alec was buried under that grave marker, in the pocket of a man who she'd never met. She pictured her sentiments darkening, mouldering and disappearing. It wasn't that easy to cut off those feelings, though. Miles Sanderson still wore the face of the man she loved.

Was it the weather, the salt and the wind, that made the graves in this churchyard look ancient? On many of the headstones, the words were barely legible. The identity of the people lying beneath them was weathering away. In ten years' time, would the name of Alec Nicholls have flaked away? Could the rain and wind and time delete that lie too?

The Alec Nicholls she had loved was dead, Esme thought. That man had ceased to be, yesterday. He would never come back to her. In many ways, she still was a widow; she felt that more today than she had for a long time. She had lost seven years of her life to grief. How was she meant to come back from that?

This graveyard was full of mothers, daughters and wives. In their final reckoning, the dead are defined by what they mean to those who go on living. They are *blessed*, *beloved* and

lamented. What was she in relation to Alec now? How would she be defined? Could one carry on being widow to a man who didn't exist? Did she still want to be linked to him? Had he ever really loved her?

Esme cried as she turned the ring that Alec Nicholls had placed on her finger, but it wouldn't slip over her knuckle. Like it or not, she was still tethered to that man who had cut and run, and lied, and now chose to carry on lying. Esme cried for her own naivety, for a waste of love, and for the man who she had once believed Alec Nicholls to be.

NATURE DIARY
THY ROOTS ARE WRAPT ABOUT
THE BONES

I find myself in a Cornish churchyard this afternoon and I am struck by how this burial place blends in with the wild boulder-strewn country that surrounds it. There are no modern marble headstones here, no glass canopies or artificial flowers. The granite gravestones might well have been here as long as the monoliths that stand in the fields around this village, but the carved dates indicate otherwise.

Honeysuckle and dog roses wind with ivy on the south side of the churchyard. Violets have spread by the gate and I can make out the shapes of ferns in the shadows. I pluck an ivy leaf and listen to the birds singing their benedictus. Blackbirds and thrushes dart between the gravestones, which are dappled with mosses and the light through the yew trees. It is impossible to look on yew trees without a feeling of sobriety, I find. Their dark shapes, like the dolmens in this region, exude a sense of antiquity.

Lichen fronds the old stones here, gold and orange and

the blue-green of verdigris creeping into copper. There are hourglasses and cherubs carved into the headstones, and fine sentiments in eighteenth-century lettering. I push nettles away with my boot and see that five generations of a family lie together. There are primroses and snowdrops planted at the base of many of the graves and I think of the mourners who return and remember.

Most cemeteries evolve over centuries, and slowly become an expression of the temperament and traditions of the community beyond their walls. But it is not always the case. I was reading about the new cemeteries in France and Flanders this week, and the thinking behind their design. Cemeteries weren't chosen for the suitability of their location, their horticultural viability wasn't a consideration; rather, most were established close to where men fell. In some locations they were dug into almost pure sand, others bare chalk, and many have water-logged, heavy clay soil. The earth in some locations was so poisoned that not a blade of grass would grow. Starting from nothing (or something worse than nothing), the designers of the new cemeteries have been obliged to focus their thoughts on what is the right way to commemorate the dead and comfort their families.

It seems that there is an innate human urge to cover the dead over with green and to make flowers grow. Even while the war was still continuing, bags of flower seed were dispatched to France and Belgium for distribution among the cemeteries, while those caring for the graves transplanted shrubs and herbaceous plants from derelict and abandoned

gardens. This practice was both about showing respect for the dead and heartening the living soldiers who must continue to pass by.

Now, with time and the luxury of peace to plan, the cemeteries' planting schemes have taken up many hours of debate, and the greatest authorities on horticulture have been consulted. It was ultimately decided that the cemetery planting should be in the style of an English cottage garden, a gentle, pastoral ideal, recognisable to the families who come after, and recalling that oft quoted line of Rupert Brooke's poem – 'some corner of a foreign field that is for ever England'. Spring bulbs have been selected, perennials and old-fashioned annuals. There will be pinks, saxifrages, heather, forget-me-nots, pansies, columbine and roses – all traditional plants in the English garden, and many of them with pertinent meanings in the language of flowers.

The architects want to create perpetual gardens and reverent spaces that are truly peaceful, but there's a strange off-note when one thinks of how long the rows of white headstones will be, each representing a life cut off too soon. To imagine tea roses growing in those places, where men knew such pain and fear, is the most peculiar juxtaposition of the familiar and the shocking. As I look at the headstones in this graveyard, I am struck by how lucky those are who live out their natural days and finally lie under named graves. On the old battlefields, too often the green coverlet conceals an absence, be it of a name, or of a body. The smoothness and tranquillity is deceptive. I read that over one hundred

thousand unidentifiable British casualties of the war may be buried beneath the legend 'A Soldier of Great War Known unto God'. To contemplate that number tests one's faith. I imagine that for those wives, mothers and children who must live with that nebulous word 'missing', all the flowers in the world will be no compensation.

The noise of the church bells startles the rooks from the yews now. As the tongues of the bells proclaim resurrection, the birds caw and circle and I think of the yew trees that have been planted in the battlefield cemeteries. They are just saplings today, but perhaps these will be venerable old trees to the grandchildren of the men who lie forever more in those overseas English gardens. Let us hope that the land is given time to recover and that these places may never again know war's ravages.

Chapter twenty-three

Alec had put the suitcase on the bench between them.

'Crocodile skin?' she'd said. '*Red* crocodile skin?'

'It's not real. It's only imitation.'

'It's very flash imitation.'

'I thought it looked festive, fun, extravagant. It seemed appropriate. I bought it on an impulse, imagining it on a train seat between us as we set out on a journey.'

'Appropriate for what? A journey to where?'

Esme had realised that she was asking lots of questions, but he was being teasingly oblique.

'For our honeymoon.'

'Our what?'

'It's rather back to front, I appreciate that. It's conventional to have the wedding before the honeymoon, I do realise. But perhaps we might fit that bit in too?'

It wasn't the proposal that Esme had imagined. They never did it like that in novels. And she hadn't seen it coming. When she'd looked at Alec, he'd been laughing. Was he just jesting?

'Have you been drinking?'

'No, but I feel like I need a stiff drink now! Oh God, please say yes. I'll beg, if I must. Do you need me to do the down-on-one-knee thing? Don't send me packing with a red crocodile-skin suitcase. Have mercy, eh?'

He'd tucked her hair back behind her ear and grinned as he leaned in to kiss her. His fingers had linked through hers over the suitcase. Of course, Esme had said yes.

She stared at the suitcase now. The crocodile skin was only a lacquer and it had started peeling on the corners, showing the cardboard below. They had taken the red suitcase to the east coast, where they'd shrieked as they paddled in an icy sea, huddled together watching the rain from a promenade wind shelter, and had three days when they didn't leave their hotel room at all. Esme had felt that her life was hurtling forward fast and she'd been giddy with it. It was like they'd both been drunk. She now wished that she could rewind and caution her younger self, make her slow down, make her reflect, but at what point would she have made it stop? Could she have got it so completely wrong?

Two years later, Alec had walked into the night, turning his back on what he had done. What had happened to the man he had cut in that fight? Had Alec really killed him? That was the implication of him running, wasn't it? The realisation that she was married to a man who could kill horrified Esme. Her Alec couldn't have done that, could he? Esme couldn't equate one version of her husband with the other. Could he have changed so much in two years?

The grey satin lining of the suitcase was coming away. She ought to glue it back into place, but then she'd also like to throw a match into it and watch it burn. Instead, for now, Esme began to fold her blouses and place them in there. She couldn't stay here, maintaining Alec's lie, having to pretend in front of Gilbert and Clarrie and Rory. But what could she say to Mrs Pickering? Perhaps she could pretend that Lillian was ill and that she needed to go home? But that was another lie, wasn't it? There now seemed to be lies in every direction that Esme looked.

Alec had talked of experiences that had left him confused in his thoughts and feelings. Was that what had made him into the man with broken glass in his hand? Was that what the war did to men? Was that trigger, that potential for violence, in all of them now? After all, they'd trained to use bayonets, not to give the enemy a good talking-to, hadn't they? But Alec hadn't killed in the heat of battle; he'd attacked a man who was on his own side. Was that something that was planted in his personality now? Last night, in her dreams, she'd seen Alec's handsome, sweet, humorous face twisting into a snarl.

She folded her nightdress, her stockings and skirts, and imagined herself unpacking them in her room in Fernlea. Was that what she should do now? Should she throw herself back into the rhythm of the household and try to forget? But that life revolved around Alec's absence – that had been the pivot that overshadowed everything else – and the structure seemed to fall apart now that it wasn't true.

Absorbed in her thoughts, she started as Clarrie called her name from the stairs. She pushed the suitcase under the bed and closed the door behind her as she stepped out onto the landing.

'There you are,' he said. 'Fenella has had a tumble in the garden. It's nothing serious – she's just turned her ankle – but she's asking for you. I think she wants some female sympathy and an arm to lean on.'

'I'm coming,' said Esme. 'I'll be right down.'

She couldn't run away from it, though, could she? Going back home wouldn't make it any different. She resolved that she must just keep her head down, keep busy, and try not to think. But how difficult it was not to think about him.

Chapter twenty-four

Esme had left Mrs Pickering in the sitting room, where she seemed to be contentedly occupied with her novel and a pot of tea. Gilbert had insisted on calling the doctor out, but nothing was broken. He'd given her some pain killers and instructions to rest. Mrs Pickering hadn't looked especially delighted by that command, but Sebastian had lent her a walking cane and she appeared to be enjoying wielding that.

Esme had unpacked her suitcase.

She'd offered to clean the kitchen while Clarrie went to the market. She needed something to do, to occupy her mind and hands, and she was also glad to be alone. Every word that she said now felt like an untruth. Even silence seemed to be an evasion. Somehow Alec had managed to tangle her up in his lies.

She'd left the drawing room as Rory entered earlier, making an excuse that she needed to take up Mrs Pickering's lunch. There were so many questions that she wished she could ask him, but how could she? She wanted him to tell her what Miles had really been like, what sort of a man he was. They evidently all liked him for his music and his jokes, but

there had to be more to him than that, didn't there? What had he told them about his background? Did they have any suspicions when he turned up? Did Rory trust him? Esme wanted to sit Rory down and to talk with him, but it was so difficult to speak to him now without feeling like she was deceiving him.

There was a plasterwork bust on the bookshelves in the drawing room. It looked ancient, but Gilbert said it was a copy of a marble figure that he'd once brought back from a holiday in Rome. The statue had two faces, looking in opposite directions, and Gilbert had told her that it was of Janus, the Roman god of gates, transitions, journeys, the start of wars and the coming of peace. Esme had held it in her hands this morning, feeling its weight as she thought about Alec. The blithe, humorous face that he applied for his friends was the same one she'd known and been charmed by – that much was consistent – but had there always been another side to him? Had he always found it so easy to lie? How much of what he'd told her was true? She'd had to resist the urge to smash the plaster figure to the floor.

Alec had lived in this house for two months in the summer of 1920. Esme pictured him taking his breakfast at this table, carrying dishes for Clarrie, and out there in the garden, digging the soil over with Rory. What had she been doing in the summer of 1920? Mr Maudsley had taken over the garden again, she recalled, and she was learning the role of a housekeeper, falling into that cycle of laundry and mending, furniture wax and silver polish. All that time, through all of

those mindless activities, she'd been mourning Alec, brittle with grief still. It seemed almost implausible that he might have been here then, laughing, swimming, singing around the piano, and meeting a girl on the beach.

Esme felt sorry for herself, she'd admit that much, but more than that, at this moment, she felt angry. Did he deserve to get away with it? What would happen if she went to the police? It was bigamy, fraud and she didn't like to think how the incident with the broken glass ought to be categorised. She twisted her wedding ring. Her finger ached from turning it.

She boiled water and scooped washing soda into a pail. Finding a stiff brush, she began to scrub the floor on her hands and knees. She didn't notice the scalding water, or how the soda stung. Alec had told her that she hadn't understood what the war had been like, but what chance had she been given to understand? His letters had been full of weather and landscape, frustrations of routine and mundane tasks, books he'd read and jokes he'd been told. What was she meant to have picked out of that? She recalled Rory's manuscript then. What version of Alec was in there? Could she ask Rory if she might read it? Would he let her? She trusted Rory to tell her the truth.

She took the pail to the back door and sat on the step while she waited for the floor to dry. Rory and Hal were working in the greenhouse and Sebastian was in his studio. So much of their life here was idyllic, and yet had they all had blood down their fingernails? Had they all run and been afraid and

made mistakes? Is that what flickered on Rory's face? It struck her that she really knew very little about the men with whom she was presently living. But what more did they know about her husband? Rory's manuscript would tell her, wouldn't it?

Chapter twenty-five

The envelope had been mixed in with his letters. Rory looked at the handwriting. Why did he think he recognised it? It looked familiar, and yet he couldn't put a name to it. The indistinct postmark might be London. He turned the envelope over. There was no sender's address on the reverse. He looked again at the slanting block capitals forming her name – *MRS E. NICHOLLS* – but then dismissed it. They could have no acquaintances in common, could they?

He watched her carrying the washing basket out to the line. His first instinct was to run and help her with the weight of it, but her eyes had avoided him in the scullery, and he'd got the impression that she wasn't in the mood to talk. For the past few days, Esme had seemed to be avoiding him. As he'd walked into the drawing room yesterday, she'd walked out. Why was that? She was occupied with Fenella's needs at present, but Rory sensed that it was more than that. Was it something he'd said? Was it a mistake to have taken her to Penzance? He'd seen the sadness in her eyes when they'd stood outside her husband's childhood home. He'd wanted to look after her then, to make it right,

but was it his place to do that? Perhaps he had assumed too much. Or could it be that Miles had said something to upset her? He'd seen them talking in the orchard and then that look on her face. Whatever it was, Esme appeared to have retreated into herself.

Rory watched her shaking out the washing and pegging blouses on the line. It was a curious between-worlds place that she occupied, he thought. Fenella spoke to her as a confidante, he'd noticed, and with motherly affection some- times, and yet Esme was obliged to launder the stains from her linen. She was too educated for this menial role, but her hands were red from laundry soap. Did she have to do it? Couldn't she have gone back to the museum after the war? Was she punishing herself in some way, or was it that she'd lost her confidence? Rory didn't want her to have to do other people's laundry. He remembered how her face brightened when she talked about plants and birds and butterflies, how her voice lifted, how much more alive she was. That ought to be her life, not this.

She straightened, shadowed her eyes with her hand, and then rubbed her temples. Perhaps she was still feeling unwell. She shouldn't have felt obliged to join the company at the weekend. He'd seen how pale she was and how her hand had trembled as he'd passed her a glass. She'd forced herself to be bright and friendly, he could see that, but she wasn't her- self. Her smile had been a little strained. And there'd been a tremor now and again in her voice. He was sorry if she'd felt she had to be there, listening to Zoubi's interminable talk of

teething and nurseries. He'd thought it rather insensitive of Zoubi to look to Esme for advice on these matters.

The laundry billowed white on the breeze and she stood with her hands on her hips.

'It'll dry fast today,' he said, crossing the lawn towards her. She turned. 'It will.'

A strand of hair rippled against her face. He had to resist the urge to reach out and tuck it behind her ear. There were shadows under her eyes, he saw, and her lips were cracked with the wind. He would have liked to dip a finger in honey and smooth it onto her cracked lips.

'I might walk the coastal path this afternoon. Would you care to walk with me?'

'I would be glad to, only I have a pile of laundry to press, and Gilbert has given Mrs Pickering a bell to ring when she requires assistance. It's hardly stopped this morning. Perhaps another day?'

'I hope so. Hell, perhaps we could hide the bell? Whatever was Gil thinking?'

She wasn't meeting his eyes. What had he done? What mistake had he made, and how might he rectify it?

'The bell fell on the floor earlier, just out of her reach, and so she shouted, "Ding!"'

At least she smiled then. He thought about sitting in Zennor church with her, his hand touching hers, the confidences they'd shared, and the things he'd almost told her. Had he said too much or too little? He wished he knew what he might say to make her happy. 'I almost forgot,' he said,

taking the letter from his pocket. 'This came for you. It got mixed in with my post.'

He handed her the envelope. Did he imagine the flinch on her face as she saw the handwriting?

Chapter twenty-six

Esme had taken the letter into the scullery. Walking away from Rory hadn't felt altogether kind. He seemed to want to talk, but she'd seen the handwriting and recognised it. Alec's writing was so familiar, even after all this time. It was the hand that had once sent her skylarks and water meadows from France, and which had told her that he longed to come home to her. Esme remembered the rush of emotions she'd experienced whenever she saw that slanting script on envelopes. How strange that, after all that had happened, Alec's handwriting was unchanged. What more could he have to tell her?

I don't know if you fully appreciate how serious it was, what the risks were – and still are. At best, I seriously injured a man in front of a room full of witnesses. I would have been arrested and tried. The most favourable outcome would have been a prison sentence. It still would be.

I feel that no jury would be able to comprehend the circumstances and pressures that caused me to behave that

way. Perhaps my excuses sound insufficient to you too? You might now feel that I am a bad person who deserves whatever is coming to him, but I beseech you to think of the other, innocent people involved. Gilbert has been like a father to me, and I hate the thought of him feeling that I've betrayed him. Can you imagine how he would feel if he knew the truth? How all of them would feel?

It's possibly unreasonable to appeal to you to think of Zoubi's feelings – but I must. She knows none of this. She's entirely innocent. My children even more so. Please, Esme, think of what the consequences will be for them if you speak. I might deserve punishment, but they don't. Will you reflect on that?

I never meant to hurt anyone, Esme, least of all you. What happened was done in extreme situations and the heat of the moment. Please believe that. I know you're angry, I saw it, and I have no right to expect forgiveness or understanding from you. I hold my hands up and admit that I have made a mess of things and I've let you down. You deserved better, and if I could go back and do it all differently, I would. I honestly would, but I can't.

Please, Esme, if you ever loved me, will you keep my secret?

I am sorry. I am _so_ sorry.

Alec

Esme remembered a young man's laughing face across a café table, how he'd made her laugh, and how she'd wanted to

spend the rest of her life looking at his smile. She remembered how intensely she'd missed being with that man, his courage, his empathy, his tenderness, and the future they'd planned together. Had that same person really penned this letter?

She didn't like the appeals and the pleases, and how he was shielding himself with the innocence of his children. When she read it again, for a second time, she heard a wheedling tone. It was manipulative. She well remembered how charming he could be, how he was capable of laying it on thick; had he been calculating back then too? She wasn't convinced by his apologies and expressions of regret. He'd been getting away with it quite nicely until last week. He might be nervous now, but she didn't sense that his conscience smarted.

Esme folded the letter back into the envelope, stashed it in her pocket, and stretched the ache from her back. It was unsettling to hear his voice again. She felt that he didn't deserve to walk away from all the mess he'd caused, and yet, what should she do?

She was surprised when she turned and saw Hal in the doorway. How long had he been standing there? Had he watched her reading the letter? Had he seen her mouthing its words? He raised a hand to her in greeting, pointed and lifted his eyebrows into question marks.

'Yes. I'm fine. Thank you. And you?'

His lowered eyes moved along the lines as he wrote on his notepad. He bit his bottom lip with his teeth. She had to step towards him to read his words.

You've been quiet this week. I've hardly seen anything of you. You're not feeling poorly still, are you?

With Hal standing in the doorway, she was trapped. She felt the pressure of his questioning eyes.

'No, not at all. I've just had work to catch up with, and Mrs Pickering's bell never stops ringing. She'll be back on her feet again next week, though. I can tell that she's starting to get bored.'

I felt that something wasn't right.

He held his letters up towards her. There was a large question mark under the words.

'Wasn't right?' As soon as she said it, she realised that she should have contradicted, closed the conversation down, instead of giving him another opening to question.

Miles, he wrote. *You looked at him oddly. I couldn't help noticing. It looked like recognition, I thought. You hadn't met him before, had you?*

Esme was aware that she was hesitating and shouldn't. 'No,' she said as firmly as she could. 'No, of course not. Why ever would you think that? I was simply curious to meet the last member of your group. Nothing more than that.'

She was perpetuating the lies. She was part of his deception now. At this moment, she hated Alec for that.

Hal nodded, but didn't look entirely convinced. 'I'm sorry,' he mouthed.

Had the others seen it too? Did they also have suspicions? Was that why Rory had been watching her this morning?

'I must get on,' she said.

Hal stepped back from the doorframe and let her pass, but she felt his eyes following her along the corridor. How much had he worked out? Her hand was still gripping the letter in her pocket. If she showed it to anyone, it was a confession. She could go to the police with it. Had Alec realised that? He'd assumed that his appeals would work. And yet – could she really put him in a prison cell?

Chapter twenty-seven

The town war memorial was a Celtic wheel cross carved with endless knots. Esme stretched her hand out and touched the words *Lest We Forget*.

'Was that part of why you wrote your book?' she asked.

Rory was silent for a moment. 'Yes.'

'Sometimes I wonder if it would be better to forget, though.'

'There are some events we'd all like to forget, if we could,' Rory said. 'But if we blank out the difficult parts, isn't there a danger that we'll make the same mistakes again?'

Esme considered: if it were possible, would she go back to the start and relive her life with Alec? Living through those years a second time, could she have changed the outcome? She didn't know that she could. Fat raindrops began to patter down. Esme watched them soaking into the stone of the cross.

'Come on,' he said. 'It's going to throw it down. We can wait in the church until it passes.'

They ran across the road, but the rain was streaming down her face by the time they'd got to the church door.

'The weather gives you no warning here, does it?'

'Not always.'

Rory's hair stuck to his forehead, darkened by the rain. There was something melancholy about his eyes today. She turned away from him and heard her own footsteps echoing into the empty building.

Stiff angels hovered on the beams above, displaying mottos on shields, like men on corners with sandwich boards. They appeared to be selling Latin wisdoms for the most part, but on one she made out the letters, *They that go down to the sea in ships; These men see the works of the Lord*. The angels all had slightly startled expressions, and their gilded curls seemed blasted back, as if they felt the force of a stiff southwest wind. Vine leaves wound overhead and curled into bunches of grapes on the bosses. The stubs of candles were guttering, throwing trembling light against the walls, and shoals of little carved fish flickered on the organ casing.

Esme sat down in a pew. Rory sat at her side, and she recalled how they'd talked in Zennor church, how she'd told him about Alec's grave, and he had said that he'd travel there with her. She'd spent all that day telling Rory about Alec, as they sat in the church, then on the bus, and all the way around Penzance. But who was that man she'd been talking about? She didn't want to say his name today. Rain dripped from her hair and made her shiver.

'Rory, you look sad this morning.'

He looked closed in upon himself, curled up into his own thoughts. There was no spark in his eyes, no humour

stretched the corners of his mouth, and she was sorry for that.

'I was going to say the same to you.'

She shook her head and smiled at him. 'I've done an awful lot of talking at you for the past month, but I've hardly given you chance to speak. You must think me awfully bad mannered.'

'Of course not! I'm glad if talking has made you feel better.'

She looked along the aisle. The columns appeared to lean outwards on the seaward side, which gave her the feeling that they might be rocking on a boat. All of those words, Esme thought, all of that missing, and longing, and questioning – what was it worth now? It seemed like so much wasted breath, and time, and sadness. The windows darkened as the rain clouds moved over and the shadows in the church deepened.

'Is it my eyes, or does this church lean? It looks slightly twisted.'

'Subsidence,' Rory said, and looked down at his lap. For once, he didn't seem to want to discuss the architecture. 'Please forgive me for asking, Esme – I've no right to ask, but it puzzles me: why did Miles write to you?'

'Miles?'

'The letter I gave you yesterday. I couldn't figure out why I recognised the handwriting at first. I knew it and yet didn't, probably because he was writing in block capitals, but I've seen it on reports often enough. It was Miles' handwriting, wasn't it?'

'Oh, that. It was just some contact details – newspaper

contacts. He'd promised that he'd send them on to me.'

It was the instruction that Alec had given her in his letter: he'd tried to disguise his handwriting on the envelope, but if anybody recognised it, this is what she was to say. Esme resented the fact that she was now following his instructions, weaving herself into further lies.

'Newspaper contacts? I can hardly imagine that your worlds overlap very much? Botany and jazz? Where do those charts converge?'

'People he knows socially.' She was aware that she was floundering. 'Just the names and contact details of news-paper people.'

'I saw you with him in the orchard.'

Had he? How much had he heard? Rory turned and looked at her directly. His eyes moved over her face and she saw all the questions there.

'We were talking about writing.'

'It didn't sound like that sort of conversation.'

'Were you listening? Did you follow me?'

'No. I only slipped out for a cigarette and saw you in the garden.'

'It was nothing. It was a conversation of no consequence. Only talk of work.'

'Was it?'

She recalled those words in Hal's handwriting: *You hadn't met him before, had you?* Had he voiced his suspicions to Rory? She closed her eyes and listened to the rhythm of the rain on the roof.

'Esme, Miles didn't do anything that he shouldn't, did he?'

'Whatever do you mean?'

Rory looked uncertain now. 'I mean, he didn't say or do anything improper?'

'No, of course, not. Why do you ask that? Is he that sort of man?'

'It's just ... oh, I don't know. I shouldn't have said anything. Miles adores Zoubi, that's as plain as day, but he can be a bit of a flirt. You've been quiet this week and I started to worry that something might have upset you.'

'He's like that?' She tried to keep the shock out of her voice. 'No. Please, don't worry. There was nothing like that at all. I'll show you the letter if you want to see it.'

'I'm sorry,' he said. 'I had no right to ask.'

Esme would have liked to tell him, to share the whole story with him, and to know that her shock, and hurt, and anger weren't unreasonable. She would have liked to tell Rory how wronged she felt, how this long history based on lies smarted, how she'd wasted seven years of her life mourning a man who didn't seem to love her. And what other secrets did he have? What more was there that she didn't know? She turned her locket between her fingers. It still contained Alec's photograph. She had a sudden urge to take it off.

'Rory, would you permit me to read your book?'

'My book?' He sounded surprised. 'You want to read it? Why?'

'There are things about the war that I'd like to understand

271

better. Watching you all together last week made me curious. I want to know your story.'

'You do?' he said. 'It's only my perspective.'

'But I'd like to understand your perspective.' She could tell that he was reluctant. She could hear it in his voice.

'You would?'

'I really would.'

She felt her chain snap and fall away. The squall had passed over now and the windows brightened. All the colours of the stained glass were lit for a moment, and then dimmed again. The broken necklace trickled into the palm of her hand.

'Well, of course, if you genuinely want to, you're welcome to read it. There are some parts that are rather dark, though.' He hesitated. 'I should warn you of that.'

She looked down at the locket in her hand. 'I need to read about those events. I want to. There's so much that people don't speak about.'

'Often with good reason.'

'But you'd thought of sending it off to a publisher, hadn't you? You told me there were scenes that you needed to record. You meant it to be read, didn't you? Lest we forget?'

He gave her a long look. 'Yes,' he eventually said.

NATURE DIARY
A LAND OF OLD, UPHEAVEN FROM
THE ABYSS

It is high summer now and no birdsong breaks the stillness of this July afternoon. At the roadside, ferns are bronzing and crisping into tighter coils, and when I stand on the edge of a wheat field, I hear little cracking sounds. It is white-gold and glimmers as it ripples. Heat shimmers in the lanes, confusing the eye, and those who know the temperament of the weather in these parts say there will be more storms. We had squalls of rain yesterday and, as we gathered fallen branches from the lawn, I was told the story of the lost land of Lyonesse.

This kingdom, once situated between Land's End and the Isles of Scilly, is said to have been submerged beneath the sea during a mighty storm. The old story goes that it was a prosperous land, with wealthy cities and one hundred and forty parish churches. But in 1099, a huge wave flooded the whole landmass, leaving only its mountain peaks – now the Isles of Scilly – above the water.

Fishermen claim to have seen peculiar shapes down in

the depths, on clear days and moonlit nights, the spires of churches and the tops of beech trees under the waves. When boats fished around the Seven Stones, doors and window frames would emerge tangled up in their nets, and there are tales of church bells being heard, ringing beneath the waves. There is a melancholy romance in the thought of the barnacled bells, the pews streaming with seaweed, and only fish gliding up and down the church aisles.

Tennyson placed King Arthur in Lyonesse ('A land of old, upheaven from the abyss ... Where fragments of forgotten people dwelt') and it was the homeland of Tristan, the lover of Queen Iseult. According to this story, first recorded in the twelfth century, King Mark of Cornwall sent Tristan, his nephew, to fetch his bride-to-be from Ireland, but after an accident with a love potion (how convenient these devices are in stories), Tristan and Iseult became bound as lovers. Mark's loyalties were torn between his beloved nephew and his bride, and that triangle would remain unresolvable until the end of the lovers' lives.

King Mark outlived them both and ultimately forgave their deceitfulness. He had his wife and her lover buried in his palace at Tintagel. From Tristan's tomb there grew a briar rose, which bent towards Iseult's grave, and rooted itself there. It was cut back three times, but on each occasion the briar regrew and linked their graves once more. Poor Mark finally conceded, and forbade that the determined briar be severed again. I cannot help but picture Mark as a gardener raising his hands in exasperated surrender.

The blossom of dog roses is luminous in the hedgerows in the twilight, and the image of the linked lovers' graves returns to me. In the jasmine-scented evenings the shapes of moths flutter and bats streak. Owls glide silently above and there are glow worms in the garden. These tiny grubs exude such a powerful light that, from a distance, a star might have fallen out of the sky. The strange beauty of these evenings almost convinces me to believe in the lore and legends that weave through everyday life here.

From *The Winter in the Spring*

October 1916

We have blackened our faces with grease and ash from the fire, and all I can see of the men is the occasional flash of the whites of their eyes and now, most unexpectedly, Warner's grin. He has brought a murderous looking club with him, all nastily studded with nails, and seems to be quite keen to use it. Mason has a knuckle knife. It is 2.14 a.m.; all is silvery with moonlight, and we're ready to go.

The luminous hands are moving around my wristwatch rather too fast. I can feel my heart racing and try to steady my breath. The men don't like raids, they're convinced that the risk isn't worth the reward, and I can't entirely say I disagree, but we've planned this as best we can. We've run through practices, know where we should be and when, and what role each of us is to play. I've memorised the drawings: where their wire is, where the line is, and the point of entry into the sap. The area was shelled yesterday, and the wire has

been destroyed, so it should be a quick in-and-out job; get an identification, and get back. That's what I've told them, and what I keep telling myself. I haven't been sleeping well this week and have had terrible dreams about letting the men down. There's a loneliness that comes with responsibility and I'm afraid of showing fear. I hope that it won't come to clubs and knuckle knives.

'Time to go,' I whisper.

We slide out on our bellies, and then crouch and sprint forward through the path that's been cut in our wire. We have been in trenches for six months now, on and off, and there is something so absolutely contrary to instinct about climbing up out of that shelter. It's not easy terrain to cross. It's hummocky with smashed beams, bricks and roof tiles, empty tin cans and rusting sheets of corrugated iron. Here and there, what looks solid falls away under my feet, and then I hear a can rolling. We all freeze and listen. Out here, in this dangerous darkness, every sound is amplified. Did they hear it too?

A star shell goes up. We watch it rise and then curve back down. It flashes a white calcium light as it impacts and we put our faces to the ground. It is a most unnatural light, a cold, chemical brightness, and it pulls grotesque shadows that sway and stretch. It fizzes, and then all is black again, a more profound darkness now. I find myself holding my breath, listening, waiting, counting, and then it comes. A rifle shot cracks, just off to the left, and then, over to the right, a machine gun briefly blasts out. We haven't been seen,

but they sense we're out here. I look at my watch. They're certainly about to hear us now.

'Wait here,' I say.

The barrage starts to come down almost as soon as the words are out of my mouth. Artillery and trench mortars open fire and it's a wall of sound. Shrapnel and high-explosive tears into the enemy line and I feel the ground beneath me quake. We see their frontline trench, marked out now with bursts of flame and smoke, and against the light I also see the wire. Fielding sees it too and I hear him swear. There are thick belts of wire between us and the target.

Fielding, Robson and I have wire cutters and we start on their first line. The wire snags and snatches at us, and the more we cut, the more we're tangling ourselves into it. It is like some hideous spider's web, and we the thrashing prey, weaving ourselves in further, and sending alerts pulsing through the membranes. We have ten minutes and then the barrage will shift back to cover our planned withdrawal. Can we get through this, into the sap and back, within ten minutes? We're not going to do this in time. I have to make the decision.

A shiver of dust falls from the ceiling of the dugout, and Miles covers his mug of tea with his hand. I felt somewhat inadequate, having to admit that we got stuck on the wire, but at least we took no casualties, and I don't see any judgement on Miles' face. His party, south of the railway line, had more success, and I heard the excitement in the men's

voices as they returned with trophies and a story to tell. All we had to show was lacerations. The deep cut on my palm is throbbing and I press my bandaged hand between my knees.

'What did you get?' I ask.

'A helmet and some stick bombs. Nothing that gives us an identification, though, which really makes it all a waste of time. It was deserted when we got in, but then they realised we were there, and started lobbing bombs at us. We got out sharpish.'

'I won't need this at least.'

I'd left a letter for my parents by my bunk, and it's somewhat cathartic to now tear it into pieces. I don't know why I wrote it. I've been on raids before and not thought to write my goodbyes. Perhaps it was Patrick's talk of unlucky numbers of magpies yesterday? Or maybe it was having to leave my tags and pay book behind and consider the possibility of becoming an unidentifiable corpse? It is very strange to put down final sentiments on paper; it felt important to pick out the right words, but those phrases seem pompous and rather embarrassing now.

'I've never written one of those letters,' Miles says.

I've known Miles for nearly five months, but it strikes me that we've had very few serious conversations. It's not that he's doesn't talk, he talks a great deal, but he always keeps it light and in the present moment. I know that his previous battalion were in the thick of it at Loos last winter, I believe he's spoken about that with Gilbert, but he's told us very little about his time with that unit. He doesn't talk about home

or family either. Some men endlessly want to tell you about their wives and children, and what they did before the war, but I don't even know if Miles is married. The peculiarity of not knowing that basic fact strikes me suddenly. I can't recall that I've ever seen him writing a letter.

'You don't have close family?'

He shakes his head. 'I lost both of my parents a couple of years before the war.'

'I'm sorry. And no siblings?'

'No. And you?'

'A brother,' I reply. 'He's out here too. Are you married? Sorry, I feel I ought to have asked that sooner.'

He grins, but then shakes his head. 'No. I've managed to dodge that bullet so far. There's no one special. Perhaps I ought to try harder there.'

I pity Miles at this moment. He's such a sociable chap and I'd imagined that he might come from a house crammed with noisy siblings. It surprises me that he has no one. I suppose there's a freedom in having no links, it untethers one from obligation and guilt, but I suddenly look at Miles differently and consider if he might be a lonely person. He is so gregarious and positive, and for the first time I wonder if that's because he needs to reach out and make connections.

A shell hits the line; we knew there would be a retaliation. Miles curses and crouches, and the fragments of my letter crumple in my hand. I resolve that I will write to my parents again tomorrow, and to Michael. I realise how fortunate I am.

Chapter twenty-eight

They stopped to look at the bramble blossom in the hedge. Rory told her how, as boys, he and his brother would be sent out with a basket to gather brambles, but they'd eat as much as they picked; she told him about making jam with her grandmother, and apple and blackberry pies. Bees echoed in the freckled chambers of foxglove flowers, emerging all dusty and heavy with pollen, and butterflies lifted from the nettles and shimmered.

As they walked, her mind kept returning to the scene she'd read that morning. She had turned through the pages of Rory's manuscript looking for his name. As Alec had told her, he'd met Gilbert's company when they were in rest billets near Béthune and concocted a story about having misplaced his transfer papers. Thereafter, he appeared as charming, irreverent, ebullient Miles, always sharing jokes and stories, playing pianos in bars and winning at cards. He was like a secondary character in a play, written in to give light relief. That scene with Rory, in the dugout after the raid, was the first time Esme had recognised elements of the real Alec, the one she knew, but it concluded with him

denying her existence. She'd known for the past week that this was effectively the case, but it had shocked her to hear him saying it directly and dispassionately. Had she really been 'no one special' to him? Did he regard her as a bullet that he hadn't manage to dodge?

She'd also been there with Rory as he'd crept towards the enemy line, trying not to show his fear, and it had moved her to imagine him penning goodbyes to his parents. She looked at the man at her side now. He had a piece of grass between his lips and was shielding his eyes as he watched a kestrel hovering. Esme felt an urge to protect the version of Rory who she'd met in his manuscript. She hadn't expected his voice on the page to be so candid. As Alec was all mask and bravado, Rory seemed somewhat tender and exposed.

'It's all brilliantly yellow and purple in September,' he said. They climbed on, up towards the boulders on the summit of the hill. 'When the gorse comes back its cadmium yellow, and with the heather it's like a fantasy landscape. If you were to paint the colours as they are, it would look implausible. I wish you could see it in autumn.'

'Perhaps you could send me an implausible painting?'

Esme stood still and felt it all shifting around her: the tug of the breeze, the hum of the bees, the smell of gorse and meadowsweet. They stood shoulder to shoulder in silence, and she wanted to say how glad she was that he got to see the colours of the heather; she also wanted to tell him about Alec and how it wasn't true that he'd had no one to write to.

'They sent me to Hampshire after the war,' he said, quite out of nowhere.

'I'm sorry?' She stopped and turned to face him. 'Hampshire?'

'To a special hospital there. It was a department that treated war neuroses. The ward was full of men who spasmed, and twitched, and screamed. It wasn't a nice place at all. If I didn't have them before, that ward might have given me nightmares.' He laughed rather mirthlessly. His eyes weren't connecting with hers. She could tell that it wasn't easy for him to say these words. 'Anyway, some of it worked and I'm better now than I was. I'm more than that – I'm good. You've never asked, you're far too polite and considerate, but you've always looked me in the eye, and I'm grateful for that.' His eyes did finally meet hers then. 'I thought I ought to say something, though, because you're reading the manuscript. That part isn't in there, I've never written about it, but I suppose it's the postscript.'

'I'm sorry you had to go through that.' In truth, she hardly noticed the occasional flicker on his face any longer. It had just become part of him.

'Eventually it may go entirely, they say. It just needs time. But it's part of who I am, part of my story, and I can't hide it.'

It felt like he was laying his cards down on the table, giving her all of his uncomfortable truths. It should be her turn to share now, she knew. They walked on, and the silence was difficult now. It was a gap between them. It was an absence of words that she ought to be sharing.

They leaned on the stones at the summit. She was glad to pause and catch her breath. Water sparkled in hollows and the wind rippled the moorland. She could see the path that they had printed through the undergrowth. Midges spiralled in sunbeams.

'It was an Iron Age hill fort,' he said. He plaited a strand of grass between his fingers. 'There would have been walls and huts inside. It's believed that they made blood sacrifices on these rocks back in the day.'

Esme imagined a palisade of pointed stakes, eyes looking out, the moor forested, and wolves slinking silently between the trees. She moved her hands over the rough texture of the rocks and thought about blood in the creases of Alec's hands. When she got back to Fernlea, she would find a pair of pliers and cut his ring from her finger. For now, she made herself focus on the golden lichen, the emerald moss and the sigh of the wind. But was there a scar on Rory's palm? Perhaps if there wasn't, it might not all be true.

'There are holes in some of the rocks,' Rory went on. 'They used to fill them with gunpowder, and fire them off on Midsummer's Eve. Can you imagine the noise? Midsummer used to be a bit mad around here.'

On the evening of Midsummer's Day, Esme had looked into the eyes of her dead husband, a man who was now married to someone else and denying her existence. If she didn't have his letter as proof, she might still be questioning her own sanity.

'Is this the highest point?' she asked.

'It is. You can see the south coast from here too.'

She looked along the length of Rory's arm and saw the shape of the lighthouse on one side and Mounts Bay on the other. The sea was a blue haze and a faint rainbow arced towards the south coast. She also saw the faintest arc of a scar on his hand. They stood like that, unspeaking, for some moments.

'I found your locket,' Rory said. 'You left it on the bench in the church.'

'I'm sorry?' She turned to him. 'I did?'

'It's a striking resemblance,' he said slowly. 'Uncanny, really.'

He knew, then. What should she say now? She couldn't deny it, could she? 'Yes,' she said.

'It's more than a resemblance, though, isn't it?' She saw him hesitate before he spoke again. 'When I looked in your locket, pieces fell into place. Only I can't quite work it all out.'

'No.' She wasn't sure what else to say. She didn't know how it fell into place either.

'Will you tell me, Esme? I can't not know. It's driving me mad. I knew there was something between you and Miles, that something had happened. I was certain of it. Unless you tell me, I won't know how to speak with Miles again. I won't know how to be with him. If you tell me, I won't pass it on to any of the others – not if you don't want me to, I promise.'

Esme looked at him. His eyes implored her. But how could she tell him? How could she begin?

285

'What's the link?' he pressed on. 'Miles isn't Alec, is he?'

With that, she didn't have any choice. Alec might have denied her existence, but she couldn't now deny his. 'I genuinely did believe that he was dead until last week.'

She saw the shock on his face. 'Dear God! But how does that work?'

'He didn't die,' she explained. 'He changed his name. He began again. Apparently, war does that to men. Apparently, I'll never understand.'

'*I* don't understand.'

He looked like he was reeling as much as she was. 'You mustn't tell any of the others,' she said quickly. 'Not for now. I need to think about what to do next.'

He put his hands through his hair. 'Why didn't you tell me last week? I wish you'd told me.'

'What could you have done? If I'd said anything, he probably would have laughed and called me a deranged widow, a mad, sad, delusional woman. I mean, it sounds so improbable, doesn't it?'

'But that's hideous. That's criminal. He's married to Zoubi. I went to their wedding. Isn't that bigamy? He'd go to prison for it.'

She could see all the questions passing behind Rory's eyes. So many more questions on his lips. His eyes scanned the horizon before they returned to hers.

'You don't know the half of it,' she said.

'Esme, what you've been through! I don't know that I could ever look at him again. How can I be in the same room

286

with him now, knowing that he did that, knowing what he did to you? I've got a good mind to go to London—'

'Please, don't! I wish I hadn't told you now.'

'You could go to the police.'

'I'm considering it.'

He was staring at her. 'But how could he do that? I thought I knew Miles. We've been through so much together. I've known him for years.'

'I thought I knew him too.'

'I hate him for deceiving and hurting you.' He took her hand in both of his and turned the ring on her finger. 'How could anyone do that to you?'

She looked away. His eyes said too much. 'That's why I asked to read your book. I supposed I might find answers in there.'

He shook his head as if he didn't know what to reply. 'What will you do?'

Up at this high point the county looked so narrow. It was just a spit of land and there was so much more sky and sea. Esme wished that she had level ground beneath her feet, but she felt like she was balancing on a ridge at the moment. Did she want to tell the police? More explanations? More consequences? Wouldn't it be easier to let it go?

'I don't know,' she said.

From *The Winter in the Spring*

February 1917

'Post for you,' says Gilbert.

There are snowflakes on his shoulders and his cheeks are flushed with cold. He sits down at the table facing me, rubs his hands and pours a whisky.

'Is it still coming down?'

'In great lumps. Miles threw a snowball at me just now. The insubordination!' He laughs.

There are two letters and I recognise the handwriting of both my mother and my father. My father rarely writes to me – he's not a natural letter writer – so it's curiosity that makes me open his envelope first. His few lines are wrapped around a packet of seeds.

'Carrot seed!' I say to Gilbert.

'I thought I heard rattling.'

My father's note instructs me that I must prepare the ground in March, digging a shallow trench, and sowing the

seed thinly. I realise that he still thinks we're in our reserve billet in Arras with the garden at the back. My last two letters clearly hadn't arrived at the time he was putting pen to paper. My father isn't one for sentiment, but it touches me that he has sent me this gift and these words of instruction. Michael always liked to work with him on the vegetable garden, and at times I've felt slightly excluded from their conversations about peat and compost, and which variety of kale gives the longest crop.

'I'm not sure that my father doesn't think I'm on a gardening tour of France.'

'Oh, for the life!'

'And parsnips from my mother, I wonder?'

The postmark is a week later than my father's. Did he tell her what he was sending? I imagine that it will have amused her. My mother's letters usually start with responses to the last news I sent, worries about what I'm eating, and concerns as to whether I'm appropriately clothed for the weather. This one doesn't. I have to read the opening paragraph three times before I can take it in.

'Nothing amiss at home, is there? You all right, old man?'

I realise that Gilbert is watching me.

'It's my brother,' I tell him. 'I didn't know he was so close by.'

I read the letter through again. I'm finding it difficult to understand the information that my mother's words are communicating.

'Has something happened?'

'My brother is dead.' I turn the letter over and read the paragraph once more. 'They had a letter from his C.O. He was killed in a raiding party. They'd gone forward to investigate the effects of a gas discharge on the enemy, but the patrol got bombed back.'

My mother's handwriting repeats all the usual platitudes about death having come quickly and painlessly. I have written those same words to parents. Did they believe them? I can't help wondering whether Michael was killed by the gas or by a bomb. Did he gasp his last breaths, or was the blast the last thing he knew? We discharged gas ourselves while we were in the Arras trenches, and took it in return. I recall, after one gas attack, that the bottom of the trench was full of dead rats, mice and stag beetles. I picture my brother's body curled among the shiny black beetles.

'My dear boy, I am so sorry.'

Gilbert comes around the table. I don't mean to cry, but he puts his arm around me and suddenly I can't help myself. I always knew that Michael would take on the farm one day, and it had seemed like his future was mapped out ahead of him. While I'd had doubts, Michael knew what he wanted from his life. How can Michael have no future? It has been strange, these past few months, knowing that he's out here too, but I never expected this. I took it for granted that we'd collect a few shared experiences, stories we'd perhaps talk of in later years, but then Michael would go home again. Bullets would bend around him. Fate would shield him from

shrapnel. This alternative isn't right. I feel as though some fundamental law of physics has broken.

I look at the packet of seeds on the table. When my father put them in an envelope a fortnight ago, he would have had no idea. I want to put my arms around my father. I want to be there with both of them, but what could I say to them to make it any better? What has been achieved by Michael's death? I can't find any words to justify it.

'My parents——' I say to Gilbert.

He nods his head. Perhaps, like me, he is thinking of all the letters he has written, all the parents who have struggled to make sense of those words. He resumes his seat opposite and pours me a whisky.

'You were close, weren't you?'

'Always.'

When I got leave last year, I walked the fields with Michael. We'd talked about putting in new drainage ditches, fixing the barn roof, and we'd dug the kitchen garden over. I hear my father's voice talking to Michael, and the sweet, steady breath of the cattle in the barn. I can almost conjure the smell of the cows and taste the liquorice sticks that Michael and I chew. How is my father coping with the knowledge that Michael will never come home now, that he'll never hear his voice again?

'I'll find somewhere to plant them.' I dry my eyes and turn the packet of seeds between my fingers.

'Yes,' Gilbert says. 'You should do that. You should write to your father and tell him that you've done it.'

He's right, of course. I know that my father won't write and tell me that he's grieving, but we can exchange letters about seedlings germinating, about soil and weather. I need that link suddenly, and instinctively feel that my father might too.

'I read somewhere that gardening is the ultimate act of faith in the future,' Gilbert goes on, 'though I'd hazard that the decision to have children might be more deserving of that title. We must look after each other now and keep on believing that a better future will come.'

'Will it?'

'It will. You might not believe it right now, but I promise you it will.'

He says it with such firmness that, for a moment, I do believe him.

Chapter twenty-nine

Esme stepped out into the garden and narrowed her eyes to the brightness. She'd spent the past hour reading Rory's manuscript and the image of him crying in Gilbert's embrace had brought tears to her own eyes. She had wanted to put her arms around him too, to tell him how sorry she was, and to ask him how his parents were now. As they'd sat in Zennor church, he'd mentioned that there was a grave in France that he needed to visit. She'd spent all that day talking about Alec. Had she not given Rory space to speak?

It was still only ten o'clock, but the buds of the dahlias were withering, the honeysuckle was crisping and bamboo leaves were curling in on themselves. The roses were dropping their heads in the heat. There were yellowing petals all over the path and a heady, spicy scent. Even the wind that stirred the trees was hot. The garden shimmered, the flower beds dazzled, and Esme wondered if Rory had ever planted the packet of seeds.

Mrs Pickering was sitting in the shade of the pear tree with her head in a Georgian romance. She glanced up from her book. 'You look overheated and all of a flutter, my dear.'

'Is it often this hot here? I didn't really bring the right clothes.'

'You must raid my wardrobe.'

'Would she find a bathing costume in there?' Rory asked.

He and Hal were walking down the garden with towels under their arms. Esme couldn't see Rory's eyes in the shadow of his sunhat, but the beginning of a grin was stretching at the corner of his mouth. It was odd to see him smiling. Just minutes earlier she'd heard his on-paper voice cracking. It made his grin seem surprising and peculiarly beautiful.

'Of course she would!'

'What?' It took Esme a moment to catch up with the conversation. Mrs Pickering was sounding a bit too eager.

She felt slightly in a daze as she was ushered up to Mrs P's room. She blinked at her own reflection in the mirror as items of bathing attire were held up in front of her. They were variously frilled, striped and all too brief. The snap of elastic brought her abruptly back into the moment.

'But I couldn't!'

'You could. Now, don't insult me. I've brought them with me because I've worn them in previous years. If I can go swimming, you most certainly can.'

'But I can't be undressed in front of strangers.'

'You won't be. You'll be wearing my bathing costume and they're hardly strangers now, are they?'

'But my legs—'

'Are younger and shapelier than my legs. They are perfectly adequate legs. Besides, they're going to be swimming

294

themselves. The object of the exercise isn't just to ogle your legs. The sooner you're in the water, the sooner it's all out of sight.'

'But—'

'Whatever is it now?'

'I can't swim!'

Mrs P didn't see this as an obstacle. Everyone had to learn sometime, and if Esme couldn't swim this morning, she would have mastered it by this afternoon, wouldn't she? And Rory would enjoy teaching her.

But wasn't she meant to be cautious about Rory's keenness? Esme was tempted to retort, but bit her lip. How many weeks was it since Mrs Pickering had instructed her to be careful of him? And now she was meant to wear a bathing costume and let him teach her how to swim? This wasn't consistent. Had Mrs P's opinion of him changed over the past seven weeks? Was Espérance moderating her opinions? Esme sensed a shift here and, for once, wished that Mrs Pickering's dos and don'ts might be more clearly labelled.

Half an hour later, Esme too was walking down the garden with a towel under her arm. She was wearing a frilly yellow bathing suit under one of Mrs Pickering's voluminous shift dresses, and while it was pleasant to feel the breeze stirring her clothes, she was conscious of being conspicuously lacking in supporting scaffolding.

Rory and Hal had taken up Mrs Pickering's shady corner in her absence. Rory was lying on his back on the lawn with

his sunhat over his face. He leaned up onto his elbow as she walked towards them.

'Now, you must go and get on with your young person's activities,' said Mrs P.

You will be glad of it, Hal wrote. *It's too hot and the sea will be heaven.*

'It is too hot,' said Esme. 'But I can't swim. I've never learned.'

We'll teach you. It's easy. Everyone can swim.

'Quite!' Rory put in. 'We swim in our mother's tummies, don't we? We swim our way into the world.'

'You can be alarmingly matter-of-fact!'

'What?' he said with a laugh. 'Well, it's true, isn't it?'

They took the path towards the cliffs, the grasses tickling at her bare ankles. Rory pointed out terns, kittiwakes and herring gulls. The cliffs were white with guano in places, and there were black shadows that shifted into the shapes of sheltering cormorants when she shaded her eyes with her hand.

'Are you okay today?' he asked while Hal was out of earshot. 'I didn't sleep very well last night. I kept thinking about Miles and how entirely he deceived us all. I have to admit, I'd still like to get on a train to London and punch him. Are you sure you don't want me to do that? I'm not one for violence, but it would give me great pleasure to apply my fist to his face.'

She'd considered the practicalities of getting on a train to London too. She wanted to confront Alec, to make him appreciate the enormity of what he'd done, to make him see

what the consequence had been for her, but she felt that he'd already closed the door on her. The image of Rory punching him wasn't entirely unattractive. What good would it do really, though?

'Let's have a day off from him, eh?' she suggested. 'I don't want to think about him today.'

Hal insisted on taking her towel as they picked their way down the path to the sea. Rory, going ahead, extended his hand so that she might grasp it if needed.

'Take it steady. The loose stones skid away under your feet.'

There was a curve of sand in the cove, but it was surrounded by jagged rocks. Esme was torn between trepidation at the sight of the rocks and a sense that she needed to submerge herself neck-down in the water as quickly as possible.

She kicked off her sandals and the sand was hot under the soles of her feet. It sent her scampering towards the water and it was a pleasure then to stand with the sea foaming around her toes. She stepped out further, holding up the hem of her dress, and the sun dazzled on the water. Small silver fish hung, suspended like insects in amber, but then flickered away from her shadow.

'Steam is rising from my feet!'

Rory rolled in the sand and suddenly was standing on his hands. His upside-down face grinned before he turned and tottered towards the waves. Was this display of contortion for her benefit? Was she meant to be impressed? The image of him crying in Gilbert's arms came back to her, but she pushed it away.

'Good God!' A wave splashed over her knees and the sudden shock of the cold made her gasp.

Hal strode out past her, splashing into the deeper water. He laughed silently as he flung himself back into the waves.

'You see,' said Rory, now righted and squinting into the sun, 'it's a piece of cake. But it might be more challenging in Fenella's frock.'

'Yes,' she said. 'You go in. I won't be a minute.'

She slipped the dress off over her head, and didn't linger to fold it, but when she looked back they were entirely occupied splashing one another and spurting water from their mouths. They kicked up spray, tried to duck each other's head and laughed. They were playful today. Esme had never seen Hal look so untroubled. She ran back towards the waves and was in the water up to her waist before they could notice her.

'You're not frightened of it, then?' Rory shouted as he turned onto his back.

'Not while my feet are still on the bottom.'

Esme stood on her tiptoes and felt the pull and push of the wash around her legs. She could so easily lean back into it, but would she sink? Her own shadow quivered uncertainly under the water. She closed her eyes and the sunlight made bonfire-night patterns of shifting reds and sparks of white light.

'Step out further,' Rory said.

She could feel ridges of sand under her feet, sharp stones here and there and weed that tickled softly around her legs. Her white limbs were all rippling and distortion. The icy

water lapped around her shoulders, and Hal and Rory were there at either side of her then.

'Push your head forwards and kick your legs back. So long as you keep on kicking, you'll never sink.'

'*You* might not sink.'

'Trust me. We won't let you sink.'

It was frightening, the letting go. That was the hardest part, finding the trust and belief, but she kicked like fury. She wasn't sure which of them had put a hand under her stomach to keep her up, but it hardly mattered at that moment. She was a frenzy of flailing limbs, spluttering and swallowing sea water. She kicked out and away from them, but then she worried that she might not be able to touch the bottom any longer. Her toes stretched and, finding the soft solidity of sand, she hung there, the water lapping up to her chin. Every few waves, she was lifted off her feet. She laughed in surprise.

'See,' said Rory. 'Easy, eh?'

He ducked under the water and then his feet came up with a great splash. Esme saw the streak of his hair, and felt the sway as he slid past, like a friendly dolphin muscling through the sea, but then he was gone. There wasn't a sign of him. She looked around. She was starting to panic in the second before he surfaced again, smiling and at ease in the water. She watched him floating on his back, his eyes closed, his face perfectly peaceful.

'Swim to me,' he said. 'Come on. If you take your feet off the bottom for a moment, it will still be there. The water really isn't that much deeper here.'

'Do you promise?'

'Yes.'

'Show me.'

'Trust me.'

Esme's method of swimming was ungainly but effective and she wanted to show Rory that she did trust him. She was out of breath, though, by the time she'd swum to him.

'I need to hold on to you!'

He extended his arms out to her. 'Keep on kicking. You'll bob like a cork. And you can open your eyes. It's easier when you can see where you're going.'

'But the salt stings.'

'It won't after a moment.'

'My heart is going like the clappers!'

'For a first time, you're being remarkably brave. I knew you were a mermaid.'

'Don't get carried away.'

Her eyes smarted and, for a moment, he was a blur. But then she blinked him into focus. Sunlight bounced on the water and flickered up onto his face. His eyelashes were matted together and sparkling in the light.

'Watch Hal,' he said. 'I love seeing him do this.'

Hal had scrambled up onto a rock and was readying to dive. He looked so young, Esme thought, as he bent his slight frame to the water, but then suddenly he was all grace, control and strength. His body curved, breaking the surface cleanly.

'He's like a kingfisher swooping into the water.'

'Hal grew up on the Welsh coast. He's been swimming since he was a tiddler. The water might well be his natural element.'

'I never imagined that he might have an accent until I read your book. I didn't know if he was born mute. I never liked to ask.'

'He had a lovely musical accent, all singsong rhymes and rolling rs. When I read his writing, I hear his words in that accent still.'

What had happened to Hal? Could she ask? To Esme it seemed profoundly sad that the young man with the insouciant, singsong voice had become solemn and silent, but he was clambering up onto the rock again now and waving.

'Ten out of ten!' Rory cupped his hands around his mouth as he shouted. Hal raised thumbs towards them before he bent to dive again. 'You'll be doing it too within the week.'

'Some chance!'

As Hal swam towards them, Esme was suddenly conscious that she was still holding Rory's hands. His hair stuck to his cheeks and rivulets of water ran down his face. There were new freckles on his cheekbones, she noticed, and shards of green in his blue eyes, like the flash of a kingfisher's wing. Esme saw the sky and the sea reflected in his eyes, and her own face in the black of his pupils. She felt the undertow of the waves lifting her feet and wasn't entirely sure that she wanted to let go of his hands.

'I should try on my own,' she said. If Hal hadn't been there, would she have kept hold of him?

'It's definitely doggy paddle,' Rory laughed as she swam. 'But it appears to work.'

After a few minutes of paddling around in circles, she found that she didn't need to kick so hard. The water seemed to want to hold her up and how glorious that sensation was. She felt very free, as the water suspended her, and her mind emptied apart from the immediate sensations. This moment – this cold and heat and feeling of floating – used up all her senses. There was only her, and the sea, and the sparkle of the sun in her eyes. Nothing remembered. Nothing ahead. No complication. Only here and now.

'Do you like it?'

'I love it.'

Esme forgot to worry about her bathing costume as she stepped out of the sea. It was only as she wrapped herself in her towel, and Rory smiled at her, that she remembered and looked down self-consciously.

'My fingers are all wrinkled,' she said, and held them out to show him.

'Here,' he planted a clear aquamarine pebble in her hand. It was like a solid piece of the sea. 'It's sea glass,' he said. 'It might have been a fishing float, an ink bottle or a medicine bottle, tossed overboard a century ago and tumbling in the sea for all that time.'

Esme thought of Alec and a day on Bamburgh beach when they had collected pieces of sea coal, all glossed like polished jet in the damp shingle. They had dulled when she found them in her pocket the next day, but she'd taken them home

as a keepsake. She saw Alec skimming stones at the waves and heard his uncomplicated long-ago laughter. It might be a century ago too. She would always miss that version of him, but that man was gone.

'A souvenir of today,' she said. 'It's beautiful.'

Clarrie was setting a table for lunch as they walked back up the garden. Gilbert pulled a chair out for Esme and poured her a glass of water.

'You look as if you enjoyed that.'

'I swam! I've never swum before. I didn't know I could do it.'

'She'll be tackling the Channel by next summer,' said Rory.

Esme put a hand through her hair. It was sticky and matted with salt, and sunburn was starting to prickle on her shoulders, but she felt like it didn't matter. She raised her face to the sky. The branches of the magnolia were black against the blue. Sun penetrated in places and stirred in bright splashes on the tablecloth. The light through the wine bottle made a jewel-green shadow.

'The state of you, Esme Nicholls!' Mrs Pickering's expression was somewhere between horror and delight. 'You've gone native, but how terrifically healthy you look. Your cheeks are glowing.'

'Thank you for letting me borrow your bathing costume. It was heavenly.'

'I'm so glad.'

Clarrie brought out dishes of soused herring and potted crab, something savoury under a pie crust, and salad from the garden. As Esme looked at the food, she realised that she was ravenous.

'What a set of savages!' Sebastian laughed as he sat down. 'Whatever have you done with Esme? Fenella, your protégée is going off piste! She was so proper when she first got off the train. So uptight. If you stay here much longer, you'll grow a pelt and start climbing trees.'

Was that how it looked? Her arms, on the table, were red and rimed with salt. At this moment, Esme thought that she rather liked this braver version of herself, who had tangled hair and didn't care. She wasn't presently sure that she wanted to go back to being proper.

'I think she looks hale and hearty. Very natural,' said Gilbert, and he raised a glass towards her. 'To July and the blossoming of Esme!'

They all clinked glasses and repeated his toast. It was terrifically embarrassing, but they did all smile at her nicely.

'Talking of savagery, it's Colonel Jackson's fundraiser at the weekend,' Gilbert went on. 'Are we up for it this year?'

'Are we ever!' said Rory. He looked positively excited by the prospect. His hair was still dripping, the water soaking through the shoulders of his shirt. He gave Esme a quick smile, like a shared secret, as his eyes connected with hers. Sebastian buffed his fingernails and raised an eyebrow.

'A fundraiser?' she asked.

'It's a bazaar, garden fete and ball, ostensibly an annual

fundraiser for the Catholic Church, but it has a habit of getting somewhat beery and raucous.'

'It turns into a bacchanalia.' Rory laughed.

'Goodness.'

'Everyone gets roaringly drunk and they all swap wives after midnight,' said Clarrie. 'That's why the children all have three eyes and scales.'

'Really?'

'Your face!' said Gilbert. 'It does get a bit rowdy, there's a lot of cider and ill-advised dancing, but it isn't all that beastly.'

'Oh, I don't know,' Clarrie said with a smile.

'I enjoyed today,' Rory said.

The fierce heat had gone out of the sun now, and the sky was a deep cerulean blue. All the colours in the garden seemed more intense this evening.

'I did too. I swam! I wasn't expecting that when I woke up this morning.'

She'd had a bath after lunch and had noticed the grains of sand swelling in the bottom of the tub. A piece of seaweed had floated out of her hair. No wonder Sebastian had said she looked a fright.

'I'd quite forgotten what your smile looks like,' he said, 'but I'm very glad to see it back again.'

'Thank you. I needed a day off from thinking about him.'

Rory nodded and she watched the water running over the parched earth. She handed him the next watering can and went to fill the one he'd just emptied from the water butt.

'I read about the packet of carrot seeds this morning,' she said, when she returned. She hadn't been sure whether she ought to say it.

'Oh,' he paused. 'That chapter.'

'I'm so sorry.'

He shook his head.

'Did you ever plant them?'

'Not that spring. As it was, we ended up with other things to keep us occupied. The seed packet got stashed away with my letters and I forgot about it, if I'm honest. I found it again when I came home and was sorting through my belongings. For some reason – I'm not entirely sure why – I put it in my pocket when Gil invited me down here.'

'Because Gilbert had said you should plant them?'

'Maybe. That was possibly at the back of my mind.'

She looked at the feathery row of carrot tops in the bed ahead. 'And did you?'

'In the spring of 1920. The packet was a bit old by then, so it didn't germinate brilliantly, but some grew and I let it go to seed.'

'And so you kept it going?'

'I did. I still am.'

'I like that,' she said.

'Who knew that consolation could be found in a carrot?'

'Consolation is in the strangest places.' She smiled at him and gripped the piece of sea glass in her pocket.

Huddersfield Courier, 15th July 1923.

NATURE DIARY
A SHOAL OF PILCHARDS AND TOURISTS

We walked along the beach with a shrimp net today. It was a pleasure to paddle through the shallows, pushing the net ahead, and the exercise proved instructive too as one realises that the unpromising-looking shoreline actually teems with life. In my first haul, I found worms and clams, tiny crabs, shrimps and infant fish. The water is so clear in the shallows, like the finest skein of silk cast over the sand.

What a thrill it is to rediscover the childish occupation of rock-pooling. Scrambling among rocks, we explore the treasures left behind by the retreating tide – limpets, periwinkles and, among the billowing strands of sea lettuce, a single star fish. Bladderwrack and laver drape the rocks, giving off a strong iodine scent in the hot sun. My rock-pooling companion explains how he uses seaweed as a garden fertiliser, and tells me that it is the custom here for households to hang seaweed on the chimney breast as a charm against household fires.

The wet sand mirrors back the blue of the sky, and the

scudding clouds, and a group of sandpipers are whistling. We pick up shells, cuttlefish and mermaids' purses, and as we walk back up the beach, I ponder the curious optics that split the sea into all the colours of the rainbow. It is indigo at one moment, shifting to jade green, and then purple as the clouds pass overhead. Tennyson described the Atlantic off Cornwall as being 'like a peacock's neck'. How perfect that description is.

The once-upon-a-time seas off Cornwall writhed with whales, giant octopuses and merfolk, and were thick with twisting silver shoals of pilchards. In 1847, thirty thousand barrels of pilchards left St Ives for Mediterranean ports. So valuable was this trade with the Catholic countries that the Cornish regularly toasted the health of the pope.

'Here's to the Pope, may he never know sorrow,
With pilchards today and pilchards tomorrow.'

As the men of this town returned from the seas, so the women and children would take over the work. The catch was barrowed from the quay to special cellars where the fish would be lined in rows, covered with layers of salt, and then topped with heavy weights. The diarist, Richard Kilvert, wrote that the smell of pilchards in St Ives was sometimes 'so terrific as to stop the church clock'.

The pilchard-fishing fleet has not fared well in recent years, though. A record harvest was recorded in 1905, when over 13 million pilchards were landed in St Ives in one week,

but since 1908 the trade has declined. Pilchard shoals are known to move about the coast in cycles, and for the past fifteen years they have strayed away from Cornish shores. It seems that pilchards come in millions or, alas, not at all.

As I look down the beach, I can see a group of lady artists standing at easels, and I'm reminded that this is one of the most painted and photographed towns in the whole of England. As the pilchards moved on, so shoals of artists moved in. Since the turn of the century they have been flocking here, fascinated by the quaintness of the old town, the customs of the native people, and the strangely attractive effects of light and shadow. I believe that there are more than thirty artists' studios within the town now, many of them occupying former net lofts or in the old pilchard cellars.

Together with the publicity of the Great Western Railway, the artists have helped to extend the desirability of this former fishing village as a holiday resort, and today its business is primarily tourism. The cottages of the crooked streets appear to huddle together, as if sharing secrets that the summer incomers mustn't overhear, but look closely and you'll see cards in the windows offering 'Vacancies' and 'Hot & cold running water'.

It is a place of curious contradictions and transitions, full of quirks and charm, where the ancient meets the modern. While there are holiday chalets, golf links and tennis courts here, there are also old women who still lay their washing out to dry on the rocks so that it may bleach in the Atlantic

air. Tourism rings the town's cash tills today, but it would be a shame if the traditional ways were to be lost.

The breeze is whisking the dry sand at the top of the beach now and I watch holidaymakers busying themselves with wind breaks, kites and cricket bats. Hair flies, young women giggle in bathing towels, and little girls ruche up their dresses. There is something irresistibly liberating about being on a beach; we all cast off our inhibitions and take a childlike delight in uncomplicated pleasures again. The sea makes us into braver, simpler versions of ourselves. These high-summer days are long and I presently feel glad of that.

Chapter thirty

Should a woman whose husband has just come back from the dead go to a dance? Esme had asked the question of herself as she looked in the mirror. Was that inappropriate? But hadn't he stepped out of the afterlife with a new wife and children in tow? And didn't he spend half of his life in jazz clubs? She hardly imagined that he was thinking regretfully about her as he manoeuvred Zoubi around London dance floors. Esme decided to go and to enjoy herself.

She had then given some time to considering how one ought to dress for a bacchanalia. Should she treat it like a tea dance? Or a church fete? Or would it be an altogether more hobbledehoy affair, for which stout walking shoes would suffice? In the end, Mrs Pickering had insisted that she borrow her green dress. With her own coral beads and sandals, Esme thought she'd achieved a satisfactory middle ground between church fundraiser and beery free-for-all.

As she stepped into the drawing-room now, though, she realised that anything went when it came to bacchanalian dress etiquette. Mrs Pickering looked like a jaunty lady

mariner in navy-blue stripes, while Gilbert was wearing what looked like a kimono as a jacket. Clarrie was sporting burgundy trousers and Sebastian was in primrose yellow linen. Even Hal, the least ostentatious of the party, was wearing a spotted red neckerchief.

'Is Rory painting himself up like a barbarian again?' Sebastian asked.

Mrs Pickering laughed. 'Heavens! I'd forgotten about that.'

If Esme had opted to wear nothing but trousers and a waistcoat, and had painted her arms blue, she would have entered the room with more trepidation, but Rory bounced through the door. He was evidently rightly confident of his reception, though, as they all duly cheered.

'Good God!' said Esme.

'It's become an annual tradition,' Gilbert said, turning to Rory. 'I think we'd be concerned for your health if you didn't have blue arms on the second Saturday in July.'

It wasn't just his arms, though. The ink came up as far as his chin. Esme wasn't sure whether he looked more like an imp or an extravagantly tattooed pirate. She shouldn't let her eyes linger on his blue chest, but—

'What's the pattern? Is it writing?'

'They're old Cornish folksongs. I've got "Sweet Nightingale" up my left arm, "Jolly Tinner Boys" up my right and most of "The White Rose" on my torso.'

'Is it woad, like the ancient Britons going into battle?' Esme asked. 'Is it all over you?'

She'd never heard Mrs Pickering guffaw before.

'It's only watercolour,' he said. 'It will wash off in the morning.'

'Think of the bathtub!' Esme couldn't help but say as she imagined the blue tidemark. She had to imagine something other than how far the writing on Rory's torso extended.

Mrs Pickering and Gilbert had gone ahead in the motor car, and they followed on in Mr Evans' cart. This was a mercy, Esme considered, since no one would have wanted to be pushed up against Rory in the back of the car and accidentally imprinted with a Cornish folksong.

'Is that your own dress?' he asked her now, as they watched the fields pass by.

'Why do you say that?' She looked at him. Was it that obvious? Given his own present lack of clothing, was he in any position to criticise another person's attire?

'I'm sorry. I didn't mean to imply anything. It's just that I've only ever see you in variations of brown, but you're tremendously green today. Jade green, isn't it? Wouldn't you say? You're normally a sparrow – an exceptionally nice sparrow, I hasten to add – but today you're a bird of paradise.'

If he had a clean, white shirt on, he would look handsome, she considered. He'd brilliantined his hair back, scrubbed the paint from his fingernails, and he smelled pleasantly of peppermints. But it was difficult to keep her eyes from the text that seemed to be exclaiming across his chest.

'I'm not Jane Eyre, you know. I don't *always* wear brown. I also wear beige, and taupe, and grey.'

'All good earth colours, but today you're more dazzlingly mineral. Why are we taking a holiday from brown sensibleness?'

'Do I look un-sensible?' He certainly did, Esme thought.

'You look like you've bloomed. It isn't your dress, then?'

'No, it's one of Mrs Pickering's.'

'It's a different version of you,' he said appraisingly. 'The colour suits you. You might be a demoiselle from an illuminated manuscript.'

Esme wasn't sure that she wanted to be a demoiselle, or un-sensible, but she was quite happy to have bloomed. She'd originally chosen to wear her tweed two-piece today, but Mrs Pickering had observed that she looked like a lady naturalist on a fly-fishing holiday.

'Aren't you already cooking in all of that tweed?' she'd asked.

'I am a little warm.'

'You'll be like a well-steamed haggis by mid-afternoon. There will be no shade, insufficient seating, and probably some cider that will make your brain boil.'

'Is that how these occasions tend to go?'

'It's the conventional pattern. Do you not have any nice summer dresses with you?'

Esme had tried to recall when she'd last possessed a nice summer dress. She had once worn white cotton and sprig-printed calicoes, but that was before the war, and those dresses were fitted to a girlish earlier version of herself. Those that she still possessed had long since been remodelled into nightdresses.

'I didn't expect it to be so hot here.'

'My green tea dress is a mile too small for me. I carry it around in the hope that I might miraculously shrink one day, but experience suggests the opposite trend. Would you try it on? It was frightfully expensive and it would give me pleasure to see it being worn.'

And so Esme had found herself standing in front of Mrs P's mirror in a length of green chiffon. It was a beautiful colour – the cool blue-green of a deep lagoon or a Roman glass vase – perhaps more malachite than jade.

'You look like a different person.' Mrs Pickering's reflection had smiled. 'You're ten years younger for a start.'

'I'm not sure it's me, though. I've never worn strong colours. I mean, it's a gorgeous colour, and a striking dress, but I'm not certain I have the confidence for it.'

'Perhaps it could be you for today? You know what this set are like – anything goes. There will be such a lot of outlandish fashion, you really won't feel conspicuous. Couldn't you enjoy being a more colourful version of yourself just for one day?'

'You ought to have a peacock feather in your hair,' Rory said now as he looked at her. 'It would complete the composition. Or perhaps you should be carrying a long-stemmed white lily. It makes me want to paint your portrait and I never do portraits.'

She had to look away from him then. 'Everybody won't immediately realise that I'm wearing someone else's dress, will they?'

'No, not at all. You've made it your own.'

The old pony clip-clopped along slowly and Esme looked down on the slanting shadows of hay bales. How peaceful and timeless the scene was. In Rory's book, she'd been reading about haymaking carrying on behind the lines of the trenches. The events that were meanwhile going on at the front made her see the men around her in a new perspective. Was that why they wanted to dress up and dance? Was that what made him write sweet, old-fashioned sentiments all over his arms?

'I feel like getting splificated tonight,' said Clarrie.

'Splificated?'

'Newted!' Rory chimed in.

'Ottered!'

'Ossified!'

'Tanked!'

Zozzled! Hal wrote on his notepad.

'Are you all speaking in tongues?' Esme asked.

'Of a kind.'

'We're going to get *drunk*,' Clarrie explained. 'And it would be most impolite if you didn't join us, Esme, dear.'

'Yes, you must participate in the splification,' Rory implored.

'But Mrs Pickering . . .'

'Bugger Mrs Pickering.'

'I'm going to get tipsy!' Esme chorused, quite forgetting propriety. Was it wrong that she felt a sense of defiance too?

*

Mr Evans left them in front of a large house with slightly fanciful gothic architecture. Gilbert and Mrs Pickering were just getting out of the motor car.

'Are we ready for some rollicking and roistering?' Gilbert asked as he shut the car door.

They stepped through an archway of bunting into a small village of tents and stalls. Esme saw a refreshment table stacked with cups and saucers, piled jumble and needlework stalls, displays of fruit and vegetables and a booth selling ices. A wheel of fortune was spinning, the groans and cheers of the crowd around it communicating where the needle came to rest, there was a hoop-la, a coconut shy, a hut where 'The Sphynx' was telling fortunes, and a rather animated beer tent. A poetry reading had just reached its conclusion on a stage, and a display of country dancing was starting. The house was decked with green branches, flags and streamers, and there was a smell of toffee apples and spilled beer. The swirling, slightly manic music of a steam organ gave the scene an out-of-time feel.

The garden was full of people; they must have come in from all the neighbouring villages, and there was a holiday atmosphere. Esme had been concerned about Rory's attire (or lack thereof), but she realised now that she needn't have worried. While most of the men were in Sunday black, and the women in white muslins, there was also a noticeable number of outlandish outfits in the crowd. She looked around and saw couples in medieval robes, pharaohs and slaves, mermaids and mermen, a wizard and a pantomime horse.

'Don't be fooled by the tea urn,' said Clarrie. 'It's a ruse. The general pattern is that it starts with brass rubbing and pottery demonstrations, but it typically degenerates quite quickly into something altogether more boisterous.'

'There's been much excitement over the Tutankhamun theme,' said Gilbert. 'I read an article about it in the local paper. Jackson has had his gardener make a papier-mâché mummy. It's in the rockery, I understand, lit by coloured electric lights. I believe you can dig for treasure there. The article implied that the treasure may be chocolate coins.'

'I wonder if there's a protective curse upon the rockery?' Rory mused. 'Does it resent being pillaged? Is it buzzing with mosquitos and evil elementals? Is ancient magic ema-nating even now through the flower beds?'

'Come on,' said Clarrie. 'Enough of the evil elementals. We need some booze.'

'Let us skirmish the hordes and secure refreshment for these dear ladies!' Gilbert set off towards the beer tent waving a pretend sword.

Esme waited outside with Mrs Pickering. The tent was packed. They might be waiting here some time.

'They're giddy this afternoon, aren't they?' said Esme.

'They're in their element!' Mrs Pickering laughed. 'Dressing up, treasure hunts, licensed intoxication and rough-housing – they're like children on Christmas Eve. Even Gilbert. And he's definitely old enough to know better.'

'There was a lot of exuberance and quite a bit of compet-itive swearing on the cart.'

'Dear me. Last time I came, Gilbert and I drove back after midnight and left the rest of them to it. They crept home in the morning and slept most of the next day. They certainly weren't so exuberant around the dinner table that night. I think they'd danced all the way through until dawn.'

'I guess that, after everything, it must be healthy for them to have a release.'

'After everything? Don't let them give you that line. No, they leap at the chance of some mischief.'

'I can't look at Rory. I don't know *where* to look! I wish he'd put a shirt on.'

'Ha! I rather think that was the idea.'

Accordions, hurdy-gurdies and fiddles were playing and a troupe of small children were synchronising dance steps on the stage. The rhythm had been taken up by some of the crowd too, though there was slightly less discipline to their moves. Many of the dancing pairs were two women, Esme noticed. She considered, had the war caused that? (Did she think too much about the war?) Mrs Pickering tapped her foot in time to the music and smiled benignly at the crowd.

'Lillian mithered me into going dancing with her last autumn,' Esme said, 'but there weren't nearly enough men to go around. Half the women in the hall were having to take the male lead. The mathematics of it struck me then. The women all seemed to be enjoying themselves, there was a lot of laughter, but I couldn't help think how sad it was.'

Esme had felt sad for the women, for the conspicuously

missing men, and for herself. She had missed Alec intensely at that moment, but that same evening he might have been in a dancehall or a nightclub in London. It was still hard to believe that could be true.

'I remember you telling me. This isn't remotely sad, though, is it?'

'No.' Esme watched the dancers. She didn't feel it today. She wouldn't let his absence make her feel sad any longer. 'Nothing seems to be sad here, does it? Or, at least, not for long.'

'I think the boys have their moments, but they all look after each other.'

'They do, don't they?' It struck Esme that this was a significant concession on Mrs Pickering's part. She'd noticed that Gilbert had been making great efforts to convince his sister of the wholesomeness of their life here, and maybe he'd succeeded.

'He was a good officer, you know,' Mrs P went on. 'Everybody said that. He cared for his men. And you can see that they respect him, can't you? This present arrangement has its faults, and eccentricities aplenty, but all in all, his utopia is a kind-hearted place. I wish he wasn't so far away, that I was more able to keep an eye on him, but he is happy, isn't he? It means a lot to me to see that.'

'Yes, he is,' Esme replied.

Gilbert emerged from the tent with a loaded tray. He carried it through the jostling crowd with a look of great concentration on his face.

'Warm cider for pleasure and vitality,' he pronounced as he placed the tray down on the table. The glasses sloshed slightly.

'It's very cloudy,' Mrs Pickering observed, holding a glass aloft.

'And frightfully strong,' said Gilbert, taking a cautious sip. It was the first time that Esme had seen Gilbert drinking anything stronger than camomile tea. She noticed Mrs Pickering giving him a look. 'Only the one,' he told her. 'High days and holidays, et cetera.'

The cider was slightly warm, but it was also delicious. Esme was thirsty and gulped at her glass.

'Steady on,' said Rory. 'I'm expecting you to be capable of dancing later.'

'If she goes at it like that, she certainly will be dancing!' Sebastian laughed.

Having secured a table, they were reluctant to give it up. The men took it in turns to make forays to the tent, and they watched the stalls and the dancing. Grills had been lit on the far side of the garden and white smoke rolled over the lawn. With the hurdy-gurdy music, the archaic costumes and the drifting smoke, Esme imagined that this was how Merrie England of Olde might have looked – or perhaps it was Merrie England with a touch of ancient Egypt.

'We should go and get some food,' Clarrie proposed. 'I feel in need of something absorbent.'

'Perhaps you young ones might go foraging and bring some victuals back for us oldies?' Gilbert suggested.

When Esme stood up, she realised that her legs were

slightly unsteady. How had that happened? She'd felt entirely well until that moment.

'Whoops,' said Rory. His grin swayed. He offered his extended arm, all scribbled over with blurring blue words.

They headed across the garden, weaving through the jostling crowd. Clarrie and Hal walked ahead and it was pleasant to be able to lean on Rory's arm then. People were wearing such bizarre costumes that it hardly mattered if he was painted blue.

'What does it say?' She examined his forearm. '"I love the white rose in its splendour"?'

'"I love the white rose in its bloom. I love the white rose so fair as she grows. It's the rose that reminds me of you."'

'How quaint,' Esme said.

'Rather lovely, isn't it? Like you.'

He didn't look at her as he said it and Esme wondered if she'd perhaps misheard him. Or maybe it was the next line of the song?

'I really do need some substance that absorbs cider,' she said. 'I think I can hear my legs sloshing.'

Curls of sausage and herrings fizzled on grills. With the smell of it, Esme suddenly realised that she was starving. She let go of Rory's arm to take her paper cone of fried potatoes. She was slightly sorry to do so.

A group of men were singing sea shanties by the rockery; rich, deep male voices joining to chorus about a whaling boat. Behind them, a banner proclaimed, *Welcome to Luxor. You are now entering the Valley of the Kings*. A man in a short

skirt and a good deal of eye make-up was smoking a pipe and endeavouring to make excitable small boys maintain an orderly queue.

'This doesn't feel like the normal world,' she said to Clarrie, who stood at her side. 'I feel I might be in a foreign country or a peculiar dream.'

'I know what you mean – a confusing, overheated, alcohol-fuelled dream.'

But had Alec been to this event? Did he know the words to these songs? Had he danced with Zoubi here? Esme felt, as she looked around, that there was so much about her husband that she would never know now. Parts of his life seemed like a foreign country too.

They threaded back towards Gilbert and Mrs Pickering, past groups who were dancing foxtrots, Charlestons and congas. The light was starting to fade, and torches had been lit now. Light flickered on grinning faces.

'You know, I think I might have fallen into a Thomas Hardy novel,' Esme mused. 'I wouldn't be at all surprised to be elbowed by Frank Troy dressed as a highwayman.'

Rory laughed. 'So long as your skirt doesn't get caught in his spurs.'

She smiled at him for knowing that.

'Gods be praised!' said Mrs Pickering. 'Food, at last! Did you have to net the fish yourselves?'

'It's bedlam beyond the begonias,' Clarrie said. 'You wouldn't believe the sights we've seen.'

'Noble work,' said Gilbert, as he held a piece of fried fish

aloft. 'Gallant efforts. A *Legion d'Honneur* to each of you, my darling boys.'

The waves of sadness passed over and Esme smiled at the laughing faces around her. It was agreeable to eat fried potatoes with her fingers and just to listen to them all talking. She wouldn't think about Alec tonight. She wouldn't let herself.

The dark crept in very quickly. While the movement around Esme seemed luxuriantly slow, time went by fast. It surprised her when Gilbert looked at his wristwatch and pronounced that it was ten o'clock.

'We should make our way round to the magnolia garden.' Rory stood, slightly unsteadily. 'There's a dance band set up. We'll miss all the fun.'

It took some time to progress through the dancers and drinkers. Esme looked up and saw torchlight flickering at the upper storeys of the house and flashing in the windows. Smoke rolled in a blue-black sky. It parted and showed star-pricked heavens. The stars were remarkably bright.

'I'm quite drunk,' Rory whispered, none too quietly, and laughed.

'Splificated?'

He grinned. 'Saturated. I've been glad to see you smiling tonight. Are you having fun?'

How fiery his hair was in the torchlight. He might well be some sort of sprite or satyr. The light glimmered in his eyes and she could feel his breath against her cheek. 'Yes,' she said.

Esme expected him to smile back at her, but he looked

serious suddenly, like he was trying to read something in her face, trying to work something out.

'Come on.' She felt his fingers winding into her hand.

They passed through an arch and stepped into a garden dominated by old specimen magnolia trees. *Magnolia grandi-flora*, Esme thought, and the recollection pleased her. Lanterns had been hung in the branches, and the light that they cast made the garden and the dancers look enchanted.

'It's like a dance in the Garden of Eden,' she said.

'Sans serpents, I hope.'

The white magnolia flowers glowed in the lantern light – they might be an illustration from a Chinese fable – and there was a sweet perfume of blossom and trodden grass. Esme looked up as fireworks shot golden light into the sky, and then Gilbert and Sebastian waltzed past.

'Did you see?' She turned to Rory.

'They're surprisingly nimble-footed, aren't they? In the privacy of Gil's room, they dance to jazz violin on the gramophone.'

'Gilbert and Sebastian?'

'You must have realised they're together?'

She hadn't realised that at all. But it didn't matter. They had spun back into the crowd and nothing really mattered any longer.

'Will you dance with me?' she asked.

'There's nothing in the world that would give me greater pleasure.'

Esme was conscious, at first, of the touch of Rory's hand

spreading across her back. She could feel the pressure of each of his fingertips, and how intently he looked at her. But she let the music take her, went with it, closed her eyes, and leaned against him.

How long did they dance for? It didn't seem like that much time had passed, but then the dancers had thinned out and there was new light in the sky. She put her head against Rory's shoulder and watched the spinning treetops until they slowed and finally fell into shadow against the blueing sky.

'Are you tired?' he asked.

'Yes,' she said. 'I'm not sure that I haven't already been dreaming. Is it possible to sleep on your feet?'

'It is.' He took a step back. She looked at him and there was such tenderness in his eyes. 'Do you want me to take you home?'

'Where are the others?'

'Clarrie drove Hal and Fenella back. Sebastian and Gil are still here somewhere.'

'Where did all the time go?'

'I wish I knew.'

They sat with their backs to the garden wall and watched the sky lighten. A gentle breeze had begun to blow. Only a handful of couples were still dancing over the trampled lawn, and there was no sign of Sebastian and Gilbert. The band had packed up and there was just a man playing a violin now, but how sad and sweet that music was.

'I don't want tonight to end,' she said.

'No. But I fear it is already tomorrow.'

'It is, isn't it?'

'You look like you want to close your eyes.' He said it so softly, and for a moment it might have been Alec's voice breathing into her ear. Just for a second, it was the May Day bank holiday nine years ago, and they were leaning together in Greenhead Park, having danced all through the night. It was the first time she had thought of him in several hours, she realised.

'Did Alec come to this dance?'

'Do you really want to know?'

'I do.'

His expression was apologetic. 'Yes.'

'He was here with Zoubi?'

Rory gave her a long look that answered her question. 'If I'd had any idea, any suspicion, any inkling—' he began.

'I had no idea. I feel a bit stupid.'

'You're not stupid at all. He deceived you. He fooled all of us.'

'I want to let it go,' she said. 'I don't want to speak to the police. I don't want any more consequences. I want it to be the past.'

'He started again. You can too, you know.' Rory rolled his head towards hers.

'He did, didn't he?'

'It's up to you to decide what you want to do next. You're not a widow any longer. You have every right to smile and dance, to be happy and to make a new life.'

'Yes,' she said.

She leaned her forehead against his. As she looked into Rory's eyes, she thought that she might have known him all her life; she had told him all of her secrets and felt that she knew all of his. There was nothing hidden between them, no mysteries, no doubts. When he moved to kiss her, she wanted it too.

Chapter thirty-one

How weary she had felt as they walked back up the drive towards the house. Esme was aware that she was leaning rather heavily on Rory's arm, but it was only as she climbed into her bed that she saw the colour. Her arms and her dress were covered with the misted smudge of Rory's words.

The colour bloomed through the water in the washbasin now. It almost looked like bruising on her arms. She stood on her tiptoes and angled her face in front of the mirror. It was on her neck and her collarbone too. There were parts of the previous night that she hardly remembered, but it was an irrefutable proof of how close they'd been. She did remember that they'd kissed. She couldn't stop thinking about that. When it had happened, it had felt right, she had wanted it – but should she have done? She was still married to Alec. The hurt of the past month came from the fact that she still loved him. Why had she let Rory kiss her then? Esme stirred the blue water in the basin and thought about Lady Macbeth's guilty hands, staining the seas scarlet, turning the green waters red.

She had felt defiant last night, emboldened by alcohol and the atmosphere. They'd all been in a happy-go-lucky

mood and had got caught up in the strange enchantment of the setting. She recalled Gilbert and Sebastian waltzing past and spiralling away then into the crowd. No one was quite themselves last night. Allowances would be made. Could she blame cider and a spirit of defiance? But how was she meant to act with Rory now? Should she tell him that last night had been a mistake?

Gilbert and Clarrie were sitting at the kitchen table with cookery books spread between them.

'Good morning,' said Gilbert. 'Or is it afternoon?'

'Halfway through the afternoon.' Clarrie looked at the kitchen clock. 'Do you want some coffee? I've spent most of the day administering strong coffee and headache powders.'

'Don't worry. I'll make myself a cup of tea, but I wouldn't say no to an aspirin.'

'You too, eh?' Gilbert looked tired. 'Sebastian is like a bear with a sore head. He thinks the cider was off.'

'Off?' Clarrie laughed at that. 'It's nothing to do with the amount that he poured down his throat, then?'

'Rory's out in the garden if you want him,' Gilbert said.

Esme asked herself if they all knew. She hesitated in the doorway. Should she go back up to her room or out into the garden? Perhaps she'd done enough hiding in her room.

She found him watering lines of lettuces. She'd been so comfortable in his company last night, she'd wanted to be close to him, but she felt awkward as she walked towards him now.

'They're talking through next week's menus in the kitchen. Shrimps in aspic! Devilled herrings! My stomach started to turn.' If she kept it light and bright, they could still just be friends, couldn't they?

Rory smiled through his hair as he looked up. 'Tummy feeling queasy?'

'I've felt better. Please remind me never to drink cider again. And you?'

'I've felt worse.'

'Gilbert says Sebastian is suffering.'

'I'll bet. He was going for it.'

'Did I really see Gilbert and Sebastian dancing together? I didn't dream that?'

He grinned. 'No, it wasn't a dream.'

'I saw Sebastian coming out of Gilbert's room one morning last week. He was wearing one of Gilbert's kimonos.'

'Was he indeed!'

'Why are you laughing? Why was Sebastian wearing Gilbert's dressing gown? He gave me a filthy look.'

'I told you: they're a couple. They have been for a long time.'

'How does that work?'

'How?' Rory widened his eyes. 'Do you want a diagram? Do you need the mechanics? They've been together for years on the quiet. Oh, they keep it hush-hush, they don't flaunt it, but haven't you noticed how they look at each other? They love each other. I suspect they perhaps always have.'

'But—' said Esme, and stalled, not entirely sure where to

go next. How had she missed seeing it sooner? She was glad if they loved one another, though she was yet to detect the features that made Sebastian lovable.

'If you don't close your mouth, you'll catch flies,' he advised. 'Is it so very shocking?'

'No. I don't suppose so. I just wasn't aware that sort of thing went on in Cornwall. Does Mrs Pickering know?'

Rory gave her a sideways look. 'Would you want to be the one to tell her?'

Esme contemplated the boundaries of Mrs Pickering's word 'eccentricity'. Was this what she had meant to imply by describing them as *bohemian*? Was Mrs P rather more broad-minded than Esme had supposed? 'I bet she does know. Nothing gets past her. They waltz beautifully.' Esme thought that Sebastian had been waltzing exceptionally well for a man who normally carried a walking cane.

'Don't they?'

'I've never dared to ask him, but how was Sebastian injured? I haven't got to that part in your book yet.'

Rory pressed his lips together, clearly supressing a smile. 'And you won't find it there. He fell getting down from the train in Victoria Station. He was on his way home again, and was so nearly there. Poor soul! It was a nasty break, but I have occasionally overheard him telling people that it was shrapnel on the Somme.'

Esme couldn't help but laugh. 'Those were almost the first words that he said to me – my war wound! What rotten luck.'

'Wasn't it? Don't let on that I told you, eh? If he wants to embroider a story, that's his business.'

'He dances remarkably well for a wounded hero. Marvellous really, isn't it? What pluck he has.'

'Are you being naughty?'

'Only a bit.'

She watched Rory walk over to the rain butt, refill his watering cans and begin on the next row. She'd felt self-conscious and conflicted as she'd stepped out into the garden, but it was so easy to talk with him, so easy to be with him. There was something calming about watching him working, the noise of the trickling water and the smell of the earth. He paused to observe a blackbird on the wall and smiled. How placid his face was today, Esme thought. It was the most pleasant face. They could carry on being like this, couldn't they?

'All the words washed off,' she observed, and then wished she hadn't said it.

'I took a loofah to myself this morning, though I'd smudged most of it off already.'

Did he realise that he'd smudged most of it onto her? She'd left the dress drying on the washing line. She hoped that Mrs Pickering wouldn't spot it there. She didn't relish the prospect of the awkward explanation. Had they all seen her dancing with Rory? Did they all know what had happened last night?

'Hal and I are going for a swim later. The ozone might put some life back into us. Would you like to come?'

She had looked at Alec's photograph earlier and had found

herself reciting excuses to it. But he'd danced with Zoubi in that garden, hadn't he? She pictured Alec's face laughing in the light of the magnolia trees. Had he kissed Zoubi that night? It was three years ago, Esme reminded herself, and they'd been together all that time. He might well have had his arms around Zoubi in a London club last night and he wouldn't have been thinking about her, would he? Rory was watching her, waiting for her reply. She didn't have to feel guilty, did she?

'Yes,' she said to him. 'I'd like that.'

From *The Winter in the Spring*

October 1917

We have orders for the front north of Langemarck and, from Boesinghe, the journey is by foot over duckboard tracks. There are no trench systems in this part of the front; there is just the waterlogged land, tracks and tapes, pillboxes, ammunition dumps, exposure and luck. To either side of me now, in the dimming light, I see a morass of churned mud and the glimmer of shell holes filled with water. The earth looks as if it has been turned over again and again, worked into a glutinous, splinter-threaded swamp. It is as if a great swathe of country has been scraped from the map, all the greens and the verticals taken away. There are no birds in the sky here; only reconnaissance planes flying high.

The mud here sucks, they say. People talk of the Flanders mud as if it were something animate and malign, like it has volition to grab you and pull you down into its depths. It is not like farm mud, not like wet fields trampled by cattle;

rather it is a gluey, yellow slime. It reminds me of the smell of cesspits and abattoirs, of stagnant water, decaying vegetation and rotting meat. In the failing light, this landscape is frightful.

There are wagons and limbers to either side of the track, some just toppled off the boards, others semi-submerged, and one turned up on its end as if it has been dropped from a great height. There are dead mules in the mud too – their stomachs hideously bloated – rusting rifles and machine gun belts. Rations, water and ammunitions come up these tracks every night, working parties, stretcher bearers, troops going up and coming back. It's an endless nocturnal traffic, and so the tracks are shelled with high explosives and gas. It doesn't fill me with confidence to know that, or to look at the wagons and the poor mules.

The track slants and kinks, diverting around the rims of shell holes, almost coming back on itself in places, working through the contours of the churned ground. Here and there, it is buckled, twisted and broken, and we must place our feet carefully. A cold wind cuts across, buffeting us, and sudden rain stings my face. Wet light glints on the helmet of Carey in front and I hear the breath of Smithard behind. When the men talk, it is in whispers, but mostly they don't talk. I've told the men that they're not permitted to smoke. I don't think I've ever needed a cigarette more.

There's a horrible inevitability to the first shrieks of shells. We leap and duck as it starts, bunch and push, feet skidding and arms clutching, trying to stay on the track. I hear a man

behind me cry and I feel an object striking my helmet with a sharp, metallic rap. I crouch down and pull my helmet onto the back of my head. Lumps of earth come down and the boards rock beneath my feet, listing like a boat in heavy weather. The darkness is full of the rush of shock and heat then, of screams, and fire and leaping mud. We flail and thrash on the track, cower and tug at one another, and in the flashing shell light it might be a macabre dance.

I look up to see Lieutenant Haines shouting words that I can't make out, but his arm is extended to the right and then we're all peeling off and running for a group of ruined buildings. I almost expect my legs to keep on sinking as I step off the duckboards, but I find solid ground and a momentum powered by fear.

This expanse of lifeless mud would have been the arable fields of a farm once, I suppose, and these its outbuildings. I think I can perhaps smell hay and cattle in this half-collapsed barn, but there are sour new smells here too. We cram in, huddling together in the black. I put my back to a wall, feeling the vibrations in the ground still, and can't take my eyes from the shimmering sky beyond the doorframe. In the darkness behind, I hear Patrick's voice. I am glad when I hear it, and as fatigue finally takes me, I remember walking in once-upon-a-time green woods.

I slept for a while somehow, but I'm awake now and stiff with cold. My puttees are solid with dried mud and I need to move. In the dawn light, I can pick out the shapes of the

men still slumped in sleep. Roberts and Forster are here with me, Collins and Mason, and Corporal Hall. In the shadows, I see Patrick rubbing his eyes, and he raises a hand to me. He grimaces as he stands and picks his way through the sleeping bodies.

'Where did everybody else go?' he whispers.

I point at the other ruins. There's an opening within the collapsed building to the left and I'm sure that I've seen movement there.

There are splatters of mud on Patrick's face and dark shadows around his eyes. He looks like a phantom version of himself this morning, I think, or perhaps this will be his face when he's an old man. Will we still be friends when we are old men? I feel sure of it. Will we sit in comfortable armchairs and reminisce about this day, marvelling at how we got through it all? He fishes a packet of cigarettes from his pocket and I notice a trembling in his hand as he holds it out towards me. That's new. Our eyes meet, we've both noticed, but I pat my pockets for matches and neither of us says a word. We sit and smoke in silence.

'Is anything alive out there, do you suppose?' Patrick asks, as he flicks ash away. 'A rat? A worm? An ant?'

'Fleas,' I reply. 'Somewhere out there fleas will be thriving. There's always fleas. I'd put money on it.'

Patrick clambers to his feet and stretches. He extends his grimed fingertips up to the lintel beam and I hear him groan slightly before he crouches down again. He looks at me then, his head cocked to one side, and I see his eyes slide.

'What is it?' I ask.

'Listen.'

'If you can magic a nightingale in this place, I might have to write a letter to the Pope.'

He puts a finger to his lips, his face utterly serious, and I listen.

'I can hear Taylor snoring, and I think that's Watkins' chest wheezing, but nothing else.'

'Listen,' he mouths the word again. He raises his eyebrows and fixes his eyes on my face.

I can hear the wind when I focus, Smithard is coughing again, and there is a groan of something mechanical in the distance. Then, suddenly, in the foreground, I hear it: a bright chatter of notes, rising and falling.

'Blackbird,' I say, and can't help but mirror the grin that's spreading across Patrick's face. I almost want to hug him.

'Here?' he whispers, and I fully understood the question and wonder in his voice.

I point my finger, alert now to movement, but it's only a tarpaulin flapping in the wind that I've seen. We train our eyes on the expanse of grey-brown land ahead. A mist is drifting, but nothing else is moving. There isn't a blade of grass or a leaf to move. But there's a flicker then. Could that have been the movement of a bird? I gesture towards the pile of rusted metal, to the far right, where I thought I'd seen it. Patrick grips my shoulder as he cranes his neck.

'There!' I say. 'Do you see? It is, damn it! It's a female blackbird.'

'Is it?'

I extend my arm out and lean against Patrick so that he might look along my fingers. He gets to his feet and takes a step forward. That's the moment when I hear the incoming shell.

There are parts that I can't remember. I can't precisely recall the impact of the shell and the chaos that must have followed. My next memory is of looking down at Patrick's face and knowing that he'd gone. The spirit that had animated his features, that had filled him with wonder, keenness and kindness, and which had made him my dear friend, had departed as surely as the blackbird.

Chapter thirty-two

Esme pushed the manuscript away. She put her hand to her mouth. She'd just witnessed the scene of Rory weeping over the body of his friend. Trying but unable to hold the tears back, he had cut one of the dog tags from the cord around Patrick's neck, and taken the papers from his pockets. He found an unposted letter to his mother there, a piece of flint, a photograph of his dog and a feather.

They'd had to move on shortly afterwards and he'd left Patrick's body in the barn. Rory had found it difficult to do that. Esme couldn't help but turn the pages on, scanning for Patrick's name. Three days later, ordered back to reserve, they'd been on the duckboard track again, and Rory had gone to look for Patrick's body. But he was no longer there. Rory had walked all around the ruins searching, asking himself if his mind was playing tricks. He had poked a stick into flooded shell holes, hefted a fallen beam and lifted sheets of corrugated iron, but Patrick's body was gone. Rory had felt swelling guilt and panic as he searched. When he heard a blackbird singing, he'd wanted to silence it. He had shouted at the bird, irrationally angry with it,

with the war, with this place, with Patrick, and finally with himself.

Esme found him working in the greenhouse.

'What's the matter?' he said.

She reached out and touched his shoulder, but then couldn't help putting her arms around him. He stood stiffly, holding his soiled fingers away from her.

'Whatever is it?' He pulled back and looked at her with concern. 'What has happened?'

'I was reading your book.'

'Oh, God. I'm sorry. Is it that bad?'

'Patrick,' she said. She looked at Rory's face and saw him six years younger, standing among the ruins, and screaming at a songbird. Alec had been right about one aspect: she'd had no idea what they'd all been through.

Rory hadn't known what to do when she'd walked into the greenhouse and put her arms around him. He'd been taking lavender cuttings and his hands were creased with soil. He'd stood there, awkwardly holding his black fingers out, every instinct telling him to fold his arms around her, but propriety requiring him just to stand there. His first assumption was that she'd heard from Miles again, but then she'd said Patrick's name. He had felt a confusing mix of emotions as she stood looking up at him with eyes that threatened to overspill.

He'd wiped his hands on his trousers, in the end, and led her outside. They sat on the step, and she'd asked if she could have a drag on his cigarette.

'You don't!' he protested.

'Needs must. It's good for nerves, isn't it?'

'But it's a filthy habit.'

He rolled his eyes at her when she coughed. 'Oh, all right,' she said, as she handed his cigarette back.

Rory had been in two minds about letting her read the manuscript. He'd tried to write it as it was, and he didn't like the idea of her eyes seeing the worse parts. He'd omitted some of the grimmer details when he'd written that chapter, though, and was glad now that he had.

'What happened to him?' Esme asked. 'Where had he gone?'

'He'd been picked up. He was lucky in that, I suppose – or, rather, it was perhaps fortunate for his family. Lots of casualties weren't recovered. He was taken back and buried in a cemetery to the west of Langemarck. I found him later. We all went there together later on, but I believe that those graves have been relocated now. It seems like a lot of moving around, doesn't it?' He batted his cigarette smoke away from her. 'I'd like to go and look for him again.'

'That was what you meant in the church when you talked about graves that you needed to visit?'

'Yes.'

'I'm sorry. I should have asked you then.'

He shook his head.

'Do you think of him when you hear blackbirds?'

He smiled at her. There was a crease of concern on her forehead. 'I think of him often. He was the closest friend

343

that I had out there and he taught me a lot – knowledge and awareness that I've been glad to have in the years since. I made it up with the blackbirds a long time ago.'

'I'm glad you can say that. I imagine that Patrick would be pleased to hear you say that too.'

'We talked about death sometimes. People did then. We used to have some terribly morbid conversations. He told me that he liked to imagine coming back as a bird – the flight, the freedom and how uncomplicated it would all be. I do occasionally watch and wonder.'

'Like King Arthur coming back as a chough and sailors becoming gulls?'

'It's a fanciful idea, isn't it?'

She took his hand. 'Perhaps. But I like it.'

They'd come out onto the terrace after dinner. Esme had said that she was warm and Rory had shaken his packet of cigarettes. Mrs Pickering had given them a look, though. The light from the dining room spilled out into the garden and Esme could hear their muffled voices around the table inside.

She saw Rory's smile when the match flared. Just for a moment, she remembered sitting in the twilight orchard with Alec, and a flare of flame illuminating his features in a way that was both glorious and devastating, but then Rory's voice was talking again – his calm, warm voice – and she refocused.

'I hope that reading about Miles hasn't upset you?' he said.

'To be honest, I hardly recognise him. I can't equate him with the man I lived with – he might as well be a fictional

344

character. But then I wonder if I ever really knew him. I find myself working through memories all the time now and trying to pick apart what was real and what wasn't.'

'You suspect he always hid things?'

'I think he was always presenting a version of himself that he wanted me to see.'

'We all do that to a degree, though, don't we?'

'I suppose,' she said. Why had she heard hesitation in his voice? Why did she sense that he needed her to agree? 'But I think there's something in Alec's character that makes him take that to extremes.' She looked at Rory. She felt that she knew him much better that she'd ever known Alec; however he wanted her to see him, his voice on paper held nothing back. 'You really ought to think again about sending your book out to publishers. It's a beautiful tribute to Patrick.'

He wound his fingers through hers. 'That means a lot. Thank you.'

It struck her that his manuscript was both a lamentation for his friend and a celebration of a young man's passion for life. A life cut too short. Once, as they'd talked about Alec, Rory had told her that the dead never truly go away, but that they live on in the minds and habits of those they leave behind. Rory had spent most of the day talking about Patrick, he had come alive for Esme in those anecdotes, and she hoped that speaking of these memories had given Rory comfort too.

'I should see if Fenella wants to retire. I've noticed her looking out of the window a couple of times. I can feel her eyes.'

He laughed. 'I saw her, but I didn't like to say.'

She stood up. 'I hope I haven't made you sad today. I feel as if I'm travelling through your memories at the moment and I'm aware that I'm taking you back to difficult places.'

'It touches me that you care. I feel fortunate that you want to read, and I'm grateful to you for letting me talk.'

'I will always be here for you when you want to talk.'

His eyes held hers for a long moment before he nodded and wished her goodnight. It was difficult to walk away.

Sebastian was sorting through the post rack in the hall. He looked up as she stepped inside and smiled. It was a particularly sharkish smile, Esme thought.

'Nocturnal ornithology again, eh? Actually, I ought to remember that one. It might prove useful someday,' he mused. '"No, Officer, of course not, we were just indulging in a spot of nocturnal ornithology!"' He laughed.

'We were hoping to hear the tawny owls,' she said, suddenly feeling defensive. Had he been listening? Had he overheard some of their conversation?

'Oh, owls tonight, is it? There's always something, isn't there?'

What game was he playing? 'They're establishing their territories,' she said.

'They don't like sharing? But it's nice to share, isn't it?' He turned back to sorting through the letters. 'No one has gone through the post today. Is Rory still out in the garden?'

'Yes. He's on the terrace.'

'Oh, good. I'll pass this one on to him.' He dangled a letter between his fingertips. 'I know he was waiting for a letter from his wife.'

Chapter thirty-three

Esme watched seagulls wheeling from her bedroom window, fulmars blown inland and all the trees in the garden gusting. Red roses billowed below and the sash window rattled. The wind was whistling under the roof tiles and she could feel the breath of it in the room. She laced her walking boots and buttoned her coat.

She'd seen Rory heading off on the path towards the village earlier, so she turned her footsteps in the opposite direction. The wind was swirling today, blowing inland one moment, and then whipping away towards the sea. She heard the waves crashing as she walked out towards the cliffs. The sea was a churning pewter colour and great long rollers were coming in. All the peacock colours were gone. The sea was grey, the sky was grey at the horizon, she couldn't tell where one ended and the other began, but black-edged clouds were rushing above. There were no boats rocking on the sea. Everything would be battened down and shuttered. Every sensible person would be safely inside today. But she wasn't sensible, was she? The wind tugged at the roots of her hair, ran her tears away, and she bent against it.

The first raindrops glittered in the light from a break in the clouds, but then the rain was coming down in slanting bars, moving in from the sea. Esme pulled her coat around her. She could taste the salt of the spray and feel the sharp coldness of it on her skin. It was a scalding coldness. She thought of washed-up bones, stripped smooth and bleached by the tides, and the pristine chambers of seashells, and wanted her foolishness to be scoured away.

She'd spent the night going over the question: why hadn't he told her he was married? They'd been talking together for nine weeks and there had never once been the merest hint. That had to be calculation, rather than oversight, didn't it? Only last night, as they'd sat on the terrace, she'd talked about feeling deceived by Alec. Had Rory not been conscious at that moment that he was deceiving her too? She remembered dancing with him in the peculiar light of the magnolia trees, and the sensation as his fingers had first spread across her back. She remembered the kiss. He shouldn't have done that. She shouldn't have let him.

The sea lashed white against the black rocks, sending up shocks of foam. She felt it boom beneath her feet. Some almighty detonation might be going off in the mines deep below. The promontory seemed to be throbbing with it, as if the whole cliff might fall away at any moment. Rory had told her that great boulders rolled across the sea when the weather was wild, huge weights of stone grinding and revolving. He said that the miners in their tunnels below heard the noise of them rolling, like thunder in the deep. Was that another

tall story to charm her? Out to sea, the storm clouds were like a mountain range.

Why had none of the others mentioned that he was married? There had been no suggestion of it. Not once. Had Rory asked them to keep it secret? Had they all agreed to that? How could she have imagined that she was among friends here? She was merely paid staff, there to attend to Mrs Pickering's needs. These men weren't her peers. They weren't her friends. How could she have believed that? The salt spray stung her eyes, so that her tears no longer sprang entirely from self-pity.

Esme screamed into the wind and the waves, and the swelling sea roared back at her. The rain streamed down her face and she felt the land heave beneath her feet. She stretched out her arms to steady herself, but the wind made a sail of her coat. She watched the seabirds being tossed and thrown back against the momentum of their wings. They swung, hung and swooped. If she ran for the edge with her arms wide, would she soar on the wind too? There was a pounding in her blood that pulled her towards the edge.

She had trusted Rory. She had cared for him. As she'd read his manuscript, she had cried for him. Esme had imagined that she might always be able to talk to him, that something permanent had been established between them, and they'd always be able to confide in one another. But then she'd believed that Alec would always be there for her too. With that trust gone, with her confidence proved to be misplaced a second time, she felt terribly embarrassed, betrayed and entirely alone.

The wind buffeted her body, pulled and pushed. As she resisted, she considered what the consequences might be if she just went with it. If she stepped off, what difference would it make? Her life could so quickly be tidied away, and there was no one who would want a keepsake. Nobody would request a photograph of her grave. Would Alec shed a single tear? He might feel relieved.

As she'd drawn the curtains last night, she'd heard their voices down in the garden below: Rory and Sebastian. They had laughed. Had they all been watching her guard coming down and laughing? Was it that she was a bad judge of character? Or did all men think so little of women's feelings? What sort of an idiot was she that she could fall for the same thing twice?

Esme closed her eyes, stretched out her fingertips, and swayed with the wind. There was only her, the roar of the storm, and the sea. She lifted her heels, pulled the wind into her mouth and rocked towards it.

Chapter thirty-four

There were white walls, white sheets and a scintillation in front of her eyes, as if she had looked at lighting, or at the stars for too long. Esme blinked in the shadows of the ceiling beams and the chasing pattern that was sunlight through the lace curtains. It was too bright. Too sudden. Too much. She closed her eyes to it. There were feet on the stairs, doors opening and closing, and the room was full of whispers, insistent one moment, but then gone the next. She slept again.

'You've slept for a long time,' said Clarrie's voice.

He was at her bedside when she opened her eyes. 'Have I?' She tried to sit up then, but how her arms ached. She felt stiff and sore.

'Let me help you,' he said.

She leaned forward into Clarrie's arms as he plumped the pillow behind her. He lifted her into a sitting position. The room rocked slightly as she straightened.

'You're a good nurse.'

'I spent a long time being a patient. There, that's better. You've had a chill,' he said. 'You've been out of it for nearly forty-eight hours. Do you remember the doctor coming?'

'To me? No.'

He put a hand to her forehead, waited a moment, and then nodded. 'Fenella sat up with you last night. She's gone for a nap now. I wondered if you might be able to eat something? I made you chicken soup. It's my Jewish grandmother's recipe. It goes down easily and is guaranteed to cure smallpox, cholera and typhoid.'

She looked around the room as he turned away. 'How did I get back here?'

'You got caught out in the storm, didn't you? Hal brought you back. Don't you remember? The pair of you were soaked through. You looked like two shivering scare-crows and left a puddle in the hall.'

She recalled standing on the cliff then, and the voice she'd heard above the roar of the sea. The voice had said her name, and she'd stepped back. Whose voice had that been?

'Hal? Is he all right?'

'He's fine. He sat by your bedside all day on Monday.'

'I didn't know.'

Clarrie placed the tray on her lap, put the spoon in her hand, and watched her as she ate. Her wrists felt weak and the spoon trembled as she brought it to her mouth. Soup ran down her chin and Clarrie smiled as he moved in to dab drips away with a napkin.

'We've had a rota. Sebastian sat with you for a bit. I believe he read you selections of Shelley and Keats.'

'Did he?'

'He said you weren't a very receptive audience.'

'No. I don't imagine that I was.' Had he really read poetry to her? She remembered that sharkish smile and felt unnerved at the thought of Sebastian watching her sleep. 'That was kind of him.'

'Wasn't it? I think he even surprised himself.'

When had she last eaten? Her tongue felt peculiar in her mouth, and the soup tasted salty. 'I'm sorry to have put you all to so much trouble.'

'We've rather enjoyed the excuse to make a fuss. I'm glad to see you sitting up, though. How do you feel?'

'Delicate. Foolish.'

'The weather changes fast here. It switches and catches you out. We've all fallen foul of it at some time. It was just fortunate that Hal was out and saw you.'

'I must thank him.'

'He'll be glad to know that you're awake. You've been dreaming, you know. You've been talking in your sleep.'

'I dread to think what I've been saying.'

'Nothing salacious, unfortunately. Nothing incriminating.' He took the tray from her. 'Go slowly. Have another sleep, if you can. Doctor Trewin said that you'll need to rest for a few days.'

'I feel as if I could sleep for a week.'

She was too hot one moment and shivering again the next. She wanted to crawl back under the blanket.

He smiled as he watched her from the doorway. 'I'm glad you're back with us, Esme.'

'Yes,' she said. 'Thank you, Clarrie. I'm glad to be back.'

Chapter thirty-five

'They've clucked around you like a set of old hens,' said Mrs Pickering. 'Making you broth, mopping your brow, talking about hot grog and mustard poultices. I'd eke it out for another couple of days, if I were you. They'll be disappointed if you recover too soon.'

'I don't know where Clarrie learned his nursing skills,' Esme said, 'but he's very good.'

'He's always in and out of hospital. I suppose one picks it up.'

'Clarrie is? Why?'

'He has epilepsy.'

'I didn't know that.'

'It's what brought him back from Paris. It didn't come on until a couple of years after the war, but then he started fitting. I believe it cured his wanderlust fairly sharpish. Anyway, how are you feeling?'

'Slightly washed-out. A bit achy. Distinctly foolish.'

'Will you tell me what happened?'

'I should have come back as soon as the rain started.'

'Hal said you were out on the edge of the cliff. If he hadn't seen you, you might have fallen.'

'It was stupid of me. I must apologise to Hal.' She didn't want to talk about it. It seemed idiotic now, but she'd felt so wretched. 'Did the storm blow itself out?'

'Eventually. But it's been wild for three days, on and off. I could hear the roof timbers creaking. It was like being at sea in a galleon.'

'I'm almost sorry I missed it.'

Mrs Pickering settled herself in the chair at her bedside. She adjusted cushions, smoothed her skirt over her knees and, seemingly satisfied, she turned one of her penetrating looks upon Esme. 'What happened between you and young Rory? He's been hanging around your door with a face like a scolded dog. Did you have a lovers' tiff?'

Mrs Pickering's choice of words set her off coughing again. 'What? No, of course not.'

'I have noticed the two of you getting rather close, all of those walks together, and the moonlight tête-à-têtes on the terrace. I'm not the only one who has remarked on it.'

Was that true? Mrs Pickering clearly didn't know about Rory's wife, but the men must. Why had nobody told her? Why had no one stopped her?

'I talk to Clarrie as much as I talk to Rory.'

'What nonsense!' Mrs Pickering wrinkled her forehead. 'It is permitted for widows, you know.'

But for married men? She had to look away from Mrs Pickering's questioning eyes. She didn't want to have this conversation. There was a rime of salt on the window behind her. It looked like an etched drawing, Esme thought, perhaps

of a cloudscape or a mystical woodland. It could be a moorland from above, a study of mosses or seaweed in a rock pool. Perhaps she could close her eyes and pretend she'd drifted off to sleep again? She heard the exasperation in Mrs Pickering's sigh.

It was an effort to get dressed. Esme still felt unsteady and needed to stretch a hand out to support herself on furniture and walls. When she caught her reflection in the mirror, she was surprised to see dark hollows around her eyes and that her lips were cracked. She looked like someone who'd been ill for a long time.

She sat down on the bed to catch her breath and, instinctively, her eyes searched for the reassurance of Alec's photograph face. But she remembered then that the empty frame was in the drawer and the tattered fragments of his image were below it. She'd dreamed about him this week – him and her, as they were. She supposed that she'd dream about him for a long time, that it would take months for her sleeping imagination to accept the truth. She'd also dreamed about Rory last night. That she shouldn't do.

She took the stairs slowly, placing her feet carefully, and clinging on to the banister rail. The door was ajar, but she knocked before she pushed it open.

'I'm not disturbing you at a critical moment, am I?' she asked Hal. He was sitting at his workbench with a paintbrush in his hand. 'You don't mind if I come in?'

He shook his head, put the brush down and shifted a pile of wood from a chair.

'I wanted to talk to you,' she began.

He reached for his notepad, turning through pages of distinctly Zoubi-esque mermaids, before writing, *I'm glad you're up. I'm happy to see you looking better. We've all been worried about you.*

'Did you follow me?' she asked. She wasn't sure that she ought to ask, but she needed to know.

He looked at her for a moment. She could see that he was deciding how he should reply. *Yes*, he eventually wrote.

'I wasn't planning to do anything foolish. Well, nothing more foolish than staggering about in the rain and getting soaked to the skin.'

Was that true? She hadn't planned her actions, it wasn't that she'd thought it through and made a decision, but if Hal hadn't been there, would she have stepped back? Her emotions had been pushing her towards the edge. Had she resisted as he pulled her back? She couldn't remember.

You looked desperately sad. I was worried about you.

'I'm sorry if I made you worry.'

He seemed to be considering the little boat on the bench in front of him, but when he turned he looked her squarely in the eye.

I have known sadness too, he wrote. *I understand that. But you must remember that you have people here who care about you.*

What was her sadness compared with his? He'd been through far worse experiences than she had. She knew that from Rory's manuscript. Hal had been there too on the duckboard track, ordered into that frightful place. But at

what point had his sadness turned into silence? In Rory's manuscript, Hal never stopped talking; whenever he was in a scene, he had opinions to share, and his was a distinctive, vibrant, playful voice. Was it that he couldn't speak now, or that he chose not to?

'I heard a voice when I was out on the cliff,' she said carefully. 'Was it you?'

Esme had thought about it over the past few hours, and she was now certain of it; there had been only him and her there, and someone had said her name. Did the voice that she'd heard fit Hal's face? Was it the voice that was there in Rory's manuscript? She couldn't imagine that it belonged to anyone else. But Hal looked down at the bench and shook his head. He tidied his tools and blew wood shavings away.

'Hal, did you say my name? Can you speak if you need to?'

Something like anguish flinched on his face and she wished that she could take the question back.

I can't.

She felt that she'd been insensitive then. Of course, he couldn't speak. If he could, he would. She reached out her hand to his. 'I'm sorry. I shouldn't have asked that. Thank you for being there,' she said. 'Thank you for caring. I'm grateful that you were there.'

He might not be able to speak, but his look said so much. His eyes lingered on hers. Why did she feel like he was reading her face? Why did she have the sense that he knew all her secrets?

Rory cares about you. You do know that, don't know? he wrote.

Chapter thirty-six

Esme hadn't felt like going down for breakfast, facing them as a group, facing Rory again, but she couldn't hide in her room for ever. Rory hadn't been in to see her. She wondered if he knew that Sebastian had told her. Was he avoiding her? Was that how it would be now?

She wasn't sure what made her put on her black dress. There hadn't been a conscious thought process in that choice, and it was only as she stepped down the stairs that she considered what they might read into it. It was one of her regular day dresses, but looking down now she felt slightly like a fraud. Had she subconsciously wanted them to look at her and see a widow, a woman not to be ridiculed and led on? She hesitated on the stairs, contemplating going back up to change, but then Gilbert was there smiling and saying how glad he was to see her up.

'We're considering how we might go about providing a matchmaking service for owls,' Gilbert explained, as they walked to the breakfast table. 'His lust and longing kept the whole household awake last night. Did you manage to get any sleep?'

'Fitfully,' she replied.

'That bird needs to cool his loins,' said Mrs Pickering. 'Sebastian has suggested a shotgun.'

'Only in jest!' he protested and laughed. His eyes fleetingly met Esme's as she took her place at the table, but she read no communication there.

'It's the tawny owl,' Rory said. 'They're not mating. It's the young birds establishing their territories.' Nobody seemed to be listening and he looked slightly frustrated. The group had evidently decided to enjoy the alternative narrative.

'Clarence's pipes are quite something too.' Mrs Pickering smiled into her coffee cup.

'I'm sorry,' said Clarrie. 'It was driving me to distraction.'

'Did you hear him?' Mrs P asked. 'He roared out of his bedroom window. Such volume! Such language! I bet the fishermen in Newlyn heard you and blushed.'

Clarrie grimaced. 'It's a bit foolish to lose your rag at a bird, isn't it?'

They passed the butter dish and jam pots between them, and all was light and amiable. Even Sebastian was merry and polite this morning. She might have dreamed the encounter in the hall. Only Rory's mood was noticeably altered: he was more subdued than usual, his eyelashes cast down, and spreading honey on his toast seemed to require great concentration. He didn't meet Esme's eye as she passed him the coffee pot.

Mrs Pickering was cutting roses for vases and Esme was called upon to stand attendant with a basket. Though Mrs P

protested, Gilbert had insisted on sketching the scene, so it had become as much a tableau as a horticultural activity. He required them to stand at awkward, decorative angles and to freeze their motions at his direction.

'This is ridiculous. I'm sure an earwig has scurried up my sleeve.'

Esme could hear Mrs Pickering's patience quickly ebbing away. Her hand held out a long-stemmed bloom, which Esme, for the moment, was forbidden to receive. It was peculiar to stand fixed like this, contemplating rose petals and Mrs Pickering's eyebrows. It was most unnatural to face one another in this way, and she felt the weight of Mrs P's examining eye.

'You were quiet at breakfast,' she said.

'Was I? I'm just tired, that's all.'

'Aren't we all? If it wasn't for the look of horror on Rory's face, I'd have seconded Sebastian's suggestion of a shotgun.'

'Surely he didn't mean it?'

'Probably not.'

'Righto! You can move again,' Gilbert shouted.

It was a relief for Esme to move her shoulders and to have Mrs Pickering's penetrating gaze shift away.

'I had to stifle a sneeze,' she said. The damask roses had a spicy scent. There was a hint of the oriental bazaar about them.

'Heavens, you mustn't sneeze! It could be the ruination of a great work of art.' She gave Esme an up and down look. 'Why are you in mourning garb today, anyway?'

'I just grabbed a dress out of the wardrobe. It was the first thing that came to hand.'

'You look like a depiction of gracious solemnity. I'm surprised you brought that dress on holiday. No wonder Gilbert wanted to sketch you against the roses.'

'I didn't think.'

She brushed a flower petal from Esme's shoulder. 'I wish you'd tell me what happened. You were all rosy-cheeked last week, but there are shadows under your eyes this morning. I'm not convinced that you and Rory haven't fallen out. He was gloomy at breakfast too. If you don't tell me, we'll only engage in feverish speculation.'

'There's really nothing to speculate about!' Esme stepped back. 'If you don't need me for the next hour, I might have a walk.'

'Yes, you do that.'

The sea flashed gold and weed welled around the rocks. Small brown fish flickered in the shallow water, and the shadows of gulls glided overhead. Standing here, on the edge of the Atlantic, the sky seemed very broad. The sea bubbled where it pushed up the sand, made fans of fine lace, spread and then gone.

As Esme had read Rory's manuscript, she'd felt for that young man. When he expressed fear, she wanted to protect him. When he was sorrowful, she wanted to put her arms around him. But how well did she actually know him? To not know that someone is married isn't to know them well

at all. Was his wife up in Yorkshire, or was she here some-where? Had she been just out of sight all summer? Esme threw a pebble at the uncaring sea.

She heard the stone sliding and then, when she looked back, there he was on the path. It was the only route down to the cove. There was no way that she could avoid facing him.

'Fenella told me you'd gone for a walk,' he said. 'I've been looking everywhere for you. She thought you might be upset.'

'No,' she said. She turned a shell between her fingers and didn't look at him. Had Mrs Pickering encouraged him to come and look for her? She'd probably enjoy speculating what that might trigger. 'I had a headache, that's all. I didn't sleep well last night. I hoped the sea air might blow it away.'

'And has it?'

'Not yet.'

His marriage was none of her business, she told herself. *He* was none of her business.

'I'm sorry about that. I didn't get a wink of sleep last night.' He hesitated. 'There's something I've been wanting to say to you, but there's never been the right moment.'

Esme watched the waves. There was a lone yacht on the edge of the horizon, its sails bright white against the intensifying blue. It didn't appear to move for a long time. 'Whatever could that be?'

'I think Sebastian might have been up to some mischief. He told you about the letter, didn't he?'

'Mischief?' She could feel his eyes on her face, but she

didn't want to look at him. 'It's absolutely none of my business. But I will admit, I am curious as to why you've never once mentioned her.' She turned to him. 'We've talked so much. I don't understand why her name has never come up.'

'I didn't know how to say it. Several times, I've been aware that I ought to, but I've never found quite the right time.'

'I suppose Alec never found the right moment either. It's evidently tricky for men to find the right time. How particular you all are with your timings.'

'Please, Esme, it's not like that. Not at all. Will you let me explain?'

'Do I have a choice?'

He sat down on the sand and looked up at her. Esme reluctantly sat down at his side. She noticed that his hands didn't seem entirely steady as he lit a cigarette. There was a sheen on his face. He wiped his top lip with his hand.

'Lexie and I might still be married,' he began, 'but we haven't lived together for the past three years. That's how I ended up here. She left me for another man. Shirley he was called, of all things. And there have been others since. Not that I made life easy for her, I'll admit that, but still – our marriage is ancient history.'

'You love ancient history.'

'But not *this* history.'

'No one has ever mentioned her. Not once.'

'Because they're my friends. Because they're kind.'

'I'm not sure Sebastian is kind. He thoroughly enjoyed telling me.'

'No. Maybe not. But I'm not especially good at talking about the situation and they make allowances for that.'

Esme could see that he found this difficult. She looked away and sifted the warm sand through her fingers. 'You're still in contact with her?'

'She writes to me when she wants money. I really ought to have started divorce proceedings, only it's sometimes easier to push difficult problems under the rug.'

'Clearly,' she said. She looked at him and remembered how Gilbert had once talked about Rory going through a rough patch. So this was it. 'No, I'm sorry. How awful for you.'

'Lexie and I don't hate each other, we just don't get on terribly well. We've both been a little inconsiderate.'

'I think that running away with a man called Shirley might be more than a little inconsiderate.'

'Perhaps. But he apparently possessed qualities that I lacked.'

His cigarette was unravelling, tattering into shreds of paper and spilling threads of tobacco. He seemed not to notice.

'Where is she now?'

'Leeds. We married before the war and she still lives in our marital home, which is fair enough because her parents put most of the money into it. We got together when we were very young, but we've grown up to be different people, who want different things from life. We've grown apart over the years and we won't grow back.'

'Are you not angry with her?'

'Should I be? If living with me was making her unhappy, it wouldn't have done either of us any good to drag it out.

Oh, I know they say you're meant to work at these matters, but some breakages can't be fixed, can they? Plus, I had some problems when I first came home, as I told you.' He kept his eyes on the sea as he spoke. 'My nerves were a bit shot. My old firm had kept my job open, but I made a mess of everything that I touched. I was a liability to Lexie and I was a liability to them. They were apologetic about letting me go, but it knocked my confidence even more. I can understand why Lexie looked elsewhere.'

'And so you came down to stay with Gilbert?'

'I only meant to stay for a few weeks, all I brought with me was a suitcase, but here we are three years on. Gil had a good line in paternal speeches when we were out in France. I think he's always enjoyed playing *paterfamilias*, though I'm not sure he ever expected to end up as the head of a supremely dysfunctional family.'

He skimmed a stone at the sea. She listened to the rush and sigh of the waves. There was something calming in that sound, in its constancy.

'It's obvious that he likes having you here. You mow his lawns, dig his borders and who else would spend all night feeding his kiln? By the sounds of it, you've all helped each other.'

As he dabbed one cigarette out, he lit another. He rubbed his eyes with the back of his hand. 'I hope so.'

'She's never mentioned in your manuscript.'

'I wasn't going to put in anything that made her look bad. I'm not a rat, and I well understand that a lot of it was my fault. I decided to keep that part of my life out of it.'

'I ought to apologise. Why should you have to tell me your personal business?'

'Because we're friends?'

'You know, I had a full-on King Lear moment on the clifftop.' She laughed and then pressed her lips together. 'That's rather embarrassing, isn't it? I tangled you up in my thoughts about Alec. I got everything confused and out of proportion. I've wanted to shout at him, but I ended up shouting at the sea and at you. What an idiot, eh?'

He shook his head. 'You've got a lot to think through and I'm the one at fault. You confided in me – I ought to have reciprocated and explained about Lexie. Sebastian told me I ought to tell you. He said I was being a hypocrite, and he was right. I know I should have said something sooner, only my failed marriage doesn't cast a particularly flattering light on me.' He looked down. 'I kept intending to tell you, but then putting it off. I did that again and again. I didn't want you to see me as a failure, I suppose.'

'As someone who could have done with a little more luck, you mean? As someone deserving of a little more kindness and understanding?'

'As someone who gets traded in for a Shirley?'

'Was he a very dashing Shirley?'

'He's five foot six and works in a confectioner's shop. Lexie was always partial to a custard tart, but I thought that was taking it a bit far.'

She was glad to see his smile again. It struck her that his eyes were the same light blue-green as the inshore sea when

seen from the cliffs. 'A superior custard tart is not to be sniffed at. I do start to feel some empathy for her.'

He exhaled. She watched the smoke curl from his lips.

'Can you forgive me?' he asked.

'There's nothing to forgive you for.'

From *The Winter in the Spring*

October 1917

I watch the jackdaws through Patrick's field glasses; their plumage is lustrous and blue in the winter sunlight. They whirl and cry around the broken belfry. It is a horrible, jagged, gothic shape, and the spiralling silhouettes of the birds make the scene all the more sombre.

Flights of starlings flitter across the ruins and the horizon shimmers behind. The swallows are gathering on wires now, preparing to head south. I imagine how Ypres must look as they tumble above, the rushes and shocks that they must register on the air. What travellers' tales they will have to tell their kind when they meet again in Africa this winter. I remember when we still thought of swallows as the bird that heralded summer, but now they have become the scavengers who crowd in to eat the flies that lift from corpses. I don't want to think of swallows that way.

This spring, I saw new life breaking out from the torn

trunks of trees; buds were opening on pitifully shredded limbs, as if to demonstrate the stubborn endurance of nature and the folly of man. In spring, I felt a sense of security in nature, a reassurance in its unalterable rhythms. I felt certain that it could come back from all the destruction that man is presently throwing at it, but autumn has tested my faith.

The landscape north of here is like something out of a Greek epic. This is a hopeless, fiendish, blasphemous place. Oil splits into rainbows on the waterlogged earth and nothing crawls here. Will crops ever grow in this land again? It is hard to imagine. Is there any sap left to rise, any seed that still carries a germ of life? I look at this place and feel weary. Everything that was lovely has gone. It is all blasted and drowned and poisoned now. I feel that everything is irretrievably spinning in the wrong direction.

'Was it a cathedral?' Hal asks.

'Once upon a time.'

I stir the rubble with my foot and see fragments of blue glass. Were those once heavenly skies or the robes of a saint? Were they parts of images that inspired centuries of faith and hope? The building looks like a tattered piece of lace now. The fine old carving of a window tracery is stark against the white sky and might fall at any moment. Architecture is unravelling all around me; everlasting knots are being unwound; irrefutable geometry is failing. The work of centuries has been undone and it feels like history has somehow got the answers wrong. Ypres is gouged, pocked and pitted. This region is one huge, godless grave.

'Gilbert says there's a swan nesting on the moat.' Hal hands me a cigarette. 'Shall we go and look for it?'

He knows that this is what Patrick would have suggested. 'Yes. If you'd like,' I reply.

Hal helped me write the letter to Patrick's mother. I was glad that he sat at my side and suggested kind ways to arrange the words. It was the hardest letter I've ever had to write, and it would have been yet more difficult to do it alone.

I was surprised by how quickly a reply came. Her envelope arrived yesterday. I dreaded to open it, fearing the questions and recriminations it might contain. I'm ashamed to say that I carried it in my pocket for several hours before I could bring myself to look. It expressed only kindness, though, appreciation for the efforts that she believed I'd made, and thanks for having been a friend to her son. She indicated that Patrick had often mentioned my name in letters. I'm afraid that made me cry.

She told me that she'd like me to keep his books and his field glasses. I was touched by that, and I will put them to good use. How strange it is to go for walks without Patrick, though. I am very fond of Hal, and I'm aware that he is trying to fill Patrick's space this afternoon, but I realise now that I have lost my closest friend. I know the notes of the nightingale's song because of Patrick, and the names of the butterflies and the wild flowers. That is a gift that he has given me, and I will carry it with me for the rest of my days. I think of Patrick lying on his belly next to me in the wood and the rapture on his face as we listened to the nightingale.

I still want to believe that there is such a thing as a human soul and that Patrick's spirit might have found its way back to the woods and the birdsong.

The ramparts have been blasted by artillery, great chasms torn out of them, and the foundations of the walls are all rudely exposed. There are ragged trees along the edge of the moat. Like some tragic chorus in an opera, they wave lamenting limbs. As it doubles in reflection, it is a powerfully bleak sight. A tangle of bramble plucks at my legs as we pick our way to the edge. The black wizened berries look like something that might be poisonous. Hal and I poke sticks in the water, which is full of torn branches and fallen stone and has a nasty brown scum at the edges. We can see no swan, though, and debate whether Gilbert perhaps made it up.

'He's putting away a lot of whisky at the moment, isn't he?' Hal asks.

'Yes.'

We've all noticed it, but no one has actually said it out loud yet. At this moment, I think Gilbert has good reason to try to wash it all away with whisky.

'Do you think it's a problem?'

'I don't know.'

'It's all on his shoulders, isn't it?'

We're all feeling it. It's on all our shoulders. Gilbert asked me if I was feeling overstrung yesterday. I said no, but it wasn't entirely the truth. I'm not sure if my strings are pulled too tight or too loose, but I don't feel right. My nerves are all jangled up, and over-keen, and I find myself sweating

even when I'm cold. I ask myself again if I could have done anything to alter the events of that day. Of course I could.

'Gilbert couldn't have done anything about Patrick.'

'No.' Hal blows out smoke and we watch ripples stretch on the moat. 'I keep thinking of questions I want to ask Patrick. It's difficult to get used to the idea that he's not here, isn't it?'

'It is,' I reply.

A flock of starlings passes over the moat, shifting as one mass, like a great billowing banner, twisting, turning and then unfurling again. A momentum seems to empower and rule the whole flight, as if each individual bird has momentarily been possessed by a collective intelligence. The flock moves as one body, but one whole that must constantly ripple and curve, as if exalting the evening, performing a massed ballet for the dying light. Here and there, as they turn, I hear the rush of a thousand wings, like a sudden wind blowing through trees. Just for a moment, I am in a wood again eighteen months ago, a copse where shining green leaves were uncurling, where there might still have been boars and hares, and I am waiting for a nightingale to sing.

NATURE DIARY
THE LANDSCAPE'S SECRETS

As we climb away from the village, we pass flocks of shaggy goats, leaping from rock to rock, and motionless donkeys. The shadows of clouds roll over the land and my companion points as a hare streaks away. The Cornish have a fear of hares, he tells me. If a hare crosses the path of a man setting out on a journey, he will return home, certain in the knowledge that to continue would be perilous. Albino hares are particularly dreaded. It is said that maidens who die of broken hearts haunt their betrayers as white hares. We walk up onto the moorland, through ling, heather and wimberry, up to the untamed, treeless heights. The fiery yellow of the gorse has faded now, but new blue-green growth is pushing through.

This is a place of remarkable light and fascinating shadow. The ordinance survey map of Cornwall is crowded with the Old English lettering that indicates ancient sites, and it is impossible to walk more than a few miles on this moorland before you encounter hill forts, stone circles and burial chambers. Usually standing remote from settlements, each

of these sites has stories – stories so old that it is no longer possible to pick the facts from the fictions. Is it knowledge of this folklore or their remoteness that gives these places an atmosphere? Perhaps it is something more innate. It feels almost wrong to speak in the presence of such mysterious antiquity. The past seems secretive, but always present here; its shadows are everywhere, but they're impenetrable. This is a land removed from ordinary time, where one feels that extraordinary things might happen.

It's believed that the earliest settlers in Cornwall came from the Alps and the Mediterranean. They put down roots in a region that was well-suited to fishing and agriculture, and they discovered tin in the county's streams. Mines have been worked in Cornwall for at least 3,000 years. It is said that Joseph of Arimathea made his fortune from the tin trade between Phoenicia and Cornwall, and the brass work in King Solomon's Temple was forged from metal from this region.

At one time, more than six-hundred mines were operating in Cornwall, but today there are around forty. As throughout the country, Cornwall has experienced a testing period since the war, and the mining districts have suffered particularly severely. All over Cornwall redundant pits, dumps and mine shafts may be sighted, testament to an ancient industry which is now disappearing.

As we look over old mine workings, thicketed with dusty nettles and hidden beneath bleached grass, my walking companion talks of Flanders. He tells me that as fronts shifted, previously ravaged areas would green over within weeks,

erupting with poppies, cornflowers, camomile and charlock, almost as if nature was making an ironical gesture at man's ravages. Or perhaps it was kindness. As we look on the healing landscape – both here and over there – there may soon be no clues as to what happened, that history may become hidden too, but the sadness will endure in the hearts of those who remember.

From *The Winter in the Spring*

May 1918

There's a canary in a cage on the ward. It's there to cheer the patients up, I know, but it makes me think of canaries in coal mines and I fancy that I smell gas.

'Talkative little soul, isn't he?' The nurse catches my eye as she leans over Hal. She looks like she's been on a long shift and her breath is slightly sour, but Hal barely seems to register her presence. 'They sing tirelessly. Bless their hearts.'

I want to open the cage and let the bird out. It's irrational of me; I shouldn't be thinking about this, but I'm not sure it is happiness that I hear in the canary's chirrup.

'Anything further you can tell us?' Gilbert asks the nurse.

'I'm afraid you'll have to ask the doctor that.'

'Has he eaten anything yet?'

'We're still trying with liquids, but he won't swallow. If we have no luck this evening, Doctor has suggested that we put a tube down his nose.'

I look at Hal's face. His eyes are wide, but no sound leaves his open mouth. A stream of profanity ought to come out at this juncture, he ought to rage objection, but seemingly that is blocked off too. This unaccustomed silence, this uncharacteristic passivity, makes me want to shake his shoulders.

The nurse takes her basin and her flannel, and moves on to the next bed. Hal's face rolls towards us and his eyes meet with ours for the first time. I see fear on his face then, an intensity in his eyes. I can see that he wants to get out of here. His lips move only slightly, but they look like they're making questions. I don't know how I would respond to any questions Hal might have.

'Do you have any pain?' Gilbert asks.

He's better at this than I am. Hal nods his head very slightly.

'Are they giving you medication for it?'

He moves his hand to mime an injection.

'Good. If you need more, you must ask for it.'

Hal raises his eyebrows.

He looks so pale this morning and there are blue smudges under his eyes. His eyes look like they've sunk deeper into his face and I see new lines and shadows on his skin. I know that Gilbert wants to ask the doctor about Hal's voice, whether it's something physical or psychological, and whether it will come back. I keep thinking of Hal singing hymns last summer, and the shockingly sweet voice that had come out of his mouth. At this moment, I could cry at the memory of that voice. I also think about Gilbert's voice on the night after

the attack, how it had cracked and wavered and he hadn't seemed to be able to bring it under control.

I watch Hal's fingers plucking at the sheet. They have scrubbed his fingernails clean, but his hands move like an old man's. I don't know what to say. Gilbert coughs and looks down.

A shell had hit just to the right, sending up a huge rush of mud. When I'd picked myself up and looked again, Hal had gone. For a moment, I'd assumed the worst, but then Gilbert had screamed for help and I'd seen him digging.

Hal was stiff when we dug him out. His body was rigid, as if he'd been dead for hours, but there was no blood anywhere, no signs of any injury on his uniform. Gilbert had rolled him onto his side and rubbed his back, the way I've seen mothers soothing babies, and then all the mud had come up. Hal had retched and it had come out of his mouth, that evil-smelling yellow mud. His eyes were screwed closed as if he was terrified to open them. It was worse when his eyes did open and he started trembling.

I hear his fingers scratching at the sheet now and think about the mud on Gilbert's hands. I can still see him, clawing back the earth, digging down, how frenzied he had looked. How desperate. He had rocked back on his heels afterwards. I couldn't tell if it was a prayer or a curse that he offered up at the sky.

Poor Clarrie is swathed in bandages today, but the doctor says that his head wound will knit together cleanly, and there shouldn't be any lasting damage. Hal's injury is more

difficult to comprehend. I've asked Gilbert whether I ought to write to his parents, but, as he says, what could we tell them at the moment?

'Are they still talking about moving you back to a hospital in England?' I ask and look for a response in Hal's eyes. His blink seems like a signal of agreement. 'Why didn't I think of wangling this one?'

I want to see the glint of humour that's usually there in Hal's eyes, that has always been there, but it's like a light has gone out. How obliviously the canary trills. This incessant warbling sounds almost callous. We sit here, listening to Hal's silence, and I want the canary to stop singing.

Hal beckons for the notepaper and pencil that are at his bedside and we sit and watch as he forms his letters. The pencil hovers over the page and he puts down his words so slowly. This morning he writes like a child who still has to focus on transforming thought into script. When he turns the notepad towards us, his handwriting is hard to read; it's suddenly not the hand I recognise from lists and reports. It is crammed and crowded, like the tension needs adjusting, and it slides off the line at the end, as if his letters are weary. I am struck that even his handwriting is changed.

I can't sleep, he has written. *I shut my eyes, but I can't let go. Will you ask them for something to knock me out? I just want to go to sleep.*

I can see it on his face. I consider, for a moment, if Hal is sorry that Gilbert dug him out.

'I'll try to catch the doctor.'

'It will all be over soon,' Gilbert says. I can tell that he wants to sound decisive and reassuring, I can hear that in his tone, but there's also a slight edge of desperation, and I notice that he's balled both of his hands into fists. I want to believe him, only he said the same thing to Sebastian and Miles yesterday, and I start to wonder if Gilbert is trying to reassure himself. He looks like he needs reassurance this morning. He hasn't shaved, which isn't like him, and I can smell the whisky coming out of the pores of his skin. 'It's turning now. The war isn't going to go on for ever more,' he continues. 'Then, when it's done, we'll look after each other, won't we?'

'Yes,' I say, though I'm not sure if it's an offer or a request.

Hal's mouth opens again and no sound comes out. But then he's nodding his head and I can see that he believes Gilbert. If Hal can put faith in these words, I must try to believe in them too, mustn't I?

'When this is over, I mean to use what resources I have for good,' Gilbert goes on. He looks down at his boots, as if he's embarrassed by his words, as well he might be. 'You've been loyal to me and I will give it back. We'll never forget those we have lost and we will go forward and live full lives for them.'

He looks up then and I see that he is in earnest. I'm not in the mood for one of Gilbert's speeches – at this moment loss and loyalty sound like hollow words, abstractions, empty slogans, and the future is beyond contemplation – but it's very difficult not to be moved by the sight of a man with tears in his eyes. I know Gilbert feels guilt and sorrow, and a great

weight of responsibility, and that he truly does want to make it all right. But there is so much wrong to put right. I think about Patrick and Laurence and Captain Hawkes, and the lives that they might have gone on to have, about MacNeil and Pierce and Smithard. The faces of so many men come back to me. I think about Michael, and the future that was meant to have been his, and my father and my mother, who must find a way forwards without him.

'Thank you,' I say. I'm not sure quite what else to say.

'We'll begin again,' Gilbert says. 'It will get better.'

I do want to believe it.

Chapter thirty-seven

Esme had read the chapter in which Rory described the attack last night, how Hal had been buried, and Gilbert had dug him out. As she sat at breakfast this morning, she thought of Rory's anguish for his friend, and the bright, musical accent that had once come out of Hal's mouth. There was significant muscle damage, but possibly also a psychological element, she'd read. Was that something that might heal with time?

Lost in her thoughts, and the scenes she'd witnessed through Rory's words, she started when Hal held his notepad out towards her.

I want to tell you a secret, he'd written.

Esme sat at Hal's workbench and looked at the bottle. He had painted her name on the glass in a curly gold copperplate. Inside, a jolly red fishing boat, its sides shiny with new paint, tilted on a choppy plasterwork sea. The waves were tipping over at their tops, and he'd fixed the boat in at such an angle that Esme could feel it lurching. Just for a minute, she was standing on the cliff again, rocking on her toes as the full force of the storm rushed in. Just for a second, she felt the

sting of sea spray, but then the roar of it fell to a whisper, and she was reminded of the moment when Rory had taken the conch shell away from her ear and she'd looked up to see his eyes watching.

'A ship called *Esme*?'

Hal nodded.

The boat's masts were bent down. Without its sails raised, her ship would go where the wind and the tides took it, no means to cut against the weather and plot its own course. It looked rather dejected somehow. She imagined a swan with its neck under a wing. A bird with a broken wing. A canary in a cage. She looked closer now and saw the little hinges on the mast.

'So that's the secret – hinges!' It wasn't the secret she'd been expecting him to reveal, but she was touched that he'd finally decided she could be trusted with this information.

There are hidden hinges on each of the masts and threads which control them. Now that the boat is fixed in place, I pull the master string and the masts rise. It's very delicate this part. The threads are easily broken. It's always a relief when the strings aren't tangled and the sails all rise as they should. I thought I'd let you pull the strings. Would you like that?

She looked at Hal and saw encouragement in his eyes and a smile that was slowly stretching on his mouth.

'I'd love that.'

You must be careful, though. If a thread snaps, that's it.

'Will you show me how?'

He wound the cotton around her fingers and mimed

that she must pull gently. Sitting side by side with Hal at the bench, his fingers winding the thread around hers, she could hear him breathing through his mouth. Could she have dreamed that he'd spoken?

Smoothly. Slowly. GENTLY! he wrote. He raised his eyebrows at her.

'I understand.'

She felt a strange sensation of elation as she watched the masts rise and the rigging all fall into shape. He'd treated the sails with some substance that made them appear to billow with a friendly wind. She imagined its momentum, heard it ripple the mainsail into tautness, and turned to Hal and laughed.

His grin was a boy's then, a shiny-eyed, crooked-toothed uncomplicatedly gleeful grin.

'That was thrilling! Thank you for letting me do that.'

You're sailing!

'I am.'

His brow creased with concentration again as he fished a scalpel through the neck of the bottle and cut the threads. Her little ship was untethered now, its anchor slipped. She remembered floating in the sea with the sun in her eyes, the trepidation and then the thrill of being buoyed up on the waves. She remembered holding on to Rory's hands and seeing the glitter of the sea in his eyes.

She's yours to take home. I hope you'll look at her and remember us.

'It's the loveliest present that anyone has ever given me.' It was the trust, as much as the gift, that mattered.

You mustn't tell anyone how it's done, he wrote. *It has to be kept a secret.*

Esme wondered who she might tell. 'I won't tell a soul.'

I've never told Sebastian.

Esme smiled. 'No, he must never know.'

I will be sorry when you go.

'Yes. I shall be sorry to leave. Perhaps we might write to one another?'

I'd like that. He tilted his head and raised his finger to her before he wrote again. *We can't tempt you to stay on?*

'Here? I've loved this place and your company, but I couldn't possibly stay. I have to go home with Mrs Pickering. I have to get back to work.'

The locations, the habits, the relationships and roles that comprised her normality had all been dictated by the fact that Alec had chosen to step out of her life, she realised. But with so much of what she'd believed to be the truth now inverted, so many facts having been falsehoods, Esme felt that the foundation stones of her existence had irretrievably shifted. Going forwards, she would be stronger, she would be wiser, she would hold on to the things that mattered to her. She would make changes to her life, she had decided that, but those changes couldn't possibly include moving to the opposite end of the country.

That's a shame.

'Yes,' she said.

She watched Hal put a cork in the bottle. Her ship was sealed now, her voyage finite. She felt the walls of her room in Fernlea shifting inwards.

He picked up his pen again. *You did know him, didn't you?*
I wasn't wrong?

Esme blinked at Hal's letters, the unexpected shapes they
made, the question she wasn't ready for. 'I'm sorry?'

Miles. You can tell me. I won't pass it on to anyone else.
I promise.

It was difficult to disengage Hal's direct gaze. Sitting here,
so close to him, in the bright circle of lamplight, she knew
he could read her face. He would see if she lied again. And
hadn't he trusted her?

'How did you know?'

It was the way you looked at each other.

She wound a piece of cotton around her finger and delib-
erated over how much she should tell him. The tightened
thread pinched. 'Yes, we'd met before. We were friends once,
long ago. We were the best of friends, but that changed. Miles
doesn't want people to know. You won't tell anyone, will you?'

I'm sorry to know that.

She could see it on his face. 'Yes, I'm sorry too.'

And I'm sorry if that makes you sad. You don't have to stay being
a person who is sad.

She considered his words. At this moment, it didn't seem
like there was much to look forward to – but then, what were
her difficulties compared with his? 'The ends of holidays are
always sad, aren't they?'

It doesn't have to be an end.

Would they come back again next summer? Would they
all still be here? It couldn't be the same again, surely?

Esme pictured her little boat on her mantelpiece in Fernlea. It looked rather lonely, one small ship adrift from its familial flotilla. But that was how it had to be. Wasn't it? She had to learn to navigate her own course now. The sharp peaks of the plaster waves churned, and she heard the masts creak as her boat rocked.

'I will look forward to getting letters from you. You must tell me what everyone is doing. It will keep me going through the winter.'

Then why go? he wrote.

Chapter thirty-eight

Esme looked down at the garden from the window of Mrs Pickering's room. The roses had passed their best now, the blooms mouldering and falling away after the rain, but the sedums and oleanders were following on, like a new melody rising in a piece of music. This manicured garden, with its tender and exotic plants, was an island apart in the timeless, untamed landscape that surrounded it. She hoped that it would last, that they could make it work. She hoped she'd have the chance to come here again.

She turned her back on the window and folded Mrs Pickering's green dress in tissue paper. Esme was relieved that the watercolour marks had washed out, but the memories remained. She laid the blouses out on the bed and began to fold each in turn. Mrs P had worn this polka dot the day that they'd motored out to Carbis Bay, the paisley pattern brought to mind the hard ridges of sand on Porthmeor Beach, and the broderie anglaise was the lunch on the lawn the day she'd learned how to swim. Would these patterns always carry those memories now?

Over the course of the summer, Esme had accumulated

objects on the mantelpiece in her room: pebbles, seashells and cuttlefish bones, pine cones and poppy seed heads, a shard of pink granite that sparkled silver in the sunlight, and the piece of sea glass that Rory had placed in her palm. Each of these objects was a memory too. One by one, she had turned them in her hands last night. Would they still hold the same enchantment when she unpacked them from her suitcase? Would the memories and the magic fade in the cold light of her room in Fernlea? She had wrapped her little boat in paper. To be taking it away from here didn't feel right.

'I'm not disturbing you?' said Rory from the doorway.

'No, of course not. I'm only doing Mrs Pickering's packing.' She turned. 'Your hair!'

'It was probably overdue.'

He ran his fingers through it. It was very neat and very short, a tidy barber's shop job, but it made him look so altered. The bones of his face stood out more and his eyes seemed larger. He looked handsome, conventional, exposed.

'You're like a poor lion who has been shorn of his mane!'

'It does feel a bit odd.'

'Whatever made you do it?'

'Oh, I don't know. Time for a change? Sebastian asked me if I was off tramping this autumn.'

It was strange to see the shaved back of his neck and the white skin that the sun hadn't touched. Esme realised that she was staring at him, but the change was so striking. It was

like a bewitched being in a fairy story had been turned back into a mortal man. She had to resist the urge to put her hand to the short hair that tapered to his neck

'You look smart, anyway.'

'I don't quite know myself in the mirror, but I'll get used to it.'

'I was making a start with Mrs Pickering's trunk. It's such a big job.'

'Are you travelling together this time?'

'Yes. I'm not required to go ahead and banish bohemianism on the return journey.'

He smiled. 'Does she really think we're depraved?'

'Frightfully. Though I suspect she likes it.'

He leaned back against the door frame and crossed his arms over his chest. 'It will seem quiet when you've gone.'

'Without Mrs Pickering's lectures on civility and manners in the dining room?'

'Yes. I will miss getting told off for incorrect use of cutlery and elbows on the dining table.'

'I'm sure we can arrange to send you some admonishing letters.'

'It won't be the same.'

'No.'

He looked down at his shoes. She had to look too and make sure that he hadn't exchanged them for well-polished brogues. No, he was still in his greying plimsolls. She was rather relieved that he hadn't been entirely transformed.

'We'll be collecting the apples soon,' he said. 'I started

sorting the baskets out this morning. I think you'd have enjoyed that.'

'I would.'

'The seal pups are out by September. You can see them from the cliffs. You think they're bathers treading water when you first spot them, but closer up they're like large, playful, wet dogs. I'd love to have shown you that.'

'Yes,' she said. She heard the appeal in his voice and an unsaid question.

'Gil has got an exhibition coming up in October. Perhaps you might persuade Fenella to come down for it?'

'It's a long way to come, isn't it?'

'I suppose,' he said, his voice flattened now.

'I've still got your Wordsworth and your John Clare. Every time I get halfway down the stairs I realise that I've forgotten to pick them up.'

'Keep them. Please. I want you to have them.'

'I couldn't possibly! They're precious to you. I know that.'

'I can buy new copies.'

'It wouldn't be the same. You've written in the margins. You've underlined words.'

As she'd read the poems, she'd considered the words that Rory had chosen to underline, and had tried to decipher the notes he'd made in the margins. There was something intimate about these marks, something very private and personal, like his whispered voice. In lending her these volumes, it had felt as if he had shared secrets with her. It had been an act of trust, she appreciated now.

'You've made me understand those poems,' he said. 'Whatever else happens, I'm grateful for this summer.'

She wasn't sure what she was meant to say to that. 'You should make a list of publishers and start sending your book off this autumn. You must do it.' She wanted him to have a focus, he looked so solemn this morning, but, as she saw his reaction, she realised she perhaps she hadn't picked the right idea.

'I think I need to rewrite some of it. I've put too much of myself into it.'

'But that's why I've found it so moving to read. It's you. You've been remarkably candid. Most people aren't. I feel privileged that you've let me read it.'

'And Alec?' he asked. Esme heard him hesitate. 'How would you feel about him being in print?'

'I don't know this person called Miles. I recognise so little of his personality.' While she'd felt empathy for Rory as she'd read, Alec was an actor playing a part. 'But, having some sense of what you were going though, I can now see why Alec might not have been making the best decisions.'

'You've made your mind up not to go to the police, then? You're not going to take it any further?'

'No. It would give me some satisfaction, I'll admit, but it would impact too many other people. I want to believe that he'll be decent with Zoubi, and that he does love his children. I have to give them that chance, don't I?'

'I respect your decision, of course, but I'm not sure I can forgive him. Whatever the circumstances, however frightful life gets, there are things that you don't do.'

'No,' she said. 'Perhaps you're right.' She'd realised that as she read: whatever Rory's frailties and challenges, he wouldn't have done what Alec did. 'I've been thinking about how I might get hold of an address for Miles Sanderson's family and what I might tell them.'

'What would you be able to tell them? If you give them the details of the grave, the game is up for Alec. But if you're too oblique, you might just unsettle them further.'

'I could tell them that he's in that cemetery, though, couldn't I? Perhaps that he's buried there in an unnamed grave?'

'They will inevitably have more questions.'

'But it moves them closer to the truth, doesn't it? At least they'd be able to visit the cemetery. It might help them to move on with their lives.'

'Is knowing that he's dead better than continuing to hope?'

'All I can say is that I wish I'd known the truth sooner.'

He put a hand to her arm. 'Trust your instinct. If you feel it's the right action to take, make contact.'

'Thank you. It's been troubling me. I can't help but keep thinking that my letter is in his pocket, and I do feel some responsibility for his family. I'm grateful for your advice.'

'We could draft a letter together, if you'd like?' he offered.

'Would you help me?'

He nodded. 'I almost forgot. I meant to give you this back.' He reached into his pocket, and her locket dangled between his fingers. 'I repaired the chain.'

She thought of Alec's photograph swinging inside. 'That was clever of you.'

'It was nothing.'

Her fingertips brushed his as she took the locket from him. She had to resist the urge to grip on to his hand.

'I should take his photograph out.'

'That's very final.'

'Yes, but it's like a memento from somebody else's life now.' She felt disconnected from the grinning young man inside the locket, and from the girl who had let him fasten it around her neck.

'Should I find you a seashell to thread onto your chain? Or a stone with a hole in it? That's meant to be lucky.'

'Is it? That's a new one. There are so many things that are meant to be lucky, or unlucky, here. It's complicated to negotiate, isn't it? If we weren't heading back at the weekend, I think I might have to draw up two lists.'

'I wish you weren't going home,' he said.

Chapter thirty-nine

'Did I interrupt a moment?' Mrs Pickering asked. She sat down on the bed.

'A moment?'

'Between you and young Rory. It looked rather intense. I felt slightly embarrassed to walk into my own room.'

'No, of course not. The chain on my locket had broken. He fixed it for me.'

'Ah, and you lifted your hair as he fastened the clasp at the back of your neck.' Mrs P clapped her hands. 'I've read that scene in a dozen novels. It's classic denouement. Did he move in for the kiss?'

'Really! No, he didn't.'

'What a pity. You could do worse.'

'But you can't stand his red hair. You said he's a dreamer and he's going nowhere. You said he's not a catch.'

'I did say that, didn't I? But he's grown on me this summer. Yes, he has youthful follies, he's sentimental and not always sensible. I mean, what sort of person paints himself blue? But he's very *good*, isn't he? He's a kind and sincere soul. Gilbert is terribly fond of him. He puts me in mind of a

young Coleridge, you know, with all this yomping around on moors and communing with ruins. I've tempered my opinion of him.'

Tempered? Esme would have liked to point out to Mrs Pickering that this was a full 180-degree about-turn, but decided that she ought to bite her tongue.

Instead she said, 'He looks unhappy at the moment. I suggested that he ought to start submitting his manuscript to publishers. He needs something to boost his confidence.'

'But who would want it? I told Gilbert that he ought to slap it on the printing press that's gathering cobwebs in the barn and put the poor boy out of his misery. Do a short print run, let him impose it on his friends, and then it can die its natural death. He'll have got it out of his system then, at least. The thing will have passed through and he'll be able to move on and look forward.'

'You make it sound like a stomach complaint.'

'Well, let Gilbert supply the cure! Isn't that better than subjecting him to months of rejections?'

'Do you think Gilbert would do that?'

Mrs Pickering stood and began to survey the top of the trunk. 'I've put a flea in his ear. Of course, poor Clarence would have to do all the hard work, but if Gilbert issues an order they all jump. Mind you, it might start something.' She bit her lip. 'By next summer they might all be penning their war memoirs or composing challenging modern verse.'

Esme smiled. 'Do you know that Gilbert fancies himself as a poet?'

Mrs P shook her head. She clearly had no time for the idea of Gilbert as a poet. 'I wouldn't have objected, you know.' She folded a scarf, added it to the trunk, and then looked up, her face suddenly serious. 'If you'd wanted to stay on, if you could see yourself making a future here, I wouldn't have stood in your way. Young Rory looks unhappy because you're leaving, that's the truth of it, and you don't exactly look thrilled at the prospect either.'

'Me? Here? I couldn't. I've never considered it.'

'No? You surprise me.'

'Well, only briefly,' Esme admitted. 'Only foolishly. The way that one always wants to stay on at the end of a holiday.'

'He's extremely keen on you. Keen as mustard. I'd go so far as to hazard that he's in love with you, whatever that means. You must see that. I wondered if you felt the same way about him.'

Love? Esme recalled the confusing rush of emotion she'd felt when Sebastian had told her about Rory's wife, how she'd cried for him when she read about Patrick's death, and that moment of recognition as the sea had reflected up into his eyes. She remembered how she'd wanted him to kiss her. 'This isn't my life, though. This isn't where I belong.'

'This isn't where any of them belong, though, is it? Not really. It's a daydream of a place where no one has entirely got their feet on the ground. That's perhaps rather the point of it.'

'Even if I wanted to, it's not realistic. It's not sensible. I need to work.'

'By the time you reach my age, you'll come to appreciate

that realism is highly over-rated. Sometimes in life, being un-realistic, being foolish, is the best possible option. Sometimes you have to take a leap.'

This was most unexpected from Mrs Pickering. She always told her charity widows that they must be cool-headed and prudent, that they must carefully manage their finances and expectations. Was this what Espérance did to people?

'I'm not brave enough,' Esme replied. It was the truth.

'That's a pity. You don't have to mourn for ever, you know. Surely your husband wouldn't want that. Haven't you given it enough time, enough sadness?'

Esme recalled seeing Alec's arm around Zoubi's shoulders, his fingertips gently caressing her skin. Esme felt that she had given him sufficient time and sadness. But mourning Alec had been such a big part of her life. It was central to it. It seemed to leave a huge space now, weakening the architec-ture of everything around it.

'I think I perhaps need a new hobby. I might take up cross-stitch or scrapbooking.'

'Must I shake you?' said Mrs P.

Chapter forty

'You know, I've always rather fancied the idea of a little publishing venture,' Gilbert said, as they lingered at the table after breakfast. 'The art and craft of it, the marriage of the emotional with the satisfyingly practical, and how one might co-operate with likeminded friends.'

'It's about time you found some purpose for that printing press.' Mrs Pickering interrupted his soliloquy. 'Unless you intend to breed spiders, it's rather a waste of space, don't you think? Some of them can give you a nasty bite, I believe.'

Gilbert turned to Rory. 'It's definitely something that you want? You're ready to share it?'

'If you'd asked me six months ago, I might not have been ready.' Rory looked into his teacup as he spoke. 'I wouldn't have had the confidence in it, but I've remembered how, when I first started writing, it seemed important to put those events down on paper. It mattered to record them and to share them. It still matters.' He looked up. 'Yes, I'm ready.'

Over breakfast they'd talked about typesetting, binding and bookshops. Clarrie would work up the pages. It would take some time to lay it all out, he said, but meanwhile they

could think about distribution. Rory didn't appear to be dissatisfied with the fact that it would only be a short print run. It seemed to matter to him more that they would work on it as a group, that they would see it through to the end together. He might have written it, but the story was all of theirs to tell, he said.

Esme had watched them talking. She was happy to hear notes of excitement as their words tumbled together. With this project, they were all looking forward, and it was a passion for them to share. It would be like the old days in Arras, Clarrie said, when they had all pulled together, only that part of their collective storyline had an ending now. Eyes connected around the table at that, they were all silent for a moment, and Esme sensed the unspoken emotion in this acknowledgment.

She thought about how Alec had been part of that group in the winter of 1916. The practical consequences of the decisions he'd made that spring wouldn't ever end. His storyline had irretrievably shifted in May 1916 and she'd been written out of it. She couldn't look at Hal or Rory as Clarrie reminisced about Arras.

Rory leaned his chin on his hand and smiled. It was such a sweet smile and Esme was so glad that he had something to focus on now, but when he looked up she saw that the sadness was still lingering there in his eyes. It would go, though, wouldn't it? He would have new pride and excitements. She wished that she could be here to witness that.

'Correspondence for the director of publishing operations,'

said Sebastian. He put a letter down on Gilbert's breakfast plate and refilled his coffee cup. Esme recognised Alec's handwriting immediately.

'Miles?' Clarrie asked.

'Yes,' Gilbert said.

Esme watched Gilbert's letter knife slicing into the envelope. Why did it make her feel nervous? After all, Alec wasn't going to tell them anything, was he? Gilbert unfolded the notepaper and his eyes skipped along the lines. How peculiar it was that they now carried on conversations from which she was excluded. But then, there was so much from which she'd been excluded. Her eye caught Rory's. He looked down at his plate.

'Everything fine?' Sebastian said.

'It is.'

Esme glimpsed their linked initials at the bottom of the page: *M & Z*. Alec's pen had bound them together into a cypher, as if he was accustomed to concluding correspondence that way. It was a fiction, and yet it wasn't, Esme thought. How difficult it was to get used to that idea.

'Thank you for hospitality, for seafood, chocolate cake and Scotch.' Gilbert smiled as he précised. 'Apologies for hangovers, swearing and abrupt exit, et cetera, et cetera.' He turned the letter. 'Hell's bells!'

Esme looked at Gilbert. He was raising his eyebrows at the page.

'What is it?' Rory asked.

'They're off. They're leaving London. Miles has been

offered a job in America and he's decided to take it. They're sailing for New York at the end of the month.'

'He's a dark horse,' said Sebastian. 'Do you think he knew? Was that why he was acting a bit odd when they came down?'

'He'd have told us, wouldn't he?' Clarrie looked around the table.

'It says here that he's just been offered the job.'

'So that's it? They're going?' Rory took the letter from Gilbert.

'Good luck to them,' said Mrs Pickering. 'I like to see a young man with gumption.'

Esme's eyes connected with Rory's across the table. So they would never see him again. Alec had decided to put distance between them. It really was an end.

Esme stepped out into the garden. A breeze billowed the trees. She watched the wind pulling through the leaves above, making them flicker and stream together, and pictured the swell in the wake of an ocean liner.

Did she feel sadness? Yes, it seemed to underline that their life together was over – she would never hear his voice or see his face again – but there was also a sense of tension unravelling. She was free of him and his tangling lies. There would be no more scenes or shocks. There wouldn't need to be any further explanations. There was a clean finality to it. Esme just had to learn how to live with that now.

She leaned her back against the trunk of the pear tree and listened to the crisp rattle of the leaves above. The pears

were dull bronze now and might well have been plucked from an antique fable. The sky, through the branches, was an impossible blue. Esme took deep breaths and rubbed her temples. The heavy scent of the jasmine was a memory that she couldn't precisely place. She could make new memories now, couldn't she?

Chapter forty-one

'Are you nervous?' Alec had asked.

Esme considered. 'No. Not at all, actually. I feel excited, if anything.'

They sat on the bench and the churchyard was all green shadows and shifting pinpoints of sunshine. A cuckoo was calling, very distantly, and insects flickered in the newly scythed grass. The vicar had just given them a solemn lecture about the responsibilities of matrimony and the seriousness of making a vow in front of God and their families. They'd had to sit there with straight faces for an hour, but as they'd stepped out of the church they had both started to laugh and become so hysterical that they'd wiped tears away.

'Do you imagine there's an emergency congregation that they pull in when there's no family?' Alec said.

'Professional wedding cooers and criers? Women who are determined to get some use out of a decent hat? I think that's more for funerals, isn't it? People love a good funeral.'

There was a jasmine climbing up the wall behind the

bench. Esme caught the sweet, spicy perfume of it and thought that whenever she breathed that scent in the future, it would bring her back to this moment.

'I started thinking about my mother while we were in there,' he said. 'It took me by surprise.'

Esme looked at Alec. His tone of voice had changed suddenly and she hadn't seen that expression on his face before. 'I'm sorry.'

'I wish you could have met her.'

She wound her fingers through his. 'I understand,' she said.

He nodded, his eyelashes cast down. 'I know you do.'

It wasn't the ideal history to have in common – the fact that they had both lost their parents – but it did mean that they understood one another.

'My mother would have approved of you.' His hand squeezed hers. 'She was a strong woman. She might only have been five foot, but there was no mystery as to who was the senior management in our house.'

'Was she? You've never really talked about her.'

'She had a rotten time of it at the end.' He withdrew his hand to light a cigarette. 'My father was ill for the last three years of his life, and in the final months she had to wash him, and dress him, and lift him in and out of bed. I wanted to help her, but there were things that she wouldn't let me do, that she wouldn't let me see. She had such willpower. I suppose she was protective of his pride.'

Esme recalled how her father had cared for her mother at the end. 'The worst circumstances make people strong. It's

like there's an extra store of mental and physical strength that we only find when we're desperate.'

'It used to frustrate me that she wouldn't let me help more – there were scenes and tasks that she deemed unfit for my eyes – and she wouldn't have anyone else come in. She only lasted another six weeks after my father died. She didn't have the heart to go on.'

'I didn't know that.' She'd known that both of his parents had died within the same year, but hadn't realised that he'd lost them both so close together. Was he still feeling the shock of that? 'I think they would be proud of you,' she said, 'coming up here, starting again, being determined to make something of your life.'

'I hope so.'

Primroses glowed where the sun caught them, pushing up from the bone-planted ground, and she could hear a robin singing. The old graves were almost black with moss, but the sunlight picked out their edges.

'Are they watching us, do you think?'

'Mother occasionally taps me on the shoulder and reminds me to scrub my fingernails, and my father's voice quite regularly booms in my head telling me not to be such a silly ass.'

She was glad to see him smile again. 'We will hold each other up, won't we?'

'We will,' he said.

Esme remembered the sincerity in Alec's eyes at that moment. His guard had been down that morning, and she'd

felt glad that she'd seen him like that before they married; she'd sensed that she had seen some essential core of his personality, and fully known the man he was. It had left her with a feeling of certainty.

She looked at his photograph in the locket now. He was wearing the same suit he'd worn on their wedding day. She remembered the texture of it as she'd put her face to his shoulder and the lily of the valley in his buttonhole. It had only been afterwards, when she knew him up close, that she'd seen the places where the lining of that suit had been repaired.

The altar of the church had been dressed with bluebells, cowslips and sycamore branches. Esme had noticed the scent of the bluebells as they stood before the vicar, a smell that seemed to be the equivalent and essence of the colour. She'd also registered the slight echo of their voices in the building. As she'd glanced back at Lillian, she'd seen all the empty pews behind, and had wondered if Alec had felt lonely as he'd travelled north to begin his new life. But neither of them would know loneliness again, she'd thought.

Esme leaned her forehead against the cool of the window-pane and looked down on the garden. How foolish she'd been to imagine that Alec might have had a garden such as this to play in as a boy. Of course, that young man with his repaired suit lining and his carefulness over money didn't come from a house like this. It wasn't that he'd lied, she reflected. It wasn't something devious. He'd simply wanted her to think the best of him and had chosen not to share the

scenes where his life had been complicated or compromised. She'd forgotten that conversation in the churchyard until this morning. He had been honest with her then, hadn't he?

They had married on the first of May, and she'd had hazel twigs and forget-me-nots in her wedding bouquet. As they'd stood in the churchyard afterwards he had sang 'For summer is a-come unto day', in such an embarrassingly loud voice that she'd both laughed and been glad that there was nobody there to hear. As they'd walked back, he had told her about May Day dances and processions in Cornwall, about Saint George, and hobby horses, and the boats all on the salt sea.

'When I was a child, everyone would wake as early as possibly on the morning of May Day and we'd sound tin horns and whistles and drums. We made such a racket!' He'd grinned. 'Respectable people would write outraged letters to the local paper, complaining about how heathen and uproarious it was, but we loved it. It was meant to drive the devil and the winter out of town and that required a lot of noise. We'd all walk out into the country then, cut green branches, and people on the farms would come out with slices of bread for us and glasses of milk. It was the start of summer. It's an auspicious day, a new beginning.' He had looked at her and smiled.

'Will you show it to me? Will you take me there one day?'

'I will,' he'd replied.

And Esme supposed that he finally had.

He had called her his May Queen that day, and she had been certain that he loved her. She hadn't been wrong, had

she? It wasn't that he was a fundamentally dishonest person, she thought now, but life had backed him into corners and she would never really know what he'd experienced in the spring of 1916. Yes, he might have been stronger, he could have made better decisions, but how would she have reacted in those circumstances?

Esme threaded the locket off her chain. It wasn't healthy to let her thoughts endlessly return to questioning his motivations, she knew that, and perhaps it was time to let it be. Part of her would always love Alec, the man he had once been, but she knew she'd never see him again.

Chapter forty-two

Esme knocked on Rory's door, but there was no response. Should she just leave his books here? The door was slightly ajar and she could see papers on the floor, drawings spilling out of a folder. It was curiosity that made her push the handle.

It looked as if he'd been sorting through his sketches. Could these be the illustrations for his book? He'd been talking with Clarrie about how he might transfer them to printing plates. At first, they appeared to be Rory's usual subjects, the characterful trees that he often chose to draw. It was only as Esme looked closer that she saw the personality of these trees was different. These were not the wind-twisted hawthorns and stunted oaks of this valley; these were broken trees, blasted trees, mutilated and tattered. They were lifeless, shredded and gaunt, frightful spectres torn by explosives, burned and severed at the trunk. They were hag-like, fang-like, denatured and disturbing.

'I'm sorry,' he said. 'I didn't mean for you to see those.'

She stood back. She hadn't heard him step into the room. 'No. I ought to apologise. The door was closed. I shouldn't have come in.'

She hugged his books to her chest, these volumes full of green woods and eternal springtimes. This was why he needed poems, wasn't it? 'I brought your books back.'

'Thank you.'

He took them from her and then knelt to gather the papers together. She watched him putting the drawings back into the folder, and wished that she could do something to take these images out of his head. Reading his manuscript, she had travelled through those places with him, but it was shocking to actually see them and know that his hand, his eye, his brain had put these images down on paper. Looking at him kneeling on the floor, she felt overwhelmed with pity and tenderness for him.

'You drew them while you were over there?'

He nodded but didn't look up. 'I felt that I had to put it down on paper.'

What sights to carry around, she thought. Could he ever forget? Would it always cast a shadow?

'I'm glad that you draw whole and healthy trees now.'

'So am I.'

He put the last of the drawings in the folder, stood and placed it on the desk. His hands didn't look entirely steady as he tied the ribbon.

'I saw Gil just before the Christmas of 1919,' he said. He looked at the folder, not at her, as he spoke. 'I was in hospital and he arrived one day, quite unexpectedly, with a box of candied chestnuts and wanted to talk. He was planning to go up to Westmorland, he told me. He was going to take a train

up to Windermere and then he meant to climb a mountain. He wanted to put matters in perspective, he said, and so he was going to climb Bow Fell. That's what he said: "I need to stand at the top of a mountain."' He smiled and finally glanced at her then. It was a complicated smile. 'But it was December, you see. There were paper chains up in the ward and it was sleeting outside. I worried about him after he left. He didn't seem at all himself and it wasn't a rational thing to want to do. The next time that I saw him, three months on, it was the opposite way round. He was the one in hospital.'

'Gilbert? What happened? Did he fall?'

'You don't know this, do you? Fenella never told you?'

'No,' she said. 'I have no idea what you're talking about.'

'You mustn't let on to Fenella that you heard it from me, do you promise?'

She nodded. Where was this going?

'Gil had been in a black mood for months, spiralling downhill, drinking too much, and feeling that there wasn't a way out, and then he took pills.'

Esme realised then. 'Gilbert tried to do away with himself.'

There had always been a hint that there might have been a difficulty in Gilbert's past; she remembered Mrs Pickering getting a telegram and then having to pack a suitcase very hastily, but she'd never imagined that it might be this.

'You must never say anything to anyone. They mustn't know that I've told you.'

She shook her head. His eyes demanded it.

'Thankfully, he didn't make a good job of it,' he went on.

'But afterwards, after Fenella had given him a good talking to, he decided to come down here. He said that he'd had a revelation in the hospital, that he needed to create a garden, to plant new trees, and that's when it all changed for him. It was a vocation suddenly, a task that he had to achieve. This was his way of starting to make it right, I suppose, and it gave him reasons to live and to look forward. It turned him around, and then he wanted to share that with the rest of us.'

'That's when he invited you all down here?'

'He wrote to us, each in turn, and reminded us of a conversation we'd once had back in Arras – a hypothetical conversation, of course, in which we'd all dreamed futures for ourselves. He told us that he wanted to help each of us realise those dreams. He'd sold the family business and now, with the money from it, he wanted to grease the wheels for his old friends, as it were, give us the space and means to let us be the men we'd once talked of becoming.'

'And so Lane End Farm became Espérance?'

'Gil said that we shouldn't go back to routines, obligations and disappointments, to half-lives, to half-living. We were the lucky ones, he said, and we should show our gratitude by making the most of every day. We should be the people we wanted to be. He was given to speechifying about it. He still is.'

'That was very kind of him.'

'Wasn't it?'

'I can't picture it, though, Gilbert trying to take his own life. I just can't see it. He has such a relish for life.'

416

'He refound it. We all did. You will too.'

Esme imagined Gilbert at the top of a snowy mountain, trying to put everything in perspective, and remembered standing on the edge of the cliff. She understood some of it.

'Yes,' she said.

'When I came home, I found a painting that I'd half finished. I'd started it in the summer of 1914, had got so far, and then had forgotten about it. I decided to complete it that spring, five years on. I thought I might enjoy doing it, but I realised as I progressed that I was painting in a different way. I'd changed, you see. Those five years had changed me.' He gestured at the folder. 'What mattered to me had changed. But, the thing is, I still wanted to paint, more than ever. It still gave me pleasure, and the whole and healthy trees were like miracles then. I looked around and there was wonder everywhere. I saw vitality, resurgence, beauty and the kindness of my friends. I wanted to live and see it all. That was my revelation.'

Esme looked and saw radiance in his smile. He shone with it. At this moment, that seemed miraculous.

'I feel glad that you can still see that.'

'We can choose to live,' he said. 'We can choose to start again. Alec started again. That's emphatically clear now. He's made that choice. Can't you?'

'What do you mean?'

'Stay.' He put his hand to her shoulder. 'Live. Live for yourself. Live here with me.'

Chapter forty-three

'The sedums come into their own now,' Gilbert said, as they walked through the garden together. 'The asters, the lilies and the cosmos. The dahlias are such good value. They go on and on.'

Looking at the dogwood blossom against the blue of the sky made Esme wish that she could paint. The satisfaction was in just observing, in just sensing, in just being, Rory said. She breathed in the sweet citrus scent of the stirring branches. The sun was warm on her shoulders, but there was a mellowness to the light today.

'You've planned the garden so well,' she said.

Esme remembered how she'd planted cyclamen for the autumn in Marsden Road, hellebores for Christmas and a witch hazel for midwinter. She had never seen it flower. It was odd to think of that cycle continuing in someone else's garden now. Whoever lived there today, she hoped it gave them pleasure.

'I never stop planning. That's my problem. I've got a vision for what I want it to be: I'd like to create intimate rooms within the garden, to have vistas that will pull you through,

to put in paths, and terraces, and more fruit trees.' Gilbert laughed. 'I have *such* plans for it! Such ambitions! I make drawings, and lists, and it keeps me awake at night.'

Esme saw, with the sweep of Gilbert's arm, that he was planning for years ahead. This autumn, he would put in yew and hornbeam hedging, he said, but it would be several years before they achieved the desired effect. He wanted to add damsons and a persimmon to the orchard, but they wouldn't fruit significantly for another five years. Gilbert was mapping decades ahead. What would she do with those years? In ten years' time, when Gilbert was picking damsons, would she still be polishing his sister's silver?

'I'm glad that it's ambition and excitement that keeps you awake at night.' She smiled at him. It was impossible not to feel the glow of Gilbert's enthusiasm.

Esme hadn't slept that night. She'd pictured Alec on a transatlantic liner, his back always turned to her, and she had walked through woods of Rory's ragged trees. Yesterday he had told her that she must live for herself now, should choose to do work that would make her happy. She could stay here too and write, he'd said. He would do everything in his power to make her happy. But it had sounded like a description of some-one else's life. As she'd struggled to quieten her thoughts, she'd pictured the locks of Mrs Pickering's trunk snapping shut, the trunk being loaded onto the cart, reversing the lane back to the station, and then the inevitability of the rhythm of the train, pulling her back, pulling her north, pulling her home. It was time to step back into her life, and yet – was that living?

'I'd like to make this garden something really special,' Gilbert went on. 'I'd love to share it, to invite people in, because gardens ought to be shared, don't you agree? It gives me such pleasure to walk together like this, to notice things together. I want other people to feel the contentment that I do, to visit and to work here too.'

'To open it up? Would Sebastian like that?' She could hardly imagine that he would.

'Oh, he'll grumble, I know. He'll bluster about it, but then, just watch, he'll adore showing off.' Gilbert grinned, but then his face was suddenly serious. 'I was unwell after the war, you know.'

Esme nodded. She shouldn't know this, she thought.

'It got me down. A lot of men were the same, I believe. I went through a phase when I couldn't get out of my bed for weeks. I was exhausted, but I couldn't sleep. It was an effort to lift my head off my chest. Ludicrously small incidents would make me cry.'

Esme looked at him and felt touched by his candidness. 'I'm so sorry you felt like that.'

'But then there was a day when one of the nurses kindly wheeled me out into the garden. It was only a little courtyard garden, simply pots and climbers, an old elm tree, and iron chairs and tables where I'd seen the ward staff smoking cigarettes. I sat there for a long time, listening to the blackbirds, watching the branches of the trees, and the clouds moving over. I could feel the sun on my face and smell the honeysuckle that was growing up the wall behind. And I knew

then, at that moment, where I needed to be and what would make me well again. I needed to get my hands in the soil. I wanted to make a garden.'

What did he mean her to take from sharing this? Esme recalled what Rory had told her the day before, about Gilbert wanting to stand on top of a mountain in order to find some perspective. He'd failed to do that then, he'd fallen, but seemingly he had found a safe, level earth here. Why had Gilbert chosen to tell her this now? Because he could see that she was falling too?

'I understand some of that,' she said.

'Working here, I feel connected with the seasons, the soil, and the weather, and like my feet are solidly planted in the earth. I know delight when seedlings germinate, when I find a bird's nest, when a plant that was dying back returns. Those are the things that make me get up in the morning, and I want other people to know those comforts and compensations too, people who are struggling, as I was. We've got the space here and I'd like to be able to help people who need it.'

'Like a therapy?'

'Something of that sort.'

'I was glad of the garden at Fernlea after Alec died. It gave me purpose and solace. It was like medicine to me. It would be wonderful if you could offer that to other people.'

It was strange to say Alec's name aloud and to talk about his death. She remembered how often she'd cried in the garden in the first few months. She'd been grateful for the solitude, that no one had seen her tears falling, that nobody

421

had been looking on when she'd crawled behind the potting shed and hugged her knees to her chest; grateful too to open her eyes and notice the breaking buds on the lilac and the birdsong.

Esme considered: had the war made Alec unwell in his mind? Was that what made him reckless? Could that make a gentle man violent? Had some horrific incident pushed him into that place, or was it an accumulation of experiences? She supposed she'd never know, but having read Rory's manuscript, she could imagine how it could have been the case. Reading those pages, she'd seen Rory pushed to the edge too, and despite all the anxieties that he'd suffered, and still suffered, he'd remained kind, loyal and strong. If Alec had been unwell back then, she hoped he was better now, but she'd never wear his locket again.

'Do you still help Maudsley at the weekends?' Gilbert asked.

'Yes, but he's very territorial. He likes to keep me in my place and remind me that he's in charge again now.'

Gilbert laughed. 'I can imagine. Don't let him elbow you out, though. Do remind him that you took care of the garden for three years.'

'He likes to remind me of all my erroneous diversions from his way of doing things.'

'The petunias in nice straight lines and the whitewashed path edges?'

'Fenella told you that?'

'She doesn't dare question his rules either.'

The poppies had shed their petals and the seed heads had

now baked to bronze rattles. She couldn't help but reach out her fingertips and make them shake. The petals had been a deep velvet purple and Esme wished that she could put a pinch of seeds in an envelope and plant them somewhere. If she dropped them into the ground, would Mr Maudsley weed them out? She would like to see some element of this garden at Fernlea, some living reminder of this summer. There would be solace in that too.

Gilbert paused to cut finished flower heads from the dahlias. Esme snapped dead heads off with her fingers and smelled a familiar lemony-herbal scent on her hands. It was companionable to work alongside Gilbert, to talk of lifting tubers and overwintering canna lilies. She felt the tension slacken in her shoulders.

'This is the stuff that feeds the soul, isn't it?' he said.

'It is.'

Esme watched bees clustering on the breaking sedum blossom and remembered how, long ago, her father had taught her to propagate plants from leaf cuttings. It had seemed miraculous to see a whole new plant growing from a single cut leaf, so much from so little. She recalled the look in Rory's eyes as he had talked of miracles and starting again. She had seen joy, hope and courage in him at that moment, and then such intensity as he'd said the word 'stay'.

'Patrick thinks we can't see him.' Gilbert smiled and pointed as the cat slinked beneath the shadow of the fennel. He was just a brief shift of movement in the tortoise-shell light.

'I didn't like to ask who Patrick was at first, but then I felt as if I knew him too when I read Rory's book.'

'This chap turned up on the doorstep as a kitten. He blinked up at us with huge green eyes and he rather reminded us of Patrick. I've no idea where he came from. Alas, he doesn't share our Patrick's reverence for bird life. The items he deposits on the doormat!'

'I could see how close they were,' she said.

'Patrick and Rory were in the same training company at the start and went through most of the war together. Patrick was only twenty-one when he died, still a youth who carried field glasses and bird-spotting books in his pockets, too young to have experienced all of that. I see him in Rory sometimes, you know. Patrick had an influence on him. He's part of the man that Rory has grown up to be. He told me yesterday that he'd like to put a dedication to Patrick at the front of his book. He still exchanges letters with Patrick's mother and he wants her to have a copy.'

'I'm sure she'll feel proud of her son.'

'Rory used to have nightmares about Patrick's death. He still does occasionally. It played on his nerves. He asked himself whether he could have done something to prevent it, whether it was his fault.'

'But it wasn't. He couldn't have done anything.'

All of his sadness was in those drawings of the broken trees, Esme realised. When he observed the living trees now, and listened to the birdsong, he was doing it for Patrick, as well as himself.

'He's had a tough time of it, but he's getting there. Writing has helped him. This publishing project will be good for him. I want him to feel proud of his work and optimistic about the future.'

They helped each other too. Esme saw that now. She understood how it worked, finally: they all held each other up.

'I'm sure Rory will be glad to help you with your plans for the garden.'

'But I can only stretch him so far. You wouldn't be interested in staying on, would you?'

Esme pictured the lines of hedges growing, the new paths that would lead through this garden, and the orchard breaking into blossom. She thought about Gilbert and Rory working here together, making designs into realities, and in the process pushing away the dark shadows. Could she make a future here too? But it was such a change of life.

'I wish I could stay, but I ought to get back.'

'It would be a pleasure to work together, though, wouldn't it?'

'It would.'

Sparrows flittered in the lilac and the wood pigeons were cooing again. She'd hardly slept last night, but she could settle down in one of the garden seats now and close her eyes. Just for a few minutes, she would like to silence the questions in her head and listen to the noises of the garden. Just to know that peace for a few moments. Just to breathe it in. She could smell the dusty scent of the salvias, and the musky perfume of the china roses, and hear Rory's voice telling her to stay. She could so easily stay.

Huddersfield Courier, 29th July 1923.

NATURE DIARY
PRE-EMPTING THE SWALLOWS

The past couple of mornings have been fresher and mist lingers in the garden. There are berries forming on the elder now, on the hawthorn and the blackthorn, and rose hips are starting to glow in the hedges. The scent of apples clings in the orchard and red admirals beat listless wings among the fallen fruit. Ripe barley is yellowing in the fields, and thistledown is blowing on the warm wind today. The seed heads dazzle in the light, and drift, and it might be the start of a summer blizzard. They bunch in the verge and one lands and trembles on my notepad now.

The corn fields will be cut next month. As in all other areas of life, there are superstitions and rituals associated with the harvest here. A series of ceremonial chants accompany the cutting of the final handful of corn, I'm told, and the last sheaf must always be cut by the oldest reaper. This is then plaited into a corn dolly and hung on the chimney in the farmhouse in the hope that it will ensure plenty until the next harvest.

It is traditional in these parts that farmers face towards the west before commencing ploughing and solemnly say, 'In the name of God, let us begin.' The potatoes have all been lifted now and those fields are striping as I write, black rooks and white gulls following the plough team. And so it begins again, the endless cycle going around. I love the rustling of leaves under foot, the smell of the woods in October, and the crump of walking through fresh snow, but I see the signs of this summer approaching its end with a heavy heart.

Swallows are congregating on the telegraph wires today. I hear them twittering, and wonder if they might be debating the route of this autumn's journey. My thoughts return to home too, and before the swallows head south, I must return north. As my summer in Cornwall concludes, I feel grateful to have seen the peacock-coloured waves and the fiery gorse, to have breathed in the scents of seaweed and briar roses, and to have heard the dialogue between the owl and the nightingale. These memories are like small miracles to me. Will I know them again next summer? How very far away that seems at present.

Chapter forty-four

The trunk had gone ahead on the cart. They'd hoisted it up together, debating whether Fenella was taking souvenir rocks home. They'd laughed at that, but it had been an effort to laugh. Hal had caught his eye and Rory knew that he understood how difficult this parting would be.

I don't like goodbyes, Hal wrote.

'No,' he said.

Fenella hugged Gilbert and thanked him for behaving himself. She told him that he must watch his waistline and take his liver tablets. They all smiled as they listened to him being kindly admonished by his sister. He promised that he would report to Yorkshire slimmer and fitter by Christmas.

Sebastian shook Esme's hand. 'Sorry if I've been an ass,' he said. 'It was never personal. Just, you know ... I might even miss you a bit. Just a very *little* bit.'

'Steady on,' Esme replied.

'Good God!' Rory said. 'What's brought on this gush of sentimentality?'

She turned to him and grinned, her eyes finally meeting his then.

They had talked for a long time last night and he had tried again to persuade her to stay. She had said that she needed to earn a living, that she needed security and some space to think. She'd hesitated, though; he had seen that. She didn't look entirely convinced by her own words. Rory had said that he'd move up to Yorkshire, if that would suit her better. He'd go back to the farm, he'd go back to an office job, if it was security she needed; he'd divorce Lexie and marry her – but, of course, she had shaken her head at that. He had told her that he loved her then, the thoughts and feelings finally crystallising into words. They had both cried in the end.

He crossed his arms over his chest. Hal put a hand on his shoulder.

'Goodbye, then,' she said to him.

'I want you to have this.' He put the book in her hands.

'Your John Clare? I told you, you can't give this away.'

'Who said anything about giving it to you? It's only a loan. You must bring it back to me next summer.'

She opened the cover. He watched her eyes, the tremble of her eyelashes. He'd drawn buds breaking into blossom on the flyleaf and the words *Please come back to me*.

'Thank you,' she said.

'I mean it. I meant everything I said last night.'

She nodded. He could see that she was finding this as difficult as he was.

'Touching though this is,' Gilbert said, 'we really need to make that train.'

Esme raised her hand to them a final time before she

closed the car door. Rory could see her face through the rear window. Her eyes held his. It was an agony to hear the engine starting. This was awful, it was wrong, he shouldn't be allowing it to happen, but it had to be her choice.

I'm sorry, Hal wrote. *I did hope that it might have worked out differently.*

'Yes,' said Rory. 'So did I.'

They waved as the car went along the drive and passed through the gates. Rory watched her face, looking back, and then gone. He heard the engine turn and then pause in the lane.

'For God's sake, man, go after her!' Hal said.

Esme looked back at the house as they turned onto the lane, and at him, standing there with his hand in the air still. She'd heard the blackbird singing as she got into the motor car. Had Rory heard it too? She hoped, as Rory's face slipped from sight, that he might be listening to the blackbird.

Mrs Pickering put her hand over Esme's. 'I'm not sure which of you looked more wretched. I hope you've made the right decision. You only have one life, and, believe me, it does gallop by terribly fast.'

Was it the right decision? Esme remembered crossing the Tamar eleven weeks ago, and how she'd needed to find memories of Alec here. At the start of this year she had felt that there was nothing left to look forward to, that her life had ceased to have a forward momentum, and so she must cherish every fragment of that past happiness. Rory had spent

last night talking about the future, a life in which she'd have the garden, writing, friends, and where he and she would be together. It was a future that existed in bright colours, vibrant with scents and textures and birdsong, and she'd seen how much he wanted it to be real. It was a fundamental change of direction, though, giving up all the security she had, and requiring her to place trust in him and in herself. But, she considered now, she already knew everything about him, didn't she? All his fears and regrets and frailties, as well as his strengths. And wasn't she stronger and wiser now too? Could she have faith in that future? Was it worth taking a chance?

The elder and the hawthorn seemed to tint deeper into their autumn colours as the hedgerows passed by. The blackthorns showed their berries, oak leaves bronzed and the brambles were touched with red. Sparrows lifted from the gorse, the flash of a jay's wing was the colour of his eyes and, as they came to the junction of the lane, there was an old buck hare in the grass.

'Did you see him?'

Gilbert crunched the gears and looked back over his shoulder. 'I'm not sure that bodes well! There are old chaps around here who believe it's terribly bad luck to spot a hare as you're setting out on a journey. It's a sign that you should go no further. An omen! They stop their carts and turn around for home.'

'Gilbert, will you stop the car?' she said.

Chapter forty-five

Esme clambered up onto the rock. It was sharp with cockles and barnacles and the effort to cling on to it stung her hands.

'I cut my knee,' she said. She watched as blood beaded and then fell in a small red rivulet.

He swam over, levered himself onto the rock and licked the blood from her leg.

'Vampire! I wasn't furnished with *that* information. Had I known that vampirism was among your hobbies and I might have made a different decision.'

'You should be more careful in these matters.'

'In choosing men? Yes. Clearly.'

Rory's still eyes watched hers. It was like all the false connections flickering behind his face had re-fused over the past few weeks. She liked to watch him working, thinking, sleeping, and how beautiful his peaceful face was. It would just take time, he had said, and it had. Time presently seemed like a miraculous thing. She put her hand to his cheek and kissed his salty mouth.

He slid off the rock and floated in the water, squinting against the sun. 'You posted your letters?'

'I walked into town with them this morning.'

'I would have walked with you.'

She narrowed her eyes to the glitter of the waves. 'I needed to think. I wanted to be certain that I was making the right decision.'

'Do you feel that you have?'

The reflected light rippled over his face. His slicked wet hair was the colour of toffee. She looked at him. She could look at him now. She didn't have to look away. 'For Mrs Sanderson, yes, though I know that knowledge will hurt. As regards staying on here, well, I'm still evaluating. You'll have to work on convincing me.'

'I will apply myself to that.'

She watched his arms moving through the water; the arms that now circled her as she slept and the hands that curled through her hair. She looked down at her own hands and the white ring of skin that still circled her finger. In the end, she'd asked Rory to take pliers to her wedding ring and it had felt like some sort of rite. The metal had warped as it was cut, and there was something very definite and undoable about that twisted, broken circle. They hadn't said anything, as such, to the others, but she'd caught eyes lingering on the place where her wedding ring had been. In private, she and Rory had laughed at the ridiculousness of both being married to other people. It didn't matter, though. This being together was enough.

She'd threaded a pebble onto her chain, a perfect hole worn through it by the sea. He had picked it off the beach and told her that it was a protective amulet that would ward

off curses, pestilence and nightmares. It was an odd sort of love token, but then she supposed it was an odd sort of arrangement. Leaning against the trunk of the quince tree, he had said that he would pick a fruit from it in December, and they would eat it together in their room, as new brides and husbands had done in ancient Greece. It was as much of a pledge as she needed.

Esme watched the light glimmering on the water, listened to the sigh and return of the waves, and remembered the words he'd inscribed inside the cover of his John Clare. When she'd seen the breaking buds that he'd drawn she'd recalled how he'd talked about the battlefield returning to life, and how the seasons must always turn. As she'd heard the car engine start, it had felt as if the journey ahead of her was the return to winter. Could she trust that spring would really come? She couldn't imagine it without him.

He was painting the autumn shapes of the trees now, the trees that would come back and burst to life again in a spring that they would share. He was drawing every day, like he wanted to record every instant of this autumn, and they were planning the illustrations he would make for her book – for *their* book. He'd also painted her portrait in the garden last week, the parasol pines framing her in parentheses, opened and closed.

The glittering light reflected up into Rory's eyes. Esme saw such beauty in his face, kindness and courage, and a history that she was looking forward to discovering more fully. She also saw a future.

'What time does the party start?' she asked.

'Gil has asked people to come for six-thirty.'

'We should be getting back, shouldn't we? I want to wash the salt out of my hair, and we can't be having the esteemed author late for his own party.'

'Race you back to the beach?'

'First back, first in the bath?'

Esme dived off the rock.

The Huddersfield Courier, 2nd September 1923.

NATURE DIARY

Note: We regret to inform loyal readers of this column that this week's Nature Diary will sadly be Esme Nicholls' last. Mrs Nicholls has written for the Huddersfield Courier *for the past nine years and her weekly observations on the flora and fauna of West Riding have given much pleasure to our readers. Through the darkest days, it brought comfort to be reminded of the continuing circulation of nature's eternal rhythms. As the poet John Clare wrote, 'The seasons, each as God bestows, are simple and sublime.' At the most bleak times, when it seemed that spring would never come, we needed that reassurance. Mrs Nicholls has decided to extend her sojourn in Cornwall and so we regrettably part ways here. Admirers of this column will, however, be heartened to learn that a collection of her Cornwall writings, 'Twelve Months in a Zennor Garden', will be published by the Espérance Press next year. This St Ives-based publisher launched recently and will issue its first volume, Lt. R. W. O'Connell's* The Winter in the Spring, *this coming November. We wish Mrs Nicholls every happiness and success in her future projects.*

Acknowledgements

Getting a novel from messy first draft to published book is a team effort and I'm fortunate to be able to work with a talented, patient and good-humoured group of people. I owe particular thanks to my agent, Teresa Chris, without whom I simply wouldn't have these opportunities, and to my editors Alice Rodgers and Clare Hey. Alice invested a huge amount of thought and care in this novel (I do feel that we co-parented this one) and I'm very grateful to Clare for giving it her expert thumbs-up and applying the final polish. The team at Simon & Schuster have all gone above and beyond any job description over the past challenging year, and I feel enormously lucky to have the support of such a committed and passionate group of people. Thank you for having faith in me and for letting me do a job that I love.

Don't miss Caroline Scott's stunning debut,
the BBC Radio 2 Book Club Pick

THE
PHOTOGRAPHER
OF THE
LOST

**If someone you loved went missing, would
you ever stop searching for them?**

1921. The Great War is over and while many survivors
have been reunited with their loved ones, Edie's
husband Francis has not come home. He has been
declared 'missing, believed killed', but when Edie
receives a mysterious photograph in the post, taken by
Francis, hope flares. And so she begins to search.

Francis' brother, Harry, is also searching. Hired by grieving
families to photograph gravesites, he has returned to the
Western Front. He too longs for Francis to be alive, so they
can forgive each other for the last conversation they ever had.

**AVAILABLE NOW IN PAPERBACK,
EBOOK AND EAUDIO**

**SIMON &
SCHUSTER**

When I Come Home Again

'A page-turning literary gem'
THE TIMES, BEST BOOKS OF 2020

1918. A soldier is arrested in Durham Cathedral in the last week of the First World War, but he has no memory of who he is or how he came to be there.

He is given the name Adam and transferred to a rehabilitation institution in the Lake District where Doctor James Haworth is determined to uncover his identity. But, unwilling to relive the trauma of war, Adam has locked his memory away, seemingly for good.

Then a newspaper publishes a feature about Adam, and three women come forward, each claiming that he is someone she lost in the war. But without memory, how do you know who to believe?

OUT NOW IN PAPERBACK, EBOOK AND EAUDIO

**SIMON &
SCHUSTER**